THE GENDERED OBJECT

From Barbie and Action Man to guns via bicycles, perfume and trainers, *The gendered object* is an intriguing collection of new writing on the way in which objects of everyday life are made socially acceptable and 'appropriate' for women or men.

What does the Strawberry Shortcake doll tell us about views of the adult female body? When does the necktie become anti-establishment? How does a woman relate to a washing machine? And can a hearing aid really be gendered? These questions are answered and many others raised in this entertaining study of design for men and women.

for Sarah, Kate & Alex

edited by Pat Kirkham

THE GENDERED OBJECT

MANCHESTER UNIVERSITY PRESS MANCHESTER AND NEW YORK

distributed exclusively in the USA and Canada by St. Martin's Press

Published by Manchester University Press Oxford Road, Manchester M13 9NR, UK
and Room 400, 175 Fifth Avenue, New York, NY 10010, USA

Distributed exclusively in the USA and Canada
by St. Martin's Press, Inc., 175 Fifth Avenue, New York, NY 10010, USA

British Library Cataloguing-in-Publication Data
A catalogue record is available from the British Library

Library of Congress Cataloging-in-Publication Data
The gendered object / edited by Pat Kirkham.
p. cm.
ISBN 0-7190-4474-X (hardcover). – ISBN 0-7190-4475-8 (pbk.)
1. Sex role. 2. Sexism. 3. Femininity (Psychology). 4. Masculinity (Psychology).
5. Attribution (Social psychology). 6. Clothing and dress – Psychological aspects.
7. Toys – Psychological aspects. I. Kirkham, Pat.
BF692.2G466 1996

95-40183

305.3 – dc20

ISBN 0 7190 4475-8 *paperback*

First published in 1996

00 99

10 9 8 7 6 5 4 3 2

Printed in Great Britain
by Bell & Bain Limited, Glasgow

CONTENTS

ILLUSTRATIONS

Every effort has been made to trace the copyright owner of the illustrations
and any person claiming copyright should contact the publishers

CONTRIBUTORS

JULIET ASH teaches the history and theory of fashion design at Ravensbourne College of Design and Communication. She is co-editor with Lee Wright of *Components of Dress: Design Marketing and Image Making in the Fashion Industry*, Routledge and Kegan Paul/Comedia (1988), and co-author with Elizabeth Wilson of *Chic Thrills: A Fashion Reader*, Pandora (1992).

JUDY ATTFIELD is Senior Lecturer in Design History, and Course Leader of the MA in Design History and Material Culture at Winchester School of Art. She was joint editor with Pat Kirkham of *A View from the Interior: Women and Design*, The Women's Press (1989), second edition 1995.

CHRISTINE BOYDELL is Senior Lecturer in Design History at the University of Central Lancashire, Preston. In 1992 she completed her PhD on the textile designer Marion Dorn. Her research interests include British textile design in the inter-war period and women and design.

CHERYL BUCKLEY is Reader in Design History in the Department of Historical and Critical Studies, University of Northumbria, Newcastle upon Tyne. Currently she is co-writing a book on fashion, gender and representation. Her publications include *Painters and Paintresses: Women Designers in the Pottery Industry 1870–1955*, The Women's Press (1990), and 'Made in patriarchy: towards a feminist analysis of women and design', in V. Margolin (ed.), *Design Discourse, History, Theory, Criticism*, University of Chicago Press, (1989).

COLIN CRUISE is from Northern Ireland. He studied Fine Art at Hornsey College of Art and Victorian Studies and English at the University of Keele. He has published several articles on the Irish novelist Forrest Reid and is currently researching the work of Simeon Solomon and later Pre-Raphaelitism. He teaches art history at Staffordshire University and is a regular contibutor to the *Tablet*.

JANE GRAVES trained as a ballet dancer but went to Oxford instead where she read English Literature. Subsequently, she went to the LSE for two years and qualified as a generic case-worker. She has taught at Central Saint Martin's College of Art and Design for twenty-seven years. Currently, she is tutor-in-charge of the Social Cultural Studies programme for three MA design courses. She also operates as a specialist dyslexia tutor. For the last six years she has been retraining as a psychoanalytical psychotherapist. She has four children.

HEATHER HENDERSHOT teaches Film and Television Studies at the University of Rochester, New York. She recently completed her doctoral thesis 'Endangering the dangerous: the regulation and censorship of children's television programming, 1968–1990' and is currently researching the race, gender and class politics of right-wing Christian youth culture.

JULIET KINCHIN has held posts in the Victoria and Albert Museum and the City of Glasgow Museums. In the 1980s she established the Christie's Decorative Arts Programme at Glasgow University, and since 1992 she has been a lecturer in Historical and Critical Studies at the Glasgow School of Art. She has published extensively on the decorative arts of the nineteenth and early twentieth centuries, particularly in the area of furniture and interiors.

PAT KIRKHAM is Professor of Design History and Cultural Studies at De Montfort University, Leicester and a member of the editorial board of *The Journal of Design History*. She has published widely on design, particularly furniture and interior design, gender studies and film. Her major recent publications include *Charles and Ray Eames: Designers of the Twentieth Century*, MIT Press (1995).

KATE LUCK is a Senior Lecturer at Bath College of Higher Education, and a member of the Utopian Studies Society and the Feminist Arts and Histories Network. She is currently completing a PhD on 'Women's trousered dress and radical thought in nineteenth-century America' at the University of North London.

SUSIE MCKELLAR is a graduate of the V&A/RCA's MA History of Design course. Her thesis 'American handguns and handguns in America: a re-assessment of the American handgun industry's role in the design and technology debate' forms the basis of her contribution to this book. She is a lecturer in the History of Design at the University of Central Lancashire.

NICHOLAS ODDY is a Lecturer in History and Critical Studies at Glasgow School of Art. His interests in design are wide ranging and he is also a keen collector of objects, particularly those related to advertising.

ANGELA PARTINGTON completed her PhD at Birmingham University in 1990, and is Lecturer in Design and Cultural History at the University of West of England, Bristol. She has published a number of articles concerning the relationship between women and visual culture, and is currently writing a book on twentieth-century British design, to be published by Manchester University Press.

MARY SCHOESER is a consultant curator and archivist, specialising in textiles. She has written widely on design and her books include *Why Leggings Are Lycra*, Longman Education (1994), and *International Textile Design*, Lawrence King (1995).

HILLEL SCHWARTZ is an independent scholar living in California, currently at work on a cultural history of noise. His most recent book is *Century's End: A Cultural History of the Fin de Siècle from the 990s through the 1990s*, Doubleday (1990; paperback 1995). Forthcoming is *Striking Likenesses, Unreasonable Facsimiles: The Culture of the Copy*.

ANNE WALES teaches Cultural History and Women's Studies at the University of Central Lancashire and is Subject Leader for Cultural and Design History. She has given papers on gender, race and representation and on gendered consumption.

ALEX WELLER recently graduated from De Montfort University, Leicester, with a BA degree in Arts and Humanities (English, Media/History of Art and Design). Her main interests are literature, film and media studies, and she is currently researching masculinity and magazine advertising.

PAUL WELLS is Subject Leader in Media Studies at De Montfort University in Leicester. He has recently completed *Understanding Animation* (Routledge) and is now preparing. *A History of British Animation* (BFI) and a book on American situation comedy.

LEE WRIGHT is a Lecturer in Historical and Theoretical Studies of Design in the University of Ulster at Belfast. She has published widely on clothing, popular culture and industrial design. Her current research concerns vernacular form and national identity in the USA.

Preface

The woman shall not wear that which pertaineth unto man, neither shall a man put on a woman's garment; for all that do so are an abomination to the Lord, thy God. (*Deuteronomy* 22:5)

It is the skirt which rules the destinies of women on the cycle. (L. Davidson, *Handbook for Lady Cyclists* (1896))

This book began as a study of the ways in which objects, particularly objects of everyday life, are made socially acceptable and 'appropriate' for either men or women. The topic grew out of my interests within design history – particularly ways of studying objects and feminist analysis – and within gender, film and cultural studies – particularly cultural constructions of femininity and masculinity. Increasingly important to my work within and across these various areas of study was the gendered coding of dress – a topic which features fairly strongly in this anthology. Increasingly absorbing my attention was the need to qualify notions of the gendered reception of texts (be they films, videos, advertisements, furniture, rooms or whatever) beyond generalisations about female or male 'audiences' (important though that was and is) towards more particular responses. I was also becoming increasingly interested in affective reactions to texts; not only the reactions of different groups of people but also variations in response to the same text by the same person at different moments in time.

My original call for essays focusing on the interactions between gender and designed objects suggested that most contributors might like to write relatively short pieces on particular objects or types of objects. In the last twenty years the emphases within design history on contextualisation, production and consumption – which, in part, developed as an antidote to the study of individual objects out of context and a brand of 'connoisseurship' which substituted for scholarship in the worst sort of élitist 'decorative arts' studies – have meant that it has been unfashionable to concentrate on objects. 'Postmodernism' has helped broaden appreciation of the multi-valency of objects but it has also made more respectable the study of objects out of context, and therefore contributors to this anthology were encouraged to take, where appropriate, an historical viewpoint on the objects or object-related topics of their choice as well as to consider their more individual and esoteric aspects. Some of the essays presented here are the result of more extensive and/or archival research than others which are deliberately more speculative and concerned with exploring topics, ideas and approaches not hitherto widely associated with design history. This volume is offered not as a definitive statement on the gendered object but rather as a scholarly, speculative and, hopefully, pleasurable

contribution to debates on gender, design and the gendering of design. I hope it will inspire further exploration of theoretical concerns and detailed case studies, each informed by the other.

After the opening essay by Judy Attfield and myself, which attempts to raise some of the broader issues related to design, gender and objects and suggest frameworks for their study, the contributions are grouped into sections which relate to: rooms; individual objects of 'industrial design'; children's toys and clothes; adult dress; cinema; and packaging and advertising. I have tried to arrange them so that there are links between them. In the first section, Juliet Kinchin's 'Interiors: nineteenth-century essays on the "masculine" and the "feminine" room' examines the texts which commented on and contributed towards the increasing polarity of room coding in the nineteenth-century middle-class interior. The other essay in that section, 'The washing machine: "Mother's not herself today"' by Jane Graves, discusses one particular gendered room, the kitchen. However, it is as much a rumination on the rituals of the washing machine and Jane's responses to it, as it is a treatise on a room type. Its focus on one particular piece of industrial design provides the link with the next section which brings together three case studies of 'hardware', namely the hearing aid, the bicycle and the gun. Hillel Schwartz's 'Hearing aids: sweet nothings, or an ear for an ear' relates the technology of hearing aids, as they developed from the beginning of the nineteenth century in Europe and the USA, to the complex cultures of the body and of hearing and not hearing. Nicholas Oddy's 'Bicycles' also examines the history of a machine, in this case from the early nineteenth century. Attention is paid to the need to have special frames for women because of the particularities of women's clothing. The gun has been associated with the male world far more than hearing aids or bicycles, and Susie McKellar's case study focuses on the special gun (and related advertising) designed for women by Smith and Wesson.

The essays related to children form a separate section. Two deal with 'hardware' for children, namely toys. Judy Attfield's 'Barbie and Action Man: adult toys for girls and boys, 1959–93' addresses these fascinating objects in terms of the active body, shaping fantasy and parental disapproval. The latter two themes are also raised in Heather Hendershot's 'Dolls: odour, disgust, femininity and toy design' which examines the gendered smell, assumptions of essentialism and the consumer products which accompanied the dolls. The section concludes with Cheryl Buckley's 'Children's clothes: design and promotion' which argues that currently clothes for small children are more highly gendered than only a few years ago. Then comes the section on adult dress, its size reflecting something of the strength of interest in this topic within recent design historical and feminist scholarship. It opens with Colin Cruise's study of male artistic dress, 'Artists' clothes: some observations on male artists and their clothes in the nineteenth century', which considers the 'look' in terms of aestheticism, 'difference' and class. Christine Boydell's 'The training shoe: "pump up the power"' considers the early history of the training shoe as an item of male sportswear, its recent gendered 'make-over' to increase its popularity with women and the promotion of trainers for women. Then follow three articles related to the covering of the male leg. Mary Schoeser's 'Legging it' begins with the recent

revival of the very tightly clothed male leg and moves back to look at the history of this dress type while Kate Luck's 'Trousers: feminism in nineteenth-century America' details the adoption and adaptation of elements of male dress by American feminists in the mid-nineteenth century. One discusses the feminised male leg, the other the masculinised female leg. The question of masculinity, power and trousers is taken up in Lee Wright's study of 'The suit: a common bond or defeated purpose?', and Juliet Ash's 'The tie: presence and absence' focuses on *the* male accessory to accompany the suit. A shorter essay by the same author explores 'Memory and objects'.

The two essays related to cinema were placed next, partly because of the importance of items of dress in each of them. 'Jackets: engendering the object in *Desperately Seeking Susan*' by Anne Wales discusses the relationship between various objects and gendered identity while Paul Wells' 'Tom and Jerry: cat suits and mouse-taken identities' considers a similar theme in relation to two well-known cartoon characters. The penultimate section comprises two essays which deal with advertising, a process which post-dates the design of objects yet is itself an important part of design and design history. 'Cosmetics: a Clinique case study' by myself and Alex Weller considers the different presentation of toiletry products for men and of those for women produced by a leading manufacturer. Angela Partington's 'Perfume: pleasure, packaging and postmodernity' also addresses issues related to masculinities and femininities but it is a broader and more theoretical study, considering perfume and its packaging in terms of 'postmodern' consumption and intertextuality. Last, but by no means least, is Juliet Ash's second essay (an offspring of the first) which addresses objects in relation to issues of memory, absence, grief and remembrance. This, with its references to the past and the present as well as to imagined pasts, presents and futures, seemed an appropriate piece with which to end the anthology.

My greatest thanks are to the authors whose work is presented here. I have greatly enjoyed the dialogues with them that are one of the privileges and pleasures of editing; I learned a great deal in the process and I thank them all most warmly. Above all, they made me think about many things anew. One example must suffice. Juliet Ash's work encouraged me to clarify my own thoughts on memory, bereavement, absence and grief and I found my thoughts continually returning to my mother and my own gendering. I unearthed an unpublished fragment of an article written in 1979 when my mother died[1] and re-working that helped me focus more clearly on the significance of gender and objects in particular rituals surrounding bereavement in Northumberland where I come from. One of the 'traditions' relating to funerals and death is the provision (by no means obligatory) for relatives and friends to ask for and/or be given objects belonging to the deceased as a memento/souvenir of that person. I realised the power of differing cultural traditions when requests by female relatives for one of my mother's 'knick-knacks' were felt by me to be so touching that they brought tears to my eyes, whereas they were seen by others who did not hail from that part of the country as insensitive, even greedy. I had already decided upon some of my mementoes, including a 1940s black velvet coat which my mother bought second-hand from the local book-

maker's wife (who could afford more expensive clothes than any of the other women in the pit village); an object still so powerfully redolent of memories of the gutsy ways in which one woman negotiated enjoying life to the full, being glamorous, working in a factory, being a mother, holding to socialist and feminist principles and strong personal ethics, that my wearing it almost makes her 'real' and almost makes me her. I had also thought that I would give her best leather gloves to my then Head of School (a remarkable woman who thought the world of my mother), a skirt to a colleague who, like my mother, took great pleasure in clothes, and some gold lamé and lurex items which my mother had promised to a teenage 'punk' friend for 'remodelling'. For me, the daughter of this generous, regular and imaginative giver of gifts, it seemed appropriate, if not imperative, to carry out what I felt would have been (and in many instances knew to be) my mother's wishes. Without knowing anything about this or the other requests, my father, at an appropriate moment towards the end of the 'do'/wake after the funeral, took me aside and quietly asked if I had 'sorted out some bits and pieces for those who might want a little something' of my mother's to keep. It was only in the preparation of this book that I fully realised that that particular aspect of the disposal and dispersal of certain objects in a certain way was my gendered job. My brother took on other responsibilities; and, indeed, when my father died played more part in deciding to whom his things went, not least because so many of the objects, like those belonging to my mother, were clearly coded in gender terms – which brings me back to the original intention of this book, namely the exploration of the gender coding of objects.

I am extremely grateful to all those who have discussed with me the issues raised in this book, particularly Judy Attfield, Beverley Skeggs, Steve Baker, Janet Thumim, Laraine Porter and my students at De Montfort University. I am grateful to all those who helped in any way, shape or form with photography and reproduction rights, particularly Andy Hoogenboom, Harry Calver, Faith Taylor and Massimo Torrigiani, and to those who sustained me through a painful period of harassment and 'unwanted gifts'. My three daughters lived more happily with this project than with some of my others and I found their comments on and examples of gendered objects most illuminating. My final thanks are to them (for that and so much else) and to all those people who contact me with new examples of the gendering of design. The most recent came in a phone call from Spain in which Eduardo Delgano told me of a hotel in Bilbao which has introduced rooms and bathrooms specially decorated for the female executive. When I first mentioned my project to him, Eduardo said he felt terrible because he had never thought of objects being gendered. Now he claims, with characteristic Catalonian charm, that his interest has become a major fascination, if not a minor obsession, which has changed his life. I cannot guarantee such dramatic changes to every reader of this anthology but I hope that, after reading it, life and looking will never be quite the same again.

Pat Kirkham, Leicester March 1995

NOTE

1 'Remembering my mother: salt of the earth', *Spare Rib*, no. 102, January 1981, pp. 26–7

Pat Kirkham & Judy Attfield

Introduction

. . . we constantly drift between the object and its demystification, powerless to render its wholeness. For if we penetrate the object, we liberate it but we destroy it; and if we acknowledge its full weight, we respect it, but we restore it to a state which is still mystified.[1]

ARTHES' closing remarks in *Mythologies* (1957) still have a powerful resonance for those interested in discovering the social meaning of things. The concept of false consciousness which prompted Barthes' now seminal work is less fashionable today but, despite an age accomplished in decoding representations and with the expanding virtual world of information technology threatening to engulf our sense of reality, the project of attempting to understand the ways in which our mental and material worlds interact is as intriguing as ever. The enduring quality of Barthes' insight is the warning it gives about the danger of reductionism in the study of material culture.

This anthology focuses on the interrelations of gender and objects – two of the most fundamental components of the cultural framework which holds together our sense of social identity.[2] It questions, through the study of objects, the myriad ways in which the dynamics of gender relations operate through material goods (just as do the dynamics of class, 'race', nation, age and other types of social relations). Relationships between objects and gender are formed and take place in ways that are so accepted as 'normal' as to become 'invisible'. Thus we sometimes fail to appreciate the effects that particular notions of femininity and masculinity have on the conception, design, advertising, purchase, giving and uses of objects, as well as on their critical and popular reception. Objects are highly, though differentially, affective and amongst the strongest bearers of meaning in our society. However, because Modernist thought has undervalued the non-rational, the ways in

which objects inflect gender through human experience as collective and per-
sonal memories, the giving and receiving of gifts, to say nothing of our dream
world, remain under-explored.[3]

In studying gendered objects it is necessary to locate them both histori-
cally and within the sphere of consumption in which the appropriation of
goods into peoples' lives is part of the cultural process of making meanings
with and through things.[4] This study reveals some of the complex meanings
embodied in and constituted by a diverse range of objects. Partington's study
of perfume and its packaging cleverly brings together issues concerning the
object as gift, which 'establishes or reaffirms symbolic bonds between indi-
viduals and objectifies social relationships but, at the same time, with the
construction of multiple identities carries meanings from the broader cul-
tural context into the domain of the personal and the intimate'. The latter is
beautifully illustrated by Madonna (see Chapter 16) whose work has recently
enhanced our understanding of masquerade and female identities, as did a
metamorphosing mouse called Jerry in the Tom and Jerry cartoons (see
Chapter 17). The wide range of objects, from male hose in the Middle Ages
(see Chapter 12) to recent training shoes (see Chapter 11), encourages
comparisons, while historical analyses force attention to the cultural and his-
torical specificity of each case study. The historical dimension highlights
some of the ways in which current gender definitions in our society differ
from those of earlier periods, in which gender boundaries were differently
and, arguably, more distinctly coded.

Considering 'objects' and 'gender' together might suggest that they have
been isolated here as pre-selected specimens to illustrate specific finite fea-
tures divorced from, or unamenable to, human interaction. Object-centred
studies have been criticised for a form of festishism which masks social rela-
tions by looking at objects for their own sake[5] but the intention here is to
emphasise the importance of the relationships between objects and people.
Although the contributions in this volume focus on objects, a common
concern is the relationships between them and people who use, wear, behold,
smell, give, miss or play with them. Objects have provided points of
commonality as well as points of departure. Several essays have in common
the notion of the constructed nature of gendered identities and the active,
informed and imaginative role of the consumer. Some authors have posited
objects in order to discuss how 'things' manage to repulse attempts to be
colonised by the 'other', despite persistent strategies of appropriation, or how
objects evoke and keep memories alive.

To be gendered is to be sexed[6] and sexuality is addressed directly in the

essays on perfume, cosmetics and toiletries, less obviously in others such as
the essays on the washing machine and the hearing aid. Some discuss the
intimate relationship of objects (and smells) to the human body, and Wells
illustrates how particular Tom and Jerry images and gags suggest sexual
ambiguity and innuendo as well as play out cat-and-mouse power relations.
Similarly, Wales' article on the film starring Madonna and Rosanne Arquette
discusses the relationships of certain objects to sexuality and power. Ash dis-
cusses the use of the tie in soft porn 'schoolgirl' images, Cruise longs for the
sensual velvet soul of the male aesthete and Schwartz integrates sensuality
and sexuality into his article on the hearing aid. Gender is also about power
and Wright's discussion of the suit addresses issues of power in relation to
that powerfully coded outfit, and Luck's study of the dress of female
emancipationists illustrates the power of public opinion to effect radical
practices. This volume goes beyond a view of the determining power of
design. That is not to say that it is not important, but simply to acknowledge
its limitations. The essays herein have tended to avoid critiques which attrib-
ute objects with powers – be they of making women conform to sexual stereo-
types if they wear a certain bra or type of high-heeled shoe, or of reducing
men to 'sex objects' if they wear a particular brand of underpants – in favour
of less 'victim', and more agency, focused arguments.

The recruitment of analytical tools from diverse sources and disciplines
reflects the interdisciplinarity of much contemporary cultural history, of
which design history is a part and from which it benefits. The diversity of
writing styles – from the orderly chronological and 'objective' to the very per-
sonal and more speculative – reflects and responds to the fascinating and
contradictory nature of the object–subject relationship. Design is posited
here as material artefact, commodity, aesthetic object, *aide-mémoire*, souve-
nir, lifestyle, political symbol; signifier supreme. Discourse and process are
framed within methods derived from historical and critical studies of visual
culture, material culture studies, media analysis, psychoanalysis, aesthetics,
philosophy, feminist practice, and gender studies – all to aid our under-
standing of the role of the gendered object in people's lives. For example,
Partington argues that design is best understood as a discourse and objects
in terms of the practices of consumption that provide their conditions of
meaning. Ash's essay on the tie uses the personal experience of bereavement
to discuss the ways in which an item of male attire relates to memory, loss
and absence and emphasises the importance of acknowledging the aesthetic
qualities of objects brought out through contemplation as opposed to use.
Graves interprets the gendered meaning of the washing machine as a site of

male control where various types of 'dirt' are eliminated thus devaluing the worth and the pleasures many women find in this so-called 'women's' work.

What objects look like and, if clothes, what people look like wearing them, is an important aspect of how they are perceived in terms of gender at any given moment. Colour and size play key roles in the coding process, the rules of which need to be well known – whether they are adhered to or transgressed. But the essays do not restrict themselves – or objects – to the visual. The heartfelt opening of Cruise's essay: 'I write to you in denim but my soul is velvet', reminds us of the symbolic nature of objects, such as fabrics, and the gendered visual and tactile nature of such symbolism. The physical presence of objects and the significance of how those physical objects are used are also crucial dimensions of meaning. Movement and gesture are seen as gender specific in Attfield's study of Barbie and Action Man, as is hearing in Schwartz's essay, while smell and gender are discussed by both Hendershot and Partington.

The pervasiveness, persistence and power as well as usefulness of binary oppositions are discussed in, and form a link between, many of the essays. They play a part in the gender differentiation of many objects, particularly in relation to colour and size. In our society today, the main visual oppositions which cluster around that of male/female include light/dark, pink/blue and large/small, although others such as geometric/organic, smooth/rough and hard/soft also apply. In terms of subversion, however, it is the appropriation of the most binary-coded items which most disturb the established order. It is helpful to stand back from the concept of 'gender' as a static categorisation – of male in binary opposition to female – and consider instead its active dimension. 'To gender' is not only to code as male or female but also 'to generate' – which can, for the purposes of this field of enquiry, be applied to the act of producing meaning. Thus, rather than viewing gender in terms of male *versus* female, it is often more useful to locate gender as one of the differentiating features which define identity. It is no longer axiomatic for feminists to assume a position in relation to androcentrism. The 'feminine' is not necessarily to be scorned; nor the 'masculine' something to be striven for. Some of the long-standing arguments presented in feminist critiques (of many things, not just design) have focused on a patriarchal system which instils 'traditional' feminine values and positions women in an unequal relationship to men through stereotypical codes and images. This study attempts to acknowledge the power and roles of stereotypes while going beyond them to tease out new meanings in the gendering, gendered acquisition, distribution and use, of objects.

Anne Gray's study of male *control* within the domestic household of the

aptly-named television remote *control* device shows just what an instrument of power a very small object can be.[7] Many people, including children, use objects in ways that designers never even thought of, let alone intended. Our students and friends supplied us with a host of examples, favourites amongst which are one girl giving her Bionic Woman doll a crew cut and another pretending her doll was a battleship. Teenage girls used a Barbie club to play out fantasies about name, age, place of residence and siblings. We photographed a three-year-old boy in his variously over-determined 'male' gear after being struck by his insistence on wearing a football strip and swimming goggles to drive his motorbike. At one moment he decided to give a ride to his female doll, but quickly changed his mind when he realised how soft it was and decided instead to use her as a cushion.

The degree to which gendered objects are part of, and inform, wider social relations is exemplified at every level of daily life. It stretches from the type of clothes we wear to work or choose to go to bed or have sex in (by no means necessarily the same) to the types of presents we give and are given, and from the design of cars to hair-dryers and hi-fi equipment. At one level, the gendering of objects is an extremely complex process, which sometimes seems impossible to elucidate, yet the over-determination of coding involved in the construction of certain objects as 'male' or 'female' can sometimes seem crude, almost comical.

Much of the unease, humorous or otherwise, caused by men 'inappropriately' clad in silk or lace is the result of the specific historical and cultural moments in which they do so. For example, the 'tightly clothed legs' considered essentially masculine in the context of the period discussed in Schoeser's study would be 'out of place' on men today. It is important to realise that many of the powerful 'traditions' and conventions related to gender have very short histories indeed. For example, the crude binary opposition implicit in 'pink for a little girl and blue for a boy' was only established in the 1930s; babies and parents managed perfectly well without such colour coding before then. Today they are even more widely used in the design and marketing of children's clothes than a few years ago. Importantly, such binary oppositions also influence those who purchase objects, and, in this case, facilitate the pleasures many adults take in seeing small humans visibly marked as gendered beings. As Buckley points out in this volume, it is impossible to consider children's clothes without also considering parenting, grandparenting, conspicuous consumption, disposable income, social class, fashion merchandising, wider representations of femininities and masculinities and the forging of personal and gender identities.

It is easy to be amused at the social taboos around such apparently harmless activities as dressing male babies in pink or men in skirts [1], but they reflect deep-rooted fears of effeminacy and homosexuality. Even at the height of 'unisex' baby and child dressing by feminist parents in the 1970s few boy babies or children were dressed in pink or in dresses (although it was the custom for male children in earlier periods of British history to wear dresses and remains customary in other cultures). The current male fashion for skirts is noticeable mainly in the large metropolitan centres, but it is an important and self-conscious statement about the artificial and arbitrary nature of the social constructions of gender, precisely because the skirt has represented the feminine for even longer than trousers have represented the masculine. The unease experienced by the disruption of apparently minor details of gender differentiation, such as the location of buttons on the 'wrong' side of a shirt or jacket, appears to be far greater in men than in women who, in general, are more used to 'appropriating' aspects of male dress than men are aspects of female dress. It is important to recognise these deep-rooted anxieties; it is precisely because of the importance of power and gender identity in our society that the fears for men of appearing female, with its concomitant loss of power, are so great.

A host of items, including underwear, aprons, hats, bags, hair styles, hairdryers, perfumes and makeup, and processes such as the packaging of perfumes and toiletries, are highly gendered. The slightest shift from the norm, not to speak of subversion, causes unease. The more over-determined the object or image, the more potent in terms of orthodoxy and its opposite. 'Real men don't eat quiche'; 'real men don't wear pinnies' – or at the very least wear leather aprons. Men are rarely seen or represented in small frilly aprons and when they are, as in the film *Rebel Without A Cause* (1956), we know that their masculinity will be called into doubt. Little wonder that the James Dean character in the movie turned out to be a juvenile delinquent; his father wore a frilly apron.

Even the objects with which we wipe our noses are closely associated with wider notions of appropriate masculinities and femininities.[8] The gender and design rituals of nose blowing are both amusing and entrenched, despite the lack of evidence about the gendered nature of mucus. Discussions about the gendering of handkerchiefs, including paper handkerchiefs, revealed that many male students insisted that paper tissues were not gendered but, at the same time, stated that they never used pastel coloured ones. Toilet roll (preferably white) was considered a 'manly' substitute but pink, mauve or flowery tissues were definitely out. The gendering

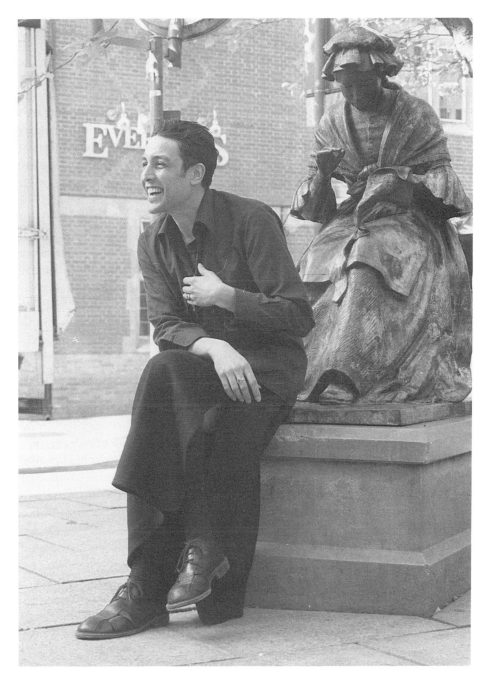

1] Man with skirt

of fabric handkerchiefs has not changed significantly since the widespread use of the paper tissue in the last thirty years but the gendering of the paper tissue has recently become more emphasised. Generally the gendering of handkerchiefs is marked by the greater strength and size (both central concerns for masculinity) of the male versions. It is intriguing that women's paper tissues are established as the 'norm', rather than being labelled as 'lady size' or 'woman size'. The insecurities seem to be around the male use of a delicate and fragile product; in order for it to be acceptable for men to use them, paper tissues have to be rendered 'masculine'. A similar case is argued in the essay by Kirkham and Weller about male toiletries. By contrast, in order for it to be acceptable for women to use weapons such as guns or 'active' sports machines such as bicycles, they have to be translated into 'feminine' objects, as in the case of the Smith and Wesson 'Ladysmith' range specially designed for women (see Chapters 5 and 6). When considered in terms of gender, even the most mundane of objects, including small paper bags, can seem bizarre. Why, for example, do certain designers and manufacturers consider that British women need the image of a crinoline lady or pretty flowers on the paper bags supplied in women's toilets (themselves a fascinating example of the gendering of objects and rooms) for the disposal of sanitary towels? It is almost equivalent to placing the image of a woman on the door of a maternity ward or a labour room in a hospital, in that menstruation, like childbirth, has not as yet been appropriated by men. Even in a 'ladies' lavatory – a room from which men are excluded – it is still deemed necessary to label as 'female' products which are not used by men. Such overdetermined cases are fascinating, not least because they illustrate the irrational and arbitrary nature of much of the gendering of objects. However, although it is easy to be amused, it is difficult to ignore or transgress codes in real life.

What might appear to some as the inalienable right of men and women to wear clothes already deemed appropriate by the society in which they live becomes a matter for the wrath of God if those clothes are not deemed appropriate *for their sex*. Amelia Bloomer, the American feminist activist who, with her sister emancipationists, adopted elements of 'male' dress for a period in the mid-nineteenth century, commented sympathetically on the right of men to wear shawls without harassment by journalists and others 'who think it their especial business to superintend the wardrobes of both men and women, and if any dare to depart from their ideas of propriety they forthwith launch out all sorts of witticisms and harsh names, and proclaim their opinions, their likes and dislikes, with all the importance of authorised dictators'

(see Chapter 13). Bloomer did not approve of the shawl which she described as 'an inconvenient and injurious article of apparel, owing to its requiring both hands to keep it on and thereby tending to contract the chest and cause stooping shoulders' but she did defend the right of men to wear it if they so wished, even quoting Deuteronomy 12:12 in favour of men and shawls.

Her spirited biblical defence was, in part, a rejoinder to the attacks made upon the 'rational dress' bloomers by clergymen and others who quoted the passage from Deuteronomy 22:5 which opens the preface to this book. The power of the press and public opinion in the forcing of Bloomer and her sisters to abandon their new modes of dressing is a salutary lesson to those who assume that such apparently innocuous and non-political objects as clothes have no direct relation to wider issues of social power and control. Many take comfort in the myth that since the Women's Liberation Movement in the late 1960s, inevitable forces of progress and gradualism have led to equal access to clothing styles and conventions. What shifts there are in cross-dressing – and, despite Jean-Paul Gaultier, *Tootsie* and *Mrs Doubtfire*, there are still not too many men in frocks – remain subject to the various and differential exercises of power of men over women, of one class over another, of heterosexuality over homosexuality.

Fascinating though some of the more unusual gendered objects are, this anthology does not foreground them at the expense of the more mundane. Attention is given to both new and old conventions in dress; to the tie and male suit as well as to men in leggings and women in trainers; to popular toys and the bicycle as well as to less obviously gendered products such as hearing aids. In terms of the overall aims of the book, both unusual and mundane objects serve to illustrate the power of convention in relation to gender and design in our society; conventions which should be so easy to flaunt, yet so often prove difficult, even embarrassing, when one tries. The study of the differential ways in which we package and advertise, say, hair removal products for men and for women (to say nothing of the products themselves), or codify supposedly unisex-ly functional objects such as umbrellas, hair-dryers and bags (hand, shoulder and back) as 'male' or 'female', has not yet taken the central place it ought to in cultural, social, and design historical studies.

Reference to objects such as umbrellas or bags immediately raises the response that they are 'unisex'. Many are, at least in the sense that, even if they were originally designed for one sex, they have been appropriated by the other. There are several points to remember here. One is that the specific histories of the original coding of the particular object as 'male' or 'female' and of subsequent appropriations are telling but more research is needed in order

to further our understanding of gender codings. Another is that, although certain products are 'unisex', they are worn and/or used and/or conceived of differently by men and women. In terms of clothing, body shape is a crucial yet frequently ignored element in the process of gendering. Body shape itself is not only constructed but also alters the appearance of a given gendered object – a good example being the wearing of 'men's' jeans by women. Frequently, an unambiguous – or less ambiguous – signifier of gender is added to a 'unisex' object, in order to clarify the question of gender, and some-times also to signal the sexual orientation of the wearer. The more taboo the object in terms of socially acceptable gender conventions, the greater the (heterosexual) pressure to make the sign. For example, in the 1980s it was common for women, particularly heterosexual women with very close-cropped hair, to wear earrings to feminise and 'soften' severe haircuts. Some of the same women, present authors included, also feminised what were then considered extremely heavy and decidedly 'unfeminine' Doc Marten boots and shoes by lacing with pink ballet ribbons.

Items of clothing belonging to the opposite sex are often adopted by heterosexual women to enhance and accentuate femininity. A tactic some-times used to negotiate or highlight the complexities and near stupidities of rigid gender coding is the 'postmodern' and sarcastic over-determined repre-sentations of gender which cannot, and are not meant to, be raised without irony or contradiction. Thus the ironic stereotyping of contemporary popular urban culture in which defining identity becomes an ever more complex catch-me-if-you-can game to escape reduction to fashion-victim formulae. When gender codes are over-determined in objects which would otherwise be expe-rienced as natural, the spectacle of 'over-the-top' artificiality renders them 'inauthentic'. But can androgyny and fashion appropriation any longer be con-sidered subversive when they are so frequently encountered in the vocabulary of street style, TV ads, and cartoons? One answer, we hope, lies in the way they are perceived and used; the worlds of gay male fashion, and young working-class and club fashions, continue to offer examples and challenges to us all.

Further and broader considerations of design would benefit from studies which do not prioritise the object (thing) over the subject (person/s) or vice versa. Though rendering the process of study and research more complex, this nevertheless makes it more possible to observe the ways in which people construct their identities through object-relations. Gender has been fore-grounded here, but other aspects of social relations can equally be called upon in the project of studying the way in which objects lend meaning to people's lives.

NOTES

1 R. Barthes, *Mythologies* (London: Granada, 1981), p. 157.
2 D. Miller, 'Artefacts and the meaning of things', in Tim Ingold (ed.), *Companion Encyclopedia of Anthropology* (London: Routledge, 1994), pp. 397–419. Daniel Miller's advocacy of 'objectification' offers an alternative way of conceptualising the meaning of things as a dynamic rather than a decoding process.
3 C. Steedman, *Landscape for a Good Woman* (London: Virago, 1991).
4 A. Appadurai (ed.), *The Social Life of Things: Commodities in Cultural Perspective* (Cambridge: CUP, 1990); R. Bowlby, *Shopping with Freud* (London: Routledge, 1993); J. Craik, *The Face of Fashion: Cultural Studies in Fashion* (London: Routledge, 1994); M. Strathern, *The Gender of the Gift* (Berkeley: University of California Press, 1990); E. Wilson, 'New components of the spectacle', in R. Boyne and A. Ratansi, *Postmodernism and Society* (Basingstoke: Macmillan, 1990), pp. 209–36.
5 D. Miller, *Material Culture and Mass Consumption* (Oxford: Blackwell, 1987), p. 18.
6 M. Foucault, *The History of Sexuality* (Harmondsworth: Penguin, 1981); E. Wright, *Psychoanalytic Criticism: Theory in Practice* (London: Methuen, 1984).
7 Anne Gray, *Video Playtime: The Gendering of Leisure Technology* (London: Routledge (Comedia), 1992).
8 N. Elias, *The Civilising Process: The History of Manners*, trans. Edmund Jephcott (Oxford: Blackwell, 1978), opens with an account of nose blowing: the 'civilising' process of blowing into a cloth handkerchief made it possible to keep the mucus in the pocket.

Interiors: nineteenth-century essays on the 'masculine' and the 'feminine' room

IN the nineteenth century the private interior space of the middle-class home was increasingly defined as feminine territory, the antithesis of the public, external world of work peopled by men. Within the domestic arena, however, the key rooms tended to be further grouped to either side of a male–female divide, the most explicit contrast being between the 'masculine' dining room and 'feminine' drawing room [2, 3]. The male domain grew

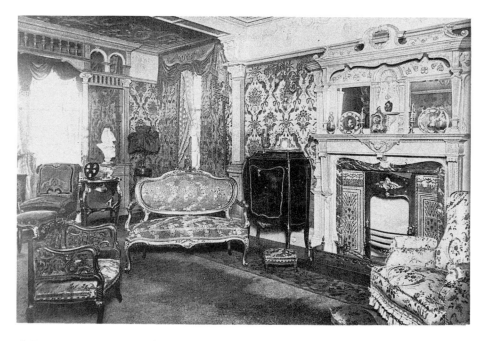

2] Drawing room setting from Wylie & Lochhead

to encompass the hall, library, business, billiard and smoking rooms, whereas the boudoir, music room, morning room and bedroom were perceived as coming under the feminine sphere of influence. Each room-type was minutely codified in terms of its function, contents and decor. Within these formulae some variety was allowed but the keynote of the masculine rooms was serious, substantial, dignified (but not ostentatious) and dark-toned. By contrast, the more feminine spaces were characterised as lighter or colourful, refined, delicate and decorative.

When Thomas Sheraton's *Cabinet Dictionary* was published in 1803, this pattern of codifying interiors was firmly in place. The drawing room, being the apartment to which women withdrew after dinner, was identified as feminine. The most expensive and culturally refined of the public rooms, which 'showed off' the occupants to visitors, it provided an impressive backdrop for formal socialising, and a context in which unmarried daughters could be sized up by potential suitors. In Sheraton's words, the furnishings were 'to concentrate the elegance of the whole house'.[1] He recommended producing a lively, glittering atmosphere with expanses of mirror, bronzed fittings and

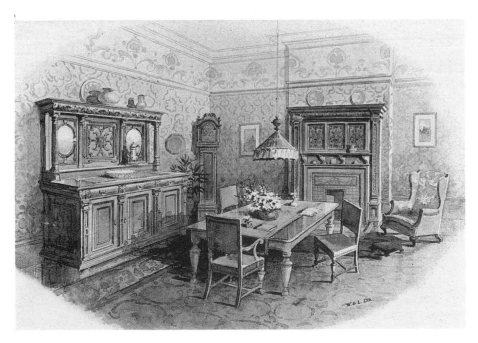

3] Dining room setting from Wylie & Lochhead

extensive use of lighting, which would then be picked up in the 'gay style' and colourful upholstery of the music room.[2] The furnishing of a genteel bedroom was to be more restrained than either the drawing or music rooms but similarly 'light in appearance'.[3]

By contrast, the ideal dining room would exude 'a very august appearance' with hereditary credentials displayed in the form of family portraits. Size was all-important. The accommodating proportions of the space were to be amplified by the 'bold, substantial and magnificent furniture', including a 'large' sideboard, a 'handsome and extensive' dining table, and chairs which were 'respectable and substantial looking'.[4] A 'bold, massive and simple' character was specified for the entrance hall which was to impress visitors from the outset with the male head of the family's 'dignity'.[5] Intellectual aspirations and classical brainwork were showcased in the gentleman's library, ideally furnished 'in imitation of the antiques' and presided over by portraits of appropriate role models ('men of science and erudition'). Nothing 'trifling' was to detract from the serious atmosphere of such masculine rooms, with 'little affairs' and 'innocent trifles' relegated to the more feminine tea room or dressing room.[6] By the same token, Sheraton specified the exclusion of books, globes and 'anything of a scientific nature' from the drawing room. There the accoutrements of artistic and less obviously intellectual accomplishments such as needlework, sketching and music-making were considered more appropriate.

The basic contrast drawn by Sheraton between the lightweight and the substantial – a contrast which resonated across different areas of sensory, intellectual, emotional and aesthetic experience – was fundamental to the elaboration of masculine and feminine furnishing schemes throughout the nineteenth century. Writing in 1864, Robert Kerr could advise that in the dining room,

> The style of finish, both for the apartment itself and the furniture, is always somewhat massive and simple . . . the whole appearance of the room ought to be that of masculine importance.

Conversely,

> The character to be always aimed at in a Drawing-room is especial cheerfulness, refinement of elegance, and what is called lightness as opposed to massiveness. Decoration and furniture ought therefore to be comparatively delicate; in short the rule is this – if the expression may be used – to be entirely ladylike. The comparison of Dining-room and Drawing-room, therefore, is in almost every way one of contrast.[7]

The masculine conventions of the dining room were invariably consti-
tuted as an oppositional foil to those of the feminine preserves. Robert Edis
echoed the male physique in his description of dining chairs in *The
Decoration and Furniture of the Town House* (1881); they were 'broad-seated
and backed, and strong', compared to their 'light-waisted', curvaceous
counterparts in the drawing room.[8] The contrast extended to the vexed ques-
tion of sincere and 'authentic' expression. Away from the deceptive surfaces
and ornamental distractions of the drawing room, it was easier to present
'masculine' furnishings as being what they seemed to be. The emphasis was
on creating an impression of utilitarian durability. Whether in terms of the
quantity of furnishings, the toughness of the materials, or the restrained use
of colour and pattern, the decorative aspects of the dining room were to be
deliberately understated: 'Few ornaments are requisite, beyond the display
on the sideboard'; 'A turkey carpet is most suitable, and from its durability,
economical'.[9] Edis expressed the generally held view that the furniture
should be 'designed for use not show' and of serviceable and durable materi-
als; 'good plain chairs of unpolished wainscot or American walnut are better
than any highly polished surfaces' and upholstery was to be 'strong, service-
able leather, or morocco in preference to velvet'.[10] This restraint helped to
lower the emotional temperature of the space, relegating the expression of
aesthetic sensibilities, of sentiment and of trivial pursuits to the feminine
preserve – just as Sheraton had done.

As a material, oak was ideal for representing notions of rugged masculin-
ity, a link reinforced over centuries through the popular literary device of the
sturdy-limbed oak wound round by the clinging vine. 'The oak is man, in firm-
ness drest, / With strength of fondness in his breast, / Delighting in the lie:-
/ The ivy is the gentle wife' (*Scots Magazine*, March 1789). 'Heart of oak' also
conjured up patriotic and martial overtones. More authentically national sen-
timent was invariably associated with masculinity. In Kerr's view the massive
simplicity of both decor and furniture in the dining room reflected the 'sub-
stantial pretensions' of British character and food, and when it came to the
selection of an appropriate historical treatment, this axis of meaning was
expressed in the preference for hefty 'Elizabethan, Jacobean' and 'Baronial'
styles, or the refinement of 'Adams' or 'Sheraton' ones.

> . . . the English styles . . . are expressive of a certain national sentiment which
> finds its strongest note in the family circle when gathered round the table at the
> evening meal. However popular the French styles may be for the drawing room
> or the boudoir they lack the distinct character which seems to be looked for in
> an English dining room.[11]

The 'distinct character' and the 'forcefully decided treatment' of the dining
room was played off against the aura of indecisive or pallid 'confusion' appar-
ently generated in the drawing room.[12] The construction of femininity in rela-
tion to predominantly French and Oriental styles had the effect of
emphasising the clarity of the masculine core culture. The peripheral nature
of 'feminine' taste, and the link between manhood and national character was
not new; it had featured in criticism of Thomas Hope's Frenchified
Household Furniture and Internal Decorations published in 1807:

> At a time when we thought every male creature in the country was occupied with
> its politics and its dangers, an English gentleman of large fortune and good
> education has found leisure to compose a folio on household furniture . . . There
> is in England we believe, a pretty general contempt for those who are seriously
> occupied with such paltry and fantastical luxuries; and at such a moment as the
> present, we confess we are not a little proud of this Roman spirit, which leaves
> the study of these *effeminate elegancies to slaves and foreigners* [emphasis
> added].[13]

Almost a century later the architect Reginald Blomfield expressed the same
commonly held sentiments:

> Three great qualities stamped the English tradition in furniture . . . steadfastness
> of purpose, reserve in design and thorough workmanship . . . As a people we
> rather pride ourselves on the resolute suppression of any florid display of
> feeling.[14]

National sentiment, the life-style of the gentry, middle-class aspirations
and the hierarchical pattern of familial relations were repeatedly reinforced,
and literally internalised, through the daily ritual of the evening meal. The
aura of hospitality, plenitude, 'cheery comfort and prosperity' was to be
enhanced by 'full tones' and the 'rich juicy colouring' of the decorative
schemes. References to dead animals in the use of leather upholstery, the
full-blooded, meaty colour schemes, and the iconography of the hunt elabo-
rated in carving, wall decoration or pictures, all insisted on the importance
of a well-provided table and, by implication, a competent (male) provider.
Clearly few men literally brought the supper home but the authority of the
male head-of-house was signified by the ample 'carver' armchair from which,
as chief carnivore, he could slice and apportion the meat for the day, a ritual
ideally enacted against the theatrical backdrop of a sideboard groaning with
food and laden with silver plate.

The basic formula for furnishing a dining room proved particularly resist-
ant to change. Although a century separates Sheraton and the German design

critic Herman Muthesius, the language and conventions are instantly recognisable:

> By long tradition the English dining room is serious and dignified in character, its colour scheme dark rather than light, its furniture heavy and made of polished mahogany; it has a Turkish carpet on the floor and oil paintings, preferably family portraits, in heavy gilt frames on the walls.[15]

The keynote remained one of massiveness and sombre masculinity, with large, powerful furniture layed out in calculated symmetry. Despite the occasional dig at the pomposity of the formula, it survived remarkably intact well into the twentieth century. According to Edward Gregory's *The Art and Craft of Home-Making*, first published in 1913 but revised and enlarged in 1925, the tastes of the 'highly respectable middle-class British public' were monotonously predictable when it came to the dining room; in nine out of ten cases walls were 'dark brown, dark green, dark red or dark blue' and the woodwork 'something approaching chocolate'. Sarcastically referencing food, Gregory commented, 'The whole arrangement smacks of sirloin of beef, Yorkshire pudding, cabbage, potato and dumpling. It is the monumental in furnishing.'[16]

Gregory also ridiculed the fetishistic quality of a room and rituals which encouraged a level of overeating he found ethically unacceptable. He questioned the attitude of mind whereby the sideboard was regarded as an altar and the carving chair represented a pulpit and argued that the 'vast and imposing superstructure' of the sideboard left one feeling 'a little overwhelmed, a little bullied and overpowered' and impelled 'to be solemn and dignified at dinner, as though we were eating in a church'. Not only the 'artistically indigestible' forms of the furniture but also the behaviour of the men therein after the women had 'withdrawn' he described as 'aggressive'. In other words, by 1913, some commentators on the 'Ideal Home' in Britain considered that the dark, heavy dining room with its connotations of boorish masculinity and overtly conspicuous consumption was out of key with the times.

Compared to the relatively stable formula for furnishing a dining room, the drawing room presented a minefield of possibilities; 'in no room of the house is there more latitude and a greater opportunity to show individual taste'.[17] There was a degree of tension between what needed to be there to make the room like those of one's peers, and the necessity to mark difference and individual (as opposed to class or public) taste. There was a plethora of styles and objects from which to choose, and no end of conflicting advice as

to how to pick and mix them. The drawing room also elicited the most vitri-
olic criticism (usually, though not exclusively, from male critics), redolent of
negative, moralising attitudes to women, which suggests either that the
drawing room was a more sensitive barometer than the dining room in terms
of taste and values, or that the construction of femininity was more hotly con-
tested than notions of masculinity within the home, or both.

The drawing room came to represent the woman of the household, and
came under the most scrutiny as precisely that. In this 'Woman's Realm', this
'lady's temple', the objectification of womanhood was complete, the furnish-
ings being seen as a seamless extension of a woman's character and appear-
ance – 'a sort of garment of her outermost soul', wrote Frances Power Cobbe
in 1866, 'harmonised with all her nature as her robe and the flower in her hair
are harmonised with her bodily beauty'.

The literature on household taste encouraged women to see themselves
in this way with suggestions to match complexion to colour schemes: 'Is she
a blonde? then let there be a modicum of pale blue within her bower . . . rose
will detract from a fair skin, pale turquoise would be preferable, but it will
not suit a fresh complexion . . . We prefer simple harmony here making the
lady the concentration of the scheme.'[18]

There was no comparable objectification of men in contemporary
descriptions of the dining room. In *The Art of Beauty* (1878) Mrs Haweis
moved effortlessly between extolling the culture of feminine beauty to the
subject of matching that beauty to the domestic environment; a continuity
enhanced, for example, by using the same fabrics for clothes and upholstery.
Not surprisingly, this chain of associative thinking often drew the drawing
room into the negative discourse surrounding women, consumerism and
fashion. Jennings was not alone in comparing a 'showy' display in the drawing
room with the indiscretion of a rouged woman 'dressed to death', wearing a
picture-hat with feathers and a shopful of trimmings. As with fashion, women
were criticised for 'dressing up' their interiors to be attractive, cleverly dis-
sembling their latent, calculating self-interest.

In nineteenth-century paintings and photographs women are often
depicted against the backdrop of the drawing room, stuck there, subject to
the visual control and aesthetic judgement of the (usually) male artist and
critic. In pictures such as George Logan's *Music Room* the women become
so depersonalised as to merge with the setting and become but one element
within an overall aestheticised arrangement of surfaces. This way of looking
at women and children as accessories to interiors was constantly reiterated
in novels and prose descriptions. Imagining his ideal drawing room in 1900,

the architect Robert Lorimer envisaged himself looking into a room in which his wife performed Chopin or Brahms on the piano and a child played on the hearthrug. Because the furnishing of the drawing room related to the art of self-presentation and the reception of visitors, it was a particularly important space for young unmarried women who had to market themselves and their accomplishments in order to attract husbands. Like luxury goods in a shop window, their families set them off against appropriate backgrounds so as to present 'a brilliant and lovely picture in its entirety'.[19] Accomplishments such as art, music and literature were frequently symbolised in decorative schemes featuring images of the Muses or musical trophies and signified through relevant props: piano, music canterbury, portfolio, small bookcase, writing desk, spinning wheel or embroidery frame.

Maintaining the bourgeois ideal of home as the antithesis of workplace while also instilling the work ethic in the young, meant women were actively encouraged to undertake productive but non-commercial activities. Through engaging in handicrafts themselves and through buying high-quality, individually worked pieces, women were seen to be nurturing traditional skills and values in the face of industrial change. Private tutors and various ladies' magazines or books gave instruction in a wide range of decorative skills or 'fancy work' which could be used to beautify the domestic interior, including chip carving, pokerwork, staining, stencilling, china or glass painting and repoussée metalwork. By the 1890s such accomplishments were also taught to middle-class women at day classes in local art schools. Having glutted the home with the fruits of their labour, an additional outlet was that of philanthropic bazaars which were the constant butt of male criticism. Take, for example, this thinly veiled critique of preparations for a charity sale in Glasgow at which one Miss Rosie Flirtington was aiming to catch her man by 'throwing her whole soul into the manufacture of enormities in wool-work, patchwork and bead-work, the hideousness of which was only equalled by their appalling uselessness, and the drawing room at 10 Blythsdale Crescent was turned into something not unlike a very badly kept rag store'.[20] On the one hand, women were encouraged to demonstrate accomplishments emphasising aesthetic refinement and technical virtuosity rather than economy of means or functionality; on the other, the results of their handicraft were condemned as 'trivial' or 'useless' for the very same reasons.

Women were in a similarly double bind when it came to buying furnishings for the drawing room. There was relentless social pressure put upon them to assert their identity and status through the purchase of 'artistic', preferably expensive, household goods. At the same time they were

constantly accused of susceptibility to the whimsical vagaries of fashion, and
unnecessary or unethical consumption. The perspective of a typically lower-
middle-class husband in 1902 is voiced in the wonderfully scathing words of
'Erchie', a character created by Neil Munro in the columns of Glasgow's
Evening Times:

> 'I can easily tell ye whit Art is', says I, 'for it cost me mony a penny . . . when Art
> broke oot, Jinnet took it bad, though she didna ken the name o' the trouble . . .
> The wally dugs, and the worsted thing, and the picture o' John Knox, were nae
> langer whit Jinnet ca'd the fashion, and something else had to tak' their place.
> That was Art: it's a lingerin' disease; she has the dregs o't yet, and whiles buys
> shillin' things that's nae use for onything except dustin'.[21]

Less satirical, but no less damning, is Herman Muthesius' verdict on the
typical British drawing room of the same period:

> It suffers in general from having too many odds and ends packed into it, and the
> deliberate informality too often degenerates into confusion . . . caprice and that
> love of frippery and knick-knacks by the thousand that characterises the modern
> English society woman. It has the least style of all rooms.[22]

The apparently random and unselective accumulation of objects, only
recently rescued from historical oblivion and contemporary snobbery, was
seen to reflect woman's innate intellectual inferiority and inability to grasp
the larger-scale dynamics of interior decoration. Women were generally felt
to have an affinity for decoration, and to be better at apprehending two-
dimensional, small-scale detail than larger forms in space. As Kerr put it, 'The
more graceful sex are generally better qualified, both as respects taste and
leisure, to appreciate the decorative element in whatever form of develop-
ment.'[23] This perceived propensity was reinforced by gendered role-play from
an early age. For their bedrooms Lady Barker suggested that girls should be
encouraged to 'collect tasteful little odds and ends of ornamental work . . .
and shown the difference between what is and what is not artistically and
intrinsically valuable, either for form or colour'; boys on the other hand were
to spurn ornament and 'have bare boards with only a rug to stand on at the
bedside and fireplace'.[24]

The little girl had to grow up to be the ideal wife-mother and preside over
the drawing room which formed the spiritual and cultural core of the home.
She reconciled all feeling and activity around her and created an atmosphere
of harmonious bliss; 'rest, sociability and comfort in an artistic framework'.[25]
Notions of civilising 'refinement' were expressed in the proliferation and
complexity of objects, the variation of mass and outline in their grouping and

an emphasis on high finish – lashings of gilding, silky fabrics, elaborate veneers and glassy French-polished surfaces. Smoothness was linked to the 'feminine' and with social polish. Rough-edged men were civilised by 'the gracious refinement of woman's subtle spell',[26] and the process of having to negotiate the apparently fragile and unstable 'clutter' of the drawing room.

Related to the concept of refinement and class status was an emphasis on 'richness'. In a literal sense more money was invested in the furnishing of the drawing room than any other interior in the house at this time. It contained the largest quantity of items, and materials of a perceptibly higher quality than those used elsewhere; velvet or silk damask upholstery as opposed to horsehair and repp, and rosewood, walnut and satinwood in preference to plain pine or oak. The art of the virtuous home-maker lay in high-profile expenditure without appearing vulgar or trashy. Collecting interests focused on small but exquisite and rare or curious items which would stimulate the imagination and educate through the emanation of moral sentiment, history and cosmopolitan culture, a notion relatively cheaply paraphrased in less affluent homes with a few bits of bric-a-brac and mass-produced china and furniture. Richness was about describing visual intricacy as well as cost, and was manifested in the tendency to create elaborate combinations of contrasting colours, textures, materials and forms – both in the overall composition of the room and in single objects. Although widely available and mostly spun and woven by machine, textiles retained associations of richness and costliness. The womb-like muffling of the drawing room in layers of curtains, carpets, fluffy rugs, frilly lampshades, cushions and padded upholstery gave the space a distinctive sound and feel aimed at inducing a state of physical and mental comfort. It also discreetly echoed the intimacy and sensuality of the boudoir, and the comfort of the nursery. The protective cocoon of textiles metaphorically communicated the refining and mediating role of woman and culture in softening the harshness of reality. If the outside world could not be controlled, the interior of the home could.

In line with this protective theme, Frances Power Cobbe described the relationship of a woman to her home as that of 'calyx to flower, shell to mollusk'. Women, their clothes, their homes, their morality seemed to merge interchangeably with the natural. To J. C. Loudon, whose influential writings of the 1840s covered all aspects of the house and garden, gentle undulations, insensible transitions, smooth and soft surfaces were features which made both landscape gardens and women beautiful. According to him, women were 'naturally' indoor people who had a 'natural' love of flowers and indoor

gardening.[27] Indeed, the potted plant became the perfect image of domesticated womanhood in the nineteenth century – bound but beautiful, diminutive, decorative and too delicate for the outside world.

The regenerative, colourful and sensual power of Nature certainly enhanced the concept of the drawing room as an antidote to the drab and deadening world of work. It was presented as an environment in which the imagination could run riot and in which spiritual and cultural values could burgeon. The virtuous countryside had long had a moral edge over the corrupting city. At the same time there was an unavoidable paradox in the idea that women should embody the Natural in what was the most intensely artificial room within the home. On a metaphorical level references to the reproductive capacity of Nature provided an allegory for the reproduction of wealth. Woman as part of Nature contributed to economic growth by reproducing manpower. At the same time organic movement or form could operate as a signifier for the pliability and weakness of the female character, and the more instinctual, sensual aspects of her make-up. Femininity was invariably connected with the pastoral, decorative and sweet-scented side of Nature, as opposed to the whiff of blood and violence implicit in the dining room. Indeed the olfactory perception of leather and wood-panelling impregnated with smells of food, drink and smoke was as important in referencing masculinity as the perfumed airy scent of the drawing room was in terms of femininity.

This axis between femininity and Nature was symbolised in the drawing room and boudoir through the inclusion of flowers, plantlife (*jardinières*, fern cases, aquaria), and still-life or landscape pictures. Gardens were evoked more indirectly through conventionalised ornament derived from nature: 'Flowers of brilliant hue, foliage . . . birds, animals, landscape – one and all are at the designer's command, and by attention to the symbols conveyed in their introduction so that each may possess its particular meaning the most pleasing results are obtained.'[28] The picturesque variety of objects and their apparently natural grouping, which contrasted with the formal symmetry of the dining room, was described as 'disorder', 'confusion', 'chaotic' – terms used elsewhere in connection with the perceived limitations of women's intellectual capacity.

As in the dining room, historical and foreign styles were used to conjure up atmosphere and associations. An impressionistic evocation of a particular style was enough to provide a shorthand code for the function and character of a particular room type, and their use was so widespread that they could be paraphrased through a compressed descriptive vocabulary. The outline of a

large-scale overstuffed chair (let alone oriental fabrics or patterns) was enough to mobilise 'Turkish' associations. In relation to the themes of richness, refinement and the evocation of nature, eighteenth-century French styles had everything going for them; elements from 'Tous les Louis' created an impression that was organic, glitzy and cushioned, with overtones of aristocratic refinement. Their many admirers resisted the zeal of reformers and critics like Jennings to whom a Louis XV bureau suggested 'a frivolous court and Aphrodisian dames – an age of meretricious glitter, of excessive luxury of cupids, and quivers and amourettes',[29] and who failed to recognise that this was part of their very appeal. Likewise Moresque and oriental styles offered a discreet hint of colourful luxury, mystery and sensuality. Chinoiserie and other exotic aspects of eighteenth-century styles were recommended as a means of releasing the imagination: 'There is a certain irresponsibility, gaiety and naivety about Chinese ornament which makes it particularly suited for use in a drawing room where pure fancy may legitimately have play.'[30] By a process of transference the descriptive terminology used once again applied equally well to both notions of femininity and aspects of style.

Perhaps even more than style, colour provided an important conceptual cue as to the function of a space and its emotional tenor: 'The colouring of rooms should be an echo of their uses. The colour of a library ought to be comparatively severe; that of a dining-room grave; that of a drawing-room gay. Light colours are the most suitable for bedrooms.'[31] 'Lightness' was one of the most recurrent words in descriptions of the feminine domain, used both in a literal sense and to imply more abstract qualities analogous to wider cultural values. At its most prosaic the term referred to colours and materials within the interior, and the level of natural or artificial light. It could also describe the more delicate scale and structure of the furniture. From here it was a short step to ascribing lightness to the actual activities which went on in such spaces. In 1878 one critic described both bedroom and drawing room as 'devoted to lighter and more feminine purposes'. Once this association was made, 'light' decor could easily become a by-product of intellectual inanity or superficial frivolity:

> An author who desires to follow out solid theories and generally severe lines of thought has been known to say that he cannot possibly do it in a room that is papered and painted in amber and white. The surroundings are too exhilarating and lead him off to lighter themes.[32]

Similarly Jennings, writing in 1902, referred to 'the lighter intellectual causeries' of the Woman's Realm, to which even 'the inferior sex' could

contribute their share.[33] In Muthesius' opinion, the 'lightness' and super-
ficiality of the socialising which took place in the drawing room, 'precludes
seriousness in the decoration and content of the room. The trend through-
out is towards prettiness, casualness and lightness, a feminine characteristic.'
It comes as no suprise that women's brains, like other aspects of their
physique, were generally thought to be smaller and lighter than men's.[34]

Construed more positively, lightness of colour and form provided a
material analogy for the hygienic and spiritual purity of the household. In
their capacity as guardians of the family's health and moral welfare, women
could more easily embody such values than men who were more closely
implicated with the filthy world of work and corrupting commerce. This was
reinforced by the Romantic gendered dichotomy of temperament which
stressed the feminine propensity for spirituality. In other words the battle
against dirt had a moral and spiritual dimension. Within the home generally,
and the drawing room in particular, women were expected to create an oasis
of light and calm amid the squalid grime of urban living. In a practical sense
this involved women in a losing battle. The stylishly light schemes were a
liability. W. J. Loftie, writing in 1876, describes the case of a woman who had
installed a Parisian scheme, including an Aubusson carpet with a white
ground, mirrored panels and fantastical gilt mouldings, only to find it faded
and filthy after a year.[35]

The gendered distinctions outlined so far in this discussion remained
suprisingly consistent throughout the nineteenth century despite the in-
creasing plethora of styles and goods from which consumers could choose,
and slight shifts in the planning and specificity of room use. This is not to say
that there was a universally valid formula or definitive set of meanings for
each room type. Some individuals were clearly more attuned to the minutiae
of style than others and there were varying degrees of self-consciousness in
the manipulation or rejection of this type of cultural capital. The literary
sources off which this essay has fed tended to reflect ideal furnishing state-
ments rather than the way things necessarily were, and to voice the percep-
tions of a partial, male-dominated establishment. Middle-class women in the
nineteenth century were not as witless, passive and angst-ridden as some of
the authors would have us believe. However, such works provide valuable
sources for mapping out a range of plausible meanings. Indeed they can be
read as indicative of the complex webs of cultural meaning woven by women
in interiors that were multi-layered, not only in terms of fabrics but in terms
of affectivity, sensibilities and associations.

While relations between the sexes did not change with every new style,

they were clearly being questioned and slowly redefined in the late nine-
teenth and early twentieth centuries. The gendered conventions, although
still in evidence, seem to have been less rigidly applied in more 'progressive'
aesthetic schemes of the 1880s and 1890s. The cult of simplicity entailed a
paring down of the drawing room's ornamental features, the thinning out of
contents, and the simplification of planning. The expression of 'lightness' was
merged with the concept of refinement in a more reductivist aesthetic. In the
context of urban grime, and related threats of human abasement, crime,
pollution and disease, the dominant emphasis on lightness by the end of the
nineteenth century can be read as an attempt to control matter out of place,
reinforcing threatened boundaries. At the same time, the more informal
categorisation of room use and emphasis on the eclectic blending of styles
suggest a slight blurring of the boundaries, a trend towards greater integra-
tion between the sexes. The hall and library, for example, were now increas-
ingly furnished as family 'living rooms', and more open planning was leading
to greater continuity between adjacent interiors.

It was at this point that Charles Rennie Mackintosh and his wife
Margaret Macdonald chose to re-emphasise the male–female divide,
exaggerating and making visible the operation of visual codes which had been
'naturalised' in interior decoration of the preceding century [4, 5]. They
subtly manipulated the received conventions in new and interesting ways
which reflected a more consensual, positively constructed view of gender
relations than that held by the majority of their contemporaries.

On both a professional and personal level Mackintosh's relationship with
Margaret Macdonald was clearly one of profound mutual respect. Far from
being merely part of the furniture, Macdonald actively collaborated in the
creation of the domestic interiors for which Mackintosh has become famed
(to an extent which raises questions about authorship). It was a creative
collaboration which can be compared to the companionable love and co-
operation claimed as the highest expression of the evolutionary process by
their maverick friend Patrick Geddes, philosopher, social theorist, town
planner, in his book *The Evolution of Sex* (1889). A further role model was
provided by the partnership of Francis Newbery, headmaster of the Glasgow
School of Art at the time, and Jessie Rowat, who became head of the influ-
ential Embroidery Department. The principle of 'equal but different', of gen-
dered opposites integrated to form a unity of impression, was also central to
theosophical thought which was so influential in avant-garde artistic circles.
W. B. Yeats felt that society was entering one of those rare periods of unity of
being, and mutual interpenetration of the sexes, which would find expression

in a bisexual art that allowed for the perfection of each partner without voiding the identity of the other.[36]

He could almost have been talking about the Mackintoshes' domestic interiors. In keeping with the conventions discussed in the earlier part of this essay they dramatised the gendered differentiation between the rooms, adhering to the principle of dark hall, library and dining room played off against light drawing room, music room and bedroom. The pattern was repeated in Southpark Avenue, Hill House, Hous'Hill, and House for an Art Lover. Each of these commissions exploited the visual and tactile conventions associated with each room type, rather than the associational aesthetics of historical styles. In other words the furnishing schemes represented a move from a positivist and value-laden evocation of history to a more open-ended, poetic expression of gender. The almost parodic exaggerations of the dark–light and male–female divide served to make visible the received nature of the conventions outlined in this essay, underlining the theme of dualistic opposites held in holistic tension and balance.

4] The Mackintosh dining room

Like many other avant-garde designers then practising elsewhere in Europe and America the work of Mackintosh and Macdonald was informed by the principle of synthesis, the interpenetration of art and life, home and work, male and female. Every aspect of their home life was embraced within their creative subjectivity. Through the interiors of their home in Southpark Avenue in Glasgow they created a circuitous journey of the imagination, aestheticising the daily round of activities within the home in a series of visual and tactile experiences representing different facets of a spiritual transformation. The inhabitant moved between the dark nether regions of the masculine preserve (the ground-floor hall and dining room) and the heightened spirituality, interiority and lightness of the feminine rooms above. Physically and metaphorically s/he ascended through the house into increasingly intimate spaces ever more removed from the outer world. There is the sense of a steady casting off of vulgar sensation and the 'debris of the phenomenological world'.[37] The process started with the symbolic divesting of outer garments in the transitional space of the hallway. Mentally and phys-

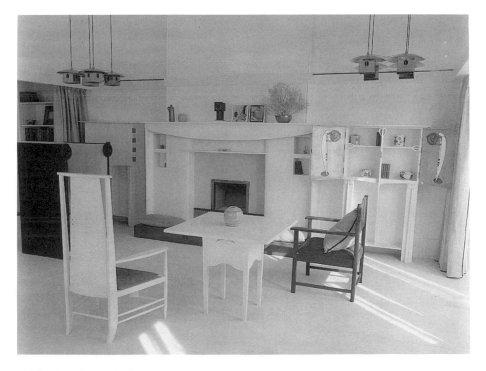

5] The Mackintosh drawing room

ically a change of gear was required to mark the move between public and private domains. Adjacent to the hall, and linked in terms of the 'masculine' colours, textures and materials, was the dining room, a space associated with eating and therefore the corporeal and material aspects of sustaining existence. (The walls were faecal-like in colour.) In the Hill House designed for Walter Blackie, Mackintosh situated a suitably dark and austere library next to the front door, following common practice. In this way business-related contact with the public world of commerce was not allowed to impinge upon the domestic intimacy of the rest of the home too extensively. The experience of moving through such dark 'masculine' spaces was integral to the perception of the contrasting lightness of the more 'feminine' rooms. In the Southpark Avenue drawing room there were subtle references to nature, as one would have expected, in the stylised decorative motifs and gently organic forms of the furniture; also in the accents of mauves and mossy greens. The stark, attenuated shapes of the seating served to emphasise the suppression of bodily comfort in favour of other-worldly, more spiritual values.

As Heinrich Wölfflin wrote in 1922, 'Not everything is possible at all times.'[38] Mackintosh and Macdonald certainly extended the possibilities of artistic expression, and challenged perceptions. Nevertheless they too – or at least their clients – were bound by existing ways of seeing and inherited patterns of meaning, as Charles Rennie Mackintosh's switch of board room within the Glasgow School of Art demonstrates: the Board of Governors evidently felt uneasy in the wonderfully light and airy space which Mackintosh created for them, and eventually decamped to a clubby, dark-panelled room which emanated a suitably masculine gravitas. Rooted in traditions that predated and were practised throughout the nineteenth century, they felt comfortable with that.

NOTES

 1 T. Sheraton, *The Cabinet Dictionary* (London, 1803), p. 218.
 2 *Ibid.*, p. 216.
 3 *Ibid.*, p. 219.
 4 *Ibid.*, pp. 194, 218.
 5 *Ibid.*, p. 216
 6 *Ibid.*, pp. 218–19.
 7 R. Kerr, *The Gentleman's House* (London, 1864), p. 107.
 8 R. Edis, *The Decoration and Furniture of the Town House* (London, 1881), p. 181.
 9 J. Arrowsmith, *The Paper Hanger's and Upholsterer's Guide* (London, 1854).
 10 Edis, *The Decoration and Furniture of the Town House*, p. 181.
 11 Kerr, *The Gentleman's House*, p. 94; H. J. Jennings, *Our Homes and How to Beautify Them* (London, 1902), p. 152.

12 W. Pearce, *Painting and Decoration* (London, 1878), p. 76.

13 *Edinburgh Review* (1807), Article XIV, pp. 478–9.

14 *Modern British Domestic Architecture and Decoration*, ed C. Holme, Studio Special Number (London, 1901), p. 18.

15 H. Muthesius, *Das Englische Haus* (Berlin, 1904, English edn 1979), p. 206.

16 E. Gregory, *The Art and Craft of Home-Making* (1913, revised edn 1925), p. 50.

17 Gregory, *Art and Craft of Home-Making*, p. 43.

18 O. Davis, *Instructions for the Adornment of Dwelling Houses: Interior Decoration* (London, 1880), p. 25.

19 *Ibid.*

20 *Quiz* (March 18 1881), p. 5.

21 N. Munro, *Kerr Handy and Other Tales* (Edinburgh and London, 1931), p. 653; originally published in colums of the Glasgow Evening News, *c.* 1901.

22 Muthesius, *Das Englische Haus*, p. 211.

23 Kerr, *The Gentleman's House*, p. 86.

24 Lady Barker, *Bedroom and Boudoir* (London, 1878), p. 13.

25 Jennings, *Our Homes*, p. 171.

26 *Ibid.*

27 J. C. Loudon. *An Encyclopaedia of Cottage, Farm and Villa Architecture and Furniture* (London, 1839, new edition), p. 808.

28 Davis, *Instructions for Adornment*, p. 61.

29 Jennings, *Our Homes*, p. 23.

30 Gregory, *Art and Craft of Home-Making*, p. 94.

31 Loudon, *op cit.*, p. 1015.

32 *Evening News*, March 7 1901.

33 Jennings, *Our Homes*, p. 173.

34 Quoted in B. Dijkstra, *Idols of Perversity* (Oxford, 1986), p. 169.

35 *A Plea For Art in the House* (London, 1876).

36 See Jan Gordon, '"Decadent spaces": notes for a phenomenology of the fin de siècle', in *Decadence and the 1890s*, Stratford upon Avon Studies, no. 17 (London 1979), p. 34.

37 *Ibid.*

38 H. Wölfflin, *Principles of Art History* (sixth edition 1922, reprinted New York 1950), p. ix.

The washing machine: '**Mother's not herself today**'[1]

I CAME to the washing machine late. It is true I had had a brief flirtation with a pre-1914 washing machine, the property of my aunt. This gigantic circular object was a shade of pale green which made it seem faintly and permanently unwell, a suspicion that was reinforced by its performance. Having hauled it forth from its cell, plugged it in, and filled it (by hand of course), it proceeded to turn a strangely shaped lump of metal backwards and forwards in the midst of its enormous bulk. The clothes nearest to this device stirred tremulously. I cannot say they got any cleaner. After a day of rinsing them in the sink, and struggling with the mechanical problem of emptying and filling this insatiable being, I usually found I had a flood on my hands as well. Initially I thought the flood good fun and paddled around merrily, often up to my ankles. But others did not share my enthusiasm and I went off it pretty quickly myself.

I then discovered the launderette, where I sat reading and writing essays and letters and leaping into occasional bursts of frantic activity. After I married and had children we went to the launderette in the evening, and dashed to the pub for a swift pint whilst the clothes went round and round. The launderette was our night out, a shared pleasure and a joint responsibility. Certain categories of washing, however, were excluded from this ritual activity, in particular nappies. With four children born in five years, most children's clothes were soon having to be washed at home, by hand, in order to keep up with the law of supply and demand. I was more than pleased when I finally acquired a washing machine.

However, in doing so I had lost the last bastion between me and the dreaded identity that I had been resisting with passion ever since my first child had been born – that of housewife. Now I washed clothes alone and at home, amidst a mêlée of other tasks. The washing machine's limitations were rapidly as apparent as its advantages. There were many essential tasks it did

not perform. Whereas by dint of switching on the vacuum cleaner I could secure a quick ten minutes of solitude whilst I wrote a poem (my children always charged off to play elsewhere at the mere sight, let alone sound, lest they should be required to pick up something), the noise of the washing machine had no such advantage.

As a result of a passion for babies I had assumed I would become a mother, but I rapidly discovered motherhood only exists in paintings of the Virgin Mary. The passport office refused to allow me to describe myself as 'mother' and substituted 'housewife', and I had a similar, though more ironic, experience in court when adopting a child. Thus the most essential part of my life during those passionate six years was denied, smothered in a defini- tion of myself through a sequence of actions which I found trivial and tedious. I would have happily turned over the tasks of cooking, cleaning and washing to somebody else, but the children I wished to bring up myself.

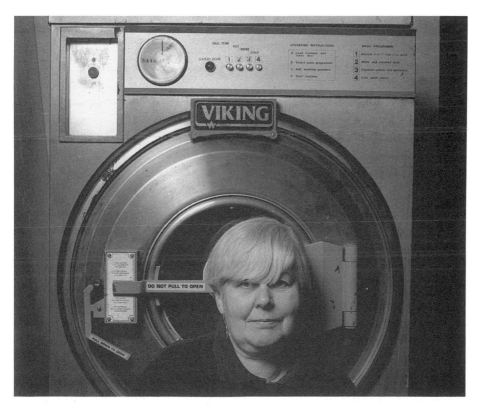

6] Jane Graves with washing machine

I was not somebody, on the other hand, who felt inclined to let go and relapse into total squalor. Brought up by aunts and a grandmother with a bottle of Dettol in one hand and the Bible in the other, I shared their anal obsessions. I was inclined to regard the upper-middle-class family into which I had married as utterly filthy, deprived as they were of the benefits of disinfectant. But, although clean and evangelical, I still did not want to be a housewife.

As far as I am concerned the 'house-wife' does not exist. She is a patriarchal wet-dream, designed (albeit unconsciously) to curb the pleasure and *jouissance* of the woman and to remind her that enjoying her baby is all very well, but her real task is to be a wife-in-a-house. Care of the home is always lumped in with motherhood. Melanie Klein's theoretical stance on motherhood places much emphasis on the child's envy of the mother's reproductive powers. When the small child becomes an adult it seems the fear may still continue to exist if s/he has no feeling about the role of the father in the scheme of things.[2] Overwhelmed by the appalling memory of female power s/he co-operates with a terrified society which cannot grasp the idea that patriarchy serves the interests of nobody and feels that the deconstruction of motherhood must be the first priority. Put mother in a machine and make her safe. Fragment her fecundity into a series of domestic activities which can be realised as mechanical tasks. Make her into a series of white goods and all will be well. The washing machine keeps us all clean and pure. Her clothbound smile is our security . . .

In the twentieth century woman and the kitchen have been irrecoverably yoked together. In this kitchen where the very utensils are but an extension of maternal activity, the oven soon became the final endorsement of maternal function (hence the phrase 'a bun in the oven'). But now the oven has a rival. The washing machine has become hearth and home, an animated version of the maternal kitchen, a symbolic restatement of woman's role, preserving order by a ceaseless unrewarded repetition. It is the assurance of mother's secret inevitable presence in the face of absence. It is like a perpetual game of hide and seek, the household gods of a postmodern society, a faceless sightless mask which reminds us of the first loving gaze so essential to our survival, but fails, as is inevitable in a postmodern world, to get its act together to give ourselves back to ourselves. It is a kitsch version of the maternal smile which mocks our pleasures as well as our necessities.

In the nineteenth century the separation of work from home created special problems for working-class women. As long as the home was the site of production, domestic activities and child-rearing were incidental to, but

not incompatible with, other tasks.[3] But it was accepted as 'natural' for them to labour in the new factories just as it was 'natural' for middle-class women to be reduced to a decorative device for soothing male egos (the first steps in the creation of the housewife). Working-class mothers did not escape censure for being the victims of this dilemma. It was the role of the 'do-gooding' middle-class woman, whilst leaving her children and house in the care of servants, to visit and harangue the working class about their domestic and child-rearing practice. One must always remember that 'cleanliness is next to godliness'. The working class were thought of as 'the great unwashed' and were blamed for their failure to keep themselves and their clothes clean despite an absence of water and washing facilities. Then, as now, it was seen as the fault of the individual rather than of the society which had created the problem, although when the middle-class woman used her comparative freedom to campaign for her civil liberties, she was also cast in the mould of the negligent mother. (The 'dirt' that was flung at her was usually rich in sexual innuendo.)

Anxiety about maternal negligence has in no way diminished in the twentieth century. Sondheim's lyric from *Into The Woods* (1991) – 'Mother cannot guide you / Now you're on your own' – triggers fear and recognition because it identifies the ultimate threat to a patriarchal society, an absent mother. But this still doesn't mean that women are not required to earn money – as well as cook the meals, nurse the sick, the elderly, the mentally ill, the handicapped, bring up the children, and above all else keep the family clean. No woman can expect to be regarded as a good mother if she cannot produce an endless supply of clean clothes. And anyway, to the 'housewife' at least, using her washing machine must always be a pleasure as well as assuring her children, and her neighbours, of her maternal commitment. White socks are the evidence she cares. Washing may be a lowly activity nearly always performed by women (unlike cooking it does not have a two-tier status with men functioning as chefs and women as producers of meals), but with a washing-machine pain is converted into pleasure, back-breaking work into gaiety and laughter. The washing machine is the badge, the insignia, the natural extension and justification of the existence of the housewife. It is the smile on her face.

Ironically, as the establishment complains bitterly about the decline of the family, the demands on women have increased – if not in range, certainly in depth and subtlety. Marriage is now supposed to be a combination of exciting sex, companionship and above all else wise parenthood (concepts unrecognised, if not unknown, in pre-twentieth-century Anglo-Saxon

societies). Complaints about the latch-key mother began in the 1950s together with the baby-boom and return to 'the angel in the house' syndrome which helped secure the job market for men after the Second World War. Since the 1950s there has been much talk of bonding, but serious discussion of these issues is largely confined to particular discourses, to midwives, psychotherapists and social workers. There is also much talk of the 'house-wife', that insulting term so dearly loved by the advertising industry, yet so useless to women. This is primarily because it suggests a simplistic cogency in women's lives which has never had any bearing on the reality, with its implication that women and houses exist in a symbiotic relationship. It says nothing about children (they figure only as an accessory) but emphasises woman's dependency on man. (One should remember that joint mortgages for married couples only became the norm in the 1970s.)

Women's lives have been increasingly fragmented into complex and con-flicting roles, and the mainspring of the energy which sustains them through this gyroscopic nightmare is guilt, especially towards their children. Even if you believe 'bonding' is resolved in the first few hours/weeks/months of life you are left with the problem that children need to be safeguarded for ten? fifteen? eighteen? years. The hazards seem to have increased. Not only traffic but terrifying new risks of abduction and child abuse inhibit any parent's desire to send a child out to play. And just as cars ironically solve the risk from traffic, so another object, the washing machine, represents maternal pres-ence and action. It stands in for the mother's being, just as does an au pair.

Media constructions of the housewife with a washing machine are of classless guilt-free beings. These illusionary creatures cope with conflicting demands without angst, literally dancing across the screen or page, denying fatigue, effort or conflict. There is an implicit threat in their smooth resolu-tion, however, because if you fail the problem must be with you. Who, after all, would wish to suggest that those dainty well-manicured hands can be cal-loused by effort, that any activity in which women participate can be described as work (not even the 'labour' of birth itself)? Women do not work. They enjoy themselves, and it's their fault if they do not. Like children, their principal activity is play, an activity despised because it is seen as being outside the realm of paid work. Work is still only recognised as such if it con-forms to the model of an activity performed in a particular place, within spe-cific time constraints for specified wages, and traditionally controlled, if not always performed, by men. (One might even go so far as to say, in some cul-tures at least, seldom performed by men.) But men are paid more often, and more than women, and financial reward (within Western capitalism) is the

key definition of the activity. If you are not paid it is not work, and women have not been paid for domestic activities, because they can be dismissed as 'labours of love'.

Although it is now recognised that women must participate in the world of work for financial and ideological reasons, they also carry the extra burden of resolving the conflict between work and home. The domestic space must remain as a specific site of pleasure, but one in which the protagonist – the woman – is temporally but regularly eliminated and reconstructed. The washing machine plays a contradictory role. It 'hides' the work of the wife and mother, its supposedly labour-saving nature apparently liberating her for pleasure or paid work. Yet, at the same time, because it stands in for 'woman' and performs domestic actions, it reminds everyone that the housewife still exists whilst she is increasingly engaged along with men in the round of patri-archal oppression. (It is not to be forgotten that men are victims too.)

And what have women to complain about anyway? After all men have invented for them 'white goods', refrigerators, microwaves, dishwashers, ovens and washing machines; the so-called labour-saving devices. These white goods eliminate the perception of female labour but not the reality of their effort. Women still select the 'dirties'. They must interpret the instructions for selection, for 'whites', 'coloured dainties', 'wool', 'heavily' or 'lightly soiled', 'cold' or 'hot' wash, even special operations such as 'stiffening' or 'starching'. Yet there are many tasks the washing machine does not perform. It does not itself pick up and sort the dirty clothes, it does not hang clothes on the line, it does not air them, it does not return them to the family's drawers.

Whoever writes the cheque (archetypally the man) perpetrates a financial device for eliminating 'complaint'. The woman who moans, the nag, the shrew, what a drag! 'I've bought you a washing machine . . . what more do you want?' They knew how to deal with women like that once. There were once special machines for silencing women's tongues, and if all else failed there was always the ducking stool . . . or the stake. And women tend to feel they ought to be silent, not to complain, to be grateful . . . and yet, yet. We are close here to the housewife's 'neurosis': Dora's mother, for example, who never gets a look-in, cowering under the combined contempt of Dora and Freud, who noted:

> I never made the mother's acquaintance, but from the accounts given me by the girl and her father I was led to imagine an uncultivated woman and above all else a foolish one. She presented the picture, in fact, of what might be called the 'housewife's psychosis' . . . This condition, traces of which might be found often enough in the normal housewife, inevitably reminds one of obsessional washing and other kinds of obsessional cleanliness.[4]

So if women still experience washing machines as work, it is their failure. Men wouldn't/don't, would/do they? It must mean women are misusing this splendid device out of some neurotic concern of their own. (One of my aunts does indeed wash the clothes 'before' they go in the machine.)

But do washing machines simply reflect the obsessionalism of the housewife? Washing machines overdo it, a desperate version of the raw and the cooked, from 'dirty' to 'clean'. In his essay on 'Character and anal eroticism' Freud quotes in English the phrase 'dirt is matter in the wrong place'.[5] It is there again in Mary Douglas' observation, 'If we abstract pathogenity and hygiene from our notion of dirt, we are left with the old definition of dirt as matter out of place.'[6]

So wholesome, so detached! Because what concerns the housewife is the way matter travels, and is apparently never lost. The novelist J. G. Ballard (left to bring up his three children after his wife died) is rumoured to have said 'Housework can be done in five minutes if you don't fetishise.' But most of us, i.e. women, do fetishise. We watch with a compulsive mixture of glee and despair that passage of dust which even the vacuum cleaner cannot eliminate. It is the washing machine, however, which is nearest to the rite of depollution, which actually appears to eliminate dirt, and by its ritual sequence restores a wholeness which seems at one stage (in the dirty linen basket) to be irrecoverable.

The washing machine treats all sinners equally, applies the same rules, and, hey presto! the dirty is made clean. The machine, even when it identifies different degrees of dirt, assumes all that enters therein must be subject to a straitjacket of cleansing. After you have acquired a washing machine, you will wash more regularly, more frequently and more compulsively, because now there is no excuse. If your clothes are not clean, it is because you have not visited the temple.

Following Douglas, it is categories at any price – the Durkheimian solution, in which all activities are evaluated in terms of their social utility in maintaining the cohesiveness of the group.[7] Dirt disappears in social organisation/reorganisation. The puritanical Anglo-Saxons love categories; the safety belt of desire, white socks, white shirts, white sheets; the obsessional neurosis which only corresponds to a system in the head, not in the body, a system without flesh or spirituality – and of course without women. The washing machine is the site of control – the place/space in which 'dirt' can be eliminated.

In the history of the washing machine women always get a bad press and their role in the orchestration of categories is cast into oblivion, not only by

Freud, as the housewife's neurosis. It is easy to produce a short history of the washing machine which conceals its lurking madness under such an indictment of feminine inadequacy. White goods, encased in pressed steel and the purity of Modernism, were a fine robotic solution, celebrating functionalism as an ascetic aesthetic, in itself redolent of obsessional qualities, and for the middle-class woman solving the problem of the absence of servants, whilst for the working-class woman supposedly providing her with them for the first time. Perhaps it is the machine that is obsessional, not the woman?

And why, one wonders? Can it be – is it possible – that women are really dirty? And the machine is there for this act of ritual cleansing? A sort of substitute for the 'churching' that women were once subjected to after childbirth? Soap too is a contradictory product, an incarnation of ambivalence, bad for the skin, an exploitation of animals, but the measure of the struggle for 'hygiene', the mystification of cleanliness, the recovery of innocence; and one of the first commercial goods to be advertised. Soap may be a comparatively late invention but the concept of guilt and stain goes way back. 'Out, damned spot', said Lady Macbeth and she never spoke a truer word. But stain is something we cannot ditch, and for stain read original sin, sex, snake, apple. It is interesting to think how many washing machine advertisements appeal to anxiety. Getting rid of stains can be used to eradicate residual guilt about ecology, the environment, the future, or more obviously sin; better clean and dead whatever the consequences. Bleach and washing machines testify to our longing for repentance.

But dirt and stain extend way beyond the West and way beyond Christianity. Above all else blood speaks of crime and guilt. Blood is also a memory of loss, the tragedy of guilt or despair, a leakage from the body that speaks, records, and sometimes accuses – and is not easily eradicated, even by the washing machine. Menstrual blood is the symbol *par excellence* of the terror blood arouses in us; the evidence of femaleness, the primeval smell of leakage, birth, insufficiency and desire, maybe even 'the lure of the lack'. It is the repeated testament of anthropologists that menstrual blood is a source of primary anxiety in the organisation of systems. Its representation evokes equal anxiety. Why else does Frenchie/Dietrich wipe off her lipstick before she kisses Destry goodbye at the end of *Destry Rides Again* (directed by George Marshall: USA 1949)? And the strange coagulation of advertisements related to the issue of menstruation articulates control in all its various manifestations, but never displays that which has to be controlled, blood.

The washing machine has never sunk to such contamination. It has never washed the sanitary towel. There was a time, prior to the First World War,

when women washed a disreputable triangle of cloth by hand (although the middle-class lady's was washed by a servant). Now we have disposables. Pollution has been ostracised, almost beyond the pale, although we still have to cope with the faint memory of stains on knickers and sheets.

It is childbirth that brings us nearest to the confrontation with the over-abundance of female blood, a sense of the body's wounds and vulnerability. Birth reminds us too much of death for comfort. Vera Brittain, in her *Testament of Youth*, spoke of the blood-stained uniform, the tangible memory of her dead lover killed in the 1914–18 war.[8] For many this would be the only body they would ever receive. Blood speaking the impossibility here, of abjection maybe, but also the trauma of love incarnate.

> Red lips are not so red as the stained
> Stones kissed by the English dead[9]

Bleach wipes out blood/guilt and memory, denies the need for mourning, let alone the certain knowledge that we ourselves must die.

Well, we knew patriarchy was rife: an over-hasty agenda which prefers to concentrate on anything but menstrual blood. Better the blood of a gunshot wound; a healthy man's macho wound. Patriarchy is at risk from simplification, reduced to male activity *per se* (forgetting the fact that women can be just as patriarchal as men). But a patriarchal society fears abjection, the reminders of the disintegration of the body, the knife edge of mortality at the point of birth – and death. The unbelievable horrors of the 1914–18 war were orchestrated around an overfamiliarity with abjection; when it became 'normal' to hang your hat on a disintegrating limb, or to accidentally step on a stomach and sink through it. Women know the price of human flesh too, and both men and women have traditionally paid the price for it in war – but differently. Men have died; women have sometimes died, but have also given birth to the men who are killed. They have been left to mourn and pick up the pieces of their lives after losing brothers, lovers, husbands and sons.

The washing machine is a veritable carnival amongst domestic appliances. Ignoring the instructions, you can shove in what you like. Rabelaisian, it celebrates itself, loathing dignity and restraint, preferring greed and disgust, transforming water, soap, softener into the excreta it vomits forth noisily through its tubing. It is without respect, a patriarchal solution to women's problems defeating its own ends, its excess cancelling out the obsessional desire to separate categories; an anxious bulimiac who appears to be suffering from a severe digestive problem.

Curiously, in its use it throws the categories of masculine/feminine into

confusion. The washing machine can change sex. In the launderette it can be masculine. The service wash which allows the quick exit down the boozer (conveniently ignoring the fact that the work is usually performed by a woman as well as a machine) is different from the domestic washing machine, not just because there is always something else to do while the machine is washing but also because there is no let-up from responsibility. The children can still commit hara-kiri and it will be your fault – if you are a woman.

The washing machine is promiscuous in its gargantuan appetite. It will try anything you choose to shove into it. Furthermore, once the door is shut, there is often nothing you can do to rescue your mistakes. Patriarchal, it values decision-making. And once the wheels have been set in motion, it really does not give a damn about the ultimate results of its efforts. Few have escaped the trauma of a favourite garment so shrunken as to fit only a baby, the havoc caused by the misplaced and misguided tissue, or the discovery that a garment has run. Will it – won't it wash? By which one means will it wash in the washing machine.

It is strange to discover that the absent mother is a bloke; but then many would feel that that is what fathers are for, a temporary and rather unsatisfactory substitute for a mother. Does it have to be like this? One has to appreciate that he has tried his best, whatever the result. You can discard and replace but seldom change. You must acknowledge you cannot change him. Built-in obsolescence has made sure of that. Summon the washing-machine man and he will soon confirm this. (Funny, I've never heard of a washing machine woman.) White goods seal their interior in mystery. Male innocence is a wonderful thing – one must not tamper with it. Is that why they're called white goods, I wonder?

Ecologically unsound, the washing machine is extravagant and difficult to repair. Like 'traditional' male fantasies these clichés summon up the woman; impossible to live with, impossible to live without, just as to the 'traditional' female, the washing machine is the unrepentant unreconstituted male – something to be endured rather than enjoyed. The washing machine is in control of the washing, and beyond all other patriarchal gestures, control is of the essence. Women and babies have some power (in certain situations maybe even more power than men), but what they do not have is control. In the increasing fragmentation of a social structure dependent on secondary groups, control through the system can (at times) eliminate power, words rather than physical force, manipulation rather than confrontation, and – to re-read the same conundrum – evasion rather than truth.

Control makes increasing inroads into our sense of self, our experience of our bodies. Medicine (and for many psychotherapy) has long been an intrusion and the washing machine is an operation performed by long-distance control. But, like an operation, it makes violent inroads into our relationship with ourselves. It wipes away the memory/trace of our own bodily experience. What could be more intimate than our clothes? Is it the clean or the dirty that one loves? ('Putting on a clean warm sock is like putting one's foot back in the womb', as one of my offspring remarked.) But the smell of the clothes of those we love is, as the first summer rose, delicious, elusive and always a tremulous reminder of mortality. Again gender rears its head. Both sexes have been conditioned to be anxious about smell. It is that which justifies the over-extension, the hyperbole of the washing machine. For women it focuses on blood. For men it is sweat, not fresh sweat but the history of work and beyond that the fear of the tom-cat, stale semen, the reminder of sex hidden behind the smell of sweat. (But many would say, what is sex but another kind of work?)

What should we wash? Until the 1960s, many materials and therefore garments were only suitable for dry-cleaning and school trousers were cleaned once a term 'if you were lucky'. There was an important distinction made between short and long trousers. Your mother might wash your shorts when you were a little boy, but long trousers were the signifier of puberty and manhood. After all, she might find the stains of nocturnal emissions, the knowledge of a sexuality which the culture could not accommodate. (God help mothers and underpants!) Long trousers were past purity and innocence. They were pressed uncleaned at home, while women washed their precious stockings, undies and woollens by hand. Coats, jackets and skirts were given infrequent cleaning. It was people, not the environment, that were defined as dirty.

Our experience may have changed. Anxieties about the 'dirty' environment have become more insistent, more ferocious, as we have become conscious of the damage we are inflicting on our 'inorganic body' (to use Marx's phrase). The materials, and dyes, most able to tolerate the savagery of the washing machine are those that are, or are developed by, methods of production most damaging to the environment, e.g. chemical dyes, easy-dry materials. Furthermore, these materials, and the substances we pour into the machine to clean them under the guise of 'soap' and 'soft rinse', can damage the skin. One might even argue that our modern continuous 'over-washing' makes us dirty, denies the body's 'natural' system for keeping us clean. Deprived of access to washing machines – and even washing water – it is

amazing to discover that we can cope better than we expect. (It would be interesting to investigate the experience of mountain climbers and campers.) Or, is it the case that it is the women who do the coping competently – and usually, silently?

Nonetheless, women's experience of the 'dirtiness' of the body is different from men's, not just because of a different experience of smell and dirt, but through the washing of clothes they have more knowledge of other bodies and as a result, perhaps, more trust in the body. For the 'masculine' (not always of course the male) the pleasure zones of the body are kept separate; food/mouth; penis (or even clitoris)/sex. Is it possible that the 'masculine' part of ourselves is disturbed by the inarticulate inchoate wild swirl of water in the washing machine, a remorseless memory of the womb, from whence we once all came and doubtless desire to return? Perhaps that is why we feel compelled to sit hypnotised in the launderette and watch the cycle of clothes on their amniotic travels, a reminder of the unattainable, a memory of an acknowledged desire. Only with the experience of birth do we discover our skin through the impact of the air on our vulnerable flesh. Clothes are in themselves an attempt at a second skin, a reassurance of protection and containment. But not within the washing machine. For the washing machine reduces all categories to an abysmal confusion, a senseless higgledy-piggledy. The body, male and female, collapses into its disintegrating elements – as a result of the softener maybe? Another universal synthesiser.

The word 'softener' is an ironic reminder of the sensual proprieties of washing. When I think of the three-legged stool, the dolly, which my grandmother used to wash the clothes, anticipating the tumbling action of the washing machine, what I remember is the smell of the wood imbued by hot water and soap. Proust-like, my eyes fill with tears at the thought of my grandmother, the wonderful intimacy of those days spent with her in the kitchen, the bubbles she blew for me between her soapy finger and thumb. Only with an effort can I take on board the horror of her overwork and exhaustion. Undoubtedly the romance of washing is in the eye of the beholder!

The sensuality of washing was always a romantic illusion. Washing nappies by hand for six years I developed eczema on my hands, and the thought of the smell of Napisan makes me feel sick. But the sterile overcomplication of the washing machine does not solve the wider problems for women either. Are women still being punished for their *jouissance*, their pleasure reduced to abjection? Although I did once invent a washing-machine dance . . .

NOTES

I would like to thank my children for the part they played in providing me with the material, and Steve Baker for his encouragement, suggestions and support, but above all else the MA Product Design students and their course director, Jonathon Barratt, at Central Saint Martin's College of Art and Design.

1 Norman Bates (Anthony Perkins) in Hitchcock's *Psycho* (1960).
2 M. Klein, 'Envy and gratitude', in *The Writings of Melanie Klein* (London: Virago, 1988), pp. 176–235.
3 See A. Oakley, *Housewife* (London: Pelican, 1974).
4 S. Freud, 'Dora', in *Case Histories* (London: Pelican, 1977), p. 49.
5 S. Freud, 'Character and anal eroticism', in *On Sexuality* (London: Pelican, 1977), p. 213.
6 M. Douglas, *Purity and Danger* (London: Routledge, 1966), p. 35.
7 *Ibid.*, pp. 75–7.
8 V. Brittain, *Testament of Youth* (London: Gollancz, 1981), p. 251.
9 W. Owen, 'Greater love', in *Poems of Wilfred Owen* (London: Chatto and Windus, 1968), p. 62.

Hearing aids: sweet nothings,
or an ear for an ear

WHAT about an object clearly associated with the mature human body yet ostensibly without gender? Are there any such objects? The toothbrush? The nail clipper? The hearing aid? 'Nature', wrote the English physician John Saunders in 1806, 'has placed the greater part of the Ear in a situation absolutely beyond the reach of examination in the living body.' For the hard of hearing, however, there were new, light-weight, sculpted artificial ears from France which, 'By being closely adapted to the [external part of the] Ear . . . increase the collection of sound.' With the addition of a small tube leading into the ear canal, the new outer ears or auricles were far better than the fragile Spanish auricles made of seashell, far far better than German silver auricles so heavy that they had to be kept in place by a spring fitted over the head.[1]

The natural external ear was itself a natural wonder, argued a New York physician exactly half a century later: it was, wrote J. Henry Clark, 'one of the most beautiful objects in nature', with its 'convoluted folds, its concentric circles, its evident adaptedness to collect the sounds'. As for the seat of hearing itself, that inner ear which lay well out of sight, he wrote, 'the "labyrinth" of the ear has proved a place where authors have groped in the dark for many years'.[2]

As a consequence, the auristic profession had been overrun by impostors or undermined by diffidence. 'Like most students,' wrote ear doctor William R. Wilde, father of Oscar, in 1853, 'I was taught during my apprenticeship theoretically to believe, and practically to observe, that we knew nothing about the diseases of the organs of hearing.' The orthodox courses of treat-ment, therefore, were little if any different from those advertised by 'sham' or 'vagrant' aurists. Certified ear doctors, confessed Wilde, had been 'pre-scribing nostrums, of both a local and general character, which we know they would never think of using in similar forms of disease in any of the other

organs of the body': hot water and hard soap squirted into the ear; bleeding cups or blistering behind the ear; hot tinctures, turpentine, creosote, or pungent oils intruded to scald away wax; almond oil, bacon fat, or glycerine introduced to loosen whatever was left; electricity to stimulate somnolent auditory nerves.[3]

Indeed, the ear – especially the outer ear with its lobe, its folds, its somewhat concentric circles – had long been treated as if an extension of, rather than integral to, the body. Seemingly semi-detached, it had been subject to a variety of indelicate experiments, not only in medicine. The fashionable ear had been clipped, pierced, weighted with a pendulous earring. The pornographic ear had been bitten, penetrated, inflamed. The pedagogical ear had been tugged, cuffed, pinched, slapped, and boxed. The penological ear had been branded, clipped, or sliced off. Whether sacrificed to ornament or orgasm, to education or retribution, the (outer) ear was just (in)sensitive enough to serve as the flag of social or sexual arousal, mental or moral attentiveness.

Ear trumpets visually reproduced this cultural separation of outer ear from intact body. Unless fortunate enough to have acquired one of those rare acoustic armchairs whose upholstery hid both ends of a trumpet in cushions just behind the head, a hard-of-hearing person strained to hold a trumpet up to the better ear. At intervals he (sometimes she) had to set it down and rest, for ear trumpets could be as long as twenty inches and weigh as much as a third of a pound – perhaps more if we can trust 'The Siege of the Loves – Capitulation Imminent!', an 1885 cartoon from *Harper's Weekly* in which a gouty eighteenth-century patriarch must anchor his elbow on an armrest to support the weight of the massive bell of his trumpet [7]. Although a 2½ oz. 'London Horn' could help the less seriously deaf catch a conversation from at least a dozen feet away, those who would speak to the trumpet-assisted were advised, like the young cartoon suitor, to address themselves closely and directly to the horn of the trumpet. One spoke not to the person but to the horn, not to the face but to her side. Contemporary prints showed trumpet-listeners with eyes squinted or a-glare, intent on capturing and deciphering sounds that seemed to be floating in from an impersonal distance. The point was, as hard-of-hearing Horace Furness confided to Mrs Ellen Kirk in 1888, the ear trumpet was an awkward interloper, holding one at arm's length from social intercourse and from any chance at that other sort of intercourse, 'for who would think of bawling affection through an ear-trumpet?'[4]

In theory and in practice, ear trumpets were conceived as collectors. They were derived from inverted speaking trumpets or megaphones used by

sea captains and the chiefs of volunteer fire brigades. Narrow to wide, the
trumpet funnelled sound out; wide to narrow, the trumpet took sounds in.
What happened to those sounds afterwards was a mystery. 'The External Ear
may be represented by a trumpet [to collect sound],' wrote James Paton, a
New York University student taking notes on physiology lectures by Professor
Albert H. Gallatin in 1883. 'The Middle Ear may be considered a drum [to
intensify the sounds].' As for the 'Cochlea [of the inner ear], which is wound
in a coil, here we can tell all the distinctions of sound, but how is unknown'.[5]

However impenetrable the workings of that inner ear, the ear itself had
come by 1883 to seem a supremely good detective of the secrets of the invis-
ible inner chambers of the living body – the lungs, the heart, the stomach,
the abdomen. Through percussion and then through auscultation, the physi-
cian's trained ear could make out not only the diversity but the diagnostic and
prognostic meaning of sounds from the caverns and canals of the inner body.
'Never had the physician more reason to be proud of his mastery over the
secrets of nature, than of the power which auscultation has given him', wrote
Robert Spittal of the Royal Infirmary of Edinburgh as early as 1830. Applying
an unobstructed ear to a thinly-covered chest or, as much for the sake of

7] 'The Siege of the Loves – Capitulation Imminent'!

propriety as clarity, applying a stethoscope to unobstructed breast, the physician would discover inner states of being unknown even to patients themselves – the early stages of pneumonia, murmurs of the heart, twin pregnancy. Auscultation offered a way around the inarticulateness of those patients who were unable to make known their complaints; 'it signalises diseases, which otherwise would have completely escaped the observer: in the speechless infant, which cannot yet *reflect* on its pain . . . [and] where the patient is delirious or *comatose*'.[6]

Stethoscopes, continued the Parisian doctors J. B. P. Barth and Henry Roger, were merely prosthetic devices; at their introduction in the 1820s, some had called them 'hearing trumpets' and thought them equally cumbersome, though they were basically six-inch wooden cylinders widened at the base and fitted at the top with an ivory ear disc, the better to hear with. Barth and Roger recommended the stethoscope because it 'circumscribes the sounds better, and marks their limits with more precision'. A further encouragement to its use came wherever modesty forbade the direct plantation of ear to flesh (the breasts, the groin) or where a sweaty, dirty patient made 'immediate auscultation' a less than immaculate perception.[7]

One held the stethoscope not like an ear trumpet but like a pen, and with the other hand, advised Dr Edward Brockbank of Manchester in 1911, one held the patient's shoulder, so as to maintain 'the proper distance-relationship between the examiner and the patient'. A century before, it had been the distance between the doctor and internal organs which had inspired the French internist René Laennec to roll up some cardboard into a cylinder and listen through the layers of fat of an ailing obese woman for the sounds of her heart; now the stethoscope, binaural and rubber-looped as it had come to be, seemed so powerfully penetrative that the physician had to be sure not to violate social/sexual distance while listening in on some of the most private sounds of a person's life.[8]

As an artificial ear, the stethoscope demanded an uninterrupted physical connection between physician and patient even as it demanded silence of the room, nakedness of the patient, and tactical distance of the doctor. In illustrations of auscultation, through to the present moment, patients and doctors rarely make eye contact; what the doctors are listening for, their eyes introspective or sidewise, is what patients, eyes unfocused or blank, do not know they are saying. The ear trumpet was a heavy-handed interloper, passive and indiscriminate; the stethoscope was a light-fingered intruder, active and discriminating.

A visible technology for discerning the character of the invisible, the

stethoscope operated in much the same fashion as the vaginal speculum, improvised from a basting spoon by the foremost US gynaecologist, Marion Sims. 'Introducing the bent handle of a spoon,' he wrote, 'I saw everything as no man had ever seen before . . . the walls of the vagina could be seen closing in every direction, the neck of the uterus was distinct and well-defined, and even the secretions from the neck could be seen as a tear glistening in the eye, clear even and distinct, and as plain as could be.' Thus, in 1845, was Sims' conquistadorean gaze returned with poetic justice by a silent teardrop. In 1855 the English physician William Ferguson designed tubular vaginal specula with mirrored interiors, a cross between the mirrored speculum being used for examining the interior of the ear canal and the tubular stethoscope used for listening in on the interiors of the body.[9]

Yes, there was a culturally and imaginatively strong bond during the late nineteenth century between the inaccessible labyrinth of the living ear and the uncharted territory (as Sims claimed) of the vagina. To introduce a metal probe into the living ear canal was considered as delicate and uncertain an operation as introducing a mirrored speculum within a moist vaginal canal; both the auditory and the vaginal canals were to be, as John Fosbroke had written of the ear, 'coaxed with gentle and gradual methods, not stormed by direct attacks and empirical violence'.[10] The middle ear was associated with the maintenance of balance and diseases of vertigo, described in terms similar to those applied to hysterical women. From deep in the ear issued protective (sometimes obstructive) secretions of wax and, in cases of catarrh, of malodorous runny fluids; from the walls of the uterus and vagina came secretions as defensive as they were lubricating and, in cases of 'women's problems', as malodorous as they were lumpy or thin. One thought to cure the suffering, blocked, or deafened inner ear by the inspissation of warming, potent liquids as Sims in his practice thought to cure women of their 'complaints', blockages, or sterility by surgeries to open the vagina and uterus to warm, energising, fructifying sperm.

More than ear trumpets or artificial ear attachments, the stethoscope itself visually reproduced the structure of the ear. The flanged, diaphragmatic listening piece on the patient's end of the tube resembled the ear drum; the tube, the ear canal; the ear piece at the doctor's end, the outer ear or auricle. Later improvements had flexible, binaural tubing which implicated a double labyrinth – the labyrinth of the ear itself, processing sounds in some as-yet undecipherable process, and the labyrinthine canals of the interior of the body, negotiated by means of the peculiar sounds a physician could locate and track beneath an outwardly naked body.

The stethoscope came to seem so powerful a detective because it seemed not simply to locate and collect sounds but also to convert the inaudible or unintelligible to the audible and the significant. It was, in brief, an amplifier. Like the ear itself: the famous German physicist Helmholtz had shown, technically, 'that the force of vibrations received by the drumhead is increased by the leverage of the ossicles one and one-half times in the process of transmission from the handle of the mallet to the head of the stirrup'.[11]

As phonographs, telephones, microphones, and electric megaphones came on the market during the 1880s–1890s, the habit and techniques of amplifying sound entered a wider arena, beyond the silent examining room of the auscultating physician. With the help of a player piano or a gramophone, the wealthier sort became accustomed to converting the physically mute piano roll or gramophone disc into something audible whose volume could be personally adjusted for intelligibility and sociability. Like the large horn of the Victrola, less often a collector than a projector, the ear itself was coming to be perceived as an energetic device for the amplification of sound, vital to and integral with the body.

In the company of the spirals of recorded phonographic discs, the labyrinths of telephone wires unreeling across the urban landscape, and the ever more ambitious labyrinths of carnival houses of horrors with their automatic pre-recorded shrieks and groans, the labyrinth of the ear could be heard, as it were, to be magnifying and making intelligible the sounds of modernity. As it had held its own in the course of biological evolution, wrote anatomist Albert A. Gray in 1907, so it would hold its own in the course of industrial progress. Somehow, the most hermetic part of the ear was giving meaning to the noises of civilisation.[12]

Echo and recapitulation: the ear was drawn more securely into the body by a sexual intrigue with the deeply imbedded aural labyrinth, by the medical intrigue of listening in on heart and lungs, and by increasingly frequent, intimate contacts of the ear with newly accommodating companions: telephone receivers, phonograph speakers, dictaphone and radio headsets.

We can hear the ear being drawn into the body as educational reformers at the turn of 'The Century of the Child' began to protest against the custom of cuffing or pulling a child's ear. Such attacks upon the outer ear, reformers explained, did untold violence to the inner parts of the ear, to the organ of hearing, and to the educational process itself. Reformers in Europe and the United States proved their case by conducting citywide hearing tests of schoolchildren, showing how their aural acuity was on the decline and how

children who had been classified (and ignored) by teachers as dull or worse were, often, just plain hard of hearing.[13]

We can hear the ear being drawn into the body with the appearance at century's turn of the first urban campaigns and city codes to reduce the noises associated with an industrial world of factory whistles, railroad bells, automobile horns, alarms and fire sirens. Too many loud, sudden noises could drive one from a state of 'nerves' to neurasthenia to, at last, total nervous breakdown or suicide. Insistent noises, insisted the campaigners against 'unnecessary' noise, could shake down the very constitution of a person, even while one lay asleep. The cure for the nervous conditions prompted by the cacophony and crowding of modern life, with its electric shrieks and sudden alarms, was, correspondingly, Dr Silas Weir Mitchell's famous 'Silent Cure'. The ear, it now seemed, lay close to the sensitive, determinate centre of the person, in particular to the emotional person, who commonly experienced auricular hyperaemia or 'Burning Ears'.[14]

Burning or not, ears were peculiar, in the best of senses. The Italian connoisseur and art historian Giovanni Morelli had found that ears – and hands – most revealed a 'true' painter's genius. 'For every important painter has, so to speak, a type of hand and ear peculiar to himself.' By examining the forms of ears of the central figures in a painting, Morelli (trained as a physician) could discriminate between a fine original and a school copy, an imitation, or a forgery. The ear, more than the eye or the mouth, enfolded – and gave away – the enduring, unique elements of a master stylist.[15]

The ear could also betray a convict on the loose, an escapee from an insane asylum, or any chronic 'recidivist', if one followed the profiling procedures put in place during the 1880s by Alphonse Bertillon at the Paris Prefecture of Police. Hair pulled away from the ear, the photoportrait of each suspicious face in left and right profile would yield an amazingly complete visual archive of ears. It was not so much that the ear was (as claimed by earlier physiognomists) intrinsically related to character as that it was bonded (said Bertillon) to identity and (said Dr Amédé Joux) to heredity. With mugshots carefully framed to catch the shape and slope of the ear, detectives, criminologists, and border-crossing guards in Europe and North America learned to identify fugitive Jane and John Does. In jail or at the morgue, alive or dead, one could not escape one's ears.[16]

Soldiers on the front during the First World War clapped their hands to their ears to no avail. The whistling shells landing in no man's land were too concussive, the machine guns too raucous, the pounding of artillery too reverberant. Where before noise had produced neurasthenia, in 1915 it led to

'shellshock', a condition often attributed to incessant acoustic noise compounded by the impact of sound as deeply felt vibration. Shellshocked soldiers, it was thought, could become deaf (and deaf-mute) from 'the din of battle alone', their ear drums ruptured or, 'a much more serious matter', their hearing disrupted by the 'labyrinthine shock' produced by shellbursts inches from their trenches. After the war, shellshocked men still shuddered at thunderstorms or sudden noises, which 'recall the entire neurotic display originally manifested by the patient in response to the overwhelming stimuli of the front-line situation of which the noise was an element'. If the ear had not yet been fully integrated into the body before the war, now it was, for soldiers *heard and felt*, through and through.[17]

After the war, the ear was more exposed than ever: by the shorter hair styles for men and for women, retained or adapted from the war itself; by headwear curtailed under the influence of an industrial ethic of streamlined efficiency; by the redesign of radio speakers so that headsets were no longer necessary; by the redesign of telephone receivers so that they were less enveloping; by the plastic costume jewellery of Coco Chanel and others, whose outrageous earrings flaunted the ear itself.

More integral yet more exposed, the ear was being set up for plastic surgery, an art that had advanced significantly during the Great War. During the 1920s, people of means became increasingly dissatisfied with the shape, slope, or size of their ears, asking for cosmetic reconfigurations to conform their ears to the smaller, rounded, softly-contoured ears they saw thirty feet high on the movie screen in close-ups of lovers kissing in magnificent profile.[18]

As the ear was sutured back on to the body, and as hearing was reconceived as a sense under immediate duress from the noises of modern urban life and modern warfare, so the hearing aid itself was reconfigured. Thanks to the emerging technologies of moulded plastics and electronics, it became, in form and function, increasingly integral to the ear. The more congruent it was with the body entire, the more susceptible it was to being gendered.

Wilson's 'common-sense ear drums' of the 1890s fitted in the ear without string or wire attachment. They were of little value to most people hard of hearing, but they were, to be sure – as advertisements hastened to say – 'simple, practical, comfortable, safe, and invisible'. Other hearing aids had also been designed to be 'invisible': pink-enamelled silver 'ear wells', as useful as holding one's hand up to one's ear; flesh-coloured silver 'anatomicals' which fitted over or replaced a lost auricle; tiny ear cornets that fit within the auricle and had a tinier tube leading into the auditory canal.

Invisibility appealed to women in particular. Women's ears, unlike men's, served ornamental purposes; ear trumpets and most other devices got in the way of fashion. Women's ears, more often than men's, were thought to burn in amorous shame, blush with innocence, or become flushed with romantic nervousness; hearing aids obscured or chafed at these genteel signs of, as the Victorians had it, 'making love'. Women's ears were also supposed to be more naturally acute, more musically refined; to wield an ear trumpet or sport a silver auricle was to confess to a loss of womanly character. Women had to use their ears subtly, said manuals of etiquette, as sensitive *listeners*; although deafness might be a wonderful defence against pompous but loquacious men, the sight of an ear trumpet would remove a woman from her most proper social role. A hearing aid too obvious in its situation or too obstreperous in manipulation interfered with the ornamental glow of a pair of earrings, the line of a hat or of witty repartee, the flow of a scarf or a conversation. An ostentatious or unmanageable hearing aid would bespeak a loss of refinement and subtlety; it could appear to be an insurmountable barrier to intimacy, or at least an elemental handicap to the social fluency so necessary to womanhood.

Finally, for women the ear trumpet was a sign of the End, of agedness and (given the new priority assigned by fashion and physical culture to youthfulness) doom. Annie C. Dalton in 1926 wrote wryly about the poet Edith Sitwell's own scorn for ear trumpets, which Sitwell conflated with Gabriel's trumpet:

Edith Sitwell
made a solo
of her auntie,
her rich auntie
and her trumpet
as old ladies
give to stranger-
folk to blow in.

Down the trumpet
scornful Edith
sang and chortled
her fine solo
of the Judgment-
day and Crack of
DOOM

Auntie prattled
of her boy-scouts,
Edith roaring
of the Judgment-

day, still roaring
down the trumpet –

But

Some day Edith,
too, may need one.
How she'll shiver
when she knows it,
thinking of that
scornful solo,
thinking of the
Day of Judgment;
of the solo,
of her laughter;
of her laughter
and the trumpet;
of HER dreadful,
dreadful trumpet
and the crashing
Trump of Doom![19]

So it was men, more frequently than women, and far more frequently than young women, who had used the blatant ear trumpet and most of the other bulkier hearing aids available during the nineteenth century. They had done this in much the same manner and for many of the same reasons that men, more than women, had taken to wearing eyeglasses in public. Men could better handle the ear trumpet's stigmata because society allowed them the grace of ageing, because their behaviour (like their demeanour) was supposed to be more instrumental than ornamental, and because it seemed more vital that men be able to hear, and be heard, in public.

The impetus for women of all ages to take up in public any sort of (in)visible hearing aid came from four quarters. From commercial offices whose web of new jobs for women as steno-typists and switchboard operators gave many more women the physical experience of wearing a hearing device. From 'living rooms' whose new genres of entertainment were almost exclusively aural – the gramophone, the player piano, and the radio; these devices demanded an aural attentiveness very different from the visually splendid *tableau vivant* or parlour pantomimes, and in their original forms the loudspeakers or 'table-talkers' reproduced in shape and texture the largest ear trumpets. From city streets whose increasingly complex, noisy grid called into existence a host of new aural warning systems to which one remained oblivious at great peril. From meeting halls and clubrooms where local Leagues for

the Hard of Hearing were spawned, first in New York City in 1910, then in a hundred other communities in the United States and Britain by the 1920s; the Leagues encouraged, nay, urged, widespread, regular testing of aural acuity, and they freely distributed hearing aids or, lacking a good supply, information about new technologies of assisted hearing.

With the diffusion of telephone receivers into middle-class homes and the development of amplifier systems for theatres presenting pre-recorded sound effects accompanying silent films, the private and public stages were further set for women who were hard of hearing to want to take up hearing aids. In their newfound intimacy with the body, moulded to the ear and smaller than ever before, hearing aids were as acceptable as the tampons introduced after the Great War; in their electrified amplification, hearing aids were almost as acceptable as eyeglasses.

During the 1920s, as women shed layers of underclothing and lost thereby the pockets, folds, and crevices of earlier habiliment, invisibility was an ever more appealing quality, because the apparatus of contemporary battery-powered hearing aids could not be as easily hidden in women's clothing as in a man's suit or sports jacket and trousers. Given the extreme emphasis, too, upon a light, lithe, athletic, youthful figure and a well made-up countenance, a bulky hearing aid implied weightiness and an unwonted gravity. So while the first vacuum-tube hearing aid was designed for corporate executive Alfred Dupont around 1924 at a cost of $5,000 and was the size of a desk, Mrs R. H. Dent about the same time began to accessorise the hearing aid. She 'used her genius to transform "aids" for hearing from clumsy, mirth provoking objects into chic and attractive ornaments'. The instrument could be 'concealed inside a hand-bag, a brooch or even a hat button! A cunningly designed brooch, fixed into a smart little hat and connected with the ear by an almost invisible black cord, enables even the very deaf to hear.' Other manufacturers showed how the thumb-sized earpieces of their hearing aids could be camouflaged behind hats or under curls, and how the thin wires could lead inconspicuously to battery packs clipped out of sight to garter belts, girdles, brassieres, or the edges of corselets.[20]

These new electric hearing aids, constructed upon the principle of the telephone receiver and the microphone, were more effective than any earlier hearing aids, but they were also noisier, since they generated static through the wires from battery and controls to ear-mike. They could also be severely unpleasant in operation, because they seemed to amplify higher (screeching) tones more adeptly than lower-frequency tones. This was of special concern to women, who may rely more than do men upon tone and inflection for the

information that comes from speaking. The Mears Ear Phone Company of New York in 1914 had promoted a device that allowed for eight different sound adjustments, and later manufacturers inserted tone controls as a matter of course, so that even this problem was obviated, to some degree, for women still hesitant about the purchase of such a prosthesis.[21]

As a camouflaged accessory, the electric hearing aid with its volume and tone controls allowed women who were hard of hearing to maintain the eye contact and face-to-face position lost once they began, as was usually the case, to favour their better ear. As a well-attached and somewhat miniaturised prosthesis, the hearing aid of the 1920s allowed for the mobility and postures of women seeking a new freedom of movement, having seen that freedom of movement all around them in the movies, print advertisements and posters. As a concealed spy device, the hearing aid reintegrated women into the communities from which they had felt distanced.[22]

During the Second World War radio headsets were reduced in size, so as to fit inside infantry helmets, and made more reliable, so as to withstand the roar and rattle of war. This double-pronged technology was swiftly transferred to the manufacture of hearing aids with receivers and earpieces that were smaller, more accurate, and better protected against loud or crowd noises. Even before the advent of transistorised devices in the 1950s, advertisements for hearing aids extended the traditional claims for invisibility beyond the physical to the psychosocial: not only were these post-war hearing aids disappearingly small and 'secret', but the secret shameful habits associated with the social condition of deafness would disappear once a hearing aid was in place. 'You're not a crosspatch any more!' says the granddaughter to the grandmother in a touching vignette. The copy explains: 'Dispositions often suffer when someone doesn't hear well. Straining to understand can make a delightful person upset and nervous . . . sometimes very unhappy.' Western Electric did a series of such advertisements in 1946 for its Model 63 hearing aid. A worried boy sits forward in a modernistic armchair, thinking in boldface, '**If Mom would only wear a hearing aid!**' Commiseration, in the copy alongside: 'We know how you feel, son. You're not alone. Your Dad misses a lot of normal, everyday pleasures too, because he knows Mother would rather not meet people. That's what a hearing impairment does. One person affects others.' Says Mother, in another of the series: 'I'm Back in the Family Circle Again.' Commentary: 'I never realized how much my family used to struggle to keep me in the conversation. They'd chat and laugh. I'd laugh too. But they'd know I was guessing what was said. They'd repeat it. It must have been harder for them than it was for me. Now

I hear and enjoy things with them. It's wonderful to be back "in the family" again . . .' And what of the woman who is afraid to look over her shoulder lest she catch two others in catty backchat? 'YOU May Need a Hearing Aid if people always seem to be mumbling behind your back' [8].[23]

Hard-of-hearing women must feel lost, angry, isolated, hypocritical, paranoid; hard-of-hearing men must feel bemused, out of step, ineffective, tense. 'You have watched others grow deaf. You have seen them sitting tense and uneasy in business conferences, betraying their deafness by irrelevant comments', noted one Western Electric 'puff' for men. Again, for men: 'You May Need a Hearing Aid if . . . [a father holds his left hand to his left ear and tries to puzzle out his daughter's request as she holds up the detached left arm of a doll] . . . if you are in the habit of favoring your "good ear".' A hard-of-hearing man without a hearing aid must be like the doll, one of the walking wounded. Arguing that 'To the average man, of course, the wearing of a hearing aid seems as natural as glasses', the Sonotone Company hoped to reach blue-collar workers *at work*. 'Far-sighted' employers, said the company in the middle of wartime (1943), were beginning to realise that 'it is a foolish, uneconomic waste of vital man-power to "scrap" a man's other abilities just because his ears had failed him'. Western Electric reminded men that 'People used to be shy about wearing glasses too!' In a drawing of a couple sitting in a theatre [9], the man has turned from the screen to admire his companion, a smiling, responsive woman with perfect hair, perfect teeth, and eyeglasses. 'Now he can hear again . . . go to the movies and really enjoy them . . . do a much better all-round job of living in a regained world of sound.' We look again at the illustration and what do we see? An unobtrusive hearing aid in the man's right ear which works against the claim that 'Today there's realism and frankness in admitting a hearing impairment and correcting it before bad hearing habits develop.'[24]

No, not realism and frankness but invisibility and shame. Yet the socio-emotional predicament of the hard-of-hearing woman was distinct from the socio-economic predicament of the hard-of-hearing man. Reliability and invisibility (or camouflage as, for vivid example, a battery pack and receiver in the form of a dazzling cigarette lighter) were the vouchsafes for women's hearing aids, which had to restore them to the dinner table and the card table; men's devices had to do something else, to appear to put them in effective command of every situation. '45 Years ago, Acousticon Gave HEARING to the Deafened by AMPLIFYING Sound Electrically. *Today* Acousticon Gives CLEAR HEARING without Strain by CORRECTING Sound Scientifically.' This CORRECTING of sound, its technology derived

8, 9] The Western Electric
Hearing Aid, 1946 and 1945

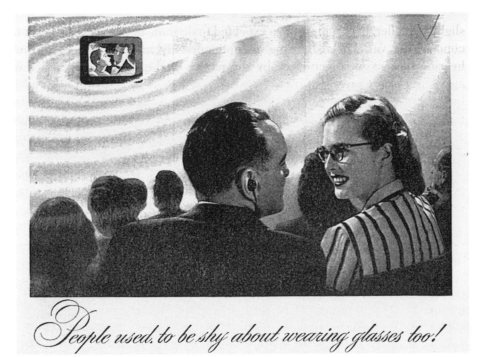

from that developed for certain radio-controlled artillery shells during the
Second World War, made the hard of hearing in 1947 ostensibly active
designers of their immediate acoustic environments. Those devices most
attuned to the socio-economic needs of hard-of-hearing men were those
which, regardless of their camouflage, allowed both for adjusting tones and
for 'tuning out, by fingertip control, unwanted, irritating background noise'.
To move from 'Selective Service' in the army to 'Selective Silence' on a ball-
room floor was a two-step from private-at-arms to captain-of-one's-fate, and
from the privacy of handicap to public confidence. If deafness had chosen
for you what you could hear, now you could determine what you would
tolerate – hubbub or conversation, noise or sweet nothings. No nonsense
here.

During the nineteenth century, the ear trumpet and its congeners were
gendered primarily by use: men used them, women generally refrained from
using them until quite elderly. During the first part of this century, hearing
aids became gendered according to their virtues: they allowed women to be
the intent listeners they were disposed to be, electrically amplified but
inconspicuous and sensitive to nuances in tone; they allowed men to be the
interactors they were meant to be, battery-assisted and resistant to noise. The
design was much the same for men and for women, whose ears are only
slightly smaller, but women were expected to do more active, serious work to
conceal the various 'disfiguring' components. By mid-century, electronic
hearing devices were gendered by the nature of the handicap which they
apparently addressed: for women, distance from friends, family, and a
husband's favours; for men, loss of authoritativeness, social inappropriate-
ness, business timing. Deafness made women (seem) cross, paranoid, unpre-
dictably responsive; deafness made men (seem) puzzled, unintelligent,
slow-acting. The Tonemaster Minuet (1948), the Paravox Model D (1950), the
Zenith Royal T (1953), the Maico Transist-ear (1955) restored one to one's
gender roles far more effectively than they restored one to the acuity of one's
youth.

By way of the hearing aid, I am suggesting that we must look beyond
dimorphic structure or design, beyond any differences in how the sexes may
take up an object, and even beyond any cultural ironies or discontinuities, to
appreciate the extent to which an object may be gendered simply by its situa-
tion within sets of beliefs about gendered acts, gendered behaviour, gendered
bodies.

NOTES

This research was supported in part by a Travel-to-Collections grant from the John W. Hartman Center for Sales, Advertising and Marketing History, Duke University, and in part by a 1994 National Endowment for the Humanities Summer Seminar Fellowship.

1 John,Cunningham Saunders, *The Anatomy of the Human Ear . . . with Notes and Additions by William Price* from the 2nd London edn (Philadelphia, 1821 [1806]), pp. 38, 112–13. For illustrations of the hearing aids described in this essay, see Friends of the Deaf League, *Helps to Hear*, no. 106 (London, 1934), for shell auricles; Mary Lou Koelkebeck *et al.*, *Historic Devices for Hearing: The CID-Goldstein Collection* (St Louis: Central Institute for the Deaf, 1984).

2 J. Henry Clark, *Sight and Hearing. How Preserved and How Lost* (New York, 1856), pp. 243–4, 248.

3 William R. Wilde, *Aural Surgery* (Philadelphia, 1853), pp. 18, 34, and cf. John Fosbroke, 'Practical observations on the pathology and treatment of deafness', *Lancet*, 1, January 15 1831), pp. 533–5.

4 H. H. F. Jayne (ed.), *The Letters of Horace H. Furness*, vol. 1 (Boston, 1922), p. 253. My sense of the effectiveness of ear trumpets and other hearing aids comes from personal tests of the devices in the collections of the Volta Bureau, Washington, D.C., and of the Central Institute for the Deaf, St Louis. Koelkebeck *et al.*, *Historic Devices*, gives results of technical measurements of the functional gain of most devices in the CID collection.

5 James Morton Paton, Student Notebooks 1880–83, MS 33, Box 1, folder 8, p. 39, in New York University Archives, New York City, quoted with permission of New York University.

6 Robert Spitall, *A Treatise on Auscultation* (Edinburgh, 1830), p. 5; J. B. P. Barth and Henry Roger, *A Practical Treatise on Auscultation*, trans. Patrick Newbigging (Lexington, 1847), pp. 4–7.

7 Barth and Roger, *Practical Treatise*, p. 7; Evory Kennedy, *Observations on Obstetric Auscultation* (New York, 1843), p. 74.

8 Edward M. Brockbank, *Heart Sounds and Murmurs* (London, 1911), p. 17; Samuel Gee, *Auscultation and Percussion*, 2nd edn (London, 1877), pp. 100–1 on Laennec, the nakedness of patients, and the superiority of the stethoscope over the naked ear.

9 J. Marion Sims, *The Story of My Life*, ed. H. Marion-Sims (New York, 1894), pp. 121–5, 234, and see his *Clinical Notes on Uterine Surgery* (New York, 1873 [1866]), pp. 14–20; Elisabeth Bennion, *Antique Medical Instruments* (Berkeley: University of California, 1979), p. 131 and plate 22; Joseph Toynbee, *The Diseases of the Ear*, with supp. by James Hinton (London, 1868), pp. 31–6 for illustrations of aural specula.

10 Fosbroke, 'Practical observations', p. 823.

11 Seth Scott Bishop, *The Ear and its Diseases* (Philadelphia, 1906), p. 59.

12 Albert A. Gray, *The Labyrinth of Animals*, 2 vols. (London, 1907), vol. I, p. 17.

13 O. F. Baerens, 'Boxing the ears', *Tri-State Medical Journal*, 3 (August 1896), pp. 344–5, reprinted in *The Laryngoscope* (1896), p. 253; Bishop, *The Ear and its Diseases*, p. 177. The Germans were probably the first to conduct systematic aural examinations of schoolchildren; see, e.g., 'Der Hörfähigkeit der Schulkinden', *Zeitschrift für Schulgesundheitspflege*, 16 (1903), pp. 240–1.

14 On early anti-noise campaigns in the United States, see Raymond W. Smilor, 'Confronting the industrial environment: the noise problem in America, 1893–1932', PhD dissertation, University of Texas at Austin, 1979. On the Silent Cure, see Silas Weir Mitchell, *Doctor and Patient* (Philadelphia, 1904 [1887], pp. 118, 131; Anna R. Burr, *Weir Mitchell* (New York, 1929), pp. 104–7; Suzanne Poirier, 'The Weir Mitchell rest cure: doctor and patients', *Women's Studies*, 10 (1983), pp. 15–40. On burning ears, see Bishop, *The Ear and its Diseases*, p. 104.

15 Giovanni Morelli, *Italian Painters*, 2 vols., trans. Constance J. Ffoulkes (London, 1900), vol. I, pp. 3–5, 71–8, 82, 90–3. See Carlo Ginzburg, *Myths, Emblems, Clues*, trans. John Tedeschi and Anne C. Tedeschi (London: Hutchinson Radius, 1990) for a commentary on Morelli's use of ears as clues and emblems.

16 R. Imhofer, 'Die Bedeutung der Ohrmuschel für die Feststellung der Identität', *Archiv für Kriminal-Anthropologie und Kriminalistik*, 26 (1906), pp. 150–63. Cf. Robert B. Bean, *The Racial Anatomy of the Philippine Islanders . . . with a Classification of Human Ears* (Philadelphia, 1910).

17 Elmer F. Southard, *Shell-shock and Other Neuropsychiatric Problems* (New York: Arno, 1973 [1919]), p. 366 on the din and 'labyrinthine shock'; Lewis Yealland, *Hysterical Disorders of Warfare* (London, 1918), pp. 31–5 on deaf-mutism; Norman Fenton, *Shell Shock and its Aftermath* (St Louis, 1926), p. 160 on post-war prognoses. For a review of the literature and controversies, see Robert D. Ritchie, 'One history of "shellshock"', PhD dissertation, University of California, San Diego, 1986.

18 E. Vaubel, 'German pioneers and teachers of plastic and reconstructive surgery', *Annals of Plastic Surgery*, 26 (January 1991), pp. 4ff.; 'New faces for old', *Bankers Magazine* (NY), 97 (December 1918), pp. 795–6; Dr A. Suzanne Noël, *La Chirurgie esthétique: son rôle social* (Paris, 1926); Charles C. Miller, *Cosmetic Surgery: The Correction of Featured Imperfections* (Philadelphia, 1924); John Liggett, *The Human Face* (New York: Stein and Day, 1974), p. 126 on operations to flatten prominent ears during the 1920s.

19 Annie C. Dalton, *The Ear Trumpet* (Toronto, 1926), pp. 1–24.

20 Wilson Ear Drum Co. advertisement, 'Deafness relieved by science', *Harper's Weekly*, 37 (August 19 1893), p. 803; 'To help the deaf', *Gateway* (July 1930) advertisement in Volta Bureau clipping file on hearing aids, Washington, D.C.; Bell Telephone Laboratories, 'A talk with Harvey Fletcher' (1963 film, 16mm), shown me at the Niels Bohr Library, American Institute of Physics, College Park, Maryland; Gem Ear Phone Company advertisement, 'The least conspicuous aid to hearing'.

21 Mears Ear Phone Company, 'Hear distinctly', *Colliers Magazine*, 59 (September 26 1914), p. 36. Women's especial sensitivity to tone, if true beyond the apparent biological fact that they are more sensitive to higher-frequency tones, may reflect, in Anglo-American patri-archal cultures, the carefully honed skill of attending to the indirect commands of power-ful male figures. Or it may reflect the perpetuation of a critical, subversive running commentary to which men are, in a manner of speaking, deaf. On this and related issues, see Deborah Tannen (ed.), *Gender and Conversational Interaction* (New York: Oxford University Press, 1993), esp. Deborah Tannen, 'The relativity of linguistic strategies: rethinking power and solidarity in gender and dominance', pp. 173–5; *idem, Conversational Style: Analyzing Talk Among Friends* (Norwood, New Jersey: Ablex, 1984).

22 See Mrs Murray Galt Motter, 'The rules of the road', *Good Housekeeping*, 83 (October 1926), pp. 251–5, esp. on listening postures.

23 Western Electric advertisements in *Saturday Evening Post* (March 9 1946, May 18 1946 and July 13 1946), and in *Life* (February 11 1946).

24 Sonotone advertisement, *Life* (October 18 1943), p. 15; Western Electric hearing aids advertisements in *Ladies Home Journal* (November 8 1941), p. 101; *Time* (June 4 1945).

Nicholas Oddy

Bicycles

THE starting point for this essay is *The Raleigh Collection*, a catalogue issued in 1983 by the Raleigh Cycle Company aimed exclusively at female cyclists. It featured 'dropped' or 'open' frame machines instantly recognisable as female bicycles. This catalogue was unusual in the history of cycle marketing in that it isolated female machines from their male counterparts. It was even more noteworthy for its attempt to feminise the machines by sexual stereotyping; the bicycles were shown in the context of fashion plates – 'Blouse by . . . Skirt by . . . Bicycle by . . .'. The text was more concerned with 'Fashion, Fun and Fitness' than with technological or mechanical specifications, and the colours of the machines veered towards whites and brights rather than more sober 'male' colours. Since then other manufacturers have followed suit and open frame machines have become more stereotypically feminine over recent years, in contrast to the erosion of factors which first determined the open frame as female. This essay explores the question of gender coded bicycles and examines the process which led to the creation of the now familiar type-forms of male and female bicycles in the nineteenth century and their subsequent supremacy.

In 1896 Lillias Davidson, president of the Lady Cyclists' Association, wrote 'It is the skirt which rules the destinies of women on the cycle.'[1] Almost since their invention bicycles had been gendered by the existence of machines aimed specifically at women which accommodated riders wearing long skirts. Their introduction suggests that bicycling was not necessarily a gendered activity, but that the bicycle itself was a gendered object; unless stated otherwise bicycles were, effectively, male.

The earliest bicycles, 'Draisiennes' (in Britain commonly called dandy or hobby horses), proclaimed their gender through frame design. Karl von Drais, who invented the machine in 1817, employed a frame structure in which the wheels were effectively hung on trunnions below a connecting

beam with the saddle mounted on top of the beam, a format which was adopted generally and was to remain unaltered until the 1860s. To ride the machine one sat astride the beam,[2] a position which interfered too much with a long skirt to make riding practicable for a respectably dressed woman. Mounting the machine by swinging a leg over the connecting beam was considered unseemly for a lady. For the machine to be accessible to women who did not wish to flaunt social convention, it would have had to be designed so that one could easily step over its frame and with sufficient 'drop' for a skirt to hang uninterrupted. Had Drais designed his machine with a low-forked beam which allowed these requirements, the concept of male and female machines might not have been established so early. As it was, both activity and object were defined as male.

The earliest female machine was probably that made by Denis Johnston, a carriage builder largely responsible for encouraging the dandy horse craze in late Regency London. It was built as early as 1819, only a year after Johnston's first entry into dandy horse design [10]; however, in that time an important precedent had been set. Johnston's female machines were, effectively, developed out of, and were seen as variations on, a male theme and as far as cycling histories go, this assumption has never been challenged.

If the frame determined the gender of the earliest machines, technology was the chief factor in gendering the driven machine of the mid-to-late nineteenth century when the widespread adoption of front-wheel drive, to all intents and purposes, precluded female bicycles. With cranks and pedals mounted each side of the hub of the front wheel, it was almost impossible to ride the machine in a long skirt. The few builders who attempted to produce female counterparts to these machines either made side-saddle versions with a crank arrangement on one side of the front wheel and a compensatory off-set rear wheel, or altered the arrangement by adopting lever drive to the rear wheel with the rider sitting forward. Both designs posed difficulties for mounting and balance when setting off, which probably explains

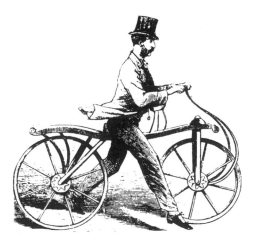

10] The English hobby horse

their apparent unpopularity. None established a sufficient following to make it necessary to classify the gender of either the 'boneshaker' of the 1860s, or the high-wheeled 'ordinary' (penny farthing) bicycle of the 1870s and 1880s; bicycles and bicycling remained unquestionably male.

Was the gendered nature of the object the key determinant in establishing the gendering of the activity during this period, over and above social pressures which operated no matter what the design of the machine? Tricycles of the 1870s and 1880s, for example, were not obviously gendered by their design unlike the male ordinary bicycle. Tricycles, generally 'open' forward of their saddles, did not challenge female dress conventions and their safety and reliability appealed to both male and female riders. Tricycling appears to have been popular with both sexes, suggesting that it was the bicycle itself rather than cycling as an activity that was the key 'male' factor in the high-wheel period.[3]

The type-forms which we recognise today as male and female bicycles date from the 'gentlemen's' and 'ladies'' bicycles of the period 1885–95 when the rear-driven 'dwarf safety' bicycle was established as the prominent bicycle design.[4] Although first successfully marketed by Starley and Sutton as the 'Rover' in 1885, machines employing the same principles had been produced in the 1870s. In 1884 H. J. Lawson had manufactured an open-frame rear-chain driven safety bicycle, the design of which seems to have had no clear gender implications. However, Lawson was interested in safety and possibly designed the frame with ease of mounting in mind for a male rider; equally the design's conspicuously curvaceous and elegant frame structure could be a response to the ridicule his ungainly 'crocodile like' bicycle designs had met with in the 1870s.[5] Lawson later claimed that his 1884 design was a ladies' machine but he does not seem to have done so at the time.[6] Nevertheless, it remains one of the few 'unisex' bicycle designs of the nineteenth century. Its physical design gendered it as neutral or female, but had Lawson managed to establish the machine in the existing market presumably it would have become socially constructed as a male object.

Lawson's 1884 design came at a time where 'closure' had not been achieved in terms of the design of safety bicycles,[7] and there was no precedent as to whether or not rear-driven safety bicycles for male riders should have open or closed frames. The determining gendering factor for Lawson's machine was its intended rider.

The 1885 'Rover' bicycle, on the other hand, was clearly gendered by design and marketing. None of Starley's designs at this time provided for a rider wearing long skirts,[8] although the Mark 2 machine (on which the rear

driver's success was founded) could easily have been redesigned for such a requirement. Starley, who seems not to have aimed much beyond the existing athletic male market, mounted an aggressive sales campaign which emphasised speed and performance rather than safety and entered Rovers in high-profile races against the established type-form of the high-wheeled ordinaries and rival front-driven safeties.[9] Other manufacturers followed suit and the rear-driven safety bicycle's potential in terms of a broader market was not fully realised until the 1890s. Starley's Rover should not be seen as radically changing cycling in the 1880s, as suggested in many histories. He established his machine firmly within the existing male cycling culture and, in so doing, established the rear-wheel chain-drive bicycle as a male machine no matter what its design. Starley's Rover was, in cultural terms, no different to the ordinary.

There are other examples of cultural construction and bicycle frame design. The cross-frame pattern safety bicycle, a rear-wheel chain-drive machine popular in the period 1885–90, was perceived as purely male at the time but, when what was effectively the same cross frame was adopted by Alex Moulton in the 1960s, its gender was reinterpreted as 'unisex' (although some established cyclists insisted it was a 'woman's' bicycle) [11].

What factors allow such a change to take place? Because in the late 1880s, it was assumed that all bicycle riders were male, the few designers who experimented with bicycles for female riders had to make it clear that such machines were specifically for women. This was soon to change. By the mid-1890s the diamond frame dominated cycle design, its high crossbar proclaiming its maleness. Female bicycles effectively became the same design with the crossbar removed or, more commonly, 'dropped' to provide a step-through frame with skirt clearance. Pinch and Bijker claim that by 1898 'closure' had been achieved in bicycle design and the type-form bicycles with which we are still familiar today had become established.[10] From then on male machines had crossbars, female machines did not [12, 13]. Thus when, after seventy years of non-use, Moulton resurrected the cross frame, its *lack* of crossbar proclaimed it as not being male, in contrast to the 1880s when this would not carry such cultural meaning. The more or less universal adoption of the diamond frame in the 1890s is the key element in the establishment of the gendered bicycle in the post-high-wheel period.

It could be argued that, had the safety bicycle continued to develop along the cross-frame pattern which offered more clearance for a skirt, women might have taken to using them and the social construction of bicycles as male would have been eroded, but such a reinterpretation could only have

been achieved had makers never offered a 'ladies'' bicycle as an alternative design to those of unstated but assumed male configuration. As it was, those makers who realised the potential of the safety bicycle for female riders produced machines designed particularly to address 'female' clothing conventions and specified them as being for ladies' use. While this was a sensible marketing move, given the rigidly gendered social

11] Moulton bicycle

conventions of the time and the likely criticism of female bicyclists as being 'masculine' were they not to use a specifically 'feminine' bicycle, the provision of defined women's machines confirmed that those not labelled as for ladies were, *per se*, gentlemen's bicycles – even if this was challenged by actual use. For example, in Paris in the 1890s divided skirts and pantaloons were fashionable and commonplace amongst female cyclists many of whom rode diamond-framed machines,[11] but this did not lead to any real attempt to reclassify the gender of the diamond frame amongst French or any other

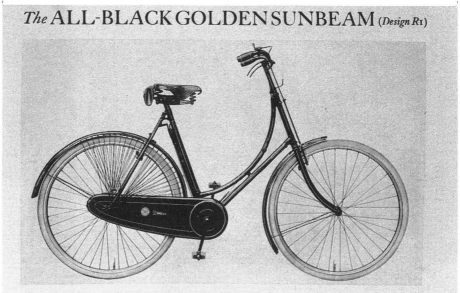

The ALL-BLACK GOLDEN SUNBEAM *(Design R1)*

TWO-SPEED—26 GUINEAS. THREE-SPEED—27 GUINEAS. *Nett Cash.*

12] Ladies' All Black Golden Sunbeam

manufacturers or commentators. Female riders were simply regarded as women riding men's bicycles.[12]

The closure of design around the diamond frame is less important in terms of establishing the principle of gendered bicycles, than in establishing the key signifier of the object's gender – the crossbar. Indeed, the longevity and success of the diamond frame has had the effect of reversing assumptions concerning gender in bicycle design. Prior to the diamond frame, all bicycle designs were presumed male unless stated otherwise; since its establishment, any bicycle which did not have a clearly defined 'crossbar' was presumed female. The so-called 'mixte' frame, which originated in France in the inter-war period as a 'unisex' design, for example, was quickly feminised because it lacked the crossbar.[13] Since the 1970s at least, few bicycle builders have considered the 'mixte' frame bicycle as anything other than a female machine. This is largely because it is basically a diamond-frame bicycle with the crossbar replaced by two tubes running from steering head to rear fork ends, thus fitting the assumption that female machines are essentially diamond-frame bicycles with the crossbar removed. The Moulton, on the other hand, is not diamond-framed. This, coupled with its small wheels, makes it so radically different to the type-form diamond-frame machine that

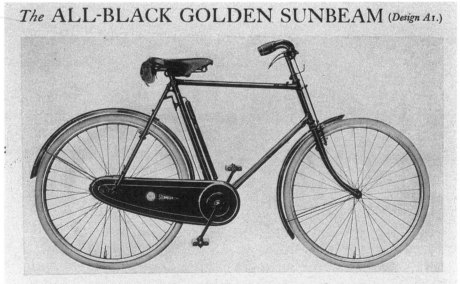

The ALL-BLACK GOLDEN SUNBEAM *(Design A1.)*

TWO-SPEED—26 GUINEAS. THREE-SPEED—27 GUINEAS. *Nett Cash.*

13] Gentlemen's All Black Golden Sunbeam

it does not call forth existing references to gender and it can be read as 'unisex'.

Paul Rosen's claim that the gender classification of bicycle design revolves round 'assumptions about women's clothing which were current a century ago and are now severely out of date if not completely irrelevant'[14] points to an interesting possibility that a design form's 'closure' takes with it the social construction of the context of its closure until an opportunity occurs for the design to be 'reopened'. If this does not happen for a long time, as in the case of cycle design, then what was a social construction becomes so obscure and irrelevant that it can only be accounted for in terms of 'tradition'.[15] It would seem that, as the practical origins of what we recognise as male and female bicycles fade into history, designers have begun to turn to aesthetic considerations to sustain gender classifications.

A purchaser of a ladies' bicycle in the 1890s would buy a bicycle similar in finish to that of its gentlemen's counterpart. Differences lay in componentry and frame design but in terms of paintwork, plating, transfers and publicity the machines would be treated as one and the same (probably because female bicycles were designed in the context of the existing male cycling culture). As cycling became more popular, there does not appear to have been any attempt to reconsider whether or not male cyclists might find open frame designs more convenient and easy, possibly because manufacturers seem to have assumed that male bicyclists in the 1890s were identical to those who rode ordinaries in the 1870s and 1880s and valued sporting specifications above all else. The almost universal black finish which characterised both male and female machines of the 1890s and 1900s also had its origins in the ordinary period of the 1870s and 1880s; it was seen as practical and serviceable, anything more flashy was presumed to be at the expense of constructional qualities. It was argued that good makers did not need to waste effort in making the machine 'best please the untrained eye'.[16] A similar lack of effort to respond to female stereotyping can be found in makers' catalogues and publicity of the late nineteenth and early twentieth centuries. Machines were illustrated in side elevation with a list of specifications given next to them. Where descriptions vary between ladies' and gentlemen's machines, most variations are limited to a word or two added to the female specification, though significantly, they were words such as 'elegant' or 'artistically finished' (in spite of the finish being no different to that of the male models).[17]

In contrast, since the Second World War and particularly in recent years, it has become more common for bicycle makers to design 'femininity' into

open frame machines and their related sales literature, of which *The Raleigh Collection* noted at the beginning of this chapter is a part. Somewhat paradoxically, as the practical reason for female machines being so classified diminishes (i.e. the provision for long full skirts) the drop frame bicycle is being made *more* rather than less 'feminine'.[18] Why? Might not a male rider find an open frame an advantage? Why do makers not drop the 'ladies' classification and try to sell the drop frame to a broader constituency?

To address such questions one needs to return to the 1890s, when the hierarchy which has continued in cycle design to this day was firmly established. Ladies' bicycles were not a design form in their own right; in spite of being more difficult to build, generally better equipped and more expensive than gentlemen's bicycles, they were a male design compromised by social conditions and were seen as *lesser* machines than their male counterparts. Throughout the 1890s various makers attempted to design a female frame which was as rigid as the diamond frame and to lighten diamond-framed machines because of track requirements. This emphasis on rigidity and lightness took little account of the actual use of the bicycles, mainly promenading and light touring for which comfort is a greater priority than rigidity or lightness and for which the dropped-frame machine was well suited. Instead, bicycle design was based on the ideal of the male sportsman. Effectively the social construction of cycling, at least in the eyes of cycle builders, had reached 'closure' during the era of the high-wheeled 'ordinary'.

In this hierarchical structure of design forms it was possible to aim up – to the athletic sporting male machine – but less easy to aim down. As social conditions changed it became more acceptable for female cyclists to ride the male diamond frame, but for a male cyclist to ride the female dropped frame was, and still is, a different matter. There are obviously close connections with cross-dressing, and it could be argued that the important feature of the dropped frame was not that it was designed for easy mounting and dismounting, or to offer a more comfortable ride, but that it was designed to be ridden in a skirt. No matter how obsolete this feature of the design has become, it is firmly rooted in the minds of both manufacturers and purchasers.[19] Few manufacturers and designers are willing to try to reassess the gender of the dropped frame, but instead turn to stereotyping. The dropped-frame bicycle has become as feminine as the skirt it was intended to accommodate, and manufacturers have begun to divorce the type-form from its diamond-frame counterpart. No longer is the female bicycle treated as a compromised male machine, rather it has become an exercise in 'femininity' in its own right.

NOTES

1 L. C. Davidson, *Handbook for Lady Cyclists* (London/Glasgow: Hay Nisbet, 1896), p. 27.
2 The Draisienne had no drive mechanism and was powered by pushing it along by kicking the feet backwards on the ground in a running motion; its early names of 'running machine', 'walking accelerator' and 'velocipede' reflect this riding method.
3 See Henry Sturmey (ed.), *The Tricyclist's Indispensable Annual* (Coventry: Iliffe & Son, 1883), p. 6: '[Tricycles have] opened up a healthy, invigorating and economical pastime to thousands of men who would never have taken the trouble to learn to ride the bicycle, as well as to the fair sex, to whom the bicycle was of course a sealed book.'
4 The arrangement of the rear driven dwarf safety was usually that of the bicycles which are familiar today: centrally positioned saddle over a crank bracket which drives the rear wheel by means of a chain, gearing being achieved by altering the size of the chain sprocket wheels. Although many early designs had different-sized front and rear wheels, by the late 1880s most only differed by about two inches in diameter (at about 30 inches) and give the effect of having equal-sized wheels.
5 T. Pinch, W. Bijker and T. Hughes, 'The social construction of facts and artefacts', in Bijker, Hughes and Pinch, *The Social Construction of Technological Systems* (Cambridge, Mass. and London: MIT Press, 1987), pp. 17–50, 39. This description probably derives from *The Cyclist* (April 21 1880) cited in Andrew Ritchie, *King of the Road. An Illustrated History of Cycling* (London: Wildwood House; Berkeley: Ten Speed Press, 1975), p. 124.
6 Derek Roberts, *Cycling History – Myths and Queries* (Birmingham: Pinkerton Press, 1991), p. 43. Note that in the George Moore illustration of this machine its rider is male.
7 Closure is the term to describe the point at which a dominant design becomes the type-form against which all others are measured.
8 John Kemp Starley was both principal designer and leading partner of Starley and Sutton.
9 Ritchie, *King of the Road*, pp. 129, 130.
10 Bijker, Hughes and Pinch, *The Social Construction of Technological Systems*, p. 39.
11 The fact was commonly observed by British commentators, for example Mary E. Kennard in *A Guide for Lady Cyclists* (London: F. V. White & Co, 1896), p. 44: 'If it were the fashion in this country for ladies of good standing and position to wear knickerbockers, and if they could appear as freely in them as in France, without shocking the non cycling portion of the community, then, no doubt much might be adduced in their favour'; and Davidson in *Handbook for Lady Cyclists*, p. 30: 'In France it is the skirted woman who is conspicuous, and who becomes the subject of general remarks about her attire.'
12 In spite of some makers turning out diamond-framed ladies' machines in the mid-1890s, e.g. 'Messrs Marriott & Cooper make a light full diamond frame for the use of those affecting the so-called "rational dress"' (F. J. Erskine, *Bicycling for Ladies*, London: Iliffe & Son, 1896, p. 25), this seems to have had little effect on perceptions of the gender of the diamond frame; indeed, some manufacturers of these machines were evidently not entirely committed to the concept of a female diamond frame themselves. John Barratt & Co.'s 'Wulfruna Lady's Rational Safety' is described on p. 13 of their 1896 catalogue as 'La Petite Parisienne Scorcher. It is light, though strong and reliable, being built with large tubes: it is also strong enough for gentlemen's use. 28" front and 26" back wheels, butt ended tangent spokes, which I consider makes it adaptable for ladies' use, and easy to reach, mount and dismount.'

 Returning to the cross frame, it is likely that, even had this design continued to be a standard type-form during the 1890s and beyond and been adopted by female riders, it would have remained a male design. Its gender could be readily reinterpreted in the 1960s because it had gone out of common use before 'closure' of the (gendered) design forms had been achieved.

13 R. C. Shaw, in *Cycling – A Teach Yourself Book* (London: English Universities Press, 1953), p. 55, described the 'mixte' frame as 'well suited for use by women and girls, but can equally reasonably be adopted by male riders, although there is some natural prejudice against it in that respect because it looks so much like what is accepted as a woman's frame'.

14 Paul Rosen, 'Cycling round the boundaries: the mutual construction of people and machines' (Conference paper delivered to the British Sociological Association Annual Conference, University of Central Lancashire, March 1994), p. 12 (unpublished).

15 By 1927 'Kuklos' (Fitzwater Wray) was able to comment, 'Nine out of ten of the people who want bicycles still trustfully enter a shop and buy one of the brand new machines of 1895 design . . . complete with "dress guards" . . . Observe the lady who has accepted the Standard Roadster of the big maker, 1927 pattern . . . the chain is covered with more obsolete relics of 1895 – either a Ford body in tin or an attache case of synthetic leather. These are "to keep her skirt out of the chain", although that disappearing garment never comes within a foot of the chain, and may generally be observed as in a state of retreat, joyously nonchalant, to the vicinity of the waist' (W. Fitzwalter Wray, *Kuklos Papers* (London: J. M. Dent & Sons Ltd, 1927), 'Of Wriggling', pp. 167–87, 179–80.

By the 1930s cycling handbooks often give no reason at all for the use of the drop frame as a ladies' machine beyond it being usual. For example, F. J. Camm, *Every Cyclists' Handbook* (London: Newnes, 1936), p. 22: 'Although it is customary to regard it as essential to drop the top bar for a lady rider this is a drawback from the point of view of design . . . where the lady rider wears breeches or a proper riding skirt the standard diamond pattern may be employed'. In spite of this advice, 'The Keen Lady Cyclist' is illustrated on p. 31 wearing breeches alongside a standard 'straight'-tubed drop frame machine.

16 Davidson, *Handbook for Lady Cyclists*, p. 40. See also Henry Erskine, *Tricycling For Ladies* (London: Iliffe & Son, 1885), p. 5; F. J. Erskine, *Lady Cycling* (London: Walter Scott Ltd, 1897), pp. 35–6.

17 A representative sample of cycle catalogues and publicity material of this period can be found in the John Johnston Collection at the (New) Bodleian Library, Oxford.

18 Rosen, *Cycling Round the Boundaries*, cited the example of Raleigh's 1993 range of children's cycles: 'The Even More Extreme, a boy's bike aimed at six to nine year olds and featuring an "outrageous extreme paint job in Jungle rain with wild croc graphics" is matched by the girl's Pretty Extreme, featuring a "stunning coral vapor paint finish with diving dolphin graphics" . . . or there is the boy's Slammer, "with menacing shark graphics", matched by the girl's Stunner in a "stunning hot pink paint finish with exotic tropical fish graphics".' The extreme nature of this gender stereotyping compares with the even weaker 'practical' reasons for having specifically boys' and girls' bicycles than men's and women's. Even in the 1890s the shorter length of girls' skirts made the deeply dropped frame unnecessary as a female type-form, and, on the other hand, for learning to ride the open frame is more practical for both sexes, while the weaknesses inherent in adult open frames are more or less irrelevant in children's frame sizes with child-weight riders.

19 It is worth noting the way in which the open frame and diamond frame are advertised to the same female market. In *Elle* magazine (June 1988) Raleigh advertised the semi-curved drop frame 'Caprice' with a wicker-work handlebar basket full of flowers alongside its rider befrocked in a full ball gown, under the caption 'Endless love'. The same magazine carried another Raleigh advertisement (July 1991) for their ATB/Mountain bike range with a diamond-frame machine standing in a docklands warehouse flat, with a wardrobe full of other machines in the range – no rider visible – beneath the caption 'What do you wear under your trousers?'

Guns: the 'last frontier on the road to equality'?

WHEN considering gender and designed objects, it is hard to conceive of something more apparently masculine than a gun – a potent symbol of masculinity in a world of calibres and carbines which has historically excluded women. Discussions about gender and firearms frequently make reference to psychoanalysis; indeed, the so-called 'priapic theory of gun ownership' has been used, mainly by handgun control lobbyists, in attempts to discredit handgun ownership.[1] They argue that 'weapons are phallic symbols representing male dominance and masculine power', and regard 'the need for a gun as serving libidinal purposes . . . to enhance or repair a damaged self-image . . . and involving narcissism . . . [p]assivity and insecurity'.[2] Counter-arguments, mainly from the anti-handgun control lobby, state that 'pragmatically' such 'derogatory . . . speculative literature on the personality characteristics of gun owners' cannot be substantiated.[3] Dr Bruce Danto, consultant psychiatrist to the United States National Institute of Justice's 1978 review of the social scientific literature on gun control, points out that most gun owners in the United States are middle-class, white, Protestant, rural Southerners, and can find no reason why they should have greater feelings of penile inadequacy than urban dwellers of other classes, races and denominations. He argues that 'pragmatically', rural gun ownership can be explained in terms of hunting. Protestantism abounds in rural communities in America, and Protestants, he claims, are more likely to hunt than Catholics and Jews. Furthermore, he argues that Protestants and gun owners tend to be 'descended from the older American stock retaining cultural values redolent of the "individualistic orientation that emanated from the American frontier"'.[4] Whichever of these views is subscribed to, they do not explain the increase in gun ownership amongst women. Psychoanalytically, gun ownership amongst women could be explained in terms of penis envy, but this largely discredited theory is not one to which I

subscribe. 'Pragmatically', gun ownership could be explained by women's need for protection rather than feelings of penile inadequacy, but this too is an area open to debate.

In the United States, the focus of this study, the perception is that women are arming themselves in the face of increased levels of violence. On a more political level, however, women arming themselves is seen by some as the 'last frontier needed to be won by women on the road to equality'[5] – a highly problematic and contentious generalisation. The placing of a gun in the hand of a woman, far from making her equal to men, raises complex problems with regard to women's sexual identities and role in society. Through looking at representations of armed women and the recent 'LadySmith' range of hand-guns produced by Smith and Wesson for women, this chapter attempts to assess the extent to which guns act as 'equalisers'.

In the Western world, women and guns are more closely associated with sex than sexual equality. Cinematically, women portrayed with firearms often fall into the Chandleresque *femme fatale* category, pandering more to a stereotyped male fantasy than threatening male hegemony. More contemporary films still retain elements of this stereotype. For example, Jamie Lee Curtis in *Blue Steel* (Kathryn Bigelow, USA, 1990) and Briget Fonda in *The Assassin* (John Badham, USA, 1993) have played attractive women who eventually fall in love with the hero and who, crucially, are armed not because they chose to be but because they have to be. Curtis in *Blue Steel* is armed because she is a police officer, an occupation chosen, it is implied, because her father abused her mother and accordingly she is motivated by a desire to see justice done. Similarly, Fonda in *The Assassin* only becomes a killer under duress. Another stereotyped representation of women and guns is the 'Rosa Klebb type'; ideologically, politically and/or sexually 'deviant', masochistic and ugly. Klebb, James Bond's arch enemy in *From Russia with Love* (Harry Saltzman, Albert Broccoli, GB, 1963), is head of SMERSH, and in charge of murder and torture. In the novel (and her cinematic portrayal is no more sympathetic) she is referred to as a 'dreadful chunk of woman'[6] with a face which is described variously as 'ugly', 'puffy' and 'toadlike'.[7] Women armed simply for self-protection are generally not represented on the silver screen. Armed women, it would seem, have to have their use of guns explained or justified to a far greater extent than do men.

There are very few examples of guns being designed specifically for women prior to the 1980s. During the late nineteenth century, 'pioneer' American women in rural communities used men's rifles and shotguns for self- and home protection and hunting. It was during this period that Smith

and Wesson started to produce their 'LadySmith' range of small, low calibre revolvers for women. However, production of these guns was short-lived possibly because, being small and easily concealable, they could be seen as 'Saturday Night Specials' – the cheap, poor quality, easily concealable revolvers that were and still are associated with criminality. It was not until after the Second World War that there was another concerted effort to design guns for women. During the consumer boom of the 1950s, Hi-Standard, a particularly design-conscious Connecticut-based firearms manufacturer, produced revolvers for women with pink, turquoise and gold handles at a time when other pastel-coloured consumer goods were being successfully marketed towards the female consumer. During the 1950s, however, handgun ownership remained a male preserve. The company was unsuccessful seemingly because women had little interest in arming themselves at that time, regardless of the colour of the product.[8]

Thirty years later, perceiving the changing position of women in American society, Smith and Wesson commissioned a Gallup Poll survey in 1984 and discovered a market of 7.8 million potential female gun owners in the United States (now estimated to be nearer 20 million).[9] Accordingly, in January 1989, the company reintroduced its 'LadySmith' range. Before discussing the design of these guns, it is important to point out that the new market does not simply reflect an increase in violence against women. Although FBI statistics reveal forcible rape to be 'consistently increasing' in America,[10] also important in assessing why women have suddenly come to the attention of some firearms manufacturers are changes in the handgun industry which have encouraged the creation of new markets.

In the early 1980s, the United States Army decided to move from the standard issue Colt .45 semi-automatic pistol to a European 9mm semi-automatic pistol, in line with NATO. This precipitated an increase in sales of all 9mm semi-automatic pistols, especially European models, in both the law enforcement and commercial markets in the United States. In order to survive the increased competition from these foreign pistols, established domestic revolver manufacturers such as Smith and Wesson had to diversify their product range and, significantly, paid considerable attention to the production and marketing of handguns for women.

In their extensive market research, Smith and Wesson questioned women about what they did and did not want their guns to be like. In 1989, taking these factors into account, the company modified two models in their existing small-frame revolver range, the Model 36 and the Model 60, which became the Model 36-LS and Model 60-LS respectively – LS standing for

'LadySmith'. The modifications made to these guns were both cosmetic and practical. Many women complained that the pistol grips on most guns were too large for their hands and therefore Smith and Wesson designed the 'LadySmith' grips smaller. Another complaint concerned the amount of pressure needed to be exerted on the trigger to fire it and, accordingly, Smith and Wesson redesigned the trigger mechanism so that less pressure was required. These were the only purely 'functional' changes made to the guns and, interestingly, the changes made to the trigger mechanism have been implemented across the whole range of Smith and Wesson small-frame revolvers, not just the 'LadySmith' range.

All the other modifications made to the existing Model 60 and the Model 36, to produce the Model 60-LS and Model 36-LS, were purely cosmetic. Unlike the Hi-Standard products of the 1950s, Smith and Wesson decided to make its women's revolvers look like serious, as opposed to 'novelty', guns. However, their functional appearance meant that the manufacturers also had to ensure that they did not look so threatening that they scared off potential owners. Consequently, Smith and Wesson introduced rosewood grips as the standard service stocks on their 'LadySmith' range, in place of the more aggressive looking and 'masculine' black rubber. Additionally, although it is possible to buy a 'LadySmith' revolver with a blue steel finish (i.e. black and shiny), frosted, stainless steel satin finishes are standard. Furthermore, all the 'LadySmith' revolvers have their edges radiused and rounded to make them smoother, both to look at and to handle. All these factors combine to give the guns a softer, less threatening appearance than that of their 'male' counterparts.

In 1990, Smith and Wesson, feeling increasingly confident about the new market, introduced a 9mm semi-automatic pistol to its ladies' range. An analysis of the redesign of the 'male' pistol, the Model 3913, provides an interesting example of how efforts to appeal to female consumers do not always go to plan. For the 'LadySmith' 9mm semi-automatic, the Model 3913-LS [14], the firm did not simply modify the appearance of the existing pistol, but redesigned the barrel so that it had a smoother and more streamlined shape. As well as this design alteration, Smith and Wesson also included some cosmetic changes. For example, the pistol is not black and steel like others produced by them but a fawn/grey colour, and the engraving of 'LadySmith' on the frame reinforces the gender difference suggested by the colour. Whilst women do buy these guns, they are not so popular as 'LadySmith' revolvers, the sales of which outstrip the pistol nine to one. This is possibly because, despite the cosmetic alterations, the pistol still has a more aggressive and

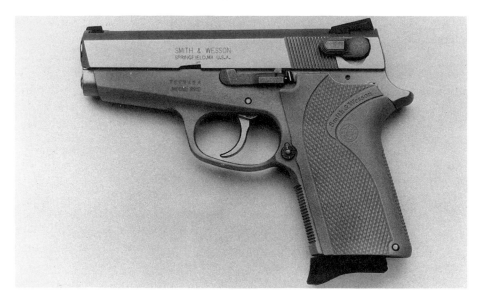

14] Smith and Wesson 'LadySmith' pistol

(para)military aesthetic and associations than the revolver.[11] Interestingly, Smith and Wesson did not anticipate that male consumers, in either the commercial or law enforcement markets, would like this new streamlined pistol. Although male consumers were less keen on the cosmetic changes, they liked the redesigned barrel and therefore Smith and Wesson now produce the same gun for men – in black, without 'LadySmith' engraved on the frame and called the Model 3913-NL (NL standing for non-LadySmith). Apart from this interesting miscalculation, Smith and Wesson have been successful in their reintroduction of the 'LadySmith' range.

Just as important as the design changes, if not more so, is the marketing of these guns. It is important to understand that this potentially huge market has come to the attention of not only manufacturers but also political groups, most especially the National Rifle Association and the Center to Prevent Handgun Violence. The latter is a pro-handgun control lobby group, which is fronted by a woman, Sarah Brady, wife of Jim Brady, Ronald Reagan's press secretary who was shot when an attempt was made on the president's life. These political groups have used the issue of women and guns to mobilise their own interests, and their activities highlight the controversial nature of this emotive subject.

When Smith and Wesson reintroduced the 'LadySmith' range, the

company was accused by the handgun control lobbyists of scaremongering for the sake of profit.[12] Smith and Wesson, sensitive to the criticism, replied by advertising the sale of guns to women rather like life insurance, emphasising the benefits of owning a gun should the 'worst' happen. Accordingly, rather than giving alarming statistics of one's chances of being knifed, raped or mugged, their sales brochure emphasises safety and security:

> As more women have entered the job market, become heads of households, purchased their own homes, they've taken on a whole new set of responsibilities. For their own decisions. For their own lives. For their own – and their families' – security. And security . . . has come to mean more than a good income and a comfortable place to live. It's come to mean safety.[13]

This text is accompanied by an illustration of a woman tucking her child into bed [15], a comforting image carefully designed not to threaten or scare. Although this type of advertising is not explicitly alarmist, it is highly emotive and manipulative, aimed at women's sense of responsibility with specific regard to their role as society's carers, nurturers and child-bearers. However, equally emotive literature aimed at women is published by the Center to Prevent Handgun Violence [16] which is interested in seeing tighter gun control regulations. Although its concerns are unquestionably more altruistic than those of Smith and Wesson, they use the same type of images designed specifically to appeal to women. Realising the powerful and emotive issues related to women and guns, both Smith and Wesson and the National Rifle Association have recruited women to support their pro-handgun stance. In 1991 Paxton Quigley, author of *Armed and Female*, was employed by Smith and Wesson as a marketing consultant and 'LadySmith' spokesperson while Elizabeth Swasey was appointed as Head of Women's Issues and Interests by the National Rifle Association.

The majority of American women who are arming themselves for self-defence, are scared, and are doing so reluctantly. Gun ownership amongst women is not considered an American birthright as it is for men and, consequently, does not hold the same significance that it does for men. Women who arm themselves may want to own a gun because they consider it to be an equaliser but this is not how guns are presented to them. The main way gun manufacturers appeal to women is through emotive, stereotyped images of women as child-bearers, nurturers and carers and the handgun control lobbyists are likewise appealing to their sense of responsibility by using the same visual language. Consequently, whether intended to promote or dissuade women to arm themselves, such literature highlights the sexual asym-

metry of our society, rather than suggesting an equalisation of gender roles
and relations.

　　Women arming themselves for reasons of self-defence have recently been
represented cinematically, most notably in *Thelma and Louise* (Ridley Scott,
USA, 1991), a film that had a mixed response in America. Whilst the gun

15] Smith and Wesson 'LadySmith'
brochure, 1989

16] Publicity material from the Center to
Prevent Handgun Violence

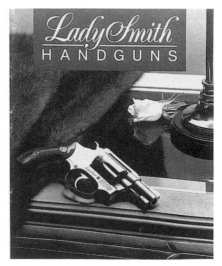

17] Smith and Wesson 'LadySmith'
brochure, 1989

manufacturers and Elizabeth Swasey saw the film as an enlightened representation of women and guns, which in some respects it is, it also received less positive responses because of the fact that the women are not police officers like Jamie Lee Curtis in *Blue Steel*; they are simply armed, independent women. There is, however, a 'reason' or 'justification' for their being armed, or for feeling the need to be armed, and that is that they have both been sexually assaulted. Thus, even in this 'enlightened' representation of armed women, there is still a need to legitimise their use of guns in a way that the use of guns by men does not demand. Clearly, more glamorous and fictional representations of women and guns which deny this reality are far more acceptable and safe. This is endorsed by manufacturers of firearms for women, including Smith and Wesson whose brochure presents an over-determined image of femininity which alludes to glamour, romance and wealth [17].

One apparently real issue concerning women arming themselves, which has been addressed by a manufacturer called Thunderwear Inc., is the problem of where women are supposed to carry their weapons. The perception, it would seem, is that holsters have 'masculine' associations and that the distance between the armpit and waist of a woman may not be large enough to accommodate a gun comfortably. Accordingly, Thunderwear Inc. produces a range of elasticated, 'in-the-pants' holsters or pouches which are worn inside a skirt or trousers. A review of Thunderwear in the journal *Women and Guns* reads:

> Imagine being a kangaroo with a pouch . . . but instead of a baby kangaroo, there's a gun in there! That's the Thunderwear principle . . . Thunderwear comes in white, a nice change from black holsters! It also comes in black and a black/white two tone combination . . . It's feather light and machine washable – you can't say that about any leather holster! . . . Now the question that I know you're all wondering about . . . what does it do to your figure? . . . Regardless of your figure type, if you wear pants or skirts with generous pleats or gathers in the front you can conceal your carry piece in Thunderwear without looking like a 'before' model for the latest diet . . . Most importantly, you can wear it with or without a belt! If you've hesitated to carry a gun for protection because your wardrobe doesn't include many belts on which to hang a holster, you may want to consider this option.[14]

Women may want to arm themselves as a way of making themselves equal, but as long as they are represented primarily as being fashion and figure conscious, even when dealing with such a serious issue as self-protection, gender divisions are reinforced. Similarly, representations of women by gun manufacturers and handgun control lobbyists as the caring and respon-

sible members of society underline how 'unnatural' armed women are, and how the gun has been exclusively coded as 'male'. The cosmetic alterations made to the design of guns for women and the representations of women invoked in their marketing are images of women 'confronting technology'; they offer stereotyped images of women in a man's world. In her book *Feminism Confronts Technology*, Judy Wajcman writes that:

> In contemporary society, hegemonic masculinity is strongly associated with aggressiveness and the capacity for violence . . . and if there is one institution in society that underwrites the ideology of hegemonic masculinity it is the military. Contemporary Western society is suffused with popular images of men as enthusiastic killers in Rambo-style fashions, war films, military toys and magazines. Weapons and particularly guns are the epitome of mastery as a means of domination. Guns are intrinsically associated with death and danger. Here the sense of mastery is enhanced by the closeness to physical danger, it is seen as the pinnacle of manly daring. The willingness of men to die – for their country, for their womenfolk, for their honour, is central to both military and manly values. Both war and weaponry are seen as exclusively male concerns, and the imagery surrounding them simultaneously portrays men as brave warriors and women as the helpless wives–mothers–daughters whose lives and honour the soldiers are fighting to protect.[15]

Here, guns are depicted as strongly gendered objects, as defenders of sexual inequality. Women, by contrast, are not depicted as active, or as gun users. They are passive, a stereotype invoked at times, by both feminist and anti-feminist literature, which views women not as inherently aggressive, but rather as being either actively or passively predisposed to non-violence.[16] Feminist 'peace' writing claims that the use of guns is a result of male violence whereas women 'value growth and preservation' rather than domination through 'death and destruction'.[17] This latter point Wajcman considers somewhat ironic because, despite being a feminist one, it is very close to the patriarchal position that 'there is no place for a woman on a battlefield'.[18] This irony is further illustrated by representations in which armed women are 'legitimised'. Women are not perceived as 'natural' gun users, and this is reflected in the appearance of the guns themselves. Under the rosewood and black rubber, the 'female' and 'male' guns discussed are equal as functional objects, but women's guns do not represent the last frontier on the road to equality. This is because, although they can kill, they are bought for different reasons. These guns are designed and sold as objects of defence to women who 'value growth and preservation', not as objects of aggression and violence for 'death and destruction'.

NOTES

I would like to thank Smith and Wesson, The Center to Prevent Handgun Violence (USA), and the National Rifle Association (USA) for their assistance with this research and permissions to reproduce the illustrations.

1 Literature concerned with the 'priapic theory of gun ownership' is cited by Don B. Kates Jnr. in a policy briefing produced for the Pacific Research Institute for Public Policy titled *Guns, Murder and the Constitution, A Realistic Assessment of Gun Control* (San Francisco, 1990). These references include 'Aspects of the priapic theory of gun ownership', in W. Tonso (ed.), *The Gun Culture and its Enemies*, 1989 and 'Sex education belongs in the gun store', *US Catholic Magazine* (August 1979).

2 E. Tanay, *Neurotic Attachment to Guns*, 'The fifty minute hour', 1976, quoted in Kates, *Guns, Murder and the Constitution*, p. 11.

3 Dr B. Danto, *National Institute of Justice Evaluation*, 1978, p. 120, quoted in Kates, *Guns, Murder and the Constitution*, p. 11.

4 Young, 'The Protestant heritage and the spirit of gun ownership', *Journal of Scientific Study of Religion*, 28 (1989), pp. 300, 307. Quoted in Kates, *Guns, Murder and the Constitution*, p. 12.

5 P. Quigley, *Armed and Female* (New York: St Martin's Paperbacks, 1989), p. xx.

6 I. Fleming, *From Russia with Love* (London: Coronet Editions, 1988), p. 206.

7 *Ibid.*, pp. 203, 205.

8 I could find no record of this company in the business records section of the Hartford Library, Connecticut. My information derives from conversations with people in the industry at this time.

9 Smith and Wesson 'LadySmith' marketing program (1992). Unpublished, Smith and Wesson archive.

10 *Crime in the United States 1991*, FBI, Uniform Crime Reports, US Department of Justice (Washington, 1992). The FBI's definition of forcible rape is as follows: 'The forcible rape, as defined in the Program is the carnal knowledge of a female forcibly and against her will. Assaults or attempts to commit rape by force or threat of force are also included, however, statutory rape (without force) and other sex offences are excluded.'

11 Smith and Wesson now produce three revolvers in their 'LadySmith' range, a .357 Magnum having been introduced in 1992, but still only one pistol. This will obviously be an influential factor in the sales ratio.

12 Interview with Elizabeth Swasey, National Rifle Association (December 1992).

13 Smith and Wesson, *LadySmith Handguns* brochure (1989), p. 1.

14 L. Bates, 'Thunderwear', *Women and Guns* (November 1992), pp. 15–18.

15 J. Wajcman, *Feminism Confronts Technology* (Cambridge: Polity Press, 1993), pp. 143–6.

16 Wajcman cites work of pacificist feminists including Sara Ruddick. See 'Pacifying the forces: drafting women in the interests of peace', *Signs*, 8:3 (1983), pp. 471–89, and Carol Gilligan, *In a Different Voice: Psychological Theory and Women's Development* (Cambridge, Mass.: Harvard University Press, 1982). The argument that women have no place in the military is quoted as being well documented by Cynthia Enloe who provides a 'wonderful illustration of the delicate manoeuvres that have been performed in order to maintain a male definition of combat' in *Ethnic Soldiers: State Security in Divided Societies* (Athens, Georgia: University of Georgia Press, 1980), and *Does Khaki Become You? The Militarisation of Women's Lives* (London: Pluto Press, 1983).

17 Wajcman, *Feminism Confronts Technology*, p. 148.

18 *Ibid.*, p. 146.

Barbie and Action Man:
adult toys for girls and boys, 1959–93

The young woman languidly brushed her long black hair. She had her head thrown back striking a pose of abandon and conscious of being looked at, but at the same time as if she were sitting alone in front of a dressing table rather than on a tube train on the Northern line. She completed the brushing, slipped on a black velvet hairband, straightened up and turned to look at herself mirrored in the window. As she did so you could see that 'she' was a he, or rather that just half of him was a 'she'. It was only one half of his head which had the long black hair, the other half was short, blond and in a conventional masculine cut. He then picked up a small troll doll lying next to him on the seat and proceeded to brush its purple bushy nylon hair before putting it hurriedly away in his back-pack as he got ready to alight. It was difficult to take in the whole outfit as he rushed past and quickly disappeared from view into the crowd on the platform. At first glance his clothes appeared conventionally unisex – all black, a fairly ordi-nary full-length belted overcoat and trousers. But was that a swish of pleated sheer georgette trouser leg, or were there two? It was all too quick to be sure. A living Barbie/Action Man doll all in one? Was the troll his Winnicottian transi-tional object[1] to dramatise the act of refashioning himself into a sexual hybrid half-man half-woman?[2]

THIS experience exemplifies the way in which increasingly, in our everyday lives, we come across the 'postmodern condition'[3] which questions definitions that at one time would have been considered unquestionable. In this case the allusion to <u>androgyny</u> did not just breach the biological explanation which assumes there can be no distinction between gender and sexuality, it broke the boundaries that separate the 'feminine' from the 'masculine' by encompassing the two in one.

Redefining gender difference through dress is not a new subject[4] but, since the 1960s and the advent of the 'consumer society', the signs of playing with gender identity through styling and fashion have moved in from the

margins to occupy a more mainstream position. This has been expressed in popular culture by interest in 'gender bending', androgyny, breaking conventional gender dress codes, and body reconstruction.

Mass-produced objects like dolls can tell us much about the creation and significance of self-image in the context of group identities. Stereotypical definitions of gender are particularly well reflected in the design of adult dolls first produced in the United States which have since become internationally available. The ones which exemplify this type of toy are Barbie, the promotional fashion doll brought out in 1959, and Action Man, the toy soldier 'action figure' which first appeared in 1966.

Although intended for children, Barbie and Action Man objectify gender as 'adult' dolls, representing fully developed mature bodies. They have been popular with children since their inception and in recent years have been collected by adults. At the same time they have also been the object of middle-class parental disapproval as prime examples of 'sexist' toys.[5]

Here, Barbie and Action Man provide a case study through which to explore the contradiction of a gendered object which appears to be reiterating and reinforcing gender stereotypes but exists in a world which increasingly questions traditional gender roles [18]. Gender stereotypes, as represented by Barbie and Action Man, become an antithesis to a popular culture that adopts androgyny as an image to redefine gender identities.[6] In the context of postmodernity conventional meanings reflected in stereotypical images can no longer be discussed unselfconsciously. This is evident in the way in which media personalities like Madonna and Schwarzenegger, invoked as 'the icons of sex and violence', become ironic and self-referential.[7] It also explains the academic interest in stereotypical representations, among which figure the subjects of this essay – Barbie and Action Man.

Design for children in general and toys in particular has been largely ignored by design historians.[8] The literature which traces the history of toys is produced by and for collectors and connoisseurs,[9] while the little of it which contextualises toys culturally, mainly considers them critically in their commodity form.[10] It is more useful to look at toys in the dynamic context of mass consumption at the stage in which they are transformed from commodity to material culture. Thus toys become the vehicles for play through which different aspects of the world can be encountered. In this way it is possible to focus on meanings at play within material space and historical time, and beyond the static interpretation derived from linguistic theory which transforms material objects into images and 'reads' them according to a self-referential sign system. The other type of analysis which avoids that kind of

reduction is that which considers the design process and production stage when gender definition is built into the products. In this case, body movement is a gender-specific feature less visible than shape and attire, but one which reveals attitudes to gender identity. The joints of dolls provide the material evidence of the ability for movement. The technical improvement added over the years to the joints in the Action Man figure embodies the increasing possibility of complex movement. Conversely, the simplicity and minimal number of joints in Barbie suggests the priority given to posing rather than action. A consideration of mobility through a study of the joints by-passes the banality of clichéd femininity and masculinity which would result from an image analysis of Barbie and Action Man.

Barbie is the most popular and widely distributed 'promotional doll' marketed by brand name. The model derived from a German doll inspired by a cartoon character called Lilli and was originally produced in Germany during the mid-1950s. The first Barbie was launched by the California-based Mattel company at the 1959 New York Toy Fair.[11] Since then it has undergone many

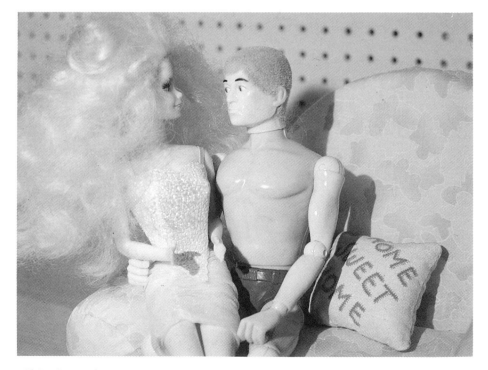

18] Barbie and Action Man

changes and diversified into a wide range of products distributed all over the world. Britain, where Barbie is marketed by Mattel UK, is considered the most important market outside the USA.[12]

The fashion doll is not new, it has existed since the eighteenth century as a means of conveying fashion trends for women. The novelty of the Barbie type was the concept of adapting the fashion doll to a plaything for girls, basing it on the model of a teenage girl with a mature adult figure. Her image, based on a cartoon, is that of a stereotypical male fantasy. Her body proportions were not intended to be realistic – were she to be translated to life size her leg length would make her seven feet tall. Barbie's exaggerated bust measurement (twice the size of her waist) has been described as 'gravity defying', and her tiny feet (the same size as her hands) are too small to hold up her body. Great play has been made of Barbie's proportions by those who have used her as a focus for protest against women being treated as 'sex objects'.

Since it was first introduced, the Barbie doll has undergone many changes, fluctuating in age from 16 to 30. She was first launched as a 'shapely

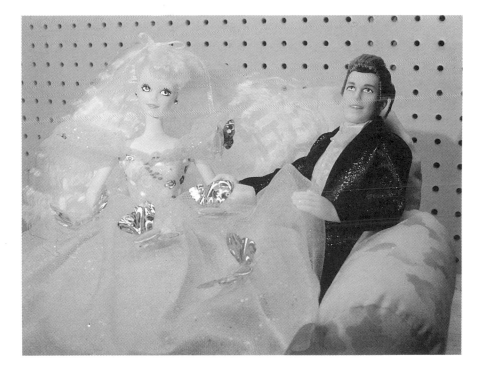

19] Barbie and Ken

teenage fashion model' with a pack of couture-inspired outfits suggesting the lifestyle of a globe-trotting fashion model. The seasonal introduction of new outfits, toys, furniture and other accessories, reflecting current fashions, are central to Mattel's marketing of Barbie products. Changes in the perception of the ideal role model for girls has also been apparent in Barbie's image which has portrayed her as both career girl and housewife. More recently emphasis has been on glamour and leisure activities. Although she is characterised as single, her wedding dress remains the most popular of her outfits. Among the many accessories, Ken, a boyfriend doll, was introduced in 1961 [**19**].

Unlike Action Man with his twenty movable joints, the original Barbie only had joints where the arms, legs and head attached to the body. In 1965 Barbie's lifestyle altered to include exercising to lose weight, and a 'bendable leg' was introduced with an internal joint at the knee[13] – a feature which has disappeared in more recent models. By 1969 Barbie was given a swivel waist so that she could be made to 'twist and turn' for the new dances. And in 1972 she acquired 'clasping hands', made to open and close to carry such accessories as a portable TV, suitcase, telephone, or tray of drinks. Ken, Barbie's boyfriend, was not particularly mobile either, although he was sometimes given bent elbows so that Barbie could hold his arm or he her waist.

1970 saw more emphasis on movement with the introduction of the 'New Living Barbie', with internal bendable joints at the elbows, knees, ankles and wrists. 'As posable as you are' claimed the advertisments. In 1975 there was a 'Free Moving Barbie' with a tab mechanism on its back which, when released, made the waist completely movable so that it could be made to bend, twist and swing a golf club or tennis racket. The 'Free Moving Barbie' was the first to be able to wear flat shoes after years of permanently arched feet for the wearing of high heels. In spite of all the changes towards an appearance of giving Barbie more movement, the innovations mainly served to increase posability, all the better to try on and display an array of glamorous outfits and accessories. The range of Barbie products increased to include a number of relatives and companions. 1975 saw the appearance of a young sister doll, 'Growing Up Skipper', who could be made to 'grow from a young girl to a teenager in seconds'.[14] By turning her arm she grew nearly one inch in height, slimmed at the waist and developed a bust line. This speeded-up pubescence provoked strong protests, yet it was the ultimate logic of Barbie's appeal to young girls – the transformation from child to grown-up.

The toy industry is acutely aware of disapproval from critical quarters and has at various times made efforts to avoid blatant images of violence and

sexism. The British National Toy Council produces leaflets for the industry on sexism and aggressive toys but it is unclear how much of its advice is followed by manufacturers, although some of them sponsor the research. After a period in which violence associated with male heroes was disguised as antics by humorous 'teenage turtles', portrayed through fictional monsters and fantasy cyborg 'terminators',[15] the reappearance in 1993 of the 'realistic' Action Man in battle dress armed with an electronic weapon has been interpreted as a revival of interest in the macho image.

When Action Man was first introduced in 1964 as G.I. Joe, its manufacturers, the US firm of Hassenfeld Brothers, considered it a risk.[16] At the end of the day, it was a doll, traditionally a girl's plaything, made for dressing and undressing and nothing like the traditional model toy soldiers for boys. But the product proved an instant success. In 1966 Hassenfeld and Hasbro were taken over by the General Mills Corporation, which also bought out Cascelloid, the firm which introduced the doll to Britain, and renamed it Action Man, marketing it under the 'Palitoy' brand name. The technology used in the Action Man joints, designed for movement rather than to give an anatomically realistic appearance, was much more complex than that of the Barbie doll. From the first model, with its twenty ball-and-socket metal-pinned joints, Action Man could be made to move at the head, neck, arms, elbows, wrists, hips, thighs, knees and ankles. He could even swivel his biceps – an anatomical feat impossible in the human body. Soft vinyl gripping hands were added in 1973, and realistic 'moving eagle eyes' in 1976 when the futuristic half-robot 'Atomic Man' was introduced. In 1979 Action Man was completely remodelled with a more athletic physique, and given all-plastic ball joints.

Charting the different types of joints incorporated into the design of Barbie and Action Man illustrates how the cliché of 'feminine' as passive and 'masculine' as active is literally embodied in the design of the toys. Barbie features only the most elemental of joints, almost as accessories to facilitate dressing, posing and the display of her various lifestyles. They were never designed at the expense of breaking the smooth contours of her legs or arms; in the case of Action Man, anatomical realism was abandoned by including an additional joint to the biceps in order to give maximum flexibility.

Barbie's and Action Man's popularity amongst children highlighted the conflict between parents' wishes to provide 'good for you' toys while wanting to cater to their children's desires and pleasures. From the start Mattel used sophisticated lifestyle marketing techniques to sell Barbie products. Television advertising positioned in children's programmes and purposely

directed at girls rather than parents contributed to making Barbie a best-seller.

Barbie's exaggerated body proportions and Action Man's engagement with combat have provoked the most criticism. A number of alternative products brought out in response to objections against toys which might encourage sexism or aggressive behaviour have not met with commercial success. For example, as anti-war feeling grew in the USA during the Vietnam war, an 'Adventurer' with a beard was added to the Action Man range to counter the military image. The 'Happy to be Me' doll, produced in the USA by the High Self-Esteem Toys Company in 1992 with 'realistic' body proportions, was intended as a 'positive image' to counter the trend of anorexia in adolescent girls.[17] Neither gained the popularity of Barbie or the military Action Man.

Some might argue that the very disapproval which Barbie and Action Man have provoked among parents can account for their popularity with children.[18] A number of colleagues confessed that as children whose parents banned Barbie and Action Man, they resorted to playing with them clandestinely (smuggling borrowed dolls into the house or going over to play with friends) or collecting them later in life.

The fascinating subject of how children actually use toys in their play can only be touched on in this essay, and it cannot be assumed that parents or toy manufacturers know how children interact with or experience the external world through their toys. Though there is little doubt that children are fascinated by the worlds of fantasy and make-believe to which toys like Barbie, My Little Pony, Transformers and Captain Scarlet give them access [20], this does not mean that they do not also create other worlds of their own.[19]

There is enough evidence to suggest that much could be learnt were we to study how children subvert the ready-made meanings inserted into toys by manufacturers. In a quest to satisfy the demands of parents who want toys to inculcate skills and socially acceptable behaviour, and still make the toys fun and attractive to children, manufacturers are caught in a double bind. A number of 'bad guy' characters to accompany Action Man made an appearance in the late 1970s and early 1980s, including Captain Zargon, a space Alien, and 'The Intruder' – a squat muscle-bound figure and Action Man's 'greatest enemy'. These were justified by the claim that 'boys have to identify with both good and bad characters when they are role-playing'. 'Bad' character dolls have not yet been created for girls. Barbie is still sold as a glamorous fashion doll, but, as a number of my informants recalled, in their play it was Barbie who was most often given the role of 'bad girl'.

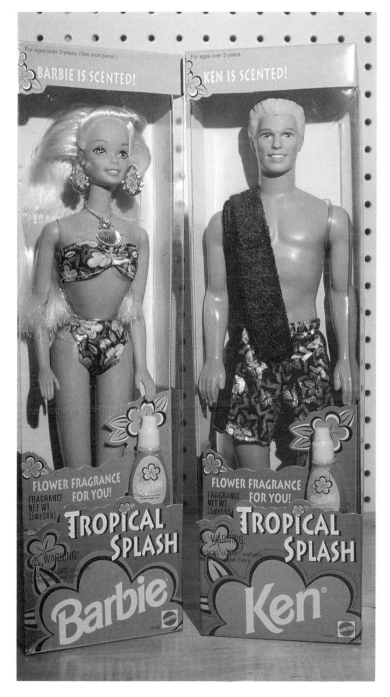

20] Tropical
Splash Barbie
and Tropical
Splash Ken

Recent studies of gender in material culture[20] have moved away from the production of androcentric knowledge by cutting across the simplistic binary opposition which defines masculinity and femininity by division, biological truth and hierarchy. In studying dolls as gendered objects there is little point in only casting them as producers of specific effects. The critique that macho soldier dolls simply instil sexist attitudes or that jointless dolls only encourage passivity in girls is naive and misinformed. Toys cannot fully determine actions or thoughts, they are themselves the focus of play – a dynamic activity used to rehearse, interpret and try out new meanings as well as products of complex social relations.

The scene described in the opening of this essay signals the current fascination for androgyny both in popular culture and as a subject of scholarly interest in material culture studies.[21] Androgyny is a symptom of postmodernity's challenging of the most apparently intractable definition of gender as natural; and as such offers an alternative way forward in the study of gender relations, away from difference and towards complementarity.

NOTES

I would like to acknowledge and thank students, colleagues and friends who have helped me with this study, in particular: Suzanne Clarke, Jon Crane, Caroline Goodfellow of the Bethnal Green Museum, Pat Kirkham, Daniel Miller, Lesley Miller, Jane North of the British Toy and Hobby Association and Andy Wilson.

1 D. W. Winnicott, *Playing and Reality* (London: Tavistock, 1971).
2 This is a description of an experience I had on the way to the Colindale Newspaper Library to do some research for this study.
3 Roy Boyne and Ali Rattansi (eds.), *Postmodernism and Society* (London: Macmillan, 1990).
4 See ch. 6, 'Gender and identity', in Elizabeth Wilson, *Adorned in Dreams* (London: Virago, 1985), pp. 117–33.
5 Ellen Seiter, 'Toys are us: marketing to children and parents', *Cultural Studies* (May 1992).
6 Current interest in androgyny in popular culture has been exemplified by the 'boys-in-dresses' image flaunted by singers like Brett Anderson of Suede. See Michael Bracewell, 'Dress codes', in *The Guardian Weekend* (July 17 1993), pp. 6–10; Vern L. and Bonnie Bullough, *Cross Dressing, Sex and Gender* (Philadelphia: University of Pennsylvania, 1993); and Marjorie Garber, *Vested Interests: Cross Dressing and Cultural Anxiety* (Harmondsworth: Penguin, 1993).
7 Suzanne Moore, 'Out of action', in *The Guardian Weekend* (July 17 1993), pp. 6–10; and Cathy Schwichtenberg (ed.), *The Madonna Connection* (Oxford: Westview Press, 1993).
8 There is some reference to the historical origins of differentiation in design specifically for children but no mention of toys in Adrian Forty's *Objects of Desire: Design and Society 1750–1980* (London: Thames & Hudson, 1986), pp. 67–72.
9 E.g. Antonia Fraser, *A History of Toys* (London: Weidenfeld & Nicolson, 1966); Caroline Goodfellow, *The Ultimate Doll Book* (London: Dorling Kindersley, 1993); Frances Baird, *Action Man: The Gold Medal Doll for Boys* (London: New Cavendish Books, 1993); Billyboy, *Barbie: Her Life and Times* (London: Colombus Books, 1987).

10 With the exception of Brian Sutton-Smith's *Toys as Culture* (New York: Gardner Press, 1986); *Le Jouet* (Paris: Autrements, 1992), no. 133; Carroll W. Pursell, 'Toys, technology and sex roles in America', in Martha Moore Trescott (ed.), *Dynamos and Virgins Revisited* (London: Scarecrow Press, 1979), pp. 252–67; Seiter, 'Toys are us'; and Susan Willis, *A Primer for Daily Life* (London: Routledge, 1991).

11 It is thought the first Barbie was made from Lilli moulds bought by Mattel from the German company who transformed a cartoon character into a plastic doll and had it manufactured in Hong Kong. Billyboy, *Barbie*, p. 19.

12 Sibyl DeWein and Joan Ashabraner, *The Collectors' Encyclopaedia of Barbie Dolls and Collectibles* (Kentucky: Collector Books, 1990), p. 113; Philip Robinson, 'Billion-dollar Barbie is not just a pretty face', *The Times* (November 27 1992), p. 23.

13 Billyboy, *Barbie*, p. 60.

14 DeWein and Ashabraner, *Encyclopaedia of Barbie Dolls*, p. 101.

15 'Toy industry' (unpublished report on US toy industry), Robin Ballin, British Consulate General, New York (March 1987).

16 Baird, *Action Man*.

17 Carolyn Shapiro, 'Cathy Meredig: a long haul to the wide-waisted world of dolldom', *Toy and Hobby World* (February 1992), pp. 84–7.

18 Daniel Miller, *Material Culture and Mass Consumption* (Oxford: Blackwell, 1987), p. 168.

19 Bruno Bettelheim's psychoanalytical study *The Uses of Enchantment: The Meaning and Importance of Fairy Tales* (Harmondsworth: Penguin, 1991) may well hold some important clues in pursuit of this question.

20 *Gender and Material Culture*, a cross-disciplinary conference at Exeter University in July 1994.

21 Maureen Mackenzie, *Androgynous Objects* (Melbourne: Harwood Academic Publishers, 1991).

Dolls: odour, disgust, femininity and toy design

Horses sweat, men perspire, and women glow. (old saying)

ODOUR plays an integral role in the cultural construction of the female body. Although women's anti-perspirant and deodorant adverts acknowledge that women are capable of sweating, they rarely represent glow, let alone sweat; this representational silence reveals a great deal about societal expectations of the gendered body. The proper female body is, above all, self-contained,[1] and commodities such as deodorant, douches and scented tampons help construct and reinforce the ideal of the properly contained, properly scented, adult female body. Because the cultural construction of gender begins in infancy (many babies wear gender-coded nappies, play with gender-coded toys and learn traditional gender roles through play and parental identification) studying the objects of girlhood, particularly dolls, elucidates our understanding of the construction of the adult feminine body.

In *Pepi, Luci, and Bom*, Pedro Almodóvar uses a girl's doll that menstruates to humorously mock the construction of the proper girl's body. Why is the menstruating doll excessive, while a crying doll is commonplace, and peeing and defecating dolls not at all unusual? There is a fine line between 'appropriate' and 'inappropriate' where female bodily containment is concerned. Tears are the (stereotypically) 'appropriate' public indicator of female excess (i.e. excessive emotion); other fluids are kept private. Odour plays an interesting role in this public–private or appropriate–inappropriate dichotomy, and odour was one of the things that initially intrigued me about Strawberry Shortcake dolls, scented toys released in 1980 by Those Characters from Cleveland, a subsidiary of the American Greetings Corporation [21]. Why was an odoured girl's doll a tremendously successful

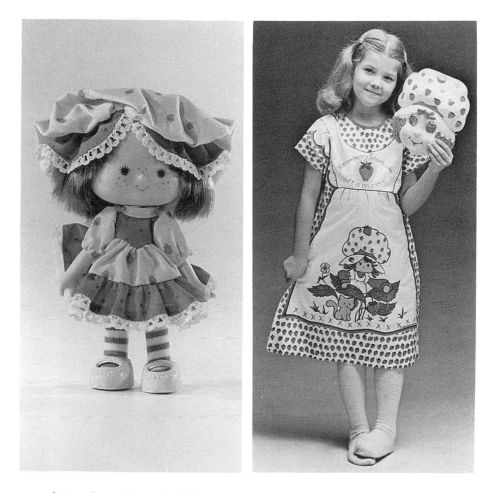

21, 22] Strawberry Shortcake doll and outfit

best-seller? Although defecating and urinating dolls attempt some degree of verisimilitude, such verisimilitude does not extend to odour. 'Real' babies are more likely to smell like excrement than strawberries but a realistically scented doll would probably not enjoy the tremendous market success of Strawberry Shortcake.

This essay considers how odour functions as a design concept targeted to women and girls and why strawberry scent is so marketable to women. While discussing gender-coded toys in general, I focus on the Strawberry

Shortcake doll in order to examine how toy designers' perceptions of the tastes/desires of women and girls underpin their belief in essential, binary gender identities. While contending that children are capable of enjoying odours of all kinds, I discuss how marketers successfully tap into culturally constructed, gender-coded tastes and why the Strawberry Shortcake doll successfully appealed to children's (particularly girls') interest in odours.

Strawberry Shortcake wears a strawberry-adorned bonnet, a cute little dress, and green and white striped stockings, and has a coterie of other food-themed friends, such as Blueberry Muffin, Apple Dumplin', and Plum Puddin', which, in their doll forms, bear fruit scents that match their names. In 1980 Strawberry Shortcake products, including lunchboxes, colouring books, underpants and strawberry scented dolls [22], grossed $100 million and were (with one exception) targeted at female consumers. Why were such products so successful, and why was scent such a powerful selling point for the dolls?

Strawberry Shortcake scented dolls function within a broader consumer network of products directed to female consumers – from douches to air fresheners – that include scent in their design. Consumer culture encourages women to be concerned about 'bad' odours hiding in their breath, genitals and armpits, as well as toilets, carpets and the very air they breathe. Products are offered which mask unwanted odours, replacing them with acceptable ones such as pine, rose, lavender, 'mountain breeze' and 'fresh scent'. A girl's doll designed with the built-in 'good' scent of strawberries fits perfectly into the continuum of odoured products aimed at female consumers.

Unlike the more savoury 'adult' scents of grown-up perfume, the sweet smell of strawberries is marketable to both girls and women. While selling girls grown-up perfumes would probably be seen as perverse, strawberries are emblematic of a more wholesome, so-called natural femininity, connoting a pre-sexual 'sweetness' and child-like innocence. There is, however, a sensual-ity to the fruit. One former Strawberry Shortcake collector told me that girls like the smell of strawberries because 'it's fruity and sweet, but somewhat seductive, not sleazy like cherries'. The seductive-yet-innocent strawberry is emblematic of the patriarchal double-bind whereby a 'feminine' woman is expected to be simultaneously non-sexual as a mother and daughter and sexual as a wife; even when playing the wife role, she is expected to be unknowing and innocent in her sexuality, to be 'somewhat seductive, not sleazy'. It is not surprising, therefore, that the strawberry, culturally coded as both innocent and sexual, is a favourite flavour of sweetly seductive adult sex lotions and oils as well as of children's snacks. Proof of the broad appeal of strawberry products is that, although Strawberry Shortcake goods were most

popular with young girls, the Shortcake product range targeted female con-
sumers of all ages. A marketing executive's claim that 'Strawberry Shortcake
lets a little girl stay a little girl' rings hollow, given the existence of Shortcake
products designed for use in the crib, classroom, office and kitchen.[2]

Strawberry Shortcake dolls must be seen as symptomatic of a broad cul-
tural discourse that links femininity, sweetness and 'proper' odours. They
embody the aphorism that little girls are made of 'sugar and spice and every-
thing nice'. As Rosalind Coward argues, sweets are discursively linked to
women via terms of endearment like 'sweetie, sweetiepie, sugar, honeybunch,
[and] lollipop',[3] and products encourage females to live out such 'sweetness'
both literally and metaphorically. Ideally, feminine demeanour is sweet and
non-abrasive, and the feminine body housing this demeanour is also sweet
and non-abrasive, with neither body odours nor razor stubble. The pungent
Strawberry Shortcake dolls – early stops on a continuum of scented feminine
products – embody this ideal of 'sweet' femininity.[4]

There is no 'conspiracy' of men who purposely invent and market scented
products in order to make women neurotic about odours. As Michel Foucault
has extensively argued, power does not emanate from a single source but
rather exists in web-like networks. Power is everywhere and unseen; no one,
including marketers of scented products, is outside of it. It is 'a faceless gaze
that transform[s] the whole social body into a field of perception: thousands
of eyes posted everywhere'.[5] I am not being flip when I add that the social
body is comprised of 'thousands of noses' as well. From earliest childhood
women are taught and persuaded to survey themselves; they are encouraged
to always feel the eye of an other upon them, made to feel other to them-
selves, as if they were outside of themselves watching themselves.[6] Women
are also encouraged to smell themselves and to imagine others smelling
them. There are many products that encourage odour paranoia in both men
and women – soaps, mouthwashes and deodorants, for example. Marketing
campaigns tactfully encourage female consumers to fear an odour emanat-
ing from their genitals, but there are no male-directed products encouraging
a similar genital paranoia. I would argue that the scented Strawberry
Shortcake doll appeals to pre-pubescent girls as a precursor to genital
deodorisers; like a douche or 'feminine hygiene' spray, it is a popular product
that appeals to the culturally fostered linking of femininity and fascination
with odours.

Whereas it is patriarchal culture, not nature, that links femininity and
odour fascination, most toy designers take a decidedly essentialist stance on
femininity, explaining feminine tastes for certain colours and odours by

relying on a binary notion of gender. Toy marketer Cy Schneider affirmed toy industry gender binarism when he unabashedly told potential toy advertisers and designers in 1987 that, 'Boys are concerned about power and strength . . . Girls are concerned with looks and cuteness.'[7] Because they consider girls' and boys' 'concerns' to be diametrically opposed, toymakers typically design products either for boys or for girls. In *Toyland: The High-Stakes Game of the Toy Industry*, Sydney Ladensohn Stern and Ted Schoenhaus assert that,

> Once the market is defined, even if a product itself could be enjoyed by children of both sexes (and it is difficult to imagine one that could not be) the manufacturer tends to design the specific product to be as appealing as possible to that target. Girls get pink, purple, lavender, blue, ruffles, frills, horses, flowers, hearts. Their products have been known to induce gagging in adults, but when Mattel designed She-Ra, Princess of Power [twin sister of He-Man], the action figure was not well received by little girls until Mattel 'pinked it up'. Boys get their toys black or silver, fast, scary, macho, gross, violent.[8]

Since toymakers believe that certain adults find girls' merchandise gag-inducing, they pay some lip-service to the need for toys that offer 'positive' role models for children, including less traditional gender roles. But they also argue that girl consumers are staunchly resistant to stronger, less traditionally feminine characters. Toy designers use 'scientifically' gathered market research which bolsters their essentialist assumptions about girl consumers.[9] The Bionic Woman doll, for example, was a disaster in pre-release laboratory test play until her beauty parlour was introduced, and the My Little Pony product line was designed in response to 1982 market research revealing that large numbers of little girls in the USA fantasised about horses before falling asleep at night.[10] Similarly, Strawberry Shortcake was designed because 'scientific' research had revealed that girls and women love strawberries – 'a special motif with proven appeal'.[11]

Parental resistance to sex role stereotyping partly explains the availability of so-called 'gender-neutral' pre-school toys, but within the toy industry there is a firm belief that as soon as toddlers become more capable of making their own toy choices they quickly reject 'gender-neutral' toys and demand more strongly gender-coded playthings, such as the Strawberry Shortcake doll.[12] Toymakers contend that their toys and cartoons merely respond to the gender identities of child consumers; if girls *like* toys with odours, toy designers magnanimously proclaim, we will provide them. If certain parents are (ostensibly) repulsed by such rigid gender roles, and if they are presumably key players in the shaping of their children's gendered identities, then the only 'logical' conclusion to be drawn from the toddler demand for non-gender-neutral toys

is that girls and boys are 'inherently' pink, fluffy and strawberry-sweet *or*
strong, silver and hard. Toy designers might accept that some adults are dis-
gusted by blatant gendering but their only concern is how such adult disgust
might affect the marketplace. What is interesting here is the tension between
parental and child tastes and how parents resist or capitulate to their chil-
dren's desires. In the case of Strawberry Shortcake, and many other best-
selling toys, it would seem that children's demands and preferences are
sufficiently strong to persuade parents to buy toys about which they may feel
politically ambivalent. Such ambivalence is not necessarily politically pro-
gressive; middle-class parents, for example, may object to the working-class
connotations of certain child tastes in toys.[13] Eliding the 'negative' response
that many adults have to boys' toy guns and other macho playthings, as well
as the complex class politics of toy revulsion, Stern and Schoenhaus cannot
imagine masculine toys inducing gagging in adults. Indeed, popular writing
on contemporary commercial toys focuses almost without exception on
supposedly inoffensive products targeted at boy consumers,[14] largely because
toy manufacturers find masculine toys more appealing than their 'cute',
viscerally repulsive (gag-inducing), feminine counterparts. Here is how they
describe corporate discomfort with the Baby Alive doll:

> Dolls that could drink and wet had been around for years, but Baby Alive was
> more advanced: she could eat 'solids'. When someone held a spoon or bottle up
> to her mouth, she masticated. Then, after a suitable interval, she defecated. The
> [toy] executives were horrified, yet fascinated. Once Loomis [the demonstrator,
> and later a maverick in Shortcake marketing] forgot to put a disposable diaper
> on the doll before feeding it, and it extruded poo-poo gel all over his arm. 'Who
> in the world would ever want such a messy thing?' asked his disgusted boss. As
> it turned out, there were vast hordes of children eager to own a defecating dolly.
> Baby Alive was the number-one-selling doll in 1973, and [the manufacturer] went
> on to sell three million of them. Extra 'cherry, banana, and lime' food packets
> were available for extra feedings (and to answer the obvious question, yes, what
> went in red, yellow, or green came out red, yellow, or green).[15]

Although it is grown-up men who *designed* this scatologically intriguing doll,
it is girl *consumers* who come across as perverse in this passage. The rhetoric
of this passage implies that pathology-free executives merely designed the
'defecating dolly', while 'vast hordes' of weird children (girls) wanted the
doll.[16] Conversely, toy designers consider it normal that boys enjoy toys that
are 'weird'. 'Incredible Edibles', for example, was a toy that moulded a choco-
latey, plastic-like substance into bug and worm shapes. In the US television
advertisements for the toy, delighted children consumed their hand-made

snacks in front of disgusted adults. This toy was packaged as a boy's product and the advertisements showed only boys. Even if in daily use children's toys may frequently defy gender binarism, advertising discourse directed to children speaks only in essentialist terms.[17] In toy advertising campaigns girls rarely behave in disgusting, improper, or 'boyish' ways.

Toymakers' marketplace explanatory logic – that the industry merely reponds to essential masculine and feminine desires – must be held up to critique. Toymakers do more than merely respond to a market; they also actively *create* that market. If girls seem to like ultra-feminine products, we must see their desire for such products as bound up with toymakers' views on 'gag-inducing' female pleasures. In addition, we must see the market for toys as a historically fluctuating one. As Susan Willis asserted in 1991:

> The recuperation of sex roles in the eighties is a stunning reversal of the Women's Movement in the late sixties and early seventies, which called into question children's sex role modeling practices. Dress codes were condemned, co-ed sports flourished, fairy tales were rewritten, and toys were liberated . . . we like to think that the cultural turmoil of the sixties changed everything. The fact is, in mass culture today there is an ever more rigidly defined separation of the sexes based on narrow notions of masculinity and femininity.[18]

Strongly gender-coded toys, such as Strawberry Shortcake, were particularly successful in the 1980s because of the Reagan-era backlash against the questioning of attitudes towards toys and sex-roles that took place in the 1970s. Strawberry Shortcake dolls are both symptomatic of and contributors to a post-1970s conservative construction of femininity.[19]

Despite the typical girl v. boy (or Barbie v. G.I. Joe/action figure) binarism, the toy trade acknowledges the possibility of one-way cross-over identification for child viewers of toy advertisements: 'Don't show an eight-year-old boy playing with an eight-year-old girl. For boys, that's an unreal situation. Girls will emulate boys, but boys will not emulate girls. When in doubt, use boys.'[20] Female to male cross-identification extends not only to toys and television commercials but also to fast foods, a key children's market. A recent *Advertising Age* article on fast food promotions targeting children notes that Pizza Hut, McDonald's and Burger King gear their advertising more to boys than to girls and that girls will accept advertising meant to appeal to boys' tastes.[21] Industry attitudes towards girl consumers are highly evocative of Laura Mulvey's suggestion that 'as desire is given cultural materiality in a text, for women (from childhood onwards) trans-sex identification is a *habit* that very easily becomes *second Nature*. However,' she adds, problematising such trans-sex identification in a way that advertising

executives would never dare, 'this Nature does not sit easily and shifts rest-
lessly in its borrowed transvestite clothes.'[22]

Considering Strawberry Shortcake in the context of other child-targeted
products such as fast food illustrates not only the pervasiveness of product
gendering, but also how relentlessly manufacturers work to *construct* the
market situation. Industry discourses disdainfully construct girl consumers
as both predictable and troublesome, their desires 'elusive' according to
Advertising Age.[23] In the sense that it is merely one of many female-targeted
pink products, Strawberry Shortcake is not unique. Shortcake is rare only in
that (like Barbie, one of the rare, permanently successful brand name girls'
toys) it appears successfully to appeal to girls' 'elusive' desires.

In spite of the oppressive picture I have drawn of consumerist identity
construction, I do not see women and girls as passive victims of consumer
culture. Although it is depressing to realise that rigidly binary gender identi-
ties are forced onto children at a very young age, it is also important to
remember that childhood is a utopian space where the transformation of
gender roles is imaginable. Young children constantly take the tools (toys)
that are supposed to 'turn them into' properly gendered adults and subvert
them through unexpected and delightfully 'inappropriate' use. Henry Jenkins
reports, for example, how in the course of a Pee-wee's Playhouse party, 'a
large He-Man doll was used alternatively as a "seat belt", lying across the lap
of several children, or as an imaginary playmate, addressed as a "naughty"
child and even spanked, to the objection of some participants who felt he was
not being "bad".'[24] Such play would seem to subvert the reductionist argu-
ment that the He-Man character is simply a macho toy that turns boys into
properly masculine adults.

Stereotypically, it is only boys who are interested in grossness. In a recent
survey, I asked Strawberry Shortcake fans – now in their late teens, and
almost all female – if they thought girls and boys tended to like different
smells. Most of them said yes, but they were adamant that different prefer-
ences were purely socially, not biologically, produced. Respondents listed as
girls' scents: fruits (maraschino cherries, strawberries and lemons in partic-
ular), perfume, flowers, pretty things, sweet smells and romantic smells.
Boys' scents included: beer, dirt, earthy smells, snails, rocks, spice, gasoline,
trees, motor oil, and 'anything sharp, hard and leathery'. Although respon-
dents aligned both boys and girls with nature smells, there was a clear align-
ment of girls with odours of 'sugar and spice and everything nice' and boys
with odours of 'snips and snails and puppydog tails'. Girls' smells were all
'good', while boys' smells tended to include more 'bad' ones. Several female

respondents indicated disgust with boys' smells, and the most repulsed respondent said that girls like 'soft smells that remind you of good memories or places or people you've liked', while boys like 'pee smells, smoke, broken and strong smells that make you want to puke'.[25] Although this respondent indicates that only boys are drawn to grossness, I think that children in general are attracted to that which repels adults. As Allison James has argued, children prize exactly those tangy, messy, noisy candies that adults abhor.[26] Jenkins concurs, explaining children's interest in 'gross' food:

> Children's candies adopt names of things 'grown-ups' find distasteful or of things that would not normally be consumed (candy cigarettes, bubble gum cigars, jelly worms, gummy mummies, etc.), assume unusual textures (rubbery, slimy, etc.) or synthetic flavors, provoke strong and sometimes unpleasant sensations (Pop Rocks that literally explode on the tongue), demand to be eaten in unsavory ways (sucking, slurping, fingering, blowing) . . . such sugary delights seduce children into playing with their food. . . . Semi-digested chewing gum is removed and stretched into saliva-coated sculptures. Slobbery suckers are passed from mouth to mouth as a kind of kiddie communion.[27]

Strawberry Shortcake scents are strong, highly synthetic and rather disgusting to the adult nose, and this may account for some of their appeal to children, especially those who delight in 'gross' odours. The scent may be appealing because it is both pleasant and unpleasant; for children the line between putrid and pleasurable is a blurred one. Indeed, it is precisely the *blurring* of the boundary that can be pleasurable. For the child playing the Strawberry Shortcake doll is considered one of many sources of putrid/pleasurable odours – like kitchen 'experiments', farts, and other childhood sources of smelly delight. To the question 'was the scent of Strawberry Shortcake dolls appealing to you?', one survey respondent answered 'Yep! I always smelled *everything* when I was a kid.' The childhood taste for 'vile' odours, foods and eating practices would seem to defy the Kristevian, adult notion of abjection, whereby it is the crossing of boundaries – such as that between inside and outside the body – that repulses. It is in part because adults demand that putrid and pleasurable remain binaries that children love that which illicitly crosses such adult boundaries. The Incredible Edibles campaign was appealing to kids precisely because it showed the fun of transgressing adult standards of taste; the advertisement showed a child eating a 'caterpillar cone', his pleasure clearly derived from adult disgust with his antics, not from the flavour of the fake insects topping his ice cream. While grown-ups may find children's tastes to be abject, children find great delight in 'improper' eating and smelling practices – a delight which seems to operate

across gender. Thus, a girl's delight in the Strawberry Shortcake synthetic odour does not necessarily or only represent an embracing of proper, feminine taste in odours. Rather, it may be read as one of many resistant smelling practices, practices that include smelling dirty socks, magic markers, etc.

My claims for resistant childhood smelling practices notwithstanding, I believe that ultimately the odour of the Strawberry Shortcake doll reflects both the toy trade's conservative, essentialist design tactics and the ways that commodities directed to female consumers exploit their culturally produced desire for 'proper' odours, a desire that is entrenched by an early age. In Vivian Gussin Paley's 1984 account of how nursery school girls and boys play differently, the following exchange is recorded:

> Andrew: All the little girls love Strawberry Shortcake now.
> Teacher: I wonder why that is.
> Andrew: They think she has a nice smell.
> Teacher: Do you like that smell?
> Andrew: Boys don't like smells.
> Teacher: Don't like smells?
> Andrew: I mean boys like bad smells. I mean dangerous smells. Like volcano smells.
> Jonathan: Vampire smells.
> Teacher: Well, Strawberry Shortcake doesn't have to worry about volcanoes or vampires. The girls never put those things in their stories [that they make up about Shortcake].
> Teddy: Because vampires aren't pretty. We like stuff that isn't pretty, but not girls. They like only pretty things.[28]

The idea of volcano and vampire smells is certainly intriguing, but it is difficult to draw much hope for non-binary gender roles from these lines. While the child's *delight* in odours appears to be unisex, gendered preferences seem to be formed quite early. Of course, some children resist culturally encouraged preferences, such as one male survey respondent who told me that he loved playing with and smelling Shortcake dolls. Yet this respondent knew that his behaviour was considered aberrant; he had to hide the dolls in his closet so that his mother would not discover them. The connotations of sexual 'perversity' were clear in his account; if the boy's mother had found the dolls, she would have thought her son queer, in more ways than one.

Only one of the almost seven hundred Strawberry Shortcake products bridges gender binarism. The manufacturers decided that vitamin pills could be marketed to both boys and girls. Yet even the vitamin pills were gender-coded – one bottle was pink and the other blue. Furthermore, the pink bottle

was labelled 'plus iron', referencing labels more commonly seen on vitamin pills meant for grown-up, menstruating women. Chewable and fruit-flavoured, Strawberry Shortcake vitamins offered girls the fantasy of internal-ising Strawberry Shortcake, the fantasy of crossing the line between being and having that doll possession and indentificatory play also enable. (The Strawberry Shortcake costume and mask offered a similar fantasy.) Strawberry Shortcake's scented body offers an additional fantasy, a fantasy wherein bodily odours that mainstream consumer culture paints as abject can be controlled, contained and even replaced by the 'nice, pretty' odour of strawberries.

It would be misguided to condemn girls for enjoying such potently appealing fantasies, for enjoying doll play, and for taking pleasure in collect-ing Strawberry Shortcake dolls. It would be equally unfair to demonise women who use air fresheners, douches and other scented, female-directed products. Rather than blaming consumers or showing how they are the passive dupes of consumer culture, in this essay I have tried to *denaturalise* the cultural linking of feminine odours and girls/women. It is not inherently 'wrong' for women to take pleasure from feminine-coded scents. What is problematic is that although both women and little girls are capable of enjoy-ing volcano and vampire smells, product design and marketing strongly dis-courage such 'masculine' pleasure. It is this curbing of potential pleasures that really stinks.

NOTES

1 When I speak of 'the ideal' female body or consumer, I am speaking of entities that could never correlate exactly with actual consumers/bodies. Individuals vary widely in their con-sumer desires and in the extent of their 'fit' into ideals of proper gender roles. In addition, the ideals of proper femininity vary with national identity, regional identity, ethnicity, eco-nomic status, religion and so on. If it seems that throughout this essay I imply a mono-lithic Feminine Ideal that is because I am describing the ideal that I see constructed in mainstream, US consumer culture, an ideal that is, with minimal variation, homogene-ously white and bourgeois and that tends to address gender in rigidly binary terms. For an interesting account of how advertising discourses address lesbian and straight consumers see Danae Clark, 'Commodity lesbianism', *Camera Obscura*, 25–26 (January/May 1991), pp. 181–201.
2 Jack Chojnacki, cited in Tony Chiu and Joyce Wansley, 'Who's red and sweet and filthy rich? Strawberry Shortcake, toyland's newest tyke-coon', *People*, 17.18 (May 10 1982), pp. 91–3.
3 Rosalind Coward, *Female Desires: How They Are Sought, Bought, and Packaged* (New York: Grove Press, 1985), p. 89.
4 In addition, Shortcake dolls are an early narrative stop in a continuum of products that encourage female subjects to have illicit feelings about (and even to identify with) odours and food.

5 Michel Foucault, *Discipline and Punish: The Birth of the Prison* (New York: Random House, 1979), p. 214.

6 John Berger, *Ways of Seeing* (New York: The Viking Press, 1973), p. 46.

7 Cy Schneider, *Children's Television: The Art, the Business, and How it Works* (Chicago: NTC Business Books, 1987), p. 95.

8 Sydney Ladensohn Stern and Ted Schoenhaus, *Toyland: The High-Stakes Game of the Toy Industry* (Chicago: Contemporary Books, 1990), p. 201.

9 Some toy companies own nursery schools where they can 'spy' on playing children. In an article on toy research and development, Doug Stewart includes a photograph of a woman spying on a playing child and glibly notes, 'tiny testers have a little fun at Fisher-Price as an adult behind a one-way mirror records their every move'. 'Where toys aren't all fun and games', *Smithsonian* (December 1989), p. 78.

10 Stern and Schoenhaus, *Toyland*, p. 117.

11 American Greetings Company, *Strawberry Shortcake: The First $100 Million* (Cleveland, Ohio: American Greetings Company, 1980), p. 9. In their 1984 promotional pamphlet, Those Characters from Cleveland (Strawberry Shortcake's licensers) state that 'Strawberry Shortcake was developed out of research showing that strawberries are a popular design motif with women.'

12 Jane Gallop contends that pink functions as much more than a marker of femininity: in 'Annie Leclerc writing a letter, with Vermeer', Gallop argues that, 'If blue, outside the infantile realm, is no longer a particularly masculine colour, might not that relate to the phallocentrism which in most our culture (as well as in most if not all others) raises the masculine to the universal human, beyond gender, so that the feminine alone must bear the burden of sexual difference? Pink then becomes THE colour of sexual difference, carrying alone within it the diacritical distinction pink/blue.' In *The Poetics of Gender*, ed. Nancy K. Miller (New York: Columbia UP, 1986), pp. 138–9.

13 Ellen Seiter explains the middle-class presumptions of toy and television protest in *Sold Separately: Children and Parents in Consumer Culture* (New Brunswick: Rutgers UP, 1993). I have not examined the class politics of parental 'gagging' in this essay because of space limitations and because Seiter has already exhaustively and convincingly done so in her text. In her chapter on 'My Little Pony' videos, for example, Seiter argues that middle-class parents object to their children's 'bad taste' in videos. 'Rarely do middle-class parents explicitly recognise that the conflict stems from the fact that mass-market children's toys and videos lean towards working-class aesthetics, gender representations, and popular genres' (p. 157).

14 The obvious exception is Barbie who has been the subject of much popular writing. Stewart, for example, describes an interesting aspect of the design process for Barbie's clothes: 'Barbie herself must at all times appear chaste. To make sure, designers avail themselves of an instrument known as the Barbie Exposure Gauge, which keeps tabs on her bust and bottom. This is a headless Barbie doll with blue ink covering its anatomically incorrect chest and a blue line running across its derrière. If any blue is exposed when Barbie sits down, or when you look down her blouse, or when she undergoes the twist test – [the designer] grabs Barbie in both hands and twists her like a pepper mill – then that costume is unacceptable' (*op. cit.*, p. 82).

15 Stern and Schoenhaus, *Toyland*, pp. 147–8.

16 I hope it does not sound like I share toy designers' disgust with the doll. For the record, I myself begged my parents for a Baby Alive doll, until they finally gave in. I was less intrigued by her defecating capabilities than by the fact that she could 'eat'.

17 Toymakers' narrow notions of femininity – indeed, the revulsion of some towards little girls' tastes and pleasures – is exemplified in one particular toy of 1988: L'il Miss Makeup,

a child-like dummy head designed for girls to put makeup on. This toy was the hit of the industry's 1988 preview show, the Toyfair; excited manufacturers who expected big sales disdainfully referred to L'il Miss Makeup as 'L'il Baby Hooker'.

18 Susan Willis, *A Primer for Daily Life* (London: Routledge, 1991), p. 24.

19 Strawberry Shortcake dolls are typical of the sex-segregated 1980s' toys and television programming that both Constance Penley and Susan Willis have described. See Willis, *A Primer* and Constance Penley, 'The cabinet of Doctor Pee-wee: consumerism and sexual terror', *Camera Obscura*, 17 (May 1988), pp. 133–53.

20 Schneider, *Children's Television*, p. 107.

21 No author given, *Advertising Age* (February 8 1993).

22 Laura Mulvey, 'Afterthoughts on "Visual Pleasure and Narrative Cinema" inspired by *Duel in the Sun*', in Constance Penley (ed.), *Feminism and Film Theory* (London: Routledge, 1988), p. 72.

23 No author given, *Advertising Age* (February 8 1993).

24 Henry Jenkins III, '"Going bonkers!": children, play and Pee-wee', *Camera Obscura*, 17 (May 1988), p. 172.

25 It seems that it is more acceptable for boys than for girls to be interested in urine.

26 Allison James, 'Confections, concoctions and conceptions', in Bernard Waites *et al.* (eds.), *Popular Culture: Past and Present* (London: Croom Helm and Open UP, 1982), pp. 294–307.

27 Jenkins, '"Going bonkers"', p. 178.

28 Vivian Gussin Paley, *Boys and Girls* (Chicago: University of Chicago Press, 1984), p. 109.

Children's clothes:
design and promotion

THE design and retailing of baby and toddler clothes represents a substantial part of the clothing industry. The British market is dominated by the multiple stores such as Marks & Spencer, F. W. Woolworths, C & A, Boots the Chemist, British Home Stores and Littlewoods, and supplemented by specialist ones, particularly Mothercare UK Ltd and Adams, as well as department stores such as John Lewis and House of Fraser. The latter sell more up-market clothes by companies such as Heskia and Teamsport, and they compete as much with the numerous small specialist shops selling foreign children's clothes, particularly French and Italian, as with the multiples. Attention to design is increasingly important to retailers in order to differentiate products, particularly in terms of price. Two companies which have sought to emphasise design in terms of children's clothes are Next and Laura Ashley, and, significantly at the lower end of the market, George Davies (formerly Managing Director of Next) has combined design awareness and low price for Asda Supermarkets' baby and children's range of clothes. Many of the shops produce brochures and catalogues promoting their baby and children's ranges, and they also advertise and fund expensive features in women's and parent/mother-to-be magazines. This chapter examines the design and promotion of baby and toddler fashions (particularly for girls) in relation to representations of gender identity through a case study of recent company promotional catalogues and brochures, particularly those produced by the Boots the Chemist chain. As I will show, gender differentiation, along fairly conventional lines, is clearly discernible in both baby and toddler clothes. Not surprisingly this differentiation of children by means of gendered clothing both reflects and reinforces traditional gender representations and identities already dominant within our contemporary society.

For most of these children's clothing manufacturers and retailers, the

visual images which are used to promote and sell their products are of increasingly critical importance in a highly competitive marketplace. Both the images and the specific designs communicate powerful ideas about 'ideal' lifestyles, appropriate consumer (and class) aspirations and gender identity. Although for many parents of a new-born baby, there are greater priorities than deciding how to dress it, there is increasing pressure, especially on women, to dress small children in fashionable clothes. All those months of anticipation and the actual period of pregnancy prepare prospective parents to consume. It is very difficult to resist the 'baby industry'. By the eighth month the mother, in particular, has generally given up on herself as an active consumer of clothes and has reduced most matters of personal dress down to one essential question – is it comfortable? For her, it is a welcome diversion to shop for baby clothes and baby paraphernalia. For those able and prepared to spend, there is plenty of choice.

However, for many parents looking for and buying baby clothes is more than a diversion. Aided and abetted by grandparents, aunts, uncles and friends it is part of the process of beginning to give an identity to the awaited baby, and trying to make sense of its likely needs in relation to one's own expectations, particularly in terms of the baby's sex. The most frequently asked question is still 'what do you want, a boy or a girl?' And, after the birth, 'is it a boy or a girl?' But it is about more than the baby's 'identity' – to some extent a reflection of that of the parents – indeed, the well-dressed baby or child is an attractive adult accessory, a cuddly status symbol.

At the forefront of people's minds is the sex of the baby and associated with this are their perceptions of the importance of communicating this in dress. In choosing baby and children's clothes, people recognise the power of design (colour, pattern, style and type of garment) to signify gender difference with a clarity not usually evident in their reading and understanding of other aspects of design. However, as with adult dress, it is not a question of gender alone. The conscious or unconscious representation of class or lifestyle is important in children's clothes and the decision to buy from Laura Ashley or Next may indicate a greater design awareness than buying from Marks & Spencer or Littlewoods. Although some may reject the ostentatious display of money evident in Italian baby equipment or French baby clothes, they can nevertheless signify their alternative taste and style by buying from select shops which stock hand-made, 'ethnic' or 'heritaged' goods. In provincial towns and cities in the North and the Midlands, taste and style are possibly more restricted because of fewer alternatives to the national chains, multiples and department stores. In these outlets design status is closely

aligned with price: 'how much' competes with fashionable design knowledge as an important selection criterion.

Significantly, large and expensive items of baby equipment such as cots, buggies, prams, and changing tables are not strongly gendered. Cots and changing tables are usually white or natural wood colours, and buggies and prams are often grey or dark blue – neutral colours used for equipment which has to be selected before the baby's sex is known and which is often used for more than one baby. The gendering comes with the accessories which include cosy-toes buggy quilts, cot linen (duvet and bumper covers), and of course, cot toys such as mobiles. Other highly desirable items for new babies are lavish suits and dresses which are often combined with hand-knits featuring complex stitches, ribbons and bows. The sheer impracticality of these white (gender-neutral), festooned, garments defies comprehension except in so far as their meaning is way beyond the mundane concepts of 'machine-washability'. 'The whiter than white wash' which Phil Goodall has described elsewhere takes on a new significance when thinking of the maintenance required for the five or six possible outfits worn in one day by a new-born, vomit-prone baby.[1] These ostentatious creations, masquerading as baby clothes, are statements of love and represent a positive commitment to the baby's future in the commodity that is of necessity foremost in the minds of many parents, money. Above everything they are symbolic of the desire to give the baby a good start in life!

Like contemporary men's and women's fashions, baby and toddler clothes convey implicit assumptions about gender, as Elizabeth Wilson has argued: 'Fashion is obsessed with gender, defines and redefines the gender boundary.'[2] But babies and children are even more vulnerable to the attitudes of others than are adults. Parents and relatives decide what the child will wear. Generally parents delight in dressing their offspring in the clothes which they have bought or have been given and, in the main, these are heavily gendered. Conflict across generations can occur when parents transgress gender boundaries; for example by dressing female babies and small children in dungarees instead of dresses. Significantly, it is less socially acceptable to dress boys in girls' clothes than vice versa; even the 'heritaged' little Lord Fauntleroy look is a feminised version of regular boys' clothes. Nevertheless for some parents, undermining and defying the establishment of rigid gender identities through their children's clothes takes on special significance as they observe the explicit and implicit assumptions about gender identity represented in them. Making sure little girls wear tracksuits and trousers becomes just as important as making sure that they play with

tools and building bricks as well as with dolls. This strategy is just one of those adopted by certain parents to try to counter the early 'negative' effects of gender stereotyping in relation to femininity.

The design and advertising of babies' and children's clothes undoubtedly reinforces the gendering of the identities for boys and girls. Just as design prescribes particular gender roles and attitudes for adults, so it does for infants: 'design practice and theory operates with specific notions of femininity, which formulates and organises women's time, skills, work, our inhabitation of space and our conceptions of self in relation to others'.[3] Although writing generally here, baby and children's clothes provide an excellent case study for Phil Goodall's ideas. With these innocuous seeming garments, an attempt is made, through design and advertising, to identify, differentiate and fix gender identity at a stage when it is precarious and only partially established. Characteristically clothes for female babies and young girls contribute to the formulation of certain codes of behaviour, types of play, and social interaction which reinforce dominant ideals of femininity. Girl toddlers in particular learn to look at themselves, to seek admiration from others for their appearance, and to display their clothes. This is partly because of parental influences, partly the desire for peer group approval, and partly pressure from the design and retailing industries which generate desirable 'female' images for girls aged two years, two months or even two days.

The most striking characteristic of the visual images of babies and toddlers used to sell clothes in magazines and company brochures is the wholesale adoption of conventions of representation taken from adult clothing advertising and promotion.[4] This is particularly true of toddler clothes but representations of baby clothes are shaped by the same process. Like the models promoting adult products, the babies and toddlers are beautiful, healthy, and predominantly white. Although the current Mothercare and Boots catalogues include one or two black and Asian children, all the depictions of 'parents' are white. Parenthood is usually represented in these brochures by glamorous images of slim, youthful and stylish mothers who betray none of the usual signs of wear and tear resulting from caring for babies and children. Not surprisingly in this fantasy land of perfect families, all the mums look happy and fulfilled; there are few signs of women torn by the conflicts of work outside and inside the home combined with the relentless demands of childcare.

Images of nature and nurturing figure prominently in many of the representations of mothers and babies who are often photographed together in soft

focus, partially clothed or completely naked, thereby playing up the biological connections between them, as well as reinforcing the idea of women's 'natural' and 'essential' role in reproduction. In advertising and promoting babies' clothes, most brochures depict gurgling, sleeping, contented babies, clean and cute, either laid in cots or with their mothers. Dinky little hats which babies love to pull off and throw over the side of the buggy, are always scrupulously in place, and white baby gro's dazzle out from the page. At first glance some clothes designed for babies appear to be undifferentiated in terms of gender; however, on closer inspection they are subtly coded. An obvious way to indicate gender is through the use of colour – white is regarded as 'unisex', but it is still 'pink for a girl and blue for a boy'. Furthermore, colour is often combined with the use of certain types of prints and decoration which mark out gender difference. For example, floral prints for girls, and abstract ones for boys; frills and lace detailing for girls, and car and train print for boys; Mickey Mouse for boys and Minnie for girls. A few printed designs seem to have a unisex application, for example some animals, stripes and dots. Although there was a strong trend towards 'unisex' children's clothing in the late 1970s and 1980s [23], in recent years the design and advertising of babies' clothes appears to articulate gender differences much more rigidly. For example, the *Baby and Child* brochures produced by Boots in 1991 and 1994 show quite a shift in their ranges of baby clothes for the two sexes. In the 1991 brochure, of thirty-four individual images of children aged between birth and eighteenth months, twenty-seven are unisex and only six are specifically gendered (five female and one male) [24]. By contrast, of thirty-four images of children of similar age in the 1994 brochure, only six are unisex, whereas sixteen are gendered female and twelve are gendered male. [25, 26] Furthermore in 1991 the representation of gender difference in babies through the design of clothes was subtle, whereas in the recent catalogue the differences are very obvious and are signified by type of garment (dresses and trousers replace baby gro's and dungarees), prints, decorative detailing, as well as by colour. Female babies are shown wearing dresses in delicate pinks, lemons and whites edged with lace, embroidery and flower motifs. Male babies, by contrast, are shown wearing short trousers, romper suits, and all-in-one baby gro' suits in bright blues, reds, greens and yellows often with animal, toy and abstract prints.[5] Even baby bodysuits and vests are gendered. Whereas in 1991 they were decorated with gender-neutral motifs such as balloons or a rocking horse, in the 1994 brochure bodysuits for girls are decorated with floral prints or edged with lace, and those for boys have prints such as 'Safari Bear' and 'Playful Pup'. In these later representations, baby girls are

coded as girls and baby boys as boys. Gender ambiguities seem to have been
erased, and gender difference reinforced with a vengeance. The 'backlash'
has reached further back than we might suppose.

Contemporary advertising and design for toddler clothes is very sophisti-
cated in the way that it draws on adult representational conventions. Toddlers
are shown displaying clothes in the manner of adult models. They pose non-
chalantly with hands in their pockets or in feigned leisure activities, some-
times directly eyeing the camera, but more often gazing into the distance with
a distracted almost sexual look. Usually they are pictured in locations similar
to those in which models are shown for fashion features in women's and
fashion magazines such as *Marie Claire*: exotic locations particularly in
foreign countries are common, as are natural surroundings such as the
beach. Rarely are they shown in an urban environment except abroad, and a
characteristic of all the locations is that they depict leisure. These children
inhabit a world of endless holidays and pleasure, and like the images of
babies, they are happy, healthy and mainly white. Unlike the images of
babies, however, these toddlers are shown interacting with others and repli-
cating grown-up relationships. Little girls are mainly pictured with other girls
and boys with boys, aping the images of adult models in men's and women's

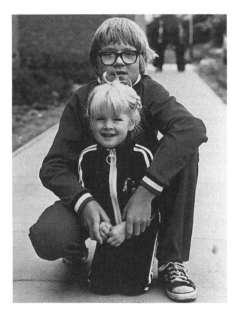

23] 'Unisex' dress **24]** *Baby and Child*, 1991

fashion magazines. Unisex images appear to be sanctioned only in play, otherwise a strict gender divide is discernible.

At first glance the design of clothes for toddlers appears less differentiated in terms of gender, but on closer inspection little girls in the 1991 and 1994 Boots brochures are clearly recognisable as female even if they are wearing shorts or some form of trousers. Gender difference is signified by long hair, hats, head-bands, and particular types of prints [24]. Furthermore these images and designs draw so much on adult garments, adult designs and adult ways of co-ordinating clothes that they replicate broader contemporary obsessions about gender. The key gender difference is that boys never wear skirts or dresses. Girls appear particularly waif-like with loosely tied long hair combined with carelessly worn garments, sometimes unbuttoned or casually opened. These little girls are ethereal in appearance and slight in build; there are no short-haired, robust and muscular tomboys clad in jeans in these toddler fashion shots. The passivity of the photographic images is replicated in the designs for the girls' clothes which are delicate, 'girlish', and pretty thus reinforcing traditional notions of feminine identity. Except for an occasional pair of shorts and dungarees, most of the summer 1994 Boots range for girls aged 18 months to 5 years consists of high-waisted dresses in ginghams,

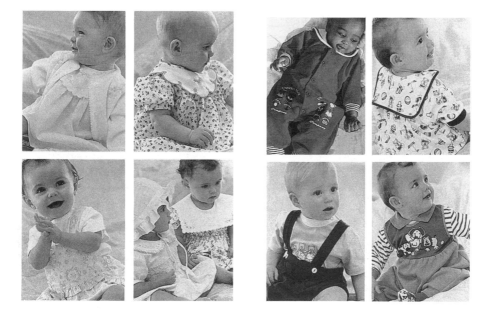

25, 26] *Baby and Child*, 1994

checks and white calico, delicately coloured, floral printed skirts, frilled
culottes and smocked blouses which recall contemporary adult fashions
with their emphasis on the 'natural', hand-made and/or ethnic look.[6]
Photographic settings of beach and countryside reinforce the connection
between femininity and nature, but it is a passive, aesthetic identity which is
delineated. Like their adult counterparts, these little girls sit decoratively
wearing flimsy hats, turbans, and head-bands which co-ordinate with the
main outfit. They appear to be waiting expectantly rather than striding off
purposely like the little boys who, wearing bold, colourful shirts and t-shirts
combined with dark-coloured cotton drill shorts or jeans, actively search for
fossils and shells, or prepare to board ship and sail off. Their clothes repre-
sent almost the exact opposite of those of the girls: they are for doing things
in, rather than being seen in. They reinforce, in yet another arena, dominant
gender identities which define masculinity as active and assertive, in contrast
to femininity which is depicted as passive, self-reflective and concerned with
the decorative and the interior rather than the exterior world.

In conclusion, the representation of gender difference in the design and
promotion of babies' and children's clothes is clearly recognisable from the
first months after birth. Both babies' and toddlers' fashions replicate the
conventions found in adult clothes which signify gender difference. Not only
are types of garments, such as dresses or trousers, used for this, but also
colour, pattern, decoration and, very importantly, the styling and display of
the garments on baby and child models. It is these fashionable images, at the
core of advertising and promotional literature, showing parents how items of
dress should be put together which are particularly powerful. They delineate
and, arguably, inscribe particular visual ideals of femininity and masculinity
which from this study appear wholly conventional. Little girls are dressed
decoratively using traditional dress codes and they adopt passive poses rem-
iniscent of fashion models in contemporary magazines, whereas little boys
sport functional clothes which enable them to interact with the environment
in an assertive and imposing manner.

For those of us who are mothers of daughters, and who have ourselves
gained pleasure and enjoyment from wearing clothes and creating fashion-
able images which, whilst coded in various ways as 'feminine', are also ques-
tioning, subversive and/or empowering, it is disconcerting to observe these
affirmations of gender difference which seek to position them as powerless,
'essentially' decorative and waif-like. Hopefully, we will have the skill and sub-
tlety to pass on to them 'positive' as well as 'negative' aspects of femininity as
represented in dress and also the possibility of their subversion.

NOTES

1 P. Goodall, 'Design and gender', *Block*, 9 (1983), pp. 50–61.

2 E. Wilson, *Adorned in Dreams: Fashion and Modernity* (London: Virago, 1985), p. 117.

3 Goodall, 'Design and gender', p. 50.

4 Brochures include *Baby and Child* from Boots (Spring/Summer 1991 and Spring/Summer 1994) and *New Baby* from Boots, *First Baby* from Mothercare (1994), *The M & S (Marks and Spencer) Magazine* (Summer 1994), *M & M (The Magazine for the Mum-to-be and New Mother)* (December 1993/January 1994 and April/May 1994).

5 See pp. 13–23 in the 1991 *Baby and Child* brochure and pp. 100–5 in the 1994 *Baby and Child* brochure.

6 See fashion features in *Marie Claire* (July, 1994).

Artists' clothes: some observations on male artists and their clothes in the nineteenth century

I write to you in denim but my soul is velvet.

I N looking at artists' clothes in the nineteenth century, the overlapping
issues of class and gender are obvious. The accentuation of class ele-
ments in the adoption of smocks, sabots and berets in France, for
example, parallels the move away from exclusive aristocratic patronage and
the artist as a middle-class tradesman. Artisan elements in clothing helped
accentuate the making and producing activities of art and, by stressing labour
and physical work, the maleness of the artistic profession. Work clothes also
allowed the artist to defy the conventions of fashion and linked the wearer to
political ideals of democracy, even revolution. However, by combining diverse
elements of clothing the artist could avoid identification with any one par-
ticular social group, stress independence and originality, and distance
himself from new expectations of masculine behaviour, particularly
participation in commerce. Assembling a 'look' from diverse elements taken
out of their social contexts, allowed the artist to become an object of his own
devising and included him in an alternative group identifiable through cloth-
ing.

There is ample evidence of an 'assemblage' approach to dressing in visual
depictions of artists and in written accounts of the artistic life. One of the
richest accounts of artistic life in Paris, George Du Maurier's *Trilby* (1894),
describes what we might call the 'garret assembly' style, especially as it
afflicted the British community of art students: 'Taffy slipped on his old
shooting jacket and his old Harrow cricket cap, with the peak turned the
other way, and the Laird put on an old greatcoat of Taffy's that reached to his
heels, and a battered straw hat that they had found in the studio when they
took it . . .' [27].[1] This style brought together apparently inappropriate

garments from other social contexts –
here school and sport – and subverted
their former function and power in the
process. When we are first introduced to
Schaunard in Murger's *Scènes de la vie
de bohème* (1851), for example, he is
wrapped in a pink spangled petticoat
which he used as a dressing gown, thus
changing the private, sexual connota-
tions of the garment.

The 'garret assembly' style was
popular at a time when men's fashions
were dull and formal. Dark heavy fabrics
hid the silhouette and gave age and
weight to the figure.[2] The chief acces-
sories – a tall hat and a watch (shown as
a watch-chain spread across the lower
chest) – indicated formality, control and
punctuality. Extolling personal qualities
(coolness, distance, reliability) and
social roles (controlling, ruling,

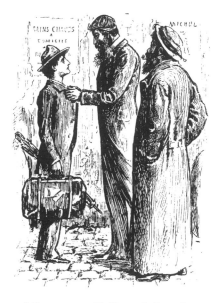

27] 'Let me go, Taffy . . .', British
artists in Paris, from Du Maurier's
Trilby, 1895 edition

buying/selling), it was the dress of Dombey and of the Trollopean controllers
of society, financiers and politicians, until the end of the century. Artists pro-
vided an alternative lifestyle and an alternative view of clothes. G. F. Watts is
revealing in his comments: 'A well-dressed gentleman ready for dinner or
attired for any ceremony is a pitiable example – his vesture nearly formless
. . . His legs, unshapen props – his shirt front, a void – his dress coat, an
unspeakable piece of ignobleness. Put it into sculpture and see the result.'[3]

In opposing the trend towards dullness and conformity artists placed
themselves and their profession apart from the increasing commercialisation
of society. Some artists also rejected many of the gendered overtones that
contemporary men's fashion implied. By the end of the century the questions
raised by the Aesthetic Movement, which adopted an extreme version of the
'garret assembly' style, were about identity and taste as well as about art and
design; about placing the self in a position of importance and stressing per-
sonal style over conformity and purchasing power.

While much has been written about the self-portrait in which the face is
seen as being the focus of the artist's identity, very little has been written
about artistic identity and personal dress styles which reveal both the social

preoccupations and expectations of the artist. Deborah Cherry, writing on women painters in nineteenth-century Britain, comments that 'portraits and self-portraits . . . were the site where formalities of subjectivity, sexuality, class and politics overlapped'.[4] The unconventionality of the men of the Pre-Raphaelite Brotherhood, she tells us, 'could not be adopted by women artists for whom, unlike men, disorderly conduct or a dishevelled appearance endangered respectability and professional activity'.[5] The issue of dress in artistic circles is, unsurprisingly, a gendered one: clothes carry messages of class, gender, one's position within the profession and one's professional reliability too. The codes are different depending on the sex of the wearer. The ways in which an artist conducted himself (including the adoption of a personal style) reflected his position and strength within a highly stratified professional structure. Frederic (later Lord) Leighton and Simeon Solomon both worked in London at the same time, within a wide circle of artists who dealt with similar imagery and clients, but had quite different personal styles. Leighton's was professional, orderly, respectable – a rarefied version of bourgeois dress. Solomon's was 'bohemian' and exotic – an alternative to the prevailing respectability of men's fashions. Male artists, therefore, commented upon their relationship to society and to their own profession in their choice of clothes. This was not simply an issue of occupational dress; artists were not usually seen *at work*; rather they were perceived as *being* artists, bearers of temperament rather than possessors of skills.

A self-portrait by Salvator Rosa of about 1640 provided a historic model for artistic dress, one that was to last a long time after the revival of interest in his paintings was over. The artist displays a shabbiness on a grand scale: long hair in a natural, undressed style, and a soft hat. The pose and expression convey both self-advertisement and self-containment, a combination of genius. Rosa's supposed social irregularities were invented in the eighteenth and early nineteenth centuries and threatened to take over from the paintings themselves as the central concern of commentators. He was an example of the artist as genius, hero and outsider; a bohemian before bohemians. His career was constructed by 'historians' at a time crucial to the rise of the modern artist and the myth lasted into the twentieth century; William Gaunt, writing in 1937, strove to find an equivalence between Rosa, his 'story' and his subjects: '. . . there are pictures in which human and geographical wildness are equally proportioned. The rags and swagger of the raffish community of rocks assume a Homeric character.'[6]

The link between Rosa's touching self-portrait (and it is touching, that faith in the magic self-image) and those late-nineteenth-century artists who

concern me here can be found in the history of artists' 'looks', beginning with
those adopted as Romantic protests against academic institutions through-
out Europe at the end of the eighteenth century. We have in Rosa's rejection
of society and his supposed assumption of a bandit's way of life an identifica-
tion of the artist with marginality, with art as an alternative to bourgeois life,
however dependent upon its patronage and promotion. When 'individuality'
and 'originality' became the watchwords for the talented and untalented
alike, marginality of lifestyle became an important indicator of 'artisticness'
itself, a tendency as much as a reality. An artist could be identified by the
clothing he wore, and could be distinguished from artists of different ten-
dencies or cliques. The brotherhoods and groups formed throughout Europe
in increasing numbers as the century progressed, including the *Primitifs*, the
Lukasbrüder, the Pre-Raphaelites and the Realists, all had dress and hair
codes that announced their difference from their bourgeois patrons and audi-
ence, as well as from each other.[7] The link between Rosa's bandits and the
bohemians who inhabited Paris from the 1840s onwards is perhaps only an
analogous one fired, in part, by the conflation of bandits with gypsies on the
operatic stage [28]. Verdi's *Il trovatore* (1853) is a good example. (What exactly
are those gypsies doing with those bandits? Camp following?) Both tribes sig-
nalled a refusal to conform to an increasingly embourgeoised Europe and
'enjoyed' a freedom from the restrictions of behaviour and dress 'suffered' by
those engaged in mainstream commercial culture. The artist joined those
tribes by becoming 'bohemian', using an argot and adopting certain customs
and living conditions as well as clothing. It should be noted, however, that
two towering figures of French cultural life at this time eschewed bohemian
dress and the 'garret assembly' style, perhaps despising the connotations of
fecklessness and false professionalism which by then had grown up around
them. Delacroix and Baudelaire both adopted versions of English upper-class
tailoring formerly identified with dandies. In so doing Baudelaire stressed an
intellectual and aesthetic quality to be found precisely in the rejection of
highly personalised bohemian dress. He recognised that the ultra-conformity
of bourgeois fashions in which the wearer's personality was submerged or
withheld, permitted the dandy to 'create an originality for [himself] within
the limits of decorum'.[8]

In Britain, the period covered by the later phase of Pre-Raphaelitism and
the Aesthetic Movement, i.e. between 1860 and 1890, was an important one
for the development of the visibility of artists and the ways in which artists
presented themselves to their public. Rossetti's long hair and softened
version of the Parisian bohemian style made him a kind of 'indoor' Rosa. His

28] French artists in the Quartier Latin,
from Gavarni's *Le Diable à Paris*, 1845–46 29] Wilde's obsession with clothes

attempt at communal living in Chelsea with Swinburne represented a new
kind of brotherhood, one which might seem to be a rejection of the spiritual-
ity of the earlier Pre-Raphaelite group. In moving away from the monastic
ideal of its German forerunners and from the reformist stance of the original
Pre-Raphaelite Brotherhood, this later group stressed the personal over the
social. Robert Buchanan took issue with the sensual properties of the paint-
ings of Rossetti and Simeon Solomon, and the poetry of Rossetti and
Swinburne. He found in Rossetti 'nothing virile, nothing tender, nothing
completely sane', uniting personal failings with the 'nasty' characteristics of
the poetry.[9] He equated lifestyle with art and noted a failure in Rossetti to
live up to commonly held ideals of masculinity. Robert Browning is revealing
in his comments made to Isa Blagden in 1870: 'I hate the effeminacy of his
[Rossetti's] school – the men that dress up like women – that use of obsolete
forms, too, and archaic accentuations to seem soft . . .'.[10] Here again personal
qualities, notably revealed through dress, are equated with the work pro-
duced, its forms, techniques and images.

Despite the acceptance and expectation that artists would look 'differ-
ent', it was not acceptable to defy gender expectations – to become 'unmanly',
soft or effeminate. The assumption of Aesthetic dress as a badge of languid
and nebulous creativity by Oscar Wilde was more related to doing nothing
than engaging in work, and more about *appearing* beautiful than about cre-

ating beautiful works [29]. At least, that was the deliberate challenge of his stance. He exposed the stereotypes of masculinity and of male dress, and questioned the economic and social structure that produced them. In these ways the costume and ideals of the Aesthetic Movement distinguish themselves from those of the Arts and Crafts Movement where the *production* of the beautiful was the central issue and where gender differentiation in work and dress was a fact if not an issue.

The brief fashion for Aesthetic dress was part of an attempt by some artists and critics to unify expressions of the beautiful in interior design, painting, costume, literature and architecture. The use of soft fabrics, such as silk and velvet, and the type of ornamentation and colour of Aesthetic dress for men implied that personal beauty could be the province of men as well as of women, thus suggesting sexual ambivalence or indifference. The well-known satires on Aestheticism by Du Maurier and Gilbert and Sullivan play upon the decorative features of the dress and the lack of dynamic 'controlling' features in the personality of the male aesthete. In this context long hair, hitherto a universal sign of the bohemian artist, could be seen as effeminate. The velvet knickerbocker suit, soft beret, silk shirt and flowing tie of the aesthete were mocked as 'unmanly oddities'.[11] Yet Max Nordau, another contemporary observer, implied a strong connection between the Aesthetic style and the 'garret assembly' style. In a ghastly image in *Degeneration* (1895) he noted that an eclectic style had invaded European society: 'one seems to be moving amongst dummies patched together at haphazard, in a mythical mortuary, from fragments of bodies . . . just as they came to hand . . .'.[12] He commented on Wilde's bizarre personal style in clothes, identifying him with 'bohemian dandy' writers such as Villiers de l'Isle-Adam, Barbey d'Aurevilly, and Charles Baudelaire, in his extreme love of costume. 'Wilde dresses in queer costumes which recall partly the fashions of the Middle Ages, partly the rococo modes . . .', he noted, recalling French rather than English fashions.[13]

Confused though Nordau's writing is, it is a discursive reaction to the threat that Aesthetic dress represented at the end of the nineteenth century. For him, this sartorial eclecticism had nothing to do with rejection of modern ethics or modern fashions and everything to do with self-advertisement, an uncontrolled 'ego-mania', which was one of the features of degeneration. In Nordau's view Aestheticism permitted the artist to abandon decorum and simply advertise a pernicious degenerate taste – to some extent a valid point of view. Whereas the dress of previous generations of artists was an *ad hoc* affair put together from various shreds by the artists themselves, with

Aesthetic dress the effect was, to a greater or lesser extent, designed, con-
trived and presented. Its existence was recorded not in self-portraits but in
studio photographic portraits and caricature. This was 'taste' but it was for
observers. As such, it became mass entertainment and needed to overstate
itself for an audience which experienced it through the popular press. It had
the effect of seeming to remove art from the marketplace. The artist's
uniform had few connotations of social class but, nevertheless, it signified
difference from, or indifference to, 'Philistine' commercial culture. More
importantly the style was seen as unmanly, forced, unnatural and deeply
antagonistic to prevailing expectations of the masculine.

The rage for *plein-air* painting throughout Europe from the 1870s had
further consequences for the ways in which artists dressed. In centres such
as Grez-sur-Loing in France, Newquay in England, and Skaagen in Denmark,
painterly preoccupations with the lives of peasants and labourers were clearly
echoed in the appropriation of old tweeds, clogs, capes, odd hats and varia-
tions on work clothes. *Plein-airistes* announced their difference from their
audience and their rejection of their own invariably middle-class origins in
siding with their peasant hosts and subjects. To some extent these late
Impressionists had been preceded in this taste by Parisian-based artists of the
Realist tendency in the 1840s and 1850s. Self-portraits by Théodule Ribot and
Gustave Courbet betray significant developments of the Rosa 'outsider ten-
dency', combining work clothes in a kind of artistic *déshabillé*. British artists
seemed particularly propelled towards this new version of the 'garret assem-
bly' style, perhaps because of the extreme formality of British tailoring and
the emphasis on respectability and conformity at home. A photograph of
R. A. M. Stevenson at Grez in the late 1870s reveals him dressed in cuban-
heeled shoes, knee-length striped socks, knickerbockers, fisherman's jersey,
dark jacket and wide-brimmed hat, sporting a large drooping moustache.[14]
Each element has a different national origin and a different context and the
whole ensemble serves to underline the difference between the male artist
and the 'commercial' man. Stevenson's knickerbockers have a different
meaning from those of the aesthetes. As Stella Mary Newton reminds us,
before the 1890s knickerbockers had been adopted 'by some of those men who
wished to look different from the ordinary urban gentleman'; '[i]ntellectuals
who had worn breeches in the 'seventies merely found themselves in
company not only with athletes who specialized in certain sports but with
those who attended functions at Court where knee-breeches were a part of
a correct dress'.[15] Certainly Stevenson's clothes distinguished him from the
'ordinary urban gentleman', but none of the elements undermined expecta-

tions of masculinity to the same extent as the Aesthetic knickerbocker. By the late 1870s Stevenson could be seen as part of a tradition of harmless eccentricity and picturesque marginality.

In all the forms of artists' dress examined here, there is a sense of distance from the commonplace, from the commercial and from those elements of masculinity perceived as controlling and ordering society. One is struck by the constant shifting around of categories, between 'low' and 'high' culture, between workers' clothing and exclusive, almost aristocratic styles. Artists redefined difference as boundaries shifted. One thing remained constant: assembling a 'look' for oneself in opposition to correct and conventional dress for men, with its tendency to extreme conformity and formality. This strictness of code can be seen as defining an acceptable masculinity and the parameters of its concerns (reserve, control, calculation). The artist abandoned those goals when he assembled a style for himself. Only in late Pre-Raphaelite and Aesthetic Movement dress did this process become critically examined in itself. There, the extreme avoidance of mainstream fashions for men drew attention to a critique of sexual roles within artistic circles. Aestheticism differed from those other 'garret assembly' styles by consciously using clothes to criticise gender and identity from within, rather than from the margins of, middle-class culture.

NOTES

1 George Du Maurier, *Trilby* (London: Osgood, McIlvaine & Co., 1895 edn), Part Third, p. 112.
2 For descriptions of male dress in the period see Ellen Moers, *The Dandy: Brummell to Beerbohm* (London: Secker & Warburg, 1960), and James Laver, *A Concise History of Costume* (London: Thames & Hudson, 1969). For artists' dress depicted in literature see Bo Jeffares, *The Artist in 19th Century English Fiction* (Gerrards Cross: Colin Smyth, 1979), and Malcolm Easton, *Artists and Writers in Paris: The Bohemian Idea 1803–1867* (London: Edward Arnold, 1964).
3 Quoted in Paula Gillett, *The Victorian Painter's World* (Gloucester: Alan Sutton, 1990), p. 81.
4 Deborah Cherry, *Painting Women* (London: Routledge and Kegan Paul, 1993), p. 91.
5 *Ibid.*, p. 84.
6 William Gaunt, *Bandits in a Landscape* (London: Studio Ltd, 1937), pp. 32–3.
7 The *Primitifs* were originally based in David's Studio in Paris. Delecluze, in *Louis David, son école et son temps*, described this odd sect of artists who adopted classical costume 'after [that] worn by the figures on Sicilian vases'. Delecluze referred to them as 'bearded friends' (their other name being the '*Barbus*'). (See Lorenz Eitner, *Neo-Classicism and Romanticism, 1750–1850*, Vol. 1 (New York: Pentice-Hall, 1971), pp. 136–40.) The *Lukasbrüder*, founded in Germany in 1809, were also known as the 'Nazarenes' because of their long hair. See Keith Andrews, *The Nazarenes: A Brotherhood of German Painters in*

Rome (Oxford: OUP, 1964). The Pre-Raphaelites, formed as a brotherhood in London in 1848, the 'year of revolutions', had no single dress or hair code, although Rossetti had shoulder-length hair at one point. For a literary 'portrait' based, at least in part, on Rossetti, and including interesting parallels between gypsy and artistic life, see Theodore Watts-Dunton, *Aylwin* (1898). The Realists, working in France between the 1840s and 1860s, adopted some aspects of workers' dress. Courbet's self-portraits (especially *Man with a Leather Belt*, c. 1845) and his portrait of P. J. Proudhon (1853) show the ways in which clothing could defy bourgeois expectations of portraiture. (See *Courbet* exhibition catalogue, Arts Council of Great Britain, London, 1978.)

8 Quoted in Jerry Palmer, 'Fierce midnights: algolagniac fantasy and the literature of the decadence', in Ian Fletcher (ed.), *Decadence and the 1890s* (London: Edward Arnold, 1979), p. 102.

9 Quoted in Derek Stanford, *Pre-Raphaelite Writing* (London: Dent/Everyman, 1973), p. 38.

10 Letter dated June 19 1870; quoted in Richard Dellamora, *Masculine Desire: The Sexual Politics of Victorian Aestheticism* (Chapel Hill: University of North Carolina Press, 1990), p. 70.

11 See Leslie Baily, *Gilbert and Sullivan and their World* (London: Thames & Hudson, 1973), p. 67

12 Max Nordau, *Degeneration* (London: William Heinemann, 1895), p. 9.

13 *Ibid.*, p. 317.

14 The photograph is reproduced, as plate 16, in Michael Jacobs, *The Good and Simple Life* (Oxford: Phaidon, 1895). See also pp. 27–9 for an account of Stevenson in Grez.

15 Stella Mary Newton, *Health, Art and Reason* (London: John Murray, 1974), p. 140. See also Phillis Cunnington and Alan Mansfield, *English Costume for Sports and Outdoor Recreation* (London: A. & C. Black, 1969).

The training shoe:
'pump up the power'

IT was not until the mid-1970s that the all-purpose sports training shoe
became widely available to the consumer. Previously the sports fan was
faced with a limited choice of footwear: the canvas pump for tennis, the
soft leather spiked running shoe for track events, the leather boot for foot-
ball or the plimsoll for general exercise activity. All-purpose training shoes
made of a combination of canvas and suede were introduced, specifically for
the male consumer, from the mid-1970s during the boom in popularity of
jogging and marathon running. Initially the female consumer was neglected;
if she had sporting interests she was forced to make do with tennis pumps
unless her feet were sufficiently large to fit trainers designed for men. The
limited choice available in the mid-1970s is in stark contrast to the abundance
of products available today. In the mail order catalogues of the mid-1970s
about half a page was devoted to training shoes; by 1984 this had increased
to between two and three pages and it doubled again in the following decade.
The sports shoe business is now a multi-billion-dollar industry and the large
range of shoes produced is accompanied by sophisticated advertising and
promotional campaigns.

Manufacturers focus on the production of shoes for two main markets:
those with a 'serious' interest in sport and fitness and those who buy trainers
for leisure wear. Companies which produce shoes specifically for those active
in sport do not exclude the possibility of their shoes being adopted for leisure
wear; indeed, the adoption of training shoes as status symbols has been a sig-
nificant means of promoting brand names. For young males an important
quality embodied in the shoe is the possibility of the communication of status
to their peers achieved by wearing the most expensive brand name – training
shoe companies target these consumers through macho advertising on page
or on screen. Competitiveness, aggression and male bonding are notions
used by advertisers in the promotion of trainers for men, at both professional

and recreational levels. It is only over the last ten years that manufacturers have begun to exploit the potential of the female market. However, women are targeted in a completely different way from male consumers, and are rarely depicted in advertising as active competitors.

This chapter will discuss the gender-specificity of the training shoe, within the context of women's concerns about health and fitness and their increasing participation in sport in the 1980s and 1990s. The design of the training shoe will be examined as will marketing strategies aimed at women; what methods do the major companies adopt in addressing this important sector of the market and how does that address compare with the male equivalent?

The design and styling of the training shoe has changed radically in the last twenty years. The market is now a highly segmented one, with a different shoe available for almost every kind of sporting activity and with most companies producing specific models for men, women, girls and boys. With the increasing popularity of aerobics, those designed specifically for women constitute the fastest growth area.

The precursors of today's training shoe were the plimsoll (also known as the sneaker or sand shoe), first designed in 1876 for playing croquet,[1] and the running shoe, developed at the end of the nineteenth century. In 1895, Joseph Foster, an amateur runner from Bolton, Lancashire, created a lightweight running shoe for himself, and in 1900 started what was to become a highly successful business, Foster and Sons – now Reebok Limited. It was the keen interest in running in the early twentieth century which provided the impetus for innovations in design with concern focused on improving the weight of the shoe as well as its road/track-holding ability. Men dominated the sport, and, although women also had a long association with running,[2] it was not until women's participation in sport expanded in the late twentieth century that sports shoes began to be gendered in the sense of there being different designs for men and for women.

In 1949, Adolph Dassler's sports shoe company Adidas (founded as football boot specialists in Germany in 1923) added three strengthening strips of leather to the uppers of their running shoe[3] and provided the model for the design of other sports shoes such as the football boot, tennis pump and, later, the all-purpose training shoe. Trainers became more widely available from the late 1970s and several were featured on the specialist sports pages of mail order catalogues. In 1978 *Grattan* included a number of training shoes, including 'Milan' (a black and white shoe for men) from Adidas, and 'Lynx' from Gola (a British company founded in 1928) which was described as a

> trainer/sports shoe . . . made to co-ordinate with ecru clothing range in woven mesh nylon with suede leather trim. Hard-wearing lightweight polyurethane soles in youth's and adult sizes 4–11.[4]

Although this shoe was not directly targeted at women the track suit with which it was co-ordinated was worn by a woman [see 30], the implication being that the shoes were intended to be unisex.

Today most manufacturers create shoes specifically for men or women, the main structural difference being the narrower last used for women's.[5] However, the most immediately discernible aesthetic difference in training shoes for men and women relates to colour combinations, some of which, according to *The Complete Handbook of Athletic Footwear*, cater for 'the more sensitive female eye'.[6] The predominant colours for women's shoes are white with pink, purple or lilac trim; for men trims are dominated by black, navy blue, green and red.

In terms of design it is necessary to distinguish between companies which cater mainly for the serious athlete and those more interested in training shoes as leisure wear. The former, while considering the aesthetics of the shoe to be important, tend to emphasise its technological qualities; the latter focus on fashionable detail, particularly colour, but also sometimes pattern. Gender distinctions in design are more marked in shoes designed specifically for leisure wear, with white with pastel details being the most obvious way to recognise shoes for women; occasionally the addition of patterned or glittered laces can also be seen. The names given to the shoes are also significant. Popular during the 1970s, the associations of the names 'Cheetah', 'Tiger', 'Lynx' and 'Puma', with fast and wild animals suggests that they were aimed at men who thought themselves fit, fast and animal-like. Later, after gender-specific lines were introduced from the late-1970s, leisure training shoes for women and girls, with names such as 'Lady Jane',[7] 'Vickie' and 'Princess',[8] became popular, while 'Starsky and Hutch',[9] 'Revenge Plus' and 'Warrior' [31] were examples of names for men and boys' shoes.[10]

Today it is still common to see gender-specific names for trainers, although companies like Nike and Reebok tend to adopt names which emphasise technological developments. For example, Reebok's 1994 'Hyperlite Low HXL' fitness shoe for women emphasises the use of a lightweight, honeycomb cushioning material called Hexalite, although their product catalogue continues to note its 'sleek, feminine styling'.[11] Nike promotes its 'Nike-Air', a patented cushioning system positioned in the sole of the shoe to deflect the shock impacted on the body when taking part in sports and therefore helping to reduce injury rates. Reebok have their 'Pump'

system, whereby shoes can be pumped with air to meet specific fit, comfort and support requirements. In addition there are a number of specific shoe components, such as 'graphlite' (a lightweight underfoot support), and 'hytrel foam' (a durable material 'offering enhanced energy return'),[12] which companies promote in their publicity. All help to emphasise that the product is an advanced technical achievement which will improve sporting performance. The technologically dominated companies have enormous numbers of product types but all agree that for women their greatest sales are in the fitness market, while for men it is the cross trainer. Improvements in the design of men's training shoes are related to injury prevention and enhancing performance when taking part in competitive sports; in women's shoes technological innovations are developed to protect the foot during aerobic exercise. The research and development related to men's and women's shoes directly relates to the specific markets the companies are targeting.

Between 1970 and 1977 expenditure on sportswear grew faster than any other clothing product, although the potential of the female market had

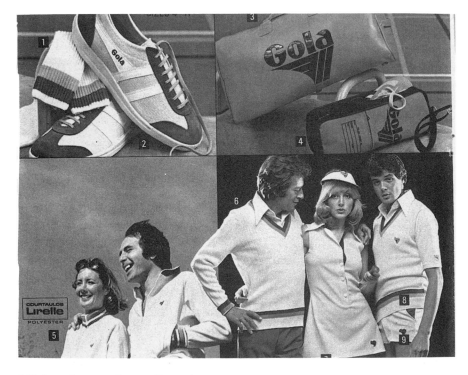

30] Gola trainers and co-ordinated sportswear

barely been tapped.[13] During the 1980s the sportswear industry increasingly directed its attentions towards women. A 1986 survey of the British sports goods industry identified that the largest growth area in sport was related to those activities which involved the participation of women. In 1977, 25 per cent of those active in sports were women; by 1986 it had risen to 40 per cent.[14] A 1991 survey reported that the female market for sporting goods was still on the increase and commented that

> sales of ladies' aerobic/fitness footwear have grown dramatically over the past few years. Reebok are the market leader with 70%, followed by Nike (8%), Avia and L.A. Gear.[15]

This upward trend is illustrated by the targeting of women in the retail sector. In the autumn of 1992, the previously male-dominated sports store Lillywhites, in London's Piccadilly, expanded to include a number of new departments aimed at women, including 'Fitness on Five' for aerobic and dance wear, and a whole floor for the woman golfer.[16] The popularity of

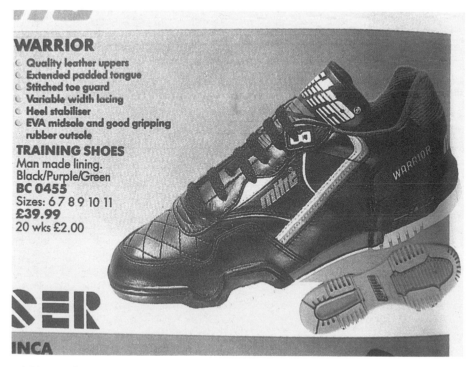

WARRIOR
- Quality leather uppers
- Extended padded tongue
- Stitched toe guard
- Variable width lacing
- Heel stabiliser
- EVA midsole and good gripping rubber outsole

TRAINING SHOES
Man made lining.
Black/Purple/Green
BC 0455
Sizes: 6 7 8 9 10 11
£39.99
20 wks £2.00

31] 'Warrior' trainer

aerobics in the 1980s and more recent variations (such as 'step' and 'slide') has increased enormously and the merchandise that is produced by sports companies to cater for the various activities has also multiplied.

Issues surrounding women's participation in sports have been widely debated,[17] and to a large extent women's exclusion and marginalisation in the sporting world has echoed exclusions from other arenas in patriarchal society. The infrequent coverage of women's sport on television often includes comments not only on their sporting achievements but on their attractiveness. Women's exclusion from various sports by male-dominated sports governing bodies also reflects women's subordinate position in the sporting world.[18] The majority of women cease to participate in competitive sports when they leave school; for some the dance studio, gym or domestic living room offers uncompetitive fitness programmes. The stimulus for undertaking such activities for many women is located, not in a need to compete or maintain a healthy body, but to produce a more 'perfect' physique. Many women feel the need to re-create their natural bodies and fitness programmes provide the solution.

To a large degree these programmes have replaced the diet as the dominant means of modifying the female body. Vigorous exercise is a healthier means of controlling body shape and has the added benefits of improving the cardiovascular system. In contrast to controlling calorie intake and to the 'perfect' bodies promoted by the fashion industry, there are a variety of 'ideal' body shapes available to the fitness participant,[19] and one can fragment the body and work on 'problem' areas. But benefits to health and the possibility of the achievement of one of a number of 'beauty' ideals should not mask the fact that, as Sarah Gilroy has argued, sport and physical activity although generally seen as empowering for men can have the opposite effect for women. Women who acquire obvious muscular power through training programmes face questions related to their femininity or even their sexuality, a problem which sportsmen never encounter.[20] This invites the question, what exactly are the trainers training women and men to do?

The dominant discourses of exercise regimes relate to youth, sex, health, energy and control. The sports shoe industry manufactures product-specific or lifestyle advertisements either in specialist magazines such as *Health and Fitness* and *Ultra-Fit* which combine information on dieting and exercise, or in lifestyle publications such as *Elle, Company, New Woman, GQ* and *FHM*. To a degree, unlike elsewhere in the shoe industry, brand name and image are paramount when it comes to the selling of training shoes. The motives for acquiring sportswear are either involvement or association,[21] and the

major sports shoe companies tend to concentrate on either the serious participant or the leisure market. Nike and Reebok, the two big names, emphasise the athletic credibility of their products by constantly referring to their research and technological achievements. Other companies which produce 'serious' sports trainers but also have an interest in the leisure market include L.A. Gear, Avia, Puma, New Balance and K. Swiss.

Advertising aimed at the male consumer has extended beyond promoting the shoe as a means of improving sporting performance and exploited its importance as a status symbol, particularly among working-class youth. Although many training shoe manufacturers pride themselves as producers of footwear for the serious athlete, they are not averse to selling their shoes outside the sports stadium. Recently some companies have been criticised for encouraging brand allegiance amongst the male youth market through advertising which emphasises action and an over-determined masculinity.[22] The use of male sports superstars is often used in conjunction with this approach. Nike's series of advertisements directed by and starring Spike Lee as the trainer-obsessed Mars Blackman with the basketball superstar Michael Jordon emphasise the product as desirable, macho and fashionable. In the light of rising crime figures relating to the illegal acquisition of Nike trainers by black male teenagers, the company was forced to reassess its advertising and produced a commercial starring Lee and Jordon which encouraged teenagers to stay in school. Reebok emphasise action and masculinity in 'The Edge' advertisement: a young male runner negotiates (at speed) the steel girders at the top of an unfinished skyscraper. This advertisement and the Lee/Jordon series succeed in presenting an image of tough frenzy which is notably absent in the promotion of the training shoe for women.

Over the last two years training shoe companies have focused their attentions on the female consumer, and their advertising aimed at women falls into three major categories: a general market (including women who may not have exercised seriously for a number of years), occasional or lapsed exercisers and regular exercisers.

During 1993–94 Nike placed advertisements in women's lifestyle magazines, such as *Elle*, aimed at the as yet untapped market of women not involved in regular exercise and insecure about their bodies. These advertisements include no overt images of sport, not even a pair of trainers or fitness clothing. Two advertisements focus on the naked female body. One shows a portrait of a small child (approximately two years old), identified as female by pink hair ribbon, and asks 'when was the last time you really felt comfortable

with your body?' The second shows a group of six women of different shapes, one holding a baby. All are naked except for a small muslin loincloth [**32**]. The image suggests that women do not come in one shape. The main text adds 'it's not the shape you are, it's the shape you're in that matters' and the sub-text, while assuring women that whatever shape they are they are beautiful, encourages women to 'make your body the best it can be for one person. Yourself. Just do it.' The messages promoted in these two advertisements may appear somewhat contradictory. Just what are they saying to women? The exclusion of any clear reference to sport and fitness succeeds in reinforcing the general attitude that femininity and sport cannot coexist. Would the inclusion of active, sweaty, powerful bodies encourage a woman who has never seriously considered exercise to buy Nike products? Probably not and the advertisements concentrate on femininity, on soft pinkish skin tones, curving female forms and a discourse which plays on the fact that many women are unhappy with their body's shape.

In 1994 Avia (an American company founded in 1980) launched a new range of women's aerobics shoes in a massive campaign covering five differ-

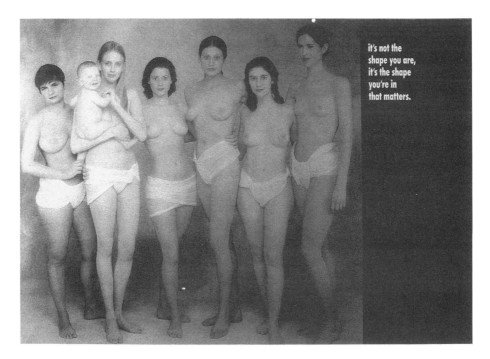

it's not the
shape you are,
it's the shape
you're in
that matters.

32] Nike advertisement

ent British women's magazines. The launch included advertising, editorials, competitions and a sponsorship and cross-merchandising campaign aimed at aerobics professionals. In contrast to the Nike advertisements, Avia targeted women who had intermittently taken part in fitness programmes. The main advertisement depicts a pair of crossed feet in new Avia aerobics shoes and socks, before or after an exercise class. Superimposed over them, in a variety of typefaces, are a multitude of reasons for not going to the aerobics class, including 'I'm mad at my boyfriend', 'It's too cold', and 'I'm still sore from last time'. However, with Avia's new shoes, 'Now there's no excuse', 'Wear them and anything else just seems a poor excuse.' The advertisement focuses on the shoes and, like the Nike ones, avoids the less attractive depiction of the strain and perspiration of exercise.[23]

Reebok is the market leader in the aerobics/fitness field, and consequently provides more shoes for the female consumer than any other company. It had a meteoric rise in the league table of sports shoe manufacturers in the 1980s. Before their rivals they exploited the potential of the aerobics market with their 'Freestyle' shoe. They now have a loyal customer base,

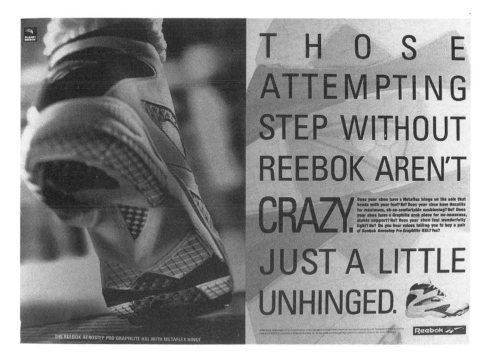

33] Reebok advertisement

a fact reflected in their approach to marketing and promotion. The company prides itself on its sensitive approach to its female customers[24] and acknowledges the range of women involved in sport. Reebok has regarded women as a separate market since the aerobics boom and initially targeted them via instructors.[25] In 1984 they launched the European-wide 'Reebok Professional Instructor Alliance':

> a free, information-based educational club which affords members a forum for exchanging valuable ideas with fellow teaching professionals, and the opportunity to keep up-to-date with the latest developments in the fitness industry.[26]

Bona-fide instructors receive a regular magazine which includes up-to-date news, special offers on shoes and equipment, as well as detailed information on shoe technology and editorials including how to deal with the latest problem of 'exercise junkies'. Reebok also 'masterminded' the 'Reebok Running Sisters Network' which puts women runners in touch with each other, whatever their age or standard of fitness.

In the specialist fitness press Reebok focuses on maintaining loyalty and winning over those already interested in sports and fitness. An advertisement launched in spring 1994 is product-specific and is aimed at serious aerobics participants [33]. It depicts their step-aerobics shoe in action against a background of pink tones; the message is 'Those attempting step without Reebok aren't crazy. Just a little unhinged.' The play on language refers to Reebok's latest technological advance – the Metaflex hinge; the assumption is that readers already participate in step aerobics and understand the necessary flexibility required of a shoe for this type of exercise.

All the companies discussed manufacture shoes which are gender-specific. While the market leaders, Nike and Reebok, no longer give products gender-specific names, differences still exist between shoes for men and women. Shoes for both men and women may carry the same name, be designed for the same purpose utilising identical technologies, but gender continues to be differentiated through the choice and distribution of particular 'feminine' or 'masculine' colours. For example, Reebok's best-selling fitness shoe for both men and women is the 'Satellite'; the women's shoe is available in either 'white/lapis/fast fuschia' or 'white/bermuda blue/sea green' while the identical men's model comes in either black, 'white/black/spark blue' or 'white/midnight blue/burgundy'. The distribution of the colour also differs slightly, with white dominating the women's shoe. This gendering through colour remains a common practice across all manufacturers, with some companies such as Americano focusing specifically on pink details for women's shoes.

The training shoe is gendered in its naming, styling, end use and promotion. A number of companies, such as Puma and Hi-Tec, continue to give their men's shoes aggressive, macho names, such as 'Squadra' and 'Defiance', while feminine names are used for women's shoes (both companies prefix many women's shoes with 'Lady'). All manufacturers also distinguish male and female shoes through colour. Indirectly, the training shoe is gendered in its end use through the socially constructed idea that men are more suited, both physically and emotionally, to sporting activity and that their motives for taking part are different from those of women. Therefore it is how the shoes are perceived and used in society that is gendered. Gender differentiation in design does not determine how the shoes will be used; this is largely achieved through marketing and advertising which is governed by socially constructed notions of gender and physical activity. On the whole it is less acceptable for women to wear trainers as everyday footwear. The ideal of a small dainty foot is not realised by the wearing of a pair of training shoes and women in New York City who wear trainers travelling to the office change their footwear before commencing work. The gendering of the shoe for women is tied up closely with the type of activity for which they are worn. The trainer is part of a fashionable ensemble, worn in the gym in the quest for the 'perfect' body.

Our society regards most competitive sports as rather less acceptable for women than for men, largely because of the challenge they present to accepted notions of femininity; that women are not naturally aggressive or competitive remains a dominant assumption. The promotion of the training shoe falls neatly into these accepted stereotypes, with advertising for men's products emphasising combat, aggression and the desire to win. In contrast, much of the advertising aimed at women reflects a complex range of factors, from the possibility of taking control of one's body and moulding it to perfection, to a focus on the product; in most cases advertisers avoid any challenge to accepted notions of femininity by omitting references to sweat and toil. Even in the pursuit of fitness one must not look as though any unfeminine effort has contributed to it.

For some women exercise and fitness programmes have replaced the diet as the mechanism which traps them in a cycle of anxiety about their bodies. Warnings to aerobics instructors about identifying women who have become fitness junkies, unable to operate normally without an exercise fix, are becoming increasingly common.[27] However, for others the possibility of looking after one's body, by taking advantage of growing opportunities provided by exercise classes, could be interpreted as a more beneficial way of attaining the perfect body shape than constant dieting.

NOTES

1 Sue Moore, 'Trainer mania', *Designing*, 26 (Spring 1991), pp. 16–17.
2 Clarita Anderson and Ann Buermann Wass, 'What did women wear to run?', *Dress: Journal of the Costume Society of America*, 17 (1990), pp. 169–84.
3 M. Cheskin, K. Sherkin and B. Bates, *The Complete Handbook of Athletic Footwear* (New York: Fairchild Publications, 1987), p. 59.
4 *Grattan* (Spring/Summer 1978), pp. 677–8.
5 Cheskin *et al.*, *Athletic Footwear*, p. 220.
6 *Ibid.*
7 *Grattan* (Spring/Summer 1979), p. 360.
8 *Grattan* (Spring/Summer 1992).
9 *Empire* (Spring/Summer 1990), p. 571.
10 *Ibid.*, p. 561.
11 *Reebok Footwear Collection* (Autumn/Winter 1994), p. 34.
12 *Reebok Professional Instructor Alliance News*, vol. 11, no. 1 (Winter 1993).
13 Peter Luscombe, *British Sports Goods Industry* (Jordon & Sons Surveys Limited, 1986), p. 34.
14 *Ibid.*, p. 2.
15 Peter Luscombe, *British Sporting Goods into the 1990s* (Jordon & Sons Surveys Limited, 1991), p. 10.
16 Serena Marler, 'On the right track', *Drapers Record* (August 15 1992), p. 36.
17 There has been extensive research on the sociology of sport with some discussion of the debates surrounding women's participation. See in particular, Jennifer Hargreaves (ed.), *Sport, Culture and Ideology* (London: Routledge, 1985); Jennifer Hargreaves, *Sporting Females: Critical Issues in the History and Sociology of Women's Sport* (London: Routledge, 1994); John Hargreaves, *Sport, Power and Culture: A Social and Historical Analysis of Popular Sports in Britain* (Cambridge: Polity Press, 1986); and Mary Boutilier and Lucinda San Giovanni, *The Sporting Woman* (Champaign, Illinois: Human Kinetics Publisher, 1983).
18 Nike placed on advertisement in *Runner's World* in 1976 highlighting the continued marginalisation of sportswomen. It depicts a cartoon of a number of women athletes running after members of the International Olympic Committee who would not allow women to run in races longer than 1,500 metres. (This advertisement is reproduced in Cheskin *et al.*, *Athletic Footwear*.)
19 Sharon Walker, 'Body perfect', *Health & Fitness* (April 1994), pp. 46–53. (This is one of several articles published recently which discuss the various body ideals available apparently with the right kind of exercise programme.)
20 Sarah Gilroy, 'The emBody-ment of power: gender and physical activity', *Leisure Studies*, 8 (1989), pp. 163–71.
21 Luscombe, *British Sports Goods Industry*, p. 30.
22 William Leith, 'Pump it up', *The Independent on Sunday* (July 8 1990), pp. 3–5.
23 I would like to thank Peter Lawson of Avia for this information.
24 I am indebted to Nicola Thompson (Instructor Alliance Programme Manager at Reebok) for information on Reebok.
25 Thanks to Nicola Thompson of Reebok.
26 *Reebok Professional Instructor Alliance News*, vol. 11, no. 1 (Winter 1993), p. 2.
27 *Ibid.*, p. 7.

Legging it

URING this century one of the most potent symbols of female emancipation has been the adoption of trousers by women, a phenomenon well-documented in social and dress histories. But the reversal of the gender of *tightly clothed* legs is an intriguing issue which seems to have escaped notice, despite the fact that it is a purely twentieth-century assumption that a sheathed leg is – or intends to be regarded as – a female leg.

For most of the six centuries prior to our own, an arrangement of attire that clearly revealed the shape of the legs was the predominant means of expressing masculine power or authority. Phrases still in use today juxtapose references to the leg and power, in the sense of getting ahead. 'To get a leg up' derives from the practice of mounting a horse in the field by standing on another's hand and indicates the 'other' as an inferior. The more contemporary 'legging it', which implies criminal behaviour, embodies a subversive element that is also germane to an exploration of the gendered leg.

In sifting through the historical development of and interplay between the tightly clothed leg and the trousered (i.e. loosely clothed) leg, it is worth remembering the association of barbarianism with trousers, which dates from the late Roman Empire. When the official dress was the unstructured toga, the trousers worn by the barbarians – central European tribes whose incursions of the third and fourth centuries began to disrupt the Empire – represented the subversion of established rule and, in the last decade of the fourth century, two attempts were made to ban the wearing of trousers by Roman subjects.

The links between thuggery and trousers were further strengthened over the next two centuries; in *Secret History*, set in the court of Byzantine emperor Justinian I (fl. 527–65), Procopius described the dress of the upper-class supporters of the rival hippodrome teams in Rome – virtually thugs who

robbed people for kicks – as a medley of the old and the new; they wore the *toga praetexta* (the purple-bordered Roman magistrate's toga) to which they had no right, tight-sleeved tunics and 'cloaks, trousers and boots . . . [which] were called the Hun style'.[1] Justinian gave to posterity his codification of Roman law, and defeated the Vandals in Africa and the Ostrogoths in Italy, thus contributing to the survival of the ideal of civilisation as embodied in the Roman Empire. Goths, Vandals, barbarians and Huns were committed to history as 'bad guys', and they all wore trousers.

The Goths were also held responsible for the destruction of classical art by Renaissance artists, for whom 'Gothic' was a derisory term for the art and architecture of their immediate predecessors. It could be coincidence but, as the Renaissance dawned in fourteenth-century Italy, fashionable male attire began a new phase that gradually incorporated the exposed and tightly clothed leg. The resulting effect has been referred to as creating a clothed nude, borne out most clearly by depictions of men in the decades either side of 1500 (when the torso was also closely covered), but apparent first in the treatment of legs some 150 years earlier. Interest in a humane, civilised and classicised world was paralleled by the creation of a masculine wardrobe that placed emphasis not just on the leg, but on the shape of the leg.

The garments that made this development possible were the breeches and hose. After 1150, illustrations of such garments become plentiful enough to suggest that the function of the hose was to hold the bottom of the breeches in place. (Alternative arrangements were cross-straps wound round the leg like puttees, or breeches shaped like jodhpurs.) For another two centuries breeches grew shorter and hose longer, but two things remained fairly constant: the hose were made of cloth, cut on the cross and pulled up over the bottom of the breeches, and the overgarment, whether shoulder-to-toe or to the knee, was loose and relatively untailored. Eventually hose came high enough to be attached to the garment covering the torso and, at about the same time, c. 1340, a short tight tunic was adopted. From then until about 1620 the male silhouette was varied by the shape of the body covering or, from about 1520, a variety of garments connected to the hose (later separate, once knitted hose became available) and reaching from waist to thigh, only occasionally descending to the knee. Sometimes they became pumpkin-like in shape, and on the young gallant of the late 1500s, stopped short at the hip. For much of the period, a gown, either long or short, was an optional overgarment, with young men favouring the short gown.

Today we see dignity and majesty in the long version of the 'gounes' or 'houppelandes' that were fashionable about 1360 to 1460 (now adopted as a

static element of official dress). Yet at the time the fullness of these pleated gowns and the abandoning of the front and back slits, which allowed the simpler, knee-length over-tunics to be worn on horseback, were both decried as effeminate, particularly when viewed from the back. If gowns spelled the 'feminine', hose signalled the masculine; a 1360s depiction of St Theodora disguised as a man confirms that legs closely clothed and revealed up to the thigh were the requisite elements for her transformation. Most of the complaints about such revealing male attire, including those voiced by Chaucer in his *Parson's Tale*, focused on the often indecent emphasis on gender; a codpiece was added in the mid-1400s and continued to be worn into the last quarter of the 1500s, serving both modesty and vanity and, perhaps more significantly, offering some degree of protection.

An (assumed) relationship between the emergence of Renaissance ideals and the revelation of a shapely male leg might be explained in terms of: a renewed interest in classical sculpture and thus 'real' body shape; the shift from faith to reason involving a change in emphasis from soul to body; or the emergence of mercantile networks that, put simplistically, created a noticeably more male-dominated world that was echoed in the dichotomy between increasingly revealing (male) and increasingly concealing (female) dress. However, art, intellectual discourse and commerce nothwithstanding, the same period also represents the lifespan of plate armour. So it is also possible that the male fashions (hose, short and shaped tunic and optional gown) noticed as different from about 1340, represented garments designed to be worn under armour, particularly since, at more or less the same point, mail leggings were abandoned in favour of hinged plate, covering toe to thigh and benefiting from a smooth, continuous padding beneath.

Contemporary accounts and illustrative material – as well as common sense – indicate that action required unencumbering clothes. Discussing mid-fourteenth-century male dress, Stella Mary Newton commented that the 'combination of long hose, a short, padded sleeved garment reaching the waist, at which point the hose were tied to it, and a long thick loose overcoat was, in contrast to the tunic and over-tunic which constituted the formal dress of the upper classes, the sports wear of the day, shared with country people and wealthy peasants'.[2] Therefore, the 'clothed nude' look also provides a link to sport. The 'clothed nude' look parodied the nude athletes of ancient Greece; thus the exposure of the shape of the male body – suggesting not only classical ideals but also youth, ambition or physical prowess – can be read as a skilful amalgam of understood symbols which relate to power of one kind or another.

In the eighteenth century, when male fashions again included hose (or stockings) to the knee and increasingly close-fitting breeches above, the power signified by such a silhouette was more often social than athletic. Elegance, in motion or repose, was a fundamental requisite of polite society, a necessity that spawned dancing masters and a proliferation of books 'chiefly for the Use and Benefit of Persons of Mean Births and Education, who have unaccountably plung'd themselves into Wealth and Power'.[3] Whether walking, bowing, dancing or fencing, the correct position of the legs was codified. In 1752, when Lord Chesterton advised his son that he should always put his best foot foremost, his meaning was literal, and the male costume of the period was constructed to ensure that the line of the leg was clearly visible.

Trousers – that is the whole variety of loosely shaped garments that characterised the lower classes or were associated with occupations (e.g. the 'slops' worn by sailors) – had coexisted with fashionable men's wear since the Renaissance. Only briefly in the seventeenth century was there a fashion for very loose knee-length 'petticoat breeches'. In *Tyranus, or The Mode* (1664), John Evelyn likened the extreme gathering of this 'exorbitant' mode to his 'Grandames loose Gown' and, in a reprise of earlier criticism of men in voluminous garments, condemned them as 'Hermaphrodite and of neither Sex'.[4]

Trousers became recharged with 'barbarianism' at the end of the eighteenth century, when for practical reasons members of the social élite abandoned breeches and hose and went *sans culotte*. But fashionable men – or their tailors – adapted the loose trousers of the populace into ankle-length pantaloons. Skin-tight (with an instep strap to keep them so) and often worn with boots, the visual break just below the knee, which had characterised the previous fashion, was preserved. The dread of loose trousers was only overcome very slowly and, although by the 1820s there was a decline in the extreme tightness of pantaloons (often made from stockinette or cut on the cross to better mould the body), military fashions, such as those associated with the Hussars, continued their use well into the middle of the century. Then, with fashionable tailoring (as opposed to the body itself) producing a shaped leg, men were still being advised to avoid loose trousers which, especially when made of a checked fabric, gave the impression of an ungentlemanly entrepreneurial spirit (or, put another way, marked out the wearer as today's equivalent of a second-hand car salesman). In light of the persistent resistance to loose trousers – except when dressed for tennis, cricket or similar sports (for shooting or bicycling knee breeches were still worn) – the baggy trousers worn by William Morris (designer, poet and socialist, 1834–96)

take on a much more radical meaning, particularly since he wore them with a smock. Looseness meant untrustworthiness, although more so in 1859 when men were advised against trousers 'as loose as a Turk's', than in 1932, when a conservative British tailor pronounced that 'soft, sloppy clothes are symbolical of a soft and sloppy race'.[5]

It should by now be obvious that when, during the 1910s and 1920s, women adopted loose 'trousers' for informal occasions, they wore a garment that had little élite masculine symbolism. The pyjama-like construction and long over-garment came from traditional garb with connotations of 'otherness', with that meaning encompassing the uncivilised, the lower classes and the untrustworthy. Far more radical was the breathtaking audacity of shortening skirts, not just because they revealed the leg (as did bathing costumes), but because they revealed a sheathed leg. Although described as 'nude' in colour, the stockings of the period were sufficiently coloured and shiny to ensure that the leg did not look bare and therefore, given the power of cultural memory, carried connotations of manliness as strong as the short hair that went with such fashions.

The label 'garçonne' gave emphasis to the boyishness of elements of 1920s style, and confirmation that the sheathed leg still suggested masculinity could be found in the reaction to its opposite – the ultra-wide Oxford bags adopted by young men in 1925 which were lampooned as effeminate. This 'vice-versa' of male and female silhouettes helped young women – visually and in reality – to take on the cultural role of a slaughtered generation of young men. A fitting role model for the new foot-soldiers of change was provided by Joan of Arc, who was canonised in 1920. In 1928, when the French Société Générale de Film commissioned an art film to be based on a strong woman of the past, director Carl Dreyer chose Joan of Arc from three options (the others being Catherine de Medici and Marie Antoinette). While professing no interest in the costumes, he chose a heroine who had adopted a male role and with it, a male appearance.[6] In 1428–29, when Joan of Arc led an army to free the besieged city of Orléans, enabling Charles VII to be crowned king of France, the male fashions called for hose, tunic and a short gown to just above the knee, belted at the hip; hair was ear length. Had a fashionable woman of 500 years later been magically transported to the same battlefield, she too (choice of fibres and fabrics apart) might have been mistaken for a man.

Sartorially speaking (and in many other respects) the 1920s marked the beginning of a period since when women's dress evolved two series of related styles that bear a remarkable resemblance to the dress of late medieval and Renaissance men. In the first, fashionable during the 1920s and 1960s, the

combination of 'hose' and shaped tunic, dropping to hip or lower thigh, reflected male fashions of about 1350–1450. A particularly close comparison can be made between a weeper from the tomb of Edward III (c. 1377–86) and a fashionable young woman of the late 1960s, so much so that the dress of both can be described in the same way: a simple but shaped garment belted at the hip, sleeves cut high into the armpit, coloured tights and short hair [34, 35]. The second, seen in the 1950s, and to a more extreme extent in the last ten years, combined shape-revealing, ankle-hugging trousers or leggings with waist-length tops that recall the 'clothed nude' male fashion of about 1500. Both styles were reserved, as before, for the young, ambitious or powerful, and were significant symbols of women's increasing social, sexual and economic freedoms. It could be argued that women's leggings deserved the term 'power dressing' even more so than the big-shouldered suit, since the latter had a far shorter history of use by men than the former.

Men did not entirely abandon their right to sheathed legs during the decades after 1920, but the 'drainpipes' of the 1950s were part of a counter-culture whose clothing unsettled the establishment in much the same way that loose-trousered barbarians had threatened the Romans. Although one can argue that the very tight pantaloons of the early nineteenth century were similarly symbolic of aggressive young men, there was at that time no female equivalent, and so the question of gender differentiation never arose. Yet in the late 1960s and early 1970s, when young men and women alike began to wear flares skin-tight to just below the knee, the cliché question – when wearers were seen from the *back* – became 'male or female'? The implication was – for the first time – that men could look effeminate in tight trousers. Seen from the *front*, of course, there was little doubt about the gender of the wearer. James Laver, the costume historian who supported the 'shifting erogenous zone' theory of fashion history, when asked if the peacock male fashions of 1968 were sinister, replied 'Maybe . . . If the patriarchal society is changing to a matriarchal one it will be women who will choose their partners – men will have to dress to attract – exaggerating their masculine qualities, like wearing tight trousers which are, in effect, codpieces.'[7] The female incursion into the realm of the sheathed leg was understood as a contemporary symbol of the new powers of women, but at the same time, women's adoption of such clothing had also altered their gender implications, bringing in tow some loss of visually communicated power or status. Laver's comment, for example, contained within it an inference that men in tight trousers meant men seeking rather than conferring approval or attention, deprived of absolute control of their destiny.

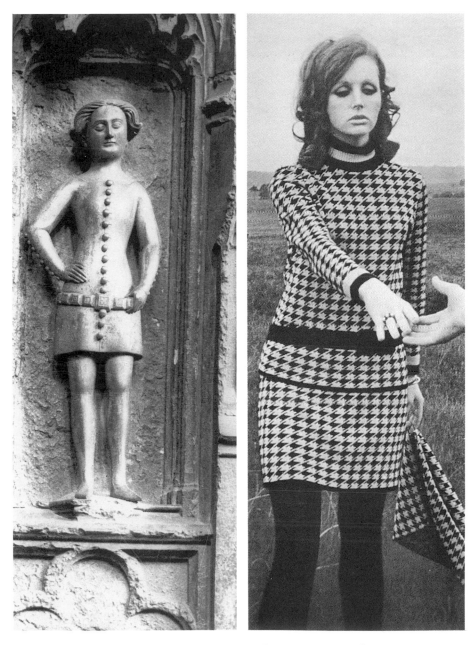

34] William of Hatfield, weeper
(courtesy of the Dean and Chapter of
Westminster)

35] From Dupont Orlan ®
advertisement

Today the sheathed leg is acceptable for men only as part of dress for athletic activities; we take for granted that otherwise it is a female form of dress. Nevertheless, leggings are not closely associated with 'femininity'; on women they still carry implications of assertiveness that several decades of leg-sheathing female fashions have not diminished. Even the pantomime, with its traditional late-Victorian principal-boy costume, still expects the audience to read 'male' when presented with a woman in a fitted jacket, hat, boots and tights. All this suggests that the male gender of, and consequent power implied by, the sheathed leg is too deeply imbedded into Western cultural memory to be erased easily, and that women, in successfully co-opting this style, have – consciously or unconsciously – discovered a potent symbol of their desire to govern their own lives.

NOTES

1 Aileen Ribeiro, *Dress and Morality* (London: Batsford, 1986), p. 29.
2 Stella Mary Newton, *Fashion in the Age of the Black Prince: A Study of the Years 1340–1365* (Woodbridge, Suffolk: Boydell Press, 1980), p. 32.
3 J. Levron, *The Man of Manners: or Plebeian Polish'd*, third edition (London, 1768), title page.
4 Cited in Norah Waugh, *The Cut of Men's Clothes 1600–1900*, fourth edition (London: Faber & Faber, 1977), p. 48.
5 Ribeiro, *Dress and Morality*, pp. 126, 158.
6 Information courtesy of Andrew Clay.
7 'Fashion is dead. Long live clothes', *Nova* (September 1968), p. 60.

Trousers: feminism in nineteenth-century America

IN 1851, Elizabeth Cady Stanton and Amelia Bloomer, two leading American feminist writers and activists, appeared in the streets of Seneca Falls in a costume which consisted of a sack coat, a loose-waisted dress which fell only to the knees and a pair of draped trousers, gathered at the ankle. Almost immediately they became the focus of a fierce debate about dress and gender which was carried on in the press, and in private homes, all across America. Stanton and Bloomer had challenged the presumption that only man should wear trousers and that woman's proper garment was the skirt, a presumption so deep-seated that it had acquired the status of 'natural' law.

What was really at stake was the question of how masculinity and femininity were to be defined. The vast majority of Americans believed that men and women had been created with essential differences and to occupy very different social spheres, each contributing to society what the other lacked; women were 'by nature' private, domestic and ruled by emotion, while men were active, rational and inherently suited to public life. According to this view, it was necessary to maintain an extreme distinction between the clothing of the sexes in order to safeguard 'natural' gender relations and to keep society in a state of moral equilibrium. Trousers symbolised masculinity and fitted man's role as practical 'doer', while skirts symbolised femininity and were 'a guard set over the wearer, going where she goes, stopping where she stops, and abiding with her as a perpetual and restraining monitor'.[1]

Any woman who was brave enough to wear trousers in mid-nineteenth-century America posed a threat to this symbolic order, and was seen to be acting 'out of her sphere', whether this was her intention or not. This was true even before the advent of 'bloomerism' in 1851; the few female health reformers who had adopted trousered dress in the preceding two years

estimated that public opinion would make it impossible for them to wear such dress in everyday life. One such reformer, Theodosia Gilbert, a doctor at the Glen Haven 'water-cure' sanatorium on Skaneateles Lake, informed the readers of the *Water Cure Journal* that she had, in 1849, devised a 'hygenic' walking suit, consisting of a pair of cashmere pantaloons and a short, loose-fitting woollen frock, and had influenced her patients to adopt the same. However, although she stated that she wished to 'monopolize more of the fresh, open air than is generally considered, or even justifiable in my sex', she was anxious to point out that she had no interest in gender politics. Even so, Gilbert knew that those who had put on trousers in the isolated 'community' at Glen Haven would need more fortitude than they perhaps possessed if they were to brave 'an intolerable public opinion' which must greet them elsewhere.[2] Gilbert here identified a major problem for would-be dress reformers; how was it possible to effect the extreme change in the habitual dress of ordinary American women which the 'laws of health' demanded, without departing so radically from convention that it 'martyred' its wearers and alienated those it sought to recruit?

Although Bloomer and Stanton, like Gilbert before them, stated that they had taken to trouser wearing on the grounds of health and comfort, as feminists they could not so easily claim that that their adoption of a rational, divided dress had no bearing on 'the mooted questions of "Woman's sphere" and "Woman's Rights"'.[3] Despite Stanton's protest that she and other feminists did 'not meet to discuss fashion, customs, or dress, the rights of man or the propriety of the sexes changing positions, but simply our inalienable rights, our duties, our true sphere', it was quite obvious that they wished women to be able to occupy a very different place in society than that which was prescribed within traditional ideologies of femininity.[4] Anyone conversant with the 'Declaration of Sentiments' which had inaugurated the Woman's Rights convention of 1848, knew that feminists had set themselves a very subversive agenda, calling for an end to women's exclusion from lawmaking, their subordination in religious matters, loss of legal responsibility and civil and property rights upon marriage, and limited access to education and professional life, taxation without representation, as well as for divorce. The fact that Stanton and Bloomer, as feminists, championed these interests, meant that it was all too easy to identify their advocacy of trousered dress with a desire to disrupt patriarchal order and usurp male privilege, despite the fact that they had already rejected an unskirted model of trousered dress for fear that its wearers would be considered as 'manly women'. This had been proposed by the German feminist Helen Marie Weber at the first

National Woman's Rights Convention of 1850. Weber advocated the wearing
of 'male attire', which in her case consisted of a dark dress coat and pants
and a cashmere waistcoat richly trimmed with gilt buttons, arguing that
'those who suppose that woman can ever be the political, social, pecuniary,
religious equal of man without conforming to his dress, deceive themselves,
and mislead others who have no minds of their own', and predicted that it
would be only ten years before the women of all civilised nations were
wearing men's dress.[5] Stanton accepted that dress reform was a precondition
of all other reforms and was impressed by the richness and fit of Weber's
costume but rejected such close 'borrowing'. She informed the readers of
Bloomer's newspaper *The Lily* that men need not fear that women would take
to trousers because this was a violation of 'beauty, taste and dignity'.[6]

By rejecting Weber's 'cross-dressing', Stanton and Bloomer were defining
the boundaries within which they were to operate. They claimed that the
'bloomer' costume had little in common with male suiting. Although Bloomer
had come to believe that there was no moral or social reason why women
should not adopt men's dress, she took great pains to demonstrate that bloomer
costume could be a 'womanly' dress. She maintained that it was 'nothing differ-
ent from the reigning fashion', made light of the shortness of the gown and the
inclusion of trousers in the 'ensemble', emphasised the draped aspects of the
trousers, which could be 'trimmed to suit the taste of the wearer', and the
prettiness of pleats or gathers around the ankles.[7] The skirt, the most obvious
symbol of femininity, was retained on the grounds that it gave fullness and ele-
gance to the figure. In general, function rather than fashion was foregrounded
and Bloomer argued that the primary function of reform dress was to free the
body rather than to ornament it. However, she did not disregard aesthetics and
suggested her followers devise a 'perfected' costume which would be 'attrac-
tive' and 'feminine' as well as 'rational' and healthy. But this was no easy task,
at a time when many fashion writers were promoting the 'invalided' woman as
a physical ideal, with particular emphasis on the corseted silhouette. There was
always the danger that those who attempted to broaden the appeal of bloom-
erism by emphasising its aesthetic and fashion potential would disregard the
'laws' of physiology, as happened when, in 1851, *Harper's New Monthly
Magazine* illustrated its own version of bloomer dress as a model for 'fair
reformers'. *Harper's* position was that, while women's attempts to invade
'men's peculiar domain in dress, incited by the strong-minded Miss Webers of
the day', had been doomed to failure, they had no objection to women wearing
trousers 'if *properly done*', i.e. within the bounds of contemporary fashion and
acceptable femininity.[8] While the text commended Oriental dress as a more

convenient alternative to trailing skirts, the accompanying engraving adhered to the conventions of the contemporary fashion plate, showing a decidedly pretty woman with a nipped-in waist, sloping shoulders, and tiny feet, wearing a richly decorated costume which was a hybrid of Eastern, Spanish and other European influences – hardly the stuff of practical reform.

By mid-1851 bloomer dress was hotly debated in popular newspapers which noted that a number of New England women had adopted trousered dress, and that 'pockets' of bloomerism were appearing as far afield as California and Texas.[9] The actual number of bloomer wearers cannot be known, with anti-bloomer newspapers denying any popular basis to the movement, and pro-bloomer publications, such as the *Syracuse Journal*, claiming that bloomered women had become so numerous in some cities that they ceased to attract attention.[10] Although bloomerism received a more positive press than has been acknowledged until relatively recently, it is significant that most writers who supported it advanced its claims by dwelling on the irrationality of 'fashion' and promoting trousered dress as a healthful and graceful alternative, without reference to connections between bloomerism and feminism. Some newspapers flatly denied that bloomerism and feminism were one and the same, and asserted that the subject of dress had nothing to do with Woman's Rights and should be allowed to stand on its own merits. Where the connection between bloomerism and feminism was made, woman's right to wear rational dress was often equated with her rights to equality as a republican citizen. This stance was taken by the *New York Daily Tribune* which printed a Fourth of July 'Declaration of Independence', claiming that, since 'fashion' was a tyrant, it was the duty of every free woman in the United States to rebel by donning the new dress.[11]

The strategies adopted by the anti-bloomer press were many and various; *Godey's Ladies' Book*, for example, rejected the dress as inappropriate 'for the great diversity to be found in the female form and structure', while other publications asserted that it promoted immodesty, either because it encouraged men to look at women's ankles, or because seated bloomers might reveal that women had knees, or because of associations with the harem and sexual licence.[12] The *New York Herald* went so far as to opine that bloomer wearers would surely end up in the lunatic asylum or state prison.[13] Many publications played upon the idea of gender inversion, a theme highlighted by the circulation of British cartoons, particularly the comic 'bloomer' images of John Leech, and their reworking by the American popular print makers Currier and Ives [36, 37]. American readers were treated to the sight of bloomers in bars, at the races, smoking cigars, engineering elopements, and

36, **37**] Bloomeriana –
A Dream, and detail

becoming coachmen and dons. Their male companions were also 'unnatural', with a passion for shopping and sentimental novels; one young man, upon receiving a proposal of marriage from a bloomered women, simpers, averts his gaze and states, 'I must really ask Mama'.[14]

The stereotypes which Leech developed were quickly taken up by American critics of feminism who wished to represent the trousered women who attended Woman's Rights conventions and other reform meetings as uncouth and unnatural. Predictions that women who wore trousers would begin to swagger and throw their weight about went hand-in-hand with assertions that they would turn into a horde of unsexed and abandoned brawlers if they attended political rallies or got the vote. Feminist lecturers who wore the bloomer dress were singled out and accused of acting 'out of their sphere' by brazenly daring to address 'promiscuous' (i.e. mixed sex) assemblies while clothed in an indecent and tasteless manner.[15] Frances Dana Gage, a prominent feminist, was moved to write to *The Lily* to protest against this view of bloomerism and claim the high moral ground for women:

> It is a comical idea to me, that men must always portray us practicing their own favourite follies when they want to make us look horrible. They cannot get up a picture of a Woman's Rights meeting or anything of that sort, but they must put cigars and pipes in our mouths, make us sit crossed-legged, or hoist our feet above their legitimate position – making us behave as disgustingly and unbecomingly as themselves . . . They have so long . . . associated their vulgar thoughts and feelings with their constitutional rights and privileges, that they seem to think them inseparable; and that if we are not kept good, clever, and modest by being kept ignorant, and under restraint, we shall take the largest liberty, and become just as bad . . . and so they get up awful caricatures, to scare us into our old places.[16]

Journalists who feared that bloomerism was part of a feminist bid for dominance over men went much further than Leech, drawing on stereotypes of disaffected old maids and vengeful wives venting their spleen on American society, portraying trouser-wearing women as 'hermaphrodite spirits who thirst to win the title of champion of one sex and victor over the other'. At the same time, male reformers who supported them were characterised as 'hermaphrodites' and 'Aunt Nancy' men who 'comb their hair smoothly back and with fingers locked across their stomachs, speak in soft voices and with upturned eyes'.[17] *The Boston Transcript* claimed that a 'Mr Bloomer' had appeared in full bloomerised rigout, which included a 'frock coatee, skirt very short, Turkish pants, large legs and gathered . . . black gaitered boots, small walking stick, with the top in his mouth', adding, sarcastically, that 'It was acknowledged that he was a man, and he was congratulated accordingly.'[18]

This kind of attack proved all too effective. Bloomer found herself writing in defence of male reformers ridiculed by the press for wearing shawls, and itemised the 'feminine' components of Stanton's dress in order to refute the charge that she had adopted men's boots and pants.[19] Stanton herself concluded that the bloomer dress was being used to maliciously falsify the aims and objectives of the Woman's Rights movement and by early 1853 had serious doubts about the costume she had sworn never to abandon, believing that her advocacy of it had lost her the presidency of the Woman's Temperance Association and had damaged her husband's political career. She tried to convince other leading feminist bloomer wearers that the price of trousered dress was too dear, and they too began to air their reservations. Susan Anthony, for example, complained that it had made her known as 'one of the women who ape men – coarse, brutal men!', and even Lucy Stone, who had felt that bloomer-wearing feminists 'should give an example by which woman may more easily work out her own emancipation', reached the conclusion that dress was of little importance when compared to 'weightier matters of justice and truth'.[20] By the end of the year, all the prominent feminist speakers who had made themselves doubly notorious by wearing trousered dress, with the notable exception of Amelia Bloomer, had succumbed to long skirts.[21] This reversion had serious repercussions because it was now argued that, if they could sacrifice principle to convention in this way, they were not fit to lead the cause.[22] Gerrit Smith, a radical congressman who had given the Woman's Rights movement considerable financial backing, withdrew his support on the grounds that Stanton and her circle had thrown away their most effective weapon in the fight against the false doctrines and sentiments which allowed woman to 'present herself to man, now in the bewitching character of a plaything, a doll, an idol, and now in the degraded character of his servant'. His prognosis was a gloomy one:

> The next 'Woman's Rights Convention' will, I take it for granted, differ little from its predecessors. It will abound in righteous demands and noble sentiments, but not in the evidence that they who would enunciate these demands and sentiments are prepared to put themselves in harmony with what they conceive and demand . . . it will be, as has been every other Woman's Rights Convention, a failure. Could I see it made up of women whose dress would indicate their translation from cowardice to courage; from slavery to freedom; from the kingdom of fancy and fashion and foolery to the kingdom of reason and righteousness, then would I hope for the elevation of woman, aye, and of man too, as perhaps I have never yet hoped.[23]

Other reformers, including those health reformers who wished to change women's dress but had never fully endorsed the Woman's Rights platform,

had every reason to be glad that feminists were abandoning trousers. This was particularly true of those involved in the 'alternative' medical practice of hydropathy, which advocated that water should be applied to the body as a preventative against illness and a cure for organic disorders. A few women within this movement, including Theodosia Gilbert, Rachel Gleason and their patients at Glen Haven, had, as noted above, first worn skirted trousered dress in 1849, and urged other women to do the same through the pages of the *Water Cure Journal*, the editors of which had been interested in the subject of women's dress since the journal's inception in 1844. Their position on dress was part and parcel of the ideological struggle between hydropaths and allopaths (practitioners of conventional medicine) over the proper management of female diseases and the meaning of the female body. Where allopaths viewed women's bodies as essentially morbid, at the mercy of the unstable ovaries and womb and lurching through puberty, menstruation, pregnancy and menopause as a series of inevitable physiological traumas, hydropaths believed that the female body existed in a state of 'natural' well-being unless 'the laws of life' were obstructed by artificial habits and social customs, including fashionable dress. In this context, the journal's female readers, who were instructed in the principles of anatomy and physiology so that they could take responsibility for their own bodies, were particularly warned against the fashionable practice of 'tight-lacing', thought to be the cause of uterine disease and miscarriage. They were also advised to wear loose, light clothing in order to achieve a state of robust healthiness and the strength to exert influence within the home – thereby to fortify the nation as a whole.[24]

By late 1850 two types of bifurcated dress for women had been featured in the *Water Cure Journal*, one without and one with skirts. The editors wisely decided to leave the exact forms of such reformed dress 'entirely to the ladies', hoping that their readers would start a vigorous correspondence on this subject. Significantly, this debate did not gather momentum until after the inauguration of 'bloomerism' at Seneca Falls but, by August 1851, correspondents were discussing the merits and defects of the two main models, accepting 'Weber' and 'Bloomer' as convenient labels.

However, with few exceptions, the articles which appeared in the journal recognised no connection between bifurcation and organised feminism. It was not that writers were not interested in reform dress as a critique of conventional ideals of femininity, rather that their brand of feminism was 'domestic' rather than overtly political in character. The editors of the *Water Cure Journal* believed that American women needed a form of dress which

would allow them to move out of the confines of the home in order to exercise their bodies and to undertake good works. They also encouraged women to take up clerical work and engage in the 'caring' professions of medicine and midwifery, but they did not endorse female suffrage or countenance women's involvement in political issues, except at the most informal level.[25]

No doubt aware of the furore which Stanton and Bloomer's costume had caused, the *Water Cure Journal* defended bifurcation against the charge that it was the uniform of the 'manly' woman. Considerable space was devoted to descriptions of the beauty of trousered dress, together with suggestions for trimmings and accessories which would make it acceptably feminine. In the pro-'Bloomer' camp Rachel Gleason, matron of the Glen Haven sanatorium and one of the first qualified female doctors in America, advocated trousers with flounced hems for those women who wanted to adopt elements of male dress without giving way to 'a gross affectation of manliness'.[26] In similar vein, Mary Williams, a supporter of 'Weber' dress, advised those who did not wish to appear 'unsex'd' to replace Weber's dress coat with a saque (a loose garment with buttons), and her masculine linen and headgear with an embroidered chemise and cravat, and a Tyrolean straw hat lined in blue or pink.[27]

By the end of 1851, the journal was throwing its weight behind the Bloomer as a more modest and feminine alternative to the Weber. Claims were also made that the bloomer dress, which had been 'invented' by American women, was a true national costume, preferable to fashionable dress styles which originated with the ungodly French *demi-monde*.[28] As a rational and progressive costume, it was thought to exemplify those national 'virtues' which fitted America for world leadership, auguring nothing less than global republicanism. The geographical progress of the reformed dress was duly noted. By Christmas 1851, it was claimed that the dress had been tried in England, Scotland and France. By the following February/March, it was reported in use in Germany, Hungary, Italy, Spain and Sweden and the capitulation of both Russia and Austria was imminently expected.[29]

This optimism was as ill-founded as it was short-lived. The most enthusiastic of hydropathic dress reformers continued to advance their claims for bloomer dress while distancing it from feminism, but the spread of bloomerism had been halted. By 1853, the majority of women who had worn bloomer dress, for whatever reason, had abandoned it or were wearing it only in the privacy of their homes[30] because trousers had been taken up in America by members of 'free love' communes and associations, who claimed that spiritual attachments between men and women should have primacy over the conventional restraints of marriage as a legal institution. Although they used

this as an argument for divorce, rather than the abolition of marriage, they were accused of sanctioning sexually aberrant behaviour and illegitimacy, and changing partners at will.

The focus for much of this criticism was Mary Gove Nichols, a hydropath who had written extensively for the *Water Cure Journal*, who was the first to describe bloomer dress as 'The American Costume', and who belonged to the 'free love' community at Modern Times, Long Island. She was viciously maligned in Charles Webber's novel *Spiritual Vampirism*, where she was portrayed as a fornicator who used her knowledge of the body to seduce innocent men into the service of a secret conclave dedicated to the destruction of American republicanism. She urges other women to dress rationally so that they will be able to overthrow men, telling them that they must seduce the 'dozen men' who wield the destiny of the age in order to achieve their goal. Aligning her with most of the radical reform movements of the decade, Webber informed his readers that it was in her last metamorphosis, as a feminist and a bloomer wearer, that Nichols was of most use to 'the forces of national disorganisation'.[31] Webber, together with other vociferous critics of free love, helped render the associations of trousered dress completely odious to those who had been attracted to dress reform via a rhetoric of republicanism and hygiene.

The struggle over the signification of trousered dress, and the debate about the relationship of dress to definitions of gender, was very complex indeed. Conservative critics of such dress were united in describing it as a violation of the 'ideal femininity' which God and custom had ordained but there was no such consensus among its radical supporters. Hydropaths, feminists and free-lovers who wore the dress did so because they believed that a healthy and convenient costume was the precondition of woman's 'perfection', yet they could not agree on the form that this 'perfection' was to take, let alone its appropriate dress style. Was the new woman to be a domestic reformer, a social philanthropist, a feminist activist or a sex radical? No doubt, some trouser wearers believed that woman, once rationally clothed, was to be all of these things but there were many more who, holding a more limited view of woman's 'proper sphere', could not endorse this idea. The history of trousered dress reform was not simply a contest between 'conservatives' and 'radicals' because radicals themselves were debating not only the meaning of trousers, but also the meaning of femininity and the female body. Just as in 1851, hydropathic dress reformers distanced themselves from feminist bloomers; by 1853 both groups asserted their differences from trouser-wearing free-lovers in the hope that the appeal of trousered dress could be

sufficiently tempered and 'sanitised' for public consumption. Leading feminists soon gave up this attempt, and though hydropaths who advocated bifurcation struggled on for several years, creating an independent Dress Reform Association in 1856, they too eventually became disheartened.[32] There was no simple equation to be made between trousered dress and radical femininity, and, as Cady Stanton had come to suspect, a reform in women's dress would have to wait for a redefinition of other aspects of women's lives, and not vice versa.

NOTES

1 Horace Mann, *A Few Thoughts on the Powers and Duties of Woman* (Syracuse: Hall, Mills & Co., 1853), p. 15. It is interesting to note that at this time, and later during the Civil War, petticoats were sent to men who were judged weak and cowardly. Amelia Bloomer saw this as a highly misogynistic practice, contending that any man who dispatched a petticoat, as 'the most fitting badge of cowardice, of meaness, of treachery, of weakness, of littleness of soul', dishonoured his mother; any woman who did so dishonoured herself'. D. C. Bloomer, *Life and Writings of Amelia Bloomer* (New York: Schocken Books, 1985), p. 260.

2 Theodosia Gilbert, 'An eyesore', *Water Cure Journal*, vol. 10 (1851), p. 117.

3 *Ibid.*

4 Theodore Stanton and Harriet Blatch (eds.), *Elizabeth Cady Stanton, as Revealed in her Letters, Diary, and Reminiscences* (New York: Harper, 1922; reprinted New York: Arno Press, 1969), p. 19. Letter from Elizabeth Cady Stanton to George Cooper, editor of the Rochester *National Reformer*, Seneca Falls, September 14 1848.

5 Weber did not attend the convention. Her views were conveyed by letter, quoted in full in S. B. Anthony, E. C. Stanton and M. J. Gage (eds.), *History of Woman Suffrage* (New York: Fowler and Wells, 1881), pp. 822–3.

6 Elizabeth Cady Stanton, 'The convention', *The Lily* (June 1850), p. 46.

7 Amelia Bloomer, 'The new costume', *The Lily* (May 1851), p. 38.

8 'Turkish costume', *Harper's New Monthly Magazine*, 14 (July 1851), p. 288.

9 For example, the *New York Daily Tribune* of June 12 1851 reprinted pro-bloomer extracts from the newspapers of thirteen states.

10 *Syracuse Journal* (May 21 1851).

11 *New York Daily Tribune* (July 18 1851), p. 7.

12 'The new or proposed new costume', *Godey's Ladys Book* (September 1851), p. 189.

13 *New York Herald* (May 21 1851).

14 The majority of Leech's bloomer cartoons, which are too numerous to list, appeared in *Punch*, vol. XXI (July to December 1851). Many of these images circulated in America in *Harper's New Monthly Magazine*.

15 For an account of the difficulties faced by female lecturers, see Lillian O'Connor, *Pioneer Women Orators* (New York: Columbia University Press, 1954).

16 Frances Dana Gage (writing as 'Aunt Fanny'), *The Lily* (February 1852), p. 14.

17 'The last vagary of the Greeley clique – the women, their rights and their champions', *New York Daily Herald* (September 7 1853), quoted in Anthony, Stanton and Gage, *Woman Suffrage*, p. 556.

18 *The Boston Transcript* (June 13 1851), quoted in P. Fatout, 'Amelia Bloomer and Bloomerism', *New York Historical Society Quarterly*, 36 (4) (October 1952), p. 369.

19 Amelia Bloomer, 'Male Bloomers', quoted in D. C. Bloomer, *Amelia Bloomer*, pp. 163–5 and 'Stanton is not acting like a man', *The Lily* (June 1852), p. 55.

20 The exchange of letters between Stanton, Anthony and Stone is referred to at length in Ida Harper, *The Life and Work of Susan B. Anthony*, vol. I (New York: Anthony Hollenbeck Press, 1899), pp. 115–16, and in A. C. Blackwell, *Lucy Stone: Pioneer Woman Suffragist* (Boston: Little, Brown, 1930), pp. 106–12.

21 Even Bloomer soon abandoned trousers. In 1855 she moved to Council Bluffs, Iowa, where she claimed that high winds made the short skirt of her trousered dress unmanageable. She also wrote to Charlotte Joy, a leading hydropath, that bloomer dress was drawing attention from debates about education, employment, labour and suffrage, and that with feminists it had been 'but an incident'. D. C. Bloomer, *Amelia Bloomer*, p. xii.

22 For example, this claim was made by Lydia Hasbrouk, *The Sibyl* (January 1 1857), p. 100.

23 Letter from Gerrit Smith to Elizabeth Cady Stanton (December 1 1855), quoted in full in Anthony, Stanton and Gage, *Woman Suffrage*, p. 838. This letter and responses to it were published in a number of reform periodicals. For a discussion of this exchange, see Dale Spender, *Women of Ideas* (London: ARK Books, 1983), pp. 246–57.

24 'Physical exercise', *Water Cure Journal*, vol. 8 (1849), p. 122, 'Women's dress', vol. 8 (1849), p. 186 and 'The female dress', vol. 9 (1850), p. 28.

25 See, for example, review of Mrs Hugo Reid's 'Woman, her education and influence', *Water Cure Journal*, vol. 14 (1852), p. 126. The editors of the journal disagreed with Reid on 'the width of Women's Rights', asserting that this did not include the right to vote. In early 1856, they also refused to endorse a poem which described a young woman, dressed in snow-white bloomers and carrying a banner proclaiming 'Woman's Rights', who would not rest despite being warned that she would have to sacrifice herself to serve the state. *Water Cure Journal*, vol. 21 (1856), p. 42.

26 Rachel Gleason, *Water Cure Journal*, vol. 11 (May 1851), p. 151.

27 Mary B. Williams, 'The Bloomer and Weber dresses: a glance at their respective merits and advantages', *Water Cure Journal*, vol. 12 (August 1851), p. 33.

28 *Water Cure Journal*, vol. 12 (December 1851), p. 135.

29 'The Hungarian Bloomer', *Water Cure Journal*, vol. 12 (October 1851).

30 Isabella Bird, a noted English traveller, wrote of her American tour of 1854 that 'Bloomerism is happily defunct in the States'. *The Englishwoman in America*, first published 1856 (Wisconsin: University of Wisconsin Press, 1966), p. 152.

31 Charles Wilkin Webber, *Spiritual Vampirism: The History of Etherial Softdown and her Friends of the New Light* (Philadelphia: Lippincott, Grambo and Co., 1853). The identification of bloomerism with free love mobilised fears that trouser wearers were encouraging illegitimacy and therefore undermining the family unit as the moral bedrock of the nation. Although this seems to conflict with the established stereotype of trouser wearers as 'masculine' women, whose lack of maternalism might depopulate America, both were definitions of 'unnatural' women, against which the moral norm could be judged.

32 The Dress Reform Association was formed on the second day of the Glen Haven Dress Reform Convention in February 1856. In her recruitment speech, Dr Harriet Austin stated that in advocating reform in dress for women, 'our object is not to advocate for her positions of singularity, eccentricity, immodesty, or to get her out of her "appropriate sphere"'. *Water Cure Journal*, vol. 21 (1856), p. 81.

The suit: a common bond or defeated purpose?

SUIT. This is still the basis of a man's costume. It has been so for over one hundred years and has evolved itself rather than been designed deliberately. As such it must be respected. It is the most comfortable costume in which a man can conduct the life which modern conditions make for him. It is a second skin in which he has placed pockets.[1]

THE Business Suit is firmly lodged within a gender discourse and this chapter debates the signification of the garment as it negotiates ideas of identity. The Suit is an apparatus of the public sphere. It is about hierarchy and status, and a garment for which the perceived message is more important than the details of style. Loosely defined as a 'set of co-ordinates', it conforms to a system of garment types – a jacket, trousers or skirt, and a waistcoat (optional); an alternative description is 'formula dressing'. The Suit defines a situation and plays a part in institutional and cultural communication systems by conveying parameters of meaning.

It will be convenient to label as 'front' that part of the individual's performance which regularly functions in a general and fixed situation . . . Front, then is the expressive equipment of a standard kind.[2]

In this context the Suit is the 'equipment' and, as such, transcends sex and gender yet shifts between them. The Suit presents an image which purposefully deinvests the wearer of 'the personal' in order to issue a statement of competence and efficiency. It is an example of 'the inscribed surface of events',[3] where clothing is the externalised landscape of the terrain of gender. Perhaps its primary concern as an object is its association with roles and in particular a male and masculine culture within which all genders may operate and, within that, the world of work. It reflects gender and deflects sexuality as well as constructing the masculine and deconstructing

femininity. The degree to which these relationships exist depends on the co-ordination and style of garment, and the specificity of the circumstances. In general, a suit which consists of a skirt and lapel-less jacket with a blouse has a greater element of what is construed as feminine than a trousered suit with a shirt and tie. The lesser the degree of female sexuality, i.e. the more the Suit lacks perceived sexual meaning, the greater the extent to which it conveys 'importance'.

The history of the Suit is inextricably entwined with the history and processes of patriarchy.[4] It cannot disengage itself from the masculine mythology and therefore it is a garment of ritual, its wearers choosing to sustain a social order rather than dislodge it. It provides a haven for genders who wish to control the level of personal expression and pays homage to the subjugation of the self, that is, 'the separateness of self from the other'.[5] The idea that a garment distances itself in terms of meaning, from the person themselves, often occurs when a sartorial system has set or fixed meanings. J. B. Priestley fictionalises this in his 1945 novel *Three Men in New Suits*:

> Then it was all different. Three men in new suits came in. The suits were blue, grey and brown; but were alike in being severely, even skimpily, cut, and in being new. The young men who wore them and wore them newly too – were not alike, for one was tallish, fair, good looking, another was of similar height but dark and beaky, and the third was burly and battered; yet there was a distinct likeness between them, as if all three had come from the same place and had been doing the same things there. And they brought with them a sharpened and hard masculinity.[6]

In this quotation, a similar image is made distinct from the physical differences of the men. The crucial aspect is the way in which the garment type creates a 'united front' which alludes to notions of maleness.

Historically the Suit is a male clothing form and therefore it can be equated with masculinity. This is the point at which gender and identity are interlinked and clothing 'positions' this discourse. This, not surprisingly, ensures complexities and contradictions when a garment such as the Suit is transferred into a female sartorial system. Is this cross-dressing? J. Wheelwright, in *Amazons and Military Maids*, comments,

> Cross-dressing for women often remained a process of imitation rather than a self-conscious claiming of the social privileges given to men.[7]

In my opinion, the female Suit goes beyond imitation as, from the beginning of women wearing suits, it was a conscious abduction of a garment primar-

ily to achieve, or at least aspire to, the privileges of men in the public sphere. This raises the question as to the nature of the debate when, even though the object is the same or similar, the histories are so different. Perhaps it focuses on the relation between emulation and mimicry. In its mimicry the Suit perpetuates 'the masculine' to differing degrees depending on how 'male' the Suit is, that is, whether it includes a skirt, a blouse or shirt etc. The greater the level of emulation (the more male in style), the more the notion of femaleness is marginalised. Except that in some situations, the level to which cross-dressing (rather than adaptation) occurs can be seen as *more*, rather than less, challenging to male culture. For example, a woman wearing a man's suit is sometimes regarded as a radical feminist. However, the fact that women have adopted *and* adapted the Suit does not make for parity or equality with men. The 'female' version may convey a 'soft' or conservative message. That is, visual similarity is meaningless if the purpose of the wearing of the garment is not only communicated but acted upon. But perhaps there is a level of resolution within this sartorial communication system. Women wearing suits are a mirror image of their male colleagues, and as such pay homage to man-ness. The suited woman is not signalling equality but *symbolising* her aspirations. The difference between a sign and a symbol is vitally important to this debate. The image may be similar, but the female version of the managerial suit is the colonisation of male form. The act of piracy is enough to establish a politicised sub-text. However, it still continues to be an affirmation of male power which can only then align itself to 'making female' as peripheral. In general, the woman's suit is plagiarised masculinity in an attempt to normalise and/or assimilate women in an often male-dominated workplace. It provides an acceptable façade within a societal code of recognition.

It is a frontier which does not display vulnerability and women often use it as a refuge of ideological form. The Managerial Suit is so established as a format that it has allowed for parodies, particularly in female culture. For example, the Chanel Suit of the 1950s cross-referenced itself to a male military history. Parody or not, the Suit continues to be a significant form because its meaning 'works'. Its function as a communicator is summed up by Plummer in a discussion on identity: 'it may control, restrict and inhibit but simultaneously offer comfort, security and assuredness'.[8] P. Caplan further informs us how a reliable system operates:

> A sense of identity is essential for the establishment of relationships . . . it is . . . a necessary means of weaving our way through a hazard strewn world and a complex set of social relations.[9]

If we see the Suit as creating an identity, albeit a professional one, then the wearing of it in appropriate places *eases* the communication between genders by allowing them to operate on a similar plane. The Suit is less an object of resistance than an object of empathy. Wearers resemble each other visually – man to man, female to male – and in the attempt to integrate, mirroring psychologically ingratiates. It organises not only visually but also socially and, as such, could be described as an item of environmental design which, similarly to architecture, informs human behaviour. In *Body Invaders* (1988), J. Emberley comments:

> the fashion apparatus holds the subject within a spectrum of choices which close at the extreme ends of total freedom on the one hand, and absolute control on the other . . .[10]

There are many ways in which control is an important aspect of the Suit and Suit wearing. An obvious example is the uniformity of its components. This has great significance when one evaluates examples such as the police uniform (British) or the 'Mao Outfit' of the Cultural Revolution (Chinese). Both are governmentally-determined versions of the Suit which are metaphors for control of the population. These aspects of control are where the notion of power and the Suit collide. The Suit invests the body with authority and, as a patriarchal product which has been translated into matriarchy, it is an object which creates a dialogue within and between genders.

> Closely related to the ideas of embodiment, of course, are ideas of specificity and difference. For women at work, especially women who want to be taken seriously for their skills and career potential, it is a continual problem to know when to hide their difference from men and when to assert it.[11]

For women then, the Suit plays a complex and sophisticated role. Proliferation of suit wearing in particular professions can represent solidarity and can delineate rank and gender; but does it denote power? John Molloy in *Dress for Success* calls Suits 'the central power garment' on the basis that they are 'positive authority symbols, worn by the upper middle class'.[12] Yet Cynthia Cockburn comments that work itself 'is a daily reminder of the working man's relative powerlessness in the face of capital'.[13] Is the Suit an external representation of power*lessness* with the aspiration, rather than the ability, to control? As the Krokers say, 'subordinations of the body to the apparatus of power are multiple'.[14] Certainly uniformity of imagery can create a unity of identity, thus the 'power' of the Suit is in its coherence. At the same time the unification allows for individual anonymity, therefore one language

of authority is interrelated to another. This can be undermined by the extent
to which wearers participate in the sartorial coding and by whom it is worn.
The building society cashier and the air steward are both examples of the Suit
utilised to suggest servility. (But is it to the customer or the corporate struc-
ture?!) Michel Foucault states,

> Discourse transmits and produces power; it reinforces it, but also undermines
> and exposes it, renders it fragile and makes it possible to thwart it.[15]

If, as mentioned earlier, you designate the Suit as 'an inscribed surface'
of denotation and connotation, then the narrative (or discourse) has a
number of variants. One of the common ingredients of meaning in all suits
is its allegiance to the idea of slavery. It is literally a 'slave to convention', i.e.
an appropriate dress code for particular job types; an acknowledgement of a
hierarchical structure; a reflection of acceptable clothing behaviour forms in
masculine and feminine cultures [38]. This element renders the Suit as
passive, a feature which defies its significance as an icon of dominance. The
paradox is (if I apply Foucault's theory) that collective visual images, that is,
standardisation, assumes impenetrable authority which should be easily sub-
verted. The Suit has all kinds of links with the ideology of power. Another
paradox is how the level of power/authority is conveyed through its character-
istics, i.e. shape, colour, etc.

The Suit is a model of streamlined form and harmony of style in which
decoration is suppressed, although, to a degree, items such as the tie,
belt, braces and shirt take on that role. Restraint in decoration and style
are usually equated with etiquette and situational pressure in which
colour coding also plays a part. For example, the dark funeral suit signals
a sombre and respectful role, while the innocuous grey suit has been
appropriated by the middle managerial strata in order to signal a non-
confrontational approach. The tailored structure of the Suit is also impor-
tant because it creates the style of garment. A double-breasted suit is an
example where style can create a more impressive image simply by pre-
senting a larger self:

> clothing, by adding to the apparent size of the body in one way or another, gives
> us an increased sense of power, a sense of extension of our body self – ultimately
> by enabling us to fill more space.[16]

The sobriety of the Suit has come to signal control which indicates that
ostentation no longer wields a power of rank, only of wealth.[17] Therefore the
tailored suit conforms to the wider set of values and aspirations of a capital-
ist society.

38] The suit and tie typify the male-dominated city landscape. Women are more flexible in their sartorial approach

> In most industrialised societies, men's clothing has become standardised more quickly and more completely than women's . . . This type of difference has probably occurred as men have different relationships to the activities spawned by the industrial society than have women.[18]

The Suit is an instantly recognisable symbol of the non-personal. It provides clues as to the designation of the wearer, not who you are but what you do. Uniforms 'set' this system more deliberately than any other garment type. They therefore allow for the greatest deception because of this 'stationary' or formatted order. If semiotically 'the body is . . . a floating sign'[19] then the Suit binds that flotation in a 'bound' sign. It locates its meaning within fixed

but flexible parameters. The wearing of suits by women has added to the debate on representation of maleness:

> the continuing confusions and divisions among and between feminists and women of all kinds around issues of sexuality and its relationship to male power give considerable concern to all those committed to the cause of women's liberation.[20]

One of the early sartorial images of feminism was the wearing of trousers which could be construed as equating the object, the male trouser, with the meaning of liberty.[21] The controversy which followed centred on the suppression of femininity, hence the tailored jacket and skirt (rather than trousers) were adopted by the Suffragettes as a way of deflecting such criticism but gaining access to a male structure of power. This partial emulation validated the Suit, galvanised the work ethic and provided (and still provides) a common bond. It is what Foucault calls 'the deployment of alliance'.[22] The Suit therefore is an object which allies itself with masculinity, even when worn by women. Cynthia Cockburn clarifies the gender issue:

> Gender, furthermore, is a relation, and we must suppose that, since masculinity and femininity only make sense in some kind of complementarity to each other, masculinity is under pressure from its other half.[23]

That means the wearing of a suit by a woman is not simply complementary but that it can set up a challenging relationship to its male counterparts. It can achieve this by being both similar and different. Televised film from the House of Commons provides a good example of this. The suits of the female Members of Parliament are conspicuous for their use of colour (rather than the orthodox grey and blue of their male colleagues) and the variety of form; signs usually read as 'feminine' but which can also be seen as 'less' and 'marginal'. This raises the question as to whether the wearing of a close emulation of a suit construed as 'male' could assert pressure for equality. My earlier argument suggests not, because the Suit as an object and sign can only move within the realm of effigy.

Therefore it is a defeated purpose. If clothing can and does engage in a political discourse then initially the problem of appropriate clothing for women in the business arena appears to be within female dress codes. The Suit appears to operate as an object with a central position around which femininity and masculinity shift and adapt. The crucial element is the degree to which it 'works' as a communicator. This has led women to utilise more surreptitious methods than simply colour or style differences. One woman in senior management I spoke to explained that she wore sharp tailored suits

with long skirts to boardroom meetings. As chairperson she chose when to cross her legs in order to reveal the split in her skirt and her stocking-clad legs beneath. She was convinced that this gesture allowed her to gain a better response from her mainly male colleagues who needed to register women as sexual. While seemingly lacking a feminist politics, in this instance, communication was more important in order to gain consensus and support.

The Suit is undoubtedly an important object in the discourses of representation of power and gender which simultaneously localises the position of sexuality and social relations. Perhaps it has maintained a static position in terms of garment type because the sartorial and cultural system within which it works remains fixed.[24] A greater variety of stylistic options exist in female sartorial culture than in its male counterpart and, in its difference within femaleness, the Suit could be said to be gender-sensitive.[25] As a body enclosure it is an indicator of gender as well as creating a visual landscape of what gender looks like. The problem is not the object itself but how it is used. However, can perceptions be changed if the object remains the same? Does the responsibility for the conveyed message lie with the wearer if, as I argue in this essay, the feminised suit does not alter perceptions by gender difference, only re-enact them? Ultimately the Suit *upholds* the balance of power as being male. Gender is a socially organising principle; the Suit elaborates upon this within a set of 'given' forms. Its transference across the male/female terrain does not engender it with enough *new* meaning to assert anything other than man-ness.

NOTES

1 H. Amies, *ABC of Men's Fashion* (London: George Newnes Ltd, 1964), p. 105.
2 E. Goffman, *The Presentation of Self in Everyday Life* (London: Penguin, 1969), p. 62.
3 A. and M. Kroker (eds.), *Body Invaders: Sexuality and the Post Modern Condition* (London: Macmillan, 1988), p. 45.
4 See D. DeMarly, *Fashions for Men* (London: Batsford, 1985), and P. Byrde, *The Male Image* (London: Batsford, 1979).
5 J. Rutherford, *Men's Silence: Predicaments in Masculinity* (London: Routledge and Kegan Paul, 1992), p. 71.
6 J. B. Priestley, *Three Men in New Suits* (London: Allison and Busby, 1945), p. 8.
7 J. Wheelwright, *Amazons and Military Maids* (London: Pandora, 1990), p. 11.
8 Cited in S. Ortner and M. Whitehead (eds.), *Sexual Meaning: The Cultural Construction of Gender and Sexuality* (Cambridge: Cambridge University Press, 1981), p. 29.
9 P. Caplan (ed.), *The Cultural Construction of Sexuality* (London: Tavistock, 1987), p. 49.
10 J. Emberley, 'The fashion apparatus and the deconstruction of post modern subjectivity', in Kroker and Kroker, *Body Invaders*, p. 48.

11 C. Cockburn, *In the Way of Women: Men's Resistance to Sex Equality in Organizations* (London: Macmillan, 1991), pp. 221–2.

12 J. Molloy, *Dress for Success* (New York: Warner, 1976).

13 C. Cockburn, *Brothers: Male Dominance and Technological Change* (London: Pluto, 1983).

14 Kroker and Kroker, *Body Invaders*, p. 21.

15 M. Foucault, *The History of Sexuality*, vol. 1 (London: Allen Lane, 1979).

16 J. C. Flugel, *The Psychology of Clothes* (London: Hogarth, 1966).

17 This shift began in the eighteenth century and was completed by the end of the nineteenth century.

18 P. Cunnington and C. Lucas, *Occupational Costume in England* (London: A. and C. Black Ltd, 1967).

19 M. E. Roach and J. B. Eicher, *The Visible Self: Perspectives on Dress* (New York: Prentice Hall, 1973), p. 179.

20 Caplan, *Cultural Construction*, p. 21.

21 See E. Wilson, *Adorned in Dreams: Fashion and Modernity* (London: Virago, 1995), S. M. Newton *Health, Art and Reason* (London: John Murray, 1974) and the article by Kate Luck in this anthology.

22 Foucault, *Sexuality*, p. 187

23 Cockburn, *In the Way of Women*, pp. 159–60.

24 Λ. Forty, *Objects of Desire: Design and Society, 1750–1980* (London: Thames & Hudson, 1986). Note: Forty attempts a typology of form within which the Suit could be termed 'archaic'.

25 R. Barnes and J. Eicher (eds.), *Dress and Gender: Making and Meaning* (New York: Berg, 1992). See Chapter 1 for useful discussion on 'Definition and classification of dress: implications for analysis of gender roles'.

The tie: presence and absence

Give me a wild tie, brother
One with a lot of sins!
A tie that will blaze
In a hectic gaze
Down where the vest begins . . .[1]

THE tie, as male-specific accessory, is approached historically in this essay, which takes as its reference the conventional presence of the tie in male sartorial dress up to the mid-1980s and its fashionable absence in contemporary 1990s menswear. This article also explores the absence and presence of the tie in female dress and its relation to sexual proclivities. The assumed 'meaning' of the tie as male accessory has shifted in the last fifteen years. In so far as it is identified with the 'establishment', it is now simultaneously represented by its presence and its absence.

The tie has, imbued in its history, aspects of a design history few other simple accessories can claim. It contains a class context and/or status in its wearing and represents aspects of subversion in the way and with what it is worn. One of the most prevailing forms of male accessory, it can denote both conventional and non-conformist dressing (as in Oscar Wilde's flamboyant wearing of a neck scarf compared with the Edwardian city gent's wearing of the straight striped tie). It also signifies gender coding; the tie has an altered meaning when worn by women as a fashion and/or indicator of sexual preference, and is an article associated with fetishistic practice, forming part of the 'schoolgirl' uniform represented in pornographic magazines and mail order catalogues.

The military origins of the tie which developed from 'a metal collar, lined with linen, worn by military men in ancient times',[2] situates it within the male

domain. The metal collar was superseded by the more comfortable stock, a piece of fabric worn in the mid-eighteenth century. This, in turn, was replaced by the cravat – a stock with ends which fell down the chest, as did the tie later. These neckpieces were all male-specific, deriving from functional neck protection, but developing to become largely decorative. In about the early nineteenth century, the cravat was superseded by 'le papillon', or bow-tie, which was the only male neckpiece originally to be worn by both men and women: 'Le papillon . . . il reste toujours ambivalent, autant féminin que masculin.'[3]

In the 1860s–1880s the tie, as we know it, developed from the elongated ends of the cravat and was tied in the 'four-in-hand' knot until the present day.[4] According to one scholarly history, the tie was equated with the subverting of an icon of establishment values – the boater – when, in 1880, young men at an Oxford University rowing club divested their boaters of the brim ribbons and tied them 'four-in-hand at their necks'.[5] By the late nineteenth century, a variety of ties existed. The looser neck-tie, highly coloured and soft around the neck, worn by aesthetes such as Oscar Wilde,[6] coexisted with the bow-tie, as worn by Aubrey Beardsley.[7] Both denoted stylish avant-gardism and were the mark of the artist. The square-ended four-in-one tie was worn by some women as well as men of the establishment, though not to the same degree. For certain women in the early Edwardian period, the wearing of a tie denoted the more acceptable aspects of female 'sensible' dress or 'cycle attire',[8] and less acceptable aspects of female sexuality when worn alongside male suits by 'fringe' women, such as Radcliffe Hall. In this instance the tie, as part of a male sartorial ensemble, denoted a subversion of the notion of 'acceptance' in so far as she and a few other lesbian women deliberately and provocatively donned male garb, as did the heroine in her book *The Well of Loneliness* (1928): 'Steven's apparel almost *is* her sexuality, and her sexual attraction is mediated through her masculine garb.'[9]

From the mid-nineteenth century until the present day, in Britain and throughout most parts of the world, the tie has remained sartorially masculine, and connected, in its sobriety, with establishment values. Yet, even as male attire, it has had its ebullient moments when the formality of the traditional tie subverted itself – particularly during the 1940s and early 1950s in the USA, and during the punk era in London, *c.* 1976–81. America, in the 1940s and 1950s, produced exuberant, naughty silk ties, some of which were reproduced in 1976 by Vivienne Westwood and Malcolm McLaren in their shop *Seditionaries* but, significantly, with over-prints of bondage on the naked women of the original design. Punk ties were not restricted to reprints and

adaptations of older ties, however, and also subverted the very form of ties which now came in leather, in smaller sizes, with zips down the front, and with zebra-stripe prints. These ties were worn by both men and women in the egalitarian punk era, when masculinity and femininity outmatched each other as authenticators of innovative androgynous styles, be it through the wearing of accessories or whole outfits.[10]

Although the tie has at times been worn by both men and women, for the most part in the twentieth century it has been associated with 'professional-ism' and the male establishment [see 38, p. 158]. Furthermore, the absence and presence of a tie for men has been determined by class, in relation to occupation and occasion. In Britain in the 1930s, for example, 'blue-collar' jobs literally meant no white collar and certainly no tie, which was kept for 'best' – for dances, weddings and funerals.

Apart from the rather obvious political associations and affiliations evoked by the red ties worn by some Communist Party members and other left-wing activists from the 1930s, little has been written about the use of the tie as political and class symbol, although, for me, one of the most poignant examples occurred in 1986. The lorry drivers who drove newspapers out of Wapping during the famous newspaper printers' lock-out by News International, wore ties in the act of strike-breaking, and the wearing of the tie became the symbolic dividing line between the working-class defender of establishment values and 'traitor' to trade unionism pitted against the working-class trade unionist striker. (In contrast, at the same time, was the fashionable lack of ties amongst the designer élite, who buttoned up their shirts or wore collars open, flat against the neckline [see 39] – a different ball-game altogether.) At the level of world politics, few have discarded the tie. Rarely have world leaders expressed anything but conventionality through the wearing of that tie, despite the variety of textures, size and shape. Statesmen have, for the most part, religiously adhered to the straight 'pointy' tie, subdued in colour, in an attempt to display no more, no less than 'normal' heterosexual, male, serious, disciplined restraint.

The world of ties does not exclude women, whether worn by schoolgirls or Madonna, and in autumn 1993 ties were seen on the catwalks of Milan, Paris, London and New York, as well as in student fashion shows, all donned by women. This 'fashionable' female tie-wearing, as with the 1970s 'Annie Hall' image (derived from Woody Allen's film of that name, in which the tie was worn loosely with an open neck by the actress Diane Keaton), did not seriously challenge existing tie stereotypes. The taking on by women of a feminised 'boy' role, through the wearing of waistcoats, ties and other male

39] The absence of the tie 40] The absence of the man

accessories, which has happened at various moments in the last hundred
years or so, does not necessarily represent a step towards female emancipa-
tion. The 'gamin' female has frequently appeared but remains the 'Dickensian
urchin', to be saved from the gutter. Women who attain real power in the
world do not wear ties.

The tie has not been well served by historians, and needs to be reclaimed
in terms of contemporary discourses. James Laver and J. C. Flugel – the
grand old men of fashion design history, writing in 1945 and 1966 respectively
– have considered the tie, and most other items of dress, both as part of an
empirical chronology of fashion history and as a psychologistic signifier of
character and gender identity. Nowhere is this more obvious than in their
pronouncements that the tie, as establishment icon, draws the attention to,
and reminds the spectator and wearer of, the phallus in its downward direc-
tion towards the male genitals. These assertions do not consider the 'look'
and 'nature' of the article they are talking about and raise a host of questions,
including whether the tie with 'cut-off' end represents a man with 'cut-off'

phallus, and whether the limpness of the fabrics suggests an inert phallus and an equally powerless male establishment.

In *The Fashioned Self* (1991) Joanne Finkelstein quotes these male 'authorities' at length and comments, in a chapter devoted to 'Signs of the modern self':

> Freud confidently described the necktie, in an essay on fetishism, as a strong symbol of the phallus. Flugel continued the association by asserting all clothes aroused sexual interest and some, in particular, were signposts to the sexual organs; clothing originated largely through the desire to enhance the sexual attractiveness of the wearer and to draw attention to the genital organs of the body.[11]

Finkelstein analyses the contemporary tie and offers a psychoanalytic analysis as limited as that of Laver or Flugel:

> The conventional long tie runs from the prominent male larynx, along the torso and terminates as a signal to the male sex organ, particularly when the man is seated. In this capacity the tie links together the physical symbols of virility, and as such can be used as a psychoanalytic proboscis that demarcates a line from manhood to manliness . . .

and goes on to note:

> The point of wearing a tie is its value as a status symbol . . . The more status it can appear to express, the greater the value.[12]

My problem with such an analysis is that the complexities of history, taste, class, gender and sexuality are subjected to one reductionist interpretation. There is no place for an aesthetic or otherwise symbolic approach to the wearing of a tie or the matching of the tie with an outfit. The choice of tie as purchase or gift is notoriously complex, and the choice of a particular one for a particular occasion even more so. For some men, their collection of ties represents a personalised and aesthetic extension of self, not a 'status' or quasi-sexual extension of a male self, as suggested by Finkelstein [40]; for others a collection of 'gifts'.

Finkelstein, within a postmodernist reinterpretation of the wearing of ties, has both accepted a simplistic psychologistic analysis and misinterpreted the variety of simultaneously existing meanings of the tie, ones which vary according to an ever-changing masculine self-identity in terms of late-twentieth-century ambiguity in sartorial male dress. Finally, I find it less than helpful in explaining the development in the early 1980s, whereby the design-conscious male began to identify 'status' as the *absence* of the tie.

At the same time as the absence of the tie was sanctioned in design-

conscious circles, female 'power-dressing' connected economic status with padded shoulders; the extension of the torso apparently symbolising the inclusion in the mid-1980s, if only temporarily, of women in managerial positions, but, significantly, without tie. The tie may not have been used because it was regarded as too symbolic of establishment maleness. Instead, many women in the city wore a floppy neck bow with their skirted suits and padded shoulders, thus returning us to the original androgyny of the bow-tie. The tie, as part of fashionable female dressing, was ironically not to appear contemporaneously until the collections of autumn 1993, associating women with yet another version of the 'gamin' look, the uninitiated young boy as vulnerable and certainly not invested with 'status' or power.

A Freudian might argue that the tie as part of female sartorial dress becomes divested of 'power' when directed to female genitalia, and thus the absence of the phallus, implying that the wearing of a traditional tie by women emphasises their *lack*. It is at this point that psychologistic and/or economic interpretations become suspect. The coexisting meanings which reside in any one worn artefact at any one time shift according to the *manner* in which it is worn or assembled with other garments (i.e. the suit, shirt, collar). The *self* is aesthetically manifested in the selection of the items worn. Gender is re-established or subverted in relation to the wearing of a previously gender-specific garment; 'power' reasserted not merely with the wearing of the tie but also, according to the status of the man in his place of work and occupation (e.g. architects/designers), in its not being worn. The *absence* of the tie thus denotes the previous state of its *presence*.

In the last ten years, the suit without a tie has become increasingly common so far as the fashionable sartorial male image is concerned. Leading designers both male and female such as Armani, Gaultier, Vivienne Westwood, Rei Kawakuba and Issey Miyake rarely show men with ties. Ties are absent or have become part of a temporary fashionable womenswear, thus adding new connotations.

The various subversions of the conventional wearing of the tie *presumes* the desire not to be identified with conventional male dress codes – with the status quo. The *not* wearing of the tie symbolises this. Thus, in the city, males wear ties, females do not; in boys' schools with school uniforms, both pupils and masters wear ties; but in girls' schools, pupils wear ties and mistresses do not. Sartorial male dress is assumed for both victims and controllers of male educational discipline and yet, when the gender coding is reversed, the wearing of the tie signifies disempowerment by being worn only by the female pupils of a female educational establishment. Thus, as the one interpretation

ST. TRINIAN'S DRESS

For naughty schoolgirls who deserve to have their bottom spanked. This full quality outfit made to traditional design should not be confused with cheap imitation . Comes with tie side matching belt.

Comes free with 2 pairs of schoolgirl knickers in navy blue.

£45.00

SALE PRICE £ 34.99

41] The presence of the tie

of meaning in a garment, the tie's signification as phallus and virility and/or power is again questionable.

When the tie is worn as part of a pornographic assemblage connoting a 'naughty' schoolgirl [see **41**], the fully grown woman takes on the identity of the young 'victim' of punishment. The tie is part of a 'schoolgirl' assemblage, a stereotype of male fantasy, which includes such fetishised garments as gym slips, stockings and suspender belts, and relates to the taboo area of sex with young girls. The tie indicates a 'schoolgirl' (as identifiable in the British education system), just as, without the accompanying text describing her as 'naughty', it indicates she requires punishment. The reader is aware of the rules and that the consequence of being 'naughty' (in nineteenth-century educational terms) is smacking. The wearing of the tie, in this context, disempowers the female wearer for the ends of absent (usually heterosexual male) satisfaction. But it may not be just a simple identification with the

female 'self' as being 'disempowered', because it is implied that she has 'been naughty', taken action into her own hands and rebelled against authority. As Mandy Merck suggests in an article concerned with lesbian identity and the wearing of the suit:

> The suited bodies cannot be read symptomatically, as forensic evidence of some transgressive identification, nor as actual disguises. In short, these women look neither butch nor male . . .[13]

Within the wearing of any one item of clothing, within any one visual image, there may be a number of gender interpretations referring to the number of 'selves', both present and hidden, which reside in any one of us at any one time.

> Meanwhile, we negotiate the contradictions of 'identity politics' in an era which privileges subjective experience even as it declares the crisis of the subject.[14]

When the tie is worn as girl's school uniform, as part of transvestite sexual identity, it takes on yet another meaning. Now the male *as* female disempowered schoolgirl may or may not require punishment by an absent male observer (with or without tie), but it is not indicated in the text whether 'she' has been 'naughty'. The tie, worn here in relation to the gym slip, denotes the possibility of the male/female wearer as passive receiver of 'normal' educational hierarchical values. The apparent acceptance of her/his role implies a choice or desire to be seen wearing the signifiers (including the tie) of that particular identity within the image of the present. As stated, the previous 'schoolgirl' image can be read as indicating submission to the male heterosexual observer/punisher, or at least a lack of equality in the relationship – but the issue becomes even more complicated if one considers the same image *vis-à-vis* a variety of female viewers (but that is a topic for a different paper). Further, when Madonna wears a tie in her film *Erotica*, it is as accessory to her *dominatrix* role where, through choice, the female wearer subverts both the 'conventional' male tie, with associations of status and gender power, *and* the male-created pornographic image of the 'victim' schoolgirl tie.

Through focusing on a particular garment of clothing, the analysis itself is in danger of becoming 'fetishistic', in the sense that 'the instinct became fastened to an object in accordance with an individual's historical adherence and biological inadequacy'.[15] But it is done with a desire to acknowledge the multifarious absent and present meanings within any one identification of a garment with a particular person's image with which there is a preoccupation, rather than condemning, in this case 'the tie', to merely inglorious connotations of repressive establishment values. It is only by considering the

variety of worn and unworn contexts of any one item of clothing that a 'whole' analysis of clothes can be begun. Putting one new overriding interpretation on any one item of clothing is tantamount to Foucault's identification of the twentieth-century's obsession with 'sex' as the determining agent of life, after its previous censorship:

> Moreover, we need to consider the possibility that one day, perhaps in a different economy of bodies and pleasures, people will no longer quite understand how the ruses of sexuality, and the power that sustains its organisation, were able to subject us to that austere monarchy of sex . . .[16]

Thus the transvestite chooses to wear a tie and gym slip as indicator of a possibly absent 'femininity', a reversal of the wearing of the tie as indicator of establishment male values, and, unlike the 'naughty' schoolgirl, not beckoning, functionally, to (heterosexual male) action/punishment.

This is not to go along with some modern views which, as Jeffrey Weeks suggests, consider that 'desire is multifarious and multi-vocal and the criteria by which it has conventionally been organised and controlled are social, and prohibitive, then there is no way in which to judge the moral and the immoral, the permitted and the impossible'.[17] It is rather to suggest that sexual transgressions, as exemplified by visuals which make absurd taken-for-granted hierarchies within Western society (symbolised by the establishment tie), are, and have been throughout history, valuable in their contribution to our understanding of a variety of human personae.

There is, in the transvestite's apparel, an indication of the possible subversion of the élite, with their assumed 'power', who organise both pleasure and pain in others' lives. At the other end of the fashion trail lies *subversion* through usage of the tie. This takes a number of forms, which represent the undermining of establishment values through use and abuse of the tie as icon of authority. Schoolboys and girls, in Britain, have been known to tie their ties short and stubby, tuck them into the side of the shirt and fray them to disrupt the weft or the school logo. The garment conveys an alternative meaning to the wearer and the observer, who may be one and the same person (unlike the spectator of Fine Art). The tie has a function, even if that function is only its meaning and not its practical usage. This simple accessory presupposes a design history language that incorporates function as other than purely usage, and welcomes interpretations in terms of aesthetics and the opposition between the presence and absence of either the garment or the person.

NOTES

1 Quoted in Rod Dyer and Ron Spark, *Vintage Ties of the Forties and Early Fifties* (New York: Abbeville Press, 1987), p. 6.

2 Doriece Colle, *Collars, Stocks, Cravats, 1665–1900* (New York: White Lion Publishers, 1972), p. 8.

3 David Mosconi and Ricardo Villarosa, *Façons de nouer sa cravate* (Paris, 1985), p. 25

4 Dyer and Spark, *Vintage Ties*, p. 23. It is generally agreed that this knot came from 'a knot used by a coach driver to control the reins of a four horse team'.

5 Sarah Gibbings, *The Tie, Trends and Traditions* (London: Studio Editions, 1990), p. 80.

6 As illustrated in photographs by Napoléon Sorony of Oscar Wilde, January 1882. Richard Ellman, *Oscar Wilde* (London: Penguin Books, 1988), p. 237.

7 *Ibid.*, p. 407, illustration of Aubrey Beardsley by William Rotherstein.

8 Lou Taylor and Elizabeth Wilson, *Through the Looking Glass* (London: BBC Books, 1989), p. 54.

9 Elizabeth Wilson in *Hallucinations: Life in the Post Modern City*, quoted by Katrina Rolley in 'Love, desire and the pursuit of the whole', in Juliet Ash and Elizabeth Wilson (eds.), *Chic Thrills: A Fashion Reader* (London: Pandora, 1992), p. 38. For a more detailed discussion of lesbian sartorial dress see both the above-mentioned books.

10 These ties were to be seen at an exhibition in London titled 'Vive le punk', held at the Horse Hospital, Colonade, Bloomsbury, in February 1993.

11 Joanne Finkelstein, *The Fashioned Self* (Cambridge: Polity Press, 1991), p. 122.

12 *Ibid.*, pp. 121–2.

13 Mandy Merck, *Perversions* (London: Virago, 1993), p. 93.

14 *Ibid.*, p. 97.

15 Michel Foucault, *The History of Sexuality, Vol. 1, An Introduction* (London: Allen Lane, 1979), p. 154.

16 *Ibid.*, p. 159.

17 Jeffrey Weeks, *Sexuality and its Discontents: Meanings, Myths and Modern Sexualities* (London: Routledge, 1985), p. 175.

Jackets: engendering the object in *Desperately Seeking Susan*

IN popular discourse, image and female identity become conflated: a woman is what she wears.[1] Nowhere is this better illustrated than in the film *Desperately Seeking Susan*,[2] which highlights the confusion of identities surrounding the exchange of a jacket and other objects. Within the film, objects form the focal point of gendered identification, desire and exchange. These objects range from the overtly feminine, such as a pink tutu or Queen Nefertiti's earrings, to the more ambivalently gendered, such as Susan's jacket. Objects are used as vehicles of female empowerment and resistance. Spectacles, for example, are used for active looking and artefacts are exchanged subversively outside the commercial economy. The female protagonists – Susan/Madonna, and Roberta/Rosanna Arquette [42] – transform systems of exchange based on masculine discourse. Objects are mediators used to appropriate the masculine subject position, to recuperate and identify with the feminine subject and to enter into a fantasy which liberates the suppressed feminine sphere in a performative parody which, at times, challenges the notion of gender itself. In certain psychoanalytic and French feminist contexts the objects in question may be gendered as 'bi-sexual',[3] in that they retrieve the feminine subject from the 'in-between',[4] refusing to function within discourses of otherness. Through the exchange and use of material objects, femininity engages with a constant *'repérage en soi'*,[5] or relocation in self, and the film becomes, in the words of Hélène Cixous, 'a process of different subjects knowing one another anew, only from the living boundaries of the other: a multiple and inexhaustible course with millions of encounters and transformations of the same into the other and into the in-between from which woman takes her forms'.[6]

Cixous contends that femininity transforms itself constantly, not with reference to oppositional constructs of masculinity and femininity, but by taking its form from the overlap or 'in-between' of masculine and feminine

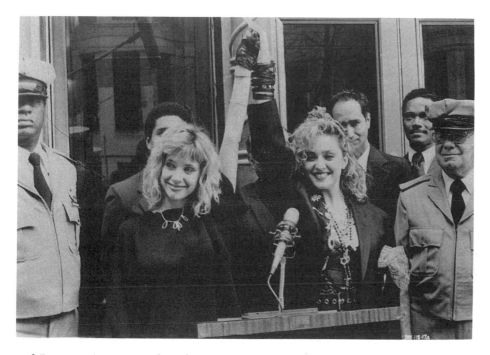

42] Rosanna Arquette and Madonna

identities. Luce Irigaray contends that the visual senses relate to the masculine while the feminine tends to relate to other senses, such as touch.[7] Drawing on ideas from feminist variants of psychoanalysis and French feminist theory, in particular from Cixous' 'The laugh of the Medusa', this article challenges Irigaray and aims to construct a visual theory of a feminised relation of things which genders the object and recuperates the feminine subject. The subject is not always masculine but you have to 'look at the Medusa straight on to see her' and not view her through oppositional constructs. Cixous states 'If woman has always functioned "within" the discourse of man . . . it is time for her to dislocate this "within" . . . and to invent for herself a language to get inside of',[8] and in my opinion *Desperately Seeking Susan* offers a form of *'écriture féminine'*.[9] Objects are used to create a visual language which constitutes a feminine discourse drawn from the 'in-between' of the masculine and the feminine, which dislocates the oppositional relationships of subject/object and masculine/feminine.

Cixous argues that women's active looking is central to the creation of a visual language which reclaims the feminine subject: 'You only have to look at the Medusa straight on to see her. And she isn't deadly. She's beautiful and

she's laughing.'[10] The feminine subject (Medusa) petrifies and then trans-
forms all systems of exchange based on (masculine) discourses which define
the feminine as 'other'.

Film spectatorship has been defined as an opposition of active (male)
subject and passive (female) object; a relationship, in part, reliant upon the
opposition of proximity and distance.[11] In *Desperately Seeking Susan*,
Roberta, a suburban housewife, follows the romance of Susan and Jim
through the newspaper personal columns in which Jim places advertisements
headed 'Desperately Seeking Susan'. In her 'desire to be desperate', Roberta
constructs a relationship with Susan reliant upon distance and confined
within the male spectatorial position.[12] Proximity and distance are themes
which are played out in an attempt to define woman as both subject and
object of desire. The desires and identifications of the feminine subject
(Roberta) and the feminine object (Susan) move the narrative forward.[13]
Material objects become central to narrative strategies and contribute to the
transformation of object to subject. In other words, it is through the acquisi-
tion of Susan's possessions that Roberta identifies with Susan and finally
becomes her.

In a scene at a party held by Roberta and her husband, Roberta gazes out
of a window at a bridge in the distance. The camera then cuts to a close-up
of Susan arriving on the same bridge the next day.[14] The bridge and the
window, non-gendered in themselves, become vehicles whereby Susan
becomes the object of Roberta's gaze. Potential fluidities within Roberta's
identity are symbolised by her reflections in the window;[15] within her
masculinised spectatorial position, Medusa/Roberta must be looked at
through a reflection. Roberta later uses a pay telescope to watch Susan with
Jim. The telescope confines Roberta within a voyeuristic mode of spectator-
ship, enabling her to view Susan from a distance and making Susan the object
of her *female* gaze, rather than of the male gaze.[16] Although Roberta (subject)
desires Susan (object), it is not a sexual desire, thus cancelling the more usual
relationship between subject and object of the gaze. Viewing devices, such as
the telescope and spectacles, gender the objects concerned in that they are
used to confound the masculine structure of the look and to appropriate the
gaze for feminine pleasure. By wearing dark glasses, Susan can view the
world without directly being looked at. The use of objects as mediators pre-
vents the process of looking from becoming one of exchange, thus dislocating
the structure of the male gaze.

'The woman who wears glasses constitutes one of the most intense visual
clichés of the cinema',[17] masculinising herself within the spectatorial

position, becoming an active bearer of the look. Usually represented as intel-
lectual, she looks, analyses and usurps the gaze, but on removing her spec-
tacles she recovers her femininity and transforms herself into spectacle.[18]
However, in *Desperately Seeking Susan*, this is reversed. Susan's friend, on
leaving the stage of The Magic Club, dressed in pink tutu and blonde wig,
removes the wig which signifies an over-determined femininity, thus detrans-
forming herself from being the spectacle of the male gaze, and puts on her
glasses, which associate her with masculinisation, thus reclaiming herself as
subject within the narrative. Susan, object of Roberta's gaze, also wears
(sun)glasses. If women in glasses can engage in active looking, women in dark
glasses can not only actively look, but also can resist being looked at. The use
of dark glasses within *Desperately Seeking Susan* parodies theories of gen-
dered looking and transforms the process of looking into an *exchange*
between subjects rather than a subject–object relation. Woman as active
looker not only petrifies masculine discourse, but also reclaims spectatorship
for the feminine sphere.

The initial location of Roberta within the masculine spectatorial position
evokes the metaphor of transvestism. The gaze is masculine, yet the surface
of the body expresses femininity.[19] Traditional boundaries of femininity are
challenged through the exchange, use and gendered interpretation of items
of clothing. Susan's jacket is *exchanged* by Susan for another desired object
(a pair of sequinned boots) and *purchased* by Roberta. For them the jacket
has an exchange value which is linked to personal desire. Object and female
identity become conflated; in acquiring Susan's jacket, Roberta hopes to
know Susan, indeed, to take on part of her or *become* her. By contrast, men
give the object its identity through their previous ownership of it; Susan
claims that the jacket belonged to Jimi Hendrix, and it is sold to Roberta as
having belonged to Elvis Presley.

Both women create their identity by use of an object which has been
gendered as masculine, but is appropriated by Susan who boldly challenges
more than the gendering of objects. This is emphasised by the casting of
Madonna, whose own image challenges existing constructions of femininity.
Other objects of male attire are appropriated elsewhere in the film. In return-
ing to the shop, Susan assertively appropriates (male) public space – the
street – whilst dressed for the private (female) sphere. Her apparel consists
of a highly gendered object, a shirt borrowed from Roberta's husband, and
underwear which surprises in its hybridity of the conventionally feminine
and the conventionally masculine. Andrea Weiss has defined female cross-
dressing as a woman transforming into a man whilst remaining a woman, and

appropriating male language and clothing to assert her power.[20] Through her use of clothing, Susan achieves the appropriation of power, not by rejecting dominant codes of femininity, but by subsuming masculinity within femininity. Roberta's acquisition of the jacket, which blurs the boundaries of femininity and masculinity, could be seen as resolving the conflict of her need for active (male) looking and her femininity and as marking a bolder femininity than she has hitherto inhabited. Roberta's desire for Susan evokes the metaphor of homosexuality within the discourses of heterosexuality. Joan Riviere has defined homosexual woman as one who displays rivalry with the father, not by desiring the mother, but by desiring his place in public discourse,[21] and Roberta's desire for Susan, expressed through acquisition of the jacket, could be read as constituting a desire for empowerment within the public sphere.

In traditional psychoanalytic terms, appearance and objects of clothing are the vehicles by which woman falls in love with the self. When Roberta falls and loses her memory whilst wearing Susan's jacket, it is assumed that she is Susan – 'that crazy girl with the jacket'. In desiring Susan, Roberta becomes her. In becoming Susan, she desires herself, with the jacket, which takes on powers above and beyond that intended by its designer or manufacturer, acting as catalyst. This constitutes Roberta's failure as a subject – a failure to achieve distance. However, it can be interpreted, not as failure, but as the gaining of a changed identity acquired through the merging of feminine identities. Thus, femininity transforms itself through what Cixous describes as 'a process of different subjects knowing one another and beginning one another anew'.[22] This is comparable to Irigaray's notion of the process of auto-eroticism, the constant relation of self to self, in which the feminine can only be known from within.[23] In order to know Susan, Roberta has to know her from within, and wear her clothes. According to Irigaray, the feminine cannot describe itself from the outside or in formal terms except by identifying with the masculine, thus by losing itself[24] – and thus by creating the metaphor of the transvestite.

I would suggest that femininity does not lose itself so much as change its forms – forms, which can only be recognised from within the feminine sphere and which, in the film, are defined through objects. The jacket is exchanged between women (same), has been owned and defined by men (other), and remains ambivalently gendered (in-between). In identifying with the jacket, femininity identifies itself with the bi-sexual; with the ability to simultaneously inhabit male and female spheres. Thus, the metaphor of the transvestite is evoked, not by the masculinised spectator (Roberta) assuming a

feminine appearance, but by the subsuming of masculine discourse within the power and visual manifestation of femininity. Susan represents the feminine which dares to enter the public discourse of man. Roberta becomes Susan and wears her 'transvestite clothes' of resistance and empowerment.

In becoming Susan and desiring her identity, Roberta adopts a bi-sexual subject position: too close to define Susan as 'other' and too distanced to decipher the hieroglyph of her identity. The 'green and gold jacket . . . with a pyramid with an eye on top' acts as the visible symbol or 'hieroglyph' of Susan's identity. In common with Nefertiti's earrings, which are also central to the narrative, the images on the jacket refer to Ancient Egyptian mythology and history and to a hieroglyphic language. The jacket evokes the metaphor of mortality, of a rite of passage from life to the afterworld in which death becomes a process of transformation. The jacket as hieroglyph potentially represents that which is unrepresentable – death and femininity.[25] The jacket belonged originally to men, but is appropriated by women, its resulting 'bi-sexuality' diffusing the threat of the association of death with femininity. In wearing the jacket, Roberta's rite of passage, or 'inexhaustible course', takes her through 'millions of encounters and transformations' towards her own sense of self.

'The desire propelling the narrative is partially a desire to become more like her (Susan), but also a desire to know her and solve the riddle of her femininity.'[26] The visual language of hieroglyphics linked to female identity emerges within psychoanalytic theory: Doane argues that 'the image of hieroglyphics strengthens the association made between femininity and the enigmatic, the indecipherable, that which is "other"'.[27] However, in decoding the feminine from within, the hieroglyph becomes not indecipherable 'other', but a means of resolving the riddles of femininity and identity. Objects provide clues to the riddle – a key to a locker containing Susan's possessions and a photograph of The Magic Club – and provide Roberta with her first clues regarding her own identity which has become merged with that of Susan. They symbolise Roberta's journey of self-discovery, themselves becoming hieroglyphs uncovering the riddles of identity and femininity.

The jacket as hieroglyph is subject to gendered interpretation. Like hieroglyphics, feminine discourse remains indecipherable to the uninitiated, to those who do not hold the key; yet it can be the most readable of languages.[28] In possessing the key, literally, to Susan's locker, as well as the jacket and other objects, Roberta not only resolves the riddle of her own identity, but is able to transform that identity. The 'riddle of femininity' is resolved from within, excluding those men unable to engage with the discourse of women.

Masculine discourse defines the jacket within the terms of commercial economy and with reference to previous male ownership. Roberta's husband describes it as 'black and gold, with a pyramid – like on a dollar bill', thus defining his own position outside of feminine discourse. The women value the jacket, not in monetary terms, but in terms of nostalgia, identification and desire. The object represents a connection between two women which cannot be decoded within masculinised discourses of power and money.

The jacket is sold on the basis of being a symbol of stardom, in the manner Christine Gledhill describes as 'social hieroglyphs'.[29] The clothing of stars has an imitative function. In the gap between one's own image and the desired image, there is the production of another image.[30] Roberta's assumption of Susan's identity through the jacket and other objects resembles the star–audience relationship. The visual language of Susan, the ambivalence of public/private and masculine/feminine, relates to Madonna's construction as a star. Clothing is an expression of self. Self can be defined as the site of ambivalence, with clothing and the body being the location for the working out of these ambivalences.[31] In its ambivalence, the jacket becomes a hieroglyph not only for the ambivalent identities of Madonna and Susan, but also for the confusion of identities between Roberta and Susan, as well as for the ambivalence of gender itself.

The bi-sexuality of gendered identity sited within the ambivalent gendering of objects can be explained theoretically in terms of gender fantasy and gender performance. Kristeva has defined identification as a strategy of wish fulfilment and observed that fantasy allows for a variety of subject positions, not just masculine and feminine.[32] This liberates identification from the oppositional relationship with desire which is characteristic within conventional psychoanalytic theory. Roberta's identification with Susan constitutes a desire and a fantasy, mediated through objects which become part of the fantasy. Her fantasy of Susan is linked to a fantasy of the feminine within the public domain. Its visual manifestation is the wearing of Susan's jacket and other clothes.[33]

The fantasy of Susan leads to Roberta taking a job at The Magic Club. Here, femininity is defined through the presence of excessive objects. Unlike the more ambivalently gendered jacket, the pink tutu, with its frills and ribbons, is overtly and excessively feminine. The pink tutu and blonde wig – both symbols of femininity in excess – worn by Roberta are those worn previously by Susan's friend. However, the wearing of these items does not necessarily denote an excessive desire for the feminine. Indeed, excess of femininity has been theorised as a form of resistance,[34] or as an attempt to

resolve a masculine identification.[35] Roberta resolves her problematic role as masculinised seeker of Susan by engaging with masquerade which is 'what women do to participate in man's desire, but at the cost of giving up their own',[36] thus engaging not only with the fantasy of Susan's identity, but also with the fantasy of femininity itself. Performance on the stage of The Magic Club becomes synonymous with gender performance. Judith Butler has suggested that masquerade disguises bi-sexual possibilities which otherwise exist,[37] and in wearing the pink tutu, Roberta's feminine/masculine subject position seems to disappear as she turns herself into object of the male gaze.

Laura Mulvey has argued that femininity in excess associates woman with the surface of the image.[38] Femininity on the surface of the body is also a feature of male cross-dressing which parodies primary gender identification,[39] and femininity in masquerade could be said to parody femininity itself. Gender parody involves a complex relationship between imitation and original, and, indeed, does not assume an original. 'Gender is but a fantasy instituted and inscribed upon the surface of bodies',[40] masking a complex configuration of anatomical sex, gender identity and gender performance. Susan becomes a fantasy inscribed upon Roberta's body. However, because Susan has never worn the pink tutu, the image of Roberta wearing it is an image in crisis. The fantasy of Susan becomes the fantasy of identity itself. Roberta parodies Susan (a parody does not assume an original) and thus parodies 'the riddle of her femininity'.

The body which the feminine woman occupies is 'an object in excess which must be lost, that is to say repressed, in order to be symbolised'.[41] The pink tutu is indeed an 'object in excess'. In her final performance at The Magic Club, Roberta has regained her memory and has become multiply identified – to her husband she is Roberta, to Des (her potential lover) she is Susan, to Susan and Jim she is a stranger. Her new identity, which resists an oppositional construction and is symbolised by the wearing of new costumes, is forged from the 'in-between' of her former self and of 'Susan', absorbing aspects of each. Roberta has undergone a transformation which Cixous would describe as 'of the same into the other and into the in-between from which woman takes her forms'.[42]

The use and exchange of objects, such as the jacket and the tutu, are central to the exchange and transformation of self. As the 'feminine' engages in a constant 'repérage en soi', or relocation in self, so the female protagonists transform systems of exchange based on traditional masculine discourse and value systems. De Certeau has defined shopping as a subversive practice in which workers reclaim the power lost in production, and the acquisition of

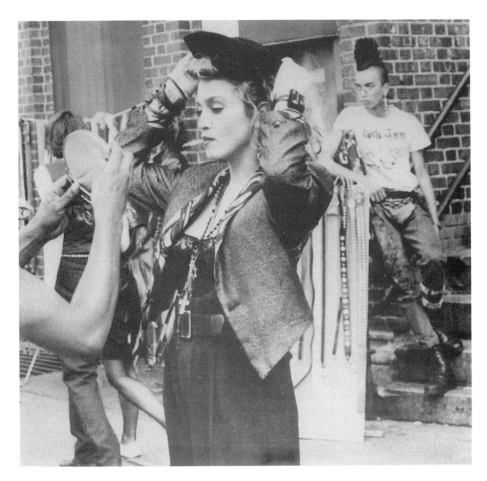

43] Madonna with a hat

'objects of desire' is used by both female protagonists in the film as a form of empowerment. The modes of acquisition constitute a form of refusal – a refusal to define themselves as property within fashion as economic exchange and to engage in 'legitimate' shopping within a commercial economy. Oppositional practices of shopping include the trying on of hats they have no intention of purchasing [**43**], Susan's exchange of the jacket for sequinned boots and Roberta's purchase of a second-hand jacket.[43] As their identities merge, material objects are exchanged. Roberta wears Susan's clothes; Susan helps herself to a jacket from Roberta's wardrobe, saying 'She owes me a coat.' In her acquisition of objects by theft, barter and borrowing, and in her use of objects to express the power of femininity in public, Susan

reacquires the power lost to her by her lack of economic status and resources.

The obviously gendered earrings of Nefertiti which have been stolen by Susan and have previously been stolen from a Cairo museum, have an economic exchange value, but, within feminine discourse, they provide a material link between women. The earrings are objects which link Susan to two women whose identities are 'unknowable': Roberta and Nefertiti. Like the jacket, the earrings have an Egyptian connection but, whereas the jacket is gendered ambivalently and suggests fluid identities, the earrings are unambiguously gendered. The jacket, passed from one person to another, symbolises a process of transformation of self through the exchange of objects, whereas the earrings are worn by Roberta and Susan simultaneously. They relate to female narcissism and self-adornment, but their link to Nefertiti represents gendered power and also the feminine as public and political – the merging of the feminine into the masculine sphere. Thus, the jacket represents an overlap of masculine and feminine and a merging of identities; the pink tutu parodies femininity which loses itself; and the earrings represent the resolution of the 'riddle of femininity'. To those who operate outside of feminine discourse, these objects remain unobtainable. It is ultimately through gendered objects, the earrings, and therefore from within the feminine sphere, that Roberta and Susan fulfil their desires.

NOTES

1 Jane Gaines and Charlotte Herzog (eds.), *Fabrications: Costume and the Female Body* (New York/London: Routledge and Kegan Paul, 1990), p. 1.
2 Susan Seidelman, USA: 1985.
3 Hélène Cixous, 'The laugh of the Medusa', trans. K. & P. Cohen, in Elizabeth Abel and Emily K. Abel (eds.), *Signs: A Reader* (Chicago: University of Chicago Press, 1983), pp. 279–97. 'Bi-sexual' refers not to sexual orientation, but to the practice of 'non-exclusion' or the ability to inhabit simultaneously male and female spheres.
4 *Ibid.*, p. 291. Cixous describes the ways creativity may take place from the cultural 'in-between'. For discussion of this see Jane Gaines, 'Women and representation – can we enjoy alternative pleasure?', in Patricia Erens (ed.), *Issues in Feminist Film Criticism* (Bloomington/Indianapolis: Indiana University Press, 1990), p. 78 and p. 89.
5 Hélène Cixous, 'Le rire de la Méduse', *L'Arc* (1975), pp. 39–54. Translated as 'each one's location in self' in Cixous, 'The laugh of the Medusa'.
6 Cixous, 'The laugh of the Medusa', p. 287.
7 Luce Irigaray, 'Woman's exile', *Ideology and Consciousness*, 1 (May 1977), p. 74.
8 Cixous, 'The laugh of the Medusa', p. 291.
9 *Ibid.*, p. 287.
10 *Ibid.*, p. 289.
11 Laura Mulvey, 'Visual pleasure and narrative cinema', *Screen*, 16 (3) (Autumn 1975).

12 Christian Metz, 'The imaginary signifier', *Screen*, 16 (2) (Summer 1975). For a further discussion of distance and the female spectator, see Mary Ann Doane, 'Film and the masquerade: theorizing the female spectator', in Erens, *Issues in Feminist Film Criticism*, pp. 45–7.

13 Jackie Stacey, 'Desperately seeking difference', in Erens, *Issues in Feminist Film Criticism*, pp. 365–79.

14 *Ibid.*, p. 375.

15 The use of reflection to symbolise the possession of an 'alter ego' is a technique used in the representation of women in 'film noir'.

16 That the female look can cancel the male point of view has been argued in lesbian studies which assigns more power to the spectator than to the text. For discussion of this see J. Gaines, 'Women and representation', in Erens, *Issues in Feminist Film Criticism*, pp. 84–5.

17 Doane, 'Film and the masquerade', p. 50.

18 *Ibid.*

19 Laura Mulvey, 'Afterthoughts on "Visual Pleasure and Narrative Cinema" . . . inspired by "Duel in the Sun"', *Framework*, 15/16/17 (1981), pp. 12–15.

20 Andrea Weiss, 'A queer feeling when I look at you: Hollywood stars and lesbian spectatorship in the 1930s', in Christine Gledhill (ed.), *Stardom: Industry of Desire* (London: Routledge and Kegan Paul, 1991), p. 289.

21 Joan Riviere, 'Womanliness as masquerade', in V. Burgin, J. Donald and C. Kaplan (eds.), *Formations of Fantasy* (London: Methuen, 1986). Riviere's essay was published originally in 1929.

22 Cixous, 'The laugh of the Medusa', p. 287.

23 Luce Irigaray, *Ce sexe qui n'est pas qu'un* (Paris: Editions de Minuit, 1977).

24 Luce Irigaray, 'Woman's exile', p. 74.

25 Cixous, 'The laugh of the Medusa', p. 289. Cixous states, 'Men say that there are two unrepresentable things: death and the feminine sex. That's because they need femininity to be associated with death . . . They need to be afraid of us.'

26 Stacey, 'Desperately seeking difference', p. 375.

27 Doane, 'Film and the masquerade', p. 41.

28 *Ibid.*, p. 42.

29 Gledhill, *Stardom*, p. xviii.

30 Jackie Stacey, 'Feminine fascinations: forms of identification in star–audience relations', in Gledhill, *Stardom*, p. 153.

31 Fred Davis, *Fashion, Culture and Identity* (Chicago: University of Chicago Press, 1992).

32 J. Kristeva, 'Woman can never be defined', in Elaine Marks and Isabelle de Courtivron (eds.), *New French Feminisms* (New York: Schocken, 1984). For discussion of Kristeva and the relationship of identity and fantasy see Judith Butler, 'Gender trouble: feminist theory and psychoanalytic discourse', in Linda J. Nicholson (ed.), *Feminism/Postmodernism* (New York/London: Routledge and Kegan Paul, 1990), pp. 333–4; and Judith Butler, 'The body politics of Julia Kristeva', *Hypatia: A Journal of Feminist Philosophy, Special Issue: French Feminism*, 3 (3), pp. 104–8.

33 Cixous, 'The laugh of the Medusa', p. 285. Relates to a discussion of women engaged in public speaking.

34 Angela McRobbie, 'Working class girls and the culture of femininity', in Women's Study Group (ed.), *Women Take Issue* (London: Hutchinson, 1978).

35 Judith Butler, *Gender Trouble: Feminism and the Subversion of Identity* (London: Routledge and Kegan Paul, 1990), p. 52.

36 Irigaray, *Ce sexe qui n'est pas qu'un*, p. 131, cited in Butler, *Gender Trouble*, p. 47. 'Masquerade' refers to putting on a 'mask of femininity'. For discussion of 'masquerade'

and the problematic of performativity with reference to Lacan, Riviere and Irigaray see Butler, *Gender Trouble*, pp. 43–52 and footnote 18, p. 159; Doane, 'Film and the masquerade', pp. 48–9; and C. Johnstone, in J. Tourneur, *Femininity and the Masquerade* (London: BFI, 1975), pp. 36–44.

37 Butler, *Gender Trouble*, p. 48. For further discussion of 'bi-sexuality' and the politics of the body, see Butler, *Gender Trouble*, pp. 122–5, and Butler, 'Gender trouble', pp. 333–6.

38 Cited in Doane, 'Film and the masquerade', p. 49.

39 Butler, 'Gender trouble', pp. 337–8.

40 Esther Newton, *Mother Camp: Female Impersonators in America* (Chicago: University of Chicago Press, 1972), p. 103.

41 Michele Montrelay, 'Inquiry into femininity', *m/f*, 1 (1978), pp. 91–2.

42 Cixous, 'The laugh of the Medusa', p. 287.

43 John Fiske's recent use of de Certeau's work to explain subversive and oppositional practices of shopping is outlined in Gaines and Herzog (eds.), *Fabrications*.

Tom and Jerry: cat suits
and mouse-taken identities

FROM 1940 to 1967, 161 Tom and Jerry cartoons were produced in three distinct eras of production. For the first seventeen years, now seen as the 'classic' period, the films were created by William Hanna and Joseph Barbera at MGM. From 1960 to 1962, they were made by UPA (United Productions of America) graduate Gene Dietch, while from 1963 to 1967, Chuck Jones, one of Warner Brothers' foremost directors, took on the challenge of sustaining the appeal of two of Hollywood's most enduring stars when the animated cartoon seemed to be in a period of terminal decline. These periods reveal different strategies in regard to narrative structure, comic invention and design. Across the years, however, unlike established duos such as Mickey and Minnie Mouse, Donald and Daisy Duck or even Popeye and Olive Oyl, Tom and Jerry have remained ambiguous in the specificity of their gender, or rather, in the ways in which the apparent certainty that both Tom and Jerry are 'male' has been manipulated to contradictory and often challenging ends. Tom and Jerry thus serve as an interesting model in considering the problematic aspects of gendering cartoon characters who, by definition, find themselves in an unstable medium constantly aware of its own capacity to deconstruct, redefine or destroy characters, contexts and continuity in the creation of comic effects.

Cartoon definitions of 'male' and 'female' largely correspond to 'real world' models, but cartoon frequently blurs distinctions between 'masculine' and 'feminine'. This takes on particular purchase in the Tom and Jerry series because it underpins specific changes – in discourses concerning the design of the characters, in the execution of 'gags' and the construction of comic events – which also correspond to shifts in directorial approach, particularly after the Hanna Barbera period, when Dietch and Jones sought to sustain aspects of the 'old style' while developing the characters through their own styles. 'Style' in this sense, however, both in the Hanna Barbera period and

after, is less about how the characters look and act, than how they facilitate
and function within comic situations. The comedy distracts the viewer from
how the characters look and act, partially masking the flux of gender posi-
tions which this essay wishes to foreground.

The construction of the 'body', even in the most determinedly hyper-
realist animation (most specifically, Disney), is a complex issue, largely
because animation has the capacity to resist 'realism' and the orthodoxies of
the physical world, redefining the body as a fluid and indestructible form.
This fluidity enables the animated body to defy physical laws – extending,
compressing, disassembling, reassembling, adjusting to impossible environ-
ments and changing shape at the animator's will. While Tex Avery remains
the virtuoso in manipulating the body to comic effects (clearly influencing
Hanna and Barbera), and Disney aims at authenticity in the physical move-
ment of its characters, 'the body' in cartoon animation is always subject to
the demands of its narrative context. Consequently, the body is subject to
what may be called 'contextual gendering', a concept addressed more fully
later in relation to Tom and Jerry cartoons.

In the first instance, there is often an apparent consistency in design
when cartoon characters seem to be explicitly 'male' or 'female'. The
Fleischer Brothers' Betty Boop is explicitly 'a woman' because her design
echoes the female form, even though she is disproportionate because of the
(male) desire to over-determine her femininity by accentuating the size of her
face, eyes and bust and fetishising her legs and genital area through the use
of a garter. This over-determination, however, provides the vocabulary by
which 'masculinity' and 'femininity' may be located in the cartoon, and which
makes even more significant those moments at which such traits and qual-
ities become indistinct within the very movement of the animation and the
construction of the narrative.

Disney animator Fred Moore, who drew Mickey and Minnie Mouse,
located key differences in the design of the two characters, even though
Minnie was 'Drawn the same as Mickey'.[1] In order to code one mouse as
female he used lace underwear, high-heeled shoes, a small hat, eyelids and
eyelashes. He recommended that Minnie's 'poses and mannerisms should be
definitely feminine'[2] and a certain 'cuteness' be achieved through having 'the
skirts high on her body – showing a large expanse of her lace panties'.[3] Most
importantly, Moore suggested,

> In order to make Minnie as feminine as possible . . . Her mouth could be smaller
> than Mickey's and maybe never open so wide into a smile, take, expression etc.
> Her eyelids and eyelashes could help very much in keeping her feminine as well

as the skirt swaying from the body on different poses, displaying pants. Carrying the little finger in the extended position also helps.[4]

Several points emerging from these design strategies relate to the particular ambiguities of the Tom and Jerry series. The cartoon female, defined through assumed traits of 'femininity', is designed in relation to the primary representation of the male character and specifically defined as a set of signifiers of femininity, which function as additional signifiers of character differentiation from the male model.[5] Particular attention is drawn to genital difference through the exposure of panties, but the dominant mode of physical differentiation lies in the design of the face – most notably eyes. Minnie Mouse, unlike Mickey, has eyelids and eyelashes, and a smaller mouth for smaller expressions and reactions. This stress upon 'petiteness' and 'prettiness' is a common design strategy for the child–woman in animation and suggests juvenilisation is feminine. This becomes of particular note when, as Stephen Jay Gould argues in a reiteration of some of Konrad Lorenz's theories, that it is *Mickey* who is progressively juvenilised in an attempt to give him the appealing characteristics of a baby to court the affections of adult audiences.[6] I wish to extend this argument by suggesting that Mickey has not only been juvenilised but also feminised, and that the modes of 'feminisation' inform the shifts of gender position in apparently 'masculine' contexts and agendas in the animated cartoon. This operates most ambiguously in the Tom and Jerry series which combined Disney design strategy in relation to 'the body' (before it is acting or acted upon) and the Warners' mode of comic timing in the chase,[7] thus enabling modes of overt 'masculinity' or 'femininity' (whether located in the design or behaviour of the characters) to be instantly changed through the 'gag'. Crucial in the determination of 'gags', however, is creation of contexts for violent exchanges between Tom and Jerry which carry with them a constant flux in power relations. The capacity for or extent of aggression and violent behaviour tends to define the degree of 'masculinity' or 'femininity' informing the characters and their behaviour. Tom and Jerry consistently exchange the roles of victim and aggressor which involves shifts in status, intelligence and ingenuity, although it should be noted that such qualities are necessarily inconsistent because each character must carry with it the possible strengths and weaknesses which facilitate the construction of comic sequences. This inconsistency in temperament sometimes has the consequence of creating an inconsistency in the coding of gender which I wish to address in terms of over-determination and contextual gendering, as well as body and identity.

Patrick Brion suggests that one of the most enduring questions raised by the Tom and Jerry cartoon series is 'Was Jerry a female?'[8] At certain moments in a number of films Jerry looks and overtly behaves like a girl within the context of 'his' relationship with Tom, and Brion notes:

> The relationship of Tom and Jerry is very curious. It vacillates between hostility and friendship. The complicity of a latent love is carefully sustained by the ambiguity of Jerry's sex. The game between them evolves from teasing to violence. Despite the explosion of several hundred sticks of dynamite and bombs and innumerable blows of all sorts, the two characters keep – and this is in the tradition of the animated cartoon – the same appearance.[9]

What Brion ignores, however, is how Tom and Jerry change during their exchanges before resuming the same appearance. Whilst he is correct in his assertion that a latent (heterosexual) love is sustained by the occasional overt signification of Jerry as a female, Brion overlooks homoerotic sub-texts, cross-species coupling and the blurring of 'gender' through cross-dressing. My concern here is to address how these issues inform Brion's point that sexual concerns become submerged beneath conflict.

The best, and most ambiguous, example of Jerry becoming a female occurs in *Baby Puss* (1942) which, coincidentally, takes up the notion of juvenilisation as feminisation and, ironically, applies it to Tom. Only identified by her legs and skirt, a little girl plays at being 'mother', dressing Tom in bonnet and diaper, placing him in a cot, and giving him a bottle of milk. Jerry, like three alley cats later in the cartoon, openly mocks him for his childishness and lack of apparent 'toughness', initiating a chase across the child's playroom. Jerry scampers into a doll's house, where he takes a bath, only to be observed by Tom peeping through an upstairs window. Whilst he is in the bath, Jerry sings in the 'dumb blonde' style of Judy Holliday and behaves in a highly feminised way. Once he notices Tom, he covers his body as if he were covering breasts and genitalia, turning his legs away as he screams in shock – before beating Tom on the nose with a scrubbing brush as punishment for his voyeurism. Jerry here is clearly coded as a girl and the intrusive factor of (Peeping) Tom's gaze is emphasised. Running from Tom, however, Jerry leaps into bed with a girl doll, who cries 'Mama' in surprise. Perversely, Jerry might now be coded as male because he is embarrassed to be next to 'a girl' (coded in bonnet, skirt and frilled panties after the style of Minnie Mouse), or as lesbian. The issue is further complicated by the fact that, following a cutaway to Tom, Jerry emerges from the doll's house wearing the doll's clothing (he has evidently undressed her) and masquerading as a 'Southern Belle' in

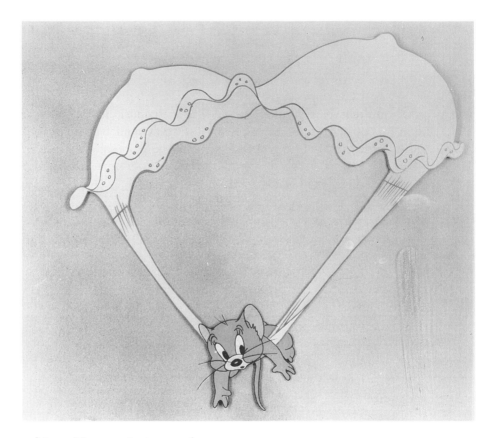

44] Jerry Mouse swinging on a bra

the hope of deluding Tom that he is not Jerry. Her clothes become 'props' for his disguise, but Jerry authenticates his femininity by remaining behaviourally consistent in gesture and posture. He is exposed when his dress falls down, revealing frilly panties and high heels. Distracted by the young girl's return, Tom lets Jerry escape. The latter then goes to the playroom window, still wearing the panties and high heels, and overtly displays himself as a pretty young girl to the alley cats by 'showing an ankle', inciting wolf-whistles and lustful stares. At this juncture, Jerry transcends the assumed knowledge that he is a male rodent and becomes 'female', attractive to the cats through this highly feminised sexual ritual.

The alley cats mock Tom for his subjugation by the little girl. They hit him, steal his milk, inflate his face, play catch with him, throw him into a goldfish bowl, and finally, in a mock operation, change his wet nappy.

Consistently hitting him over the head with a mallet to anaesthetise him, the cats use Tom as a musical instrument, playing his whiskers as harp strings in a wild routine of madcap celebration which emphasises that Tom is a feminised domestic 'kitten' as opposed to a streetwise 'cat'. His masculinity can only be judged by his relationship with Jerry, a highly skilled but less comparable adversary at the level of gender. The alley cats are most clearly coded as 'male', but in the 'carnivalesque' atmosphere of the playroom 'turned-upside-down', where pleasure is liberated through song and dance, even they subvert dominant sexual codes.[10] One cat kisses Tom; another (over)dresses as Carmen Miranda (a model for cross-dressing adopted by Daffy Duck in *Yankee Doodle Daffy*, 1943) and dances with a doll dressed as a maid. This fluidity of gender positions throughout the cartoon services the surreality of the 'gag' sequences, providing constant surprise through violating expectations and creating incongruous relationships. Jerry is over-determined as 'female' to incite libidinous rebellion and to tease Tom with his ambivalent sexuality.

Shifts in design discourse render Jerry as 'feminine' through costume or moments of 'delicate' behaviour. In moments similar to those in *Baby Puss*, Jerry becomes feminine through his movements as a dancing girl in *Mouse for Sale* (1955), once more protecting his top half as if it were naked after his disguise as a white mouse is washed away, revealing his brown fur. Jerry as dancing girl is taken to its logical extreme by Chuck Jones in the more lyrical *Snowbody Loves Me* (1964) when ballerina Jerry dances in a tutu. Jones drew Jerry as plumper and accentuated his 'sweetness' in smaller, more deliberate gestures. The slower pace of the Jones films complements the softer 'feminised' Jerry in essentially 'gagless' sequences which prioritise the grace of animated movement. In many ways, narrative and context, as well as Jerry, are gendered feminine in the Jones films.

Whilst it is rarely in doubt that Tom is 'masculine', even if sometimes 'feminised' in the presence of other cats, he occasionally cross-dresses to deceive. This 'disguise' motif occurs in *Fraidy Cat* (1942), where he wears a set of curtains as a dress as he sits afraid after listening to 'The Witching Hour', and in *Flirty Bird* (1945), when he disguises himself as a female eagle to distract a male eagle protecting Jerry. This is especially pronounced in *The Brothers Carry-Mouse-Off* (1965), when Tom becomes a perfumed female mouse – something which provokes a particular delirium in the cartoon. Jerry is initially attracted to Tom as a mouse (thus coding himself 'masculine') before more overtly masculine mice deter Jerry in their pursuit of Tom who, in trying to escape, becomes pursued by cats in what appears to be an

orthodox cat and mouse chase. Once more rapid gender shifts inform shifts in the comic agenda. The 'gag' emerges either from over-determination in gender and/or the machinations of changing audience's expectations of Tom and Jerry as characters or of them as a 'normal' cat and mouse.

Jones's attempts to feminise Tom through changing the pace of the cartoon and by rendering him less Machiavellian, ironically echoes the Tom, then 'Jasper', of the first Tom and Jerry cartoon, *Puss Gets the Boot* (1940) which, in turn, echoed the MGM studio style created by Harman and Ising. Slower paced and more deliberate in its moments of aggression and pathos, it cast Tom as a less self-conscious adversary. But within three years Hanna and Barbera had changed the design of Tom and Jerry; *The Lonesome Mouse* modernised Tom by making him more sharp-featured, sleeker and less hairy and feminised Jerry by extending his eyelashes and widening his eyes. This 1943 cartoon was the first to self-consciously acknowledge 'a relationship' between Tom and Jerry. When Jerry feels bored and alone after Tom has been thrown out of the house, Jerry engineers his return and they celebrate by ritually sharing food and contriving conflict. Their 'relationship' is much more explicit, however, when Jerry demonstrates a degree of jealousy – most frequently when Tom is attempting to seduce a white kitten. As a little green devil of jealousy reminds Jerry in *Smitten Kitten* (1952), 'Every time Tom meets a kitten, he falls in love, and that means you have problems again!' Jerry has to contend with Tom at his most 'masculine', when his actions and behaviour are clearly influenced and inspired by Tex Avery's explicitly lustful 'Wolf'. Hanna Barbera acknowledge this when a kitten produces a 'Wolf pacifier' mallet to arrest Tom's amorous advances in *The Mouse Comes to Dinner* (1945). In *The Zoot Cat* (1944), Avery is also referenced in the use of 'Charles Boyer' as Tom's voice when he attempts to seduce a kitten; Tom is 'contemporary', resplendent in a yellow and green striped zoot suit.[11]

Other feline encounters include *Puss 'n' Toots* (1942), *Texas Tom* (1950) and *Casanova Cat* (1951), all of which further confuse gender issues by implying that Jerry is a possible competitor with Tom, especially because in all three he kisses the kitten in a spirit of victory over Tom. Further episodes in which Tom attempts to romance a kitten, for example, *Solid Serenade* (1946) and *Salt Water Tabby* (1947), find Tom in combative mood, stealing the kitten's hot-dog and spitting water into her face. Jerry is embroiled in the action, but in the spirit of spoiling Tom's chances or winning back his attention. The jealousy foregrounded in *Smitten Kitten* is also fundamental to the narrative of *Springtime for Thomas* (1946). Jerry writes a forged love note to Dream Boy, the alley cat, from Toodles, the white kitten, to initiate conflict

with Tom. Allied with Tom against Dream Boy, Jerry asserts *their* relationship, before he, in turn, is distracted by a passing female mouse. In *Blue Cat Blues* (1956), in an unusually bleak episode, both Tom and Jerry contemplate suicide over lost loves and take solace in the inescapable and eternal relationship their bond represents. It is no wonder Tom kisses Jerry after a horrible nightmare in *Heavenly Puss* (1949) and after an extended chase in *Ah, Sweet Mouse-story of Life* (1965), the latter illustrating Jones's desire to romanticise the couple by temporarily feminising Jerry's response to Tom's kisses, by giving him coy eyes, shuffling feet and a bashful demeanour. Simultaneously, then, the Tom and Jerry texts generate readings which can support both a cross-species heterosexual bond, a cross-species homosexual bond and same-species heterosexual bonds.

If certain moments represent over-determination in gender design discourses, other sequences imply a subtler view of gender positioning. This, once more, informs aspects of Jerry's narrative function in certain films. If Jerry is sometimes highly feminised in relation to Tom, he is determinedly masculine when he is being pragmatic in relation to the protection of others, most particularly, Nibbles (also called Tuffy) – a little mouse which featured in thirteen films – or the duckling which featured in eight. Jerry becomes more muscular, walks with an upright confident stride, and less attention is paid to his face as a mechanism of 'cuteness', especially half-closed or wide eyes and fluttering eyelashes. Assertion and practicality are coded as 'masculine', at least in so far as they accompany Jerry's more overtly physical presence, echoing the muscular design of his cousin in *Muscles Mouse* (1951). It is in such moments that Jerry transcends size and appears to take on Tom on his own terms. It is the condition of the cartoon, of course, that creatures have abilities and powers that they do not possess outside of a cartoon vocabulary, but the scale of abilities and powers does not necessarily equate with the creature that has them. Jerry can wield heavy objects as well as Tom and can take equal punishment; his size rarely impinges on his ability to combat Tom's aggression.

The notion of size, which is central to gender coding in the 'real world', relates more to sight-gags in these cartoons. For example, in *Jerry and Jumbo* (1953), Jerry befriends a lost baby elephant who, despite his size, relies on the help and protection of 'a mouse'. He becomes instrumental in the deception of Tom, however, when he curls his trunk into a knot, paints it black, and superficially looks like a larger mouse. Tom is driven mad by the playfulness of Jerry and Jumbo as they constantly exchange places, frustrating Tom's efforts both to capture Jerry and to understand why he apparently keeps

fluctuating in size. This is compounded by the arrival of the baby elephant's mother, who joins in the deceit, and looks like an even bigger 'mouse'. In this situation, the rapid shifts in power and status relations diminish Tom's masculinity, especially when something taller or wider (including 'a mother' and 'a baby') is coded as being more 'masculine' in moments of conflict. The premise of the 'gag' here – the escalating size of a small creature – overrides the necessity for gender certainty. The cartoon in general, and Tom and Jerry in particular, superficially relies on the gender codes of the 'real world', but the cartoon environment re-contextualises gender through the deployment of established and expected gender codes in destabilised and unexpected modes of character behaviour and narrative requirement.

This 'contextual gendering' also informs the redefinition of Jerry as a mermaid in *The Cat and the Mermouse* (1949), when Jerry loses his feet and gains a tail. In Susan White's discussion of the role of the mermaid in contemporary film, most notably in Disney's *The Little Mermaid* (1989) and the Disney/Touchstone vehicle *Splash* (1984), she deploys psychoanalytic theory in determining that the mermaid's tail 'despite its phallic shape . . . is not easily defined as either male or female, as threatening or reassuring'.[12] This ambivalence further complicates readings of Jerry as a mermouse, readings already confused by the fact that Jerry violates the notion of a mermaid as half-human/half-fish, by being half-animal/half-fish. I have already established that Jerry fluctuates between male and female but this ambiguity is further compounded by the gender indeterminacy of the tail. This is threatening for Tom when he encounters Jerry underwater, at first rubbing his eyes in disbelief, then having his eyes pop out Avery-style because he cannot come to terms with the ease of Jerry's behaviour in circumstances so distant from and different to their 'normal' domesticity. Reassurance only comes with the climax of the film and Jerry's return to his 'normal' state. This occurs as we discover that the underwater sequence is a hallucination that Tom has experienced while being unconscious, evidently having been pulled from the water having nearly drowned. Tom's hallucination clearly reveals his fears of a reconstituted 'Jerry'; fears located in the 'otherness' of Jerry as an ambivalently gendered or genderless creature. 'Contextual gendering' in this instance is about the blurring of gender and identity, a destabilisation which helps facilitate the comic exchanges resulting from the new environment.

The 'body' in any animated film is a fluid form subject to constant redetermination and reconstruction. In the Tom and Jerry series body formations carry with them particular agendas about identity. Tom is constantly subjected to the process of taking the shape of an object during particularly

violent exchanges or chase sequences. A few examples from the many in Tom and Jerry films include becoming a set of bowling pins in *Jerry's Cousin* (1951), a water fountain in *Hatch up your Troubles* (1949) and *Posse Cat* (1954), a string of paper-dolls in *Cat-napping* (1951), or a doormat in *The Brothers Carry-Mouse-Off* (1965). It could be argued that as the consistency of Tom as a *character* is violated through relocating him as an infinitely flexible two-dimensional *form*, he is rendered genderless and without identity. He is merely the subject *and* object of the 'gag'. When Tom is hit by an iron, his character experiences pain, provoking sympathy, while his form instantly changes into the shape of an iron, provoking laughter. This process of temporary depersonalisation diffuses the extent of the violence and legitimises the comic aspect of the incident[13] but it also, on occasions, transforms Tom into a 'feminine' object such as a doll or an iron. Sometimes the body becomes a costume in its own right, as when Tom and Jerry strip away their outer fur as if it were clothes, often revealing underwear or naked skin. In *Of Feline Bondage* (1965), directed by Chuck Jones, Jerry becomes invisible and starts to shave Tom who inevitably retaliates in kind. By the end of the cartoon Tom sits with the top of his head and upper torso shaved, wearing an undervest, his hair intact on his legs and face. Jerry is shaved, appearing half-dressed/undressed in a fur bikini, his remaining hair resembling a fur swimming cap. Here body-as-costume clearly codes Tom as male and Jerry as female. The film also features a female fairy, drawn like Jerry, but taller and coded female in green skirt and high heels and blue blouse, the mode of costume-as-gendered-appendage.

The 'body' in animated cartoons can be free from ageing. Tom and Jerry, it seems, were perennially the same age in the Hanna Barbera period, unless 'ageing' itself could be used as a gag as, for example, in *The Missing Mouse* (1953), when Tom ages with worry as he realises that the white mouse he is vigorously washing is not Jerry but an explosive mouse who has escaped from a laboratory and will 'go off' at the slightest touch! In the post-Hanna Barbera period, Tom does seem to age while Jerry seems even more baby-like, as Gene Dietch and Chuck Jones searched for ways to develop the characters without misrepresenting them. Dietch and his team, working in Czechoslovakia, and having seen only six of the original Tom and Jerry films, tried to recontextualise the duo in new locations, including outer space, Athens, the Caribbean, the jungle and in a western, but this created a surreality that often rendered the cartoons absurd and humourless. The Tom and Jerry of these films bear little relation to the Tom and Jerry of the Hanna Barbera period. Tom was fundamentally stupid and clumsy, guileless in his attempts to capture a

cheeky but self-preserving rather than adversarial Jerry. Jones, too, was never really comfortable with the characters, nor with the scale of violence. He gave the cartoons a gentler tone and also rendered them less amusing, particularly Jerry. Jones acknowledges:

> I thought they [Hanna Barbera] did a smashing job on Jerry. I was never able to give him as much character. I probably got a more human personality out of Tom than they did, but not the same character. Tom was pretty vicious in their stuff, and was a clear-cut villain. I used the idea that nothing's clear-cut because in comedy you should be able to understand both the villain and the hero.[14]

Jones' aspiration to humanise Tom brought intimations of mortality to his subject. In *Year of the Mouse* (1965) Tom is placed in a series of situations, contrived by an invisible Jerry and his friend, where he seems to be committing suicide – by shooting himself, hanging himself and stabbing himself – and, although he finally turns the tables, the cartoon locates the possibility of death within its text. Tom is also overtly injured in *The Cat's Me-ouch* (1965), ar.d far from instantly recovering in the spirit of the Hanna Barbera cartoons, he is covered in bandages, uses crutches and is hospitalised. It is the final irony that, in the last Tom and Jerry cartoon, *Purr-chance to Dream* (1967), Tom actually takes sleeping pills to help him sleep – a sleep, of course, from which he never wakes. Jerry too becomes redetermined within these darker parameters, imagined as a ghost in *Snowbody Loves Me* (1964) and *Tomic Energy* (1965). The biggest consequence of Jones' shift of emphasis in the cartoons, however, is the transition from slapstick to whimsy and a comic ambivalence in the characters that further lyricises and romanticises their relationship. The sense of nostalgia in the Jones era is sometimes palpable, ironically, when he foregrounds modern notions of progress (as in *Advance and Be Mechanised*, 1967) only to render Tom and Jerry as ciphers.

Through the violent extremes of the Hanna Barbera period, the garish and schematic transition to cinemascope, the surreal misadventures directed by Dietch, and the sentimental warmth of the Jones period, Tom and Jerry were vehicles for the design and expression of gender ambivalence in the animated cartoon. These discourses are often submerged, and relate to the capabilities of the medium itself, especially temporariness and the suspension of certain modes of design in favour of comic possibilities, but it is the very strength of animation and the cartoon form that it can be, at once, simple, comprehensible and 'real', *and* render taboo subjects like 'gender-bending' in general – and in the case of Tom and Jerry, sexual ambiguity, cross-dressing and transvestism in particular – in complex but engaging ways.

NOTES

1 F. Thomas and O. Johnston, *Disney Animation: The Illusion of Life* (New York: Abbeville Press, 1981), p. 553.
2 *Ibid.*
3 *Ibid.*
4 *Ibid.*
5 This mode of cross-dressing is particularly apparent in Warner Brothers' cartoons, most notably in Chuck Jones' *What's Opera, Doc?* (1957), which features Bugs Bunny as a Brünnhilde-like operatic heroine.
6 S. J. Gould, 'A biological homage to Mickey Mouse', in *Fields of Writing* (New York: St Martin's Press, 1987), pp. 500–8.
7 N. M. Klein, *7 Minutes* (New York: Verso, 1993), p. 197.
8 P. Brion, *Tom and Jerry* (New York: Harmony Books, 1990), p. 38.
9 *Ibid.*
10 For a full definition and discussion of the concept of the 'carnivalesque' see M. Bakhtin, *Rabelais and his World*, trans. Helene Iswolsky (Bloomington: Indiana University Press, 1984).
11 Tex Avery deployed 'Charles Boyer', the well known French lover, when his Wolf characters were attempting to seduce the beautiful 'Red' in films like *Red Hot Riding Hood* (1943).
12 S. White, 'Split skins: female agency and bodily mutilation in *The Little Mermaid*', in J. Collins, H. Radner and A. Preacher Collins (eds.), *Film Theory Goes to the Movies* (New York: Routledge/AFI, 1993), p. 186.
13 This is also the case when Tom's body falls into pieces, for example, in *Tennis Chumps* (1949), *Cruise Cat* (1952) and *Just Ducky* (1953).
14 D. and G. Peary (eds.), *The American Animated Cartoon* (New York: Dutton Books, 1980), pp. 131–2.

Cosmetics: a Clinique case study

THIS chapter aims to examine the gendering of Clinique toiletry products for men and women, particularly the ways in which the advertising of those products differentially codes the 'male' and 'female' ones. The design requirements of product packaging and advertising include suggesting that certain qualities belong to a product. Within the worlds of advertising and marketing, the appearance and presentation of a product is at least as important as the product itself. Advertising conventions encourage the consumer to equate the quality of advertising with the quality of the product itself. At the same time, however, women, in particular, use their many and varied consumer skills to negotiate both advertisements and product packaging and arrive at informed choices, related to a variety of factors, from cost and appearance to smell and status. The meanings of an advertisement are dependent upon how its signs and 'ideological' effects are organised internally (within the text) and externally (in relation to how it is read, produced, circulated and consumed as well as other social, economic and cultural factors, including gender relations).[1] Packaging is organised externally in much the same way and both translate statements about gendered objects into gendered statements about a variety of things including types of consumer behaviour and human relationships.

The differences between advertisements for male toiletries and those for female toiletries are marked and, to a certain degree, conform to certain binary oppositions which are generally accepted to relate to men and women. In this particular case, it needs to be acknowledged that in our society men are far less accustomed than women to purchasing and using a wide range of toiletries, especially those produced by a 'select' company such as Clinique which has hitherto been associated with products for women. The 1994 advertisements for Clinique's 'male' products, which were aimed not only at men but also at women buying for men, therefore needed to take account of

this when promoting 'masculine' products that, in some or many ways, had been regarded as 'feminine'.

An important factor in the different presentations of products for men and women is colour, a distinction by which gender stereotypes are reinforced. Cosmetic advertisements frequently use colour as an 'objective correlation',[2] that is, the colour of a product and its surroundings are used to link and enhance the qualities and style of that product. Not surprisingly, therefore, colour plays an important role in the gender differentiation of Clinique products. Those for men are mostly packaged in grey bottles or tubes, with the occasional muted blue. Those for women are often packaged in transparent bottles, through which one sees a range of pastel and soft colours, particularly pink, blue, cream and yellow, while Clinique's opaque tubes and bottles are often a distinctive but soft green. The flat cake of 'male' soap is ivory whereas the rounder, softer-shaped bar of 'women's' soap is more yellow. Recent advertisements for the 'male' products were produced in black and white whereas those promoting 'female' products feature full colour, pastel shades and soft tones.

Associated as it is with documentary 'realism' and media reportage, the black and white photography is an essential element in the overall 'rational' and 'objective' tone of the 'male' advertisements. There is a boldness in the strong contrast. By comparison, the pastel colours of the 'female' advertisements signal softness, purity, gentleness and innocence – features associated with babies and infants and which suggest the more delicate, passive and soft sensibility associated with the more traditional representations of femininity. The products look as beautiful and feminine as the beauty and femininity they promise the beholder/purchaser.

The associations of seriousness and masculinity that underlie the black and white advertisements function to validate the male use of cosmetics and toiletries, products hitherto regarded as fundamentally 'female'. The references that black and white photography carries to the documentary mode of presentation and representation, and thus to realism, are crucial. The 'factual' and 'sensible' style of the advertisements indicates a desire to define the use of male cosmetics as a serious business, something that men should not be ashamed to acknowledge or take an interest in – as opposed to something reserved for women or effeminate men.

Another significant difference in the advertising is the amount of information supplied. The advertisements for male products carry significantly greater amounts of information about the product depicted. The inclusion of this informative text has a major influence upon the appearance and

impact of the advertisements. It introduces new elements of 'objective' factual reporting, reinforcing other references to documentary realism, and plays a major role in encouraging readers/potential purchasers that to buy and/or to use male cosmetics is not necessarily the first to step on the road to abandoning one's masculinity. The inclusion of 'factual' information in a direct style helps inform, initiate and reassure men who are generally less experienced than women at buying toiletries, especially the variety offered by the up-market Clinique range which includes several gels and lotions for shaving alone. By providing a more exclusive, specialised and expensive range, Clinique sets itself against more mainstream male toiletry brands such as Insignia or Gillette. The Clinique man has to *choose* the more suitable product rather than simply buying the only shaving cream produced by a particular brand, as is the case with more conventionally minded companies.

However, many women buy cosmetics and toiletries for men and they too have to negotiate the choice of 'male' products. Despite bringing greater consumer skills to the process, the uncertainties experienced by the dozen women, aged 20–30 years, with whom we discussed this issue indicate that the process is not entirely unproblematic for women and that they too find reassurance in the information and factual mode of address. That reassurance goes beyond learning about the function of the product to accepting it as a necessary and desirable (by no means the same thing) element of the masculinity/ies of the man/men in their life. In other words, women as well as men find reassurance in the information given about the relatively new products – in content as well as form.

In terms of content, the written text draws on representations of traditional masculinities to help distance the products from the domain of female toiletries. The codes and conventions used include those of utilitarianism, science, rationalism and efficiency, with words such as 'convenient', 'simple', 'no fuss' and 'unscented', working to this end – together with references to 'experts' such as dermatologists including those who 'favour aloe to avoid shaving discomfort'. Some play is made with the language of business; the male face has 'an important meeting' with a bar of soap. 'Robust', 'brisk', 'feel fit' and 'works quickly', suggest health, strength and speed. Size, endurance and reliability are also directly invoked; sexuality less directly so. Readers are informed that Clinique soap for men comes in a big brick-like bar that not only works quickly but lasts for months (they should be so lucky). The fact that the soap has no perfume is emphasised in the drive to get men to accept these new products as 'no-nonsense' ones. At the same time, however, the sensuality and pleasure sought after by the 'new man' users of these products

and/or the women who buy them for them, are catered for; there is a refer-
ence to the 'rich . . . lather that feels good on the face'.

In general, the language upholds the over-determined masculinity
evoked by the rest of the advertisement. By contrast, the over-determined
femininity of female cosmetics and toiletries is so well established within our
culture that Clinique feels confident enough to (by and large) omit the
written word from their advertisements for women's products. The very oppo-
site of much of what is there by *assertion* and *emphasis* in the advertisements
for products for men, is there by *absence* in those for products for women.
For example, in the 'male' advertisements the emphasis on speed and conve-
nience contrasts with the knowledge that the taking of time to cleanse and
make-up are established points of the complex processes and rituals of
being/becoming 'feminine'.

The 'female' advertisements contain no information whatsoever, other
than the names of the products. Young girls learn from teenage magazines,
elder sisters, mothers and friends about the benefits of cleansers, toners and
moisturisers as well as face masks and makeup. By the time they are old
enough to afford Clinique products they do not need to be 'educated' about
the functions of them. However, only firms confident of the high standing of
their product in the marketplace can afford to let the brand name stand for
itself, and 'sell' their products on aesthetics. The 'classic' case in point is the
famous Saatchi and Saatchi series of 'Cut Silk' Silk Cut cigarette advertise-
ments in the early 1980s. The lack of information within the 'female'
advertisements is testament to Clinique's reputation.

Some of the attributes of the 'female' product are conveyed within the
aesthetic quality of that product – within the packaging and the aesthetics of
the advertisement itself. Gillian Dyer states that, in this sense, the *sign* (the
product) goes beyond the 'mere depiction of a . . . thing' and is used *index-
ically* 'to indicate a further or additional meaning to the one immediately and
obviously signified'.[3] The product becomes the signifier of feelings through
conventions such as colour, light and water which evoke a series of affective
responses including freshness and pleasure.

The visual pleasures of the advertisements evoke the pleasures involved
in the application of cosmetics, not least because the images contain within
them notions of the cosmetics having just been used or, perhaps, still being
in use. There is a sense of identification – encouraged by a different type of
realism to that used in the 'male' advertisements, but, nevertheless, realism.
The thumb-print on the foundation bottle, the opened lipstick and the split
blusher suggest not only the process of putting on makeup but that real

people – messy ones who spill things – are doing it. These beautiful illustrations connect the reader/viewer to the process of self-beautification, to the making of the feminine. An understanding of the constructed nature of femininity informs not only the advertisements but also our readings of them. Associations and pleasures related to colour are added to those already evoked by the references to process and construction. The woman reader can equate the beauty, sexuality or pleasure she will achieve with the aesthetics and attributes of the product; with the sexuality of the (beautifully photographed) full, red lipstick and with the softness of the baby-pink blusher. Although accepting that there are as many readings of a text as there are readers (indeed more), we have been struck by the similarity of response of those male friends (mainly, but not exclusively, gay) who use makeup. Some of the more resolutely 'hetero' men with whom we have discussed these advertisements and who would only buy 'women's' cosmetics for women if at all (perfume, they said, 'was a different matter'), also respond to the sexuality, softness and deliberate aestheticisation of the images – but with no identification as user.

Absent here are images of or references to the impact of the product on another person, usually male. These Clinique advertisements do not directly imply 'use this product and become more appealing to the opposite sex', as is the case with certain other cosmetic and perfume advertisements, but it needs to be remembered that they draw on and are read in the context of that notion which occupies a powerful position in our culture. In the case of toiletries, as opposed to makeup, references to freshness and purity prevail; the most common feature being jets of pure, clear water – with which the products are sprayed or in which they are submerged. The water symbolises the fresh cleanliness the product promises; it stands in for the acts of washing, cleansing and purifying oneself but it is also sensual.

Two of the male advertisements also feature the cleansing aspect of beautification (far 'safer' for men than using makeup). The soap sits in a flow of suds [45] and the face scrub drips with water. The advertisements are gendered by the use of the male hand and hairy wrist (one of which wears another gendered object – a wristwatch) which occupy a large proportion of the image. Hands are large, hairy and clearly defined as masculine. The hand surrounds the product, literally encapsulating it within the masculine and ensuring that we are in no doubt about whom this product is for and who is in control of it, in yet another attempt to break down the taboos standing between men and toiletries.

The naming and labelling of objects is an important element of their

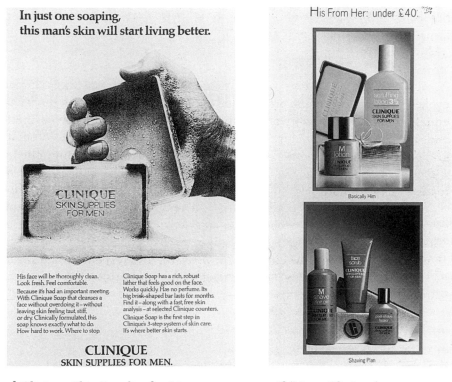

45] Clinique Skin Supplies for Men **46]** 'Merry Clinique', 1994

gender coding. The Clinique brand name is printed clearly on both the 'male' and 'female' products, the mix of clean 'modern' form with more traditional serifs connoting the quality and status that is as important to male consumers as it is to female ones. However, when used on the 'female' products the letter forms are made slightly taller, thinner and more elegant and sophisticated, in contrast to the thicker, bolder and somewhat squat form used on the 'male' products.

Because the 'female' products are well established, the label 'Clinique' suffices but the company decided that this was not sufficient in the case of the men's range. To distance and differentiate the 'male' products from the female world of cosmetics and toiletries, the sub-title of 'Skin Supplies For Men' was added to the brand name. 'Skin supplies' suggests a physical and commercial world rather than one of narcissism and pleasure. 'Supplies' suggests an organised system of necessary feeding, even a health or life-giving activity. The whole term is 'up-front' in that it openly acknowledges the

connection with the skin but it shies off any references to the beautification of that skin that the use of the Clinique brand name carries through its association with women's cosmetics and toiletries. The new range is the one which has to be self-consciously gendered by the addition of a sub-title to the existing brand name; by contrast, the 'female' products do not need to stipulate their gender with a sub-title; they are already culturally placed within the female sphere. In some cases the letter M is used to further emphasise that they are Male products. In addition, each product bears a further label, identifying it as 'Cream Shave' or 'Face Scrub'. The coyness of avoiding the word 'moisturiser' by referring to a face moisturising lotion as the 'M Lotion' counteracts somewhat the 'rationality' and apparent matter-of-factness of the advertisement which promotes it. When it comes to face shaving – a more acceptable and highly masculine activity – however, a shaving gel can be called a shaving gel – or at least a 'Clinique For Men M Shave Aloe Gel' (at Clinique prices one expects, and gets, a bit of class). Female products which are readily recognisable, such as lipsticks or blushers, are not given individual identifying labels but others are. For example, Clinique specify 'Wash-Away Gel Cleanser', 'Rinse-Off Foaming Cleanser' and 'Clarifying Lotion' (further graded by numbers), but none of them need to be labelled as 'For Women'.

Language undoubtedly plays an important role in the gender coding of Clinique products. Names such as 'Cream Cleanser' and 'Foaming Cleanser' are soft and sensual whilst playing upon notions of purity and cleanliness. By contrast, the names of the male products, such as 'Face Scrub' or 'Scruffing Lotion', incorporate more rough, tough and vigorous qualities, in an attempt to validate the products within a range of masculinities acceptable to the type of purchaser (male and female) the firm wishes to attract.

In the 'male' advertisements reference is continually made to 'his', 'him' or 'this man', the use of the 'third person' suggesting that the product is being sold to another person, as opposed to being sold directly *to* him. It is acknowledged by cosmetic and toiletry companies that the majority of their male products are bought by women for male partners, lovers, friends or relatives – a gendered relationship of 'giving' directly addressed in the 'Merry Clinique' leaflet produced by Clinique for the Christmas season 1994. In that leaflet there are a variety of headings relating to 'female' products, none of which refer to gender as they classify the gifts according to price (from under £20 to £55). The 'male' products (which occupy one page as opposed to eight for the others) appear under the caption 'His From Her: under £40' [46].

In conclusion, it would appear that although the production and use of

male toiletries are evidence of the blurring, if not breaking down, of what have been rigid gender boundaries in the 'touchy' area of male cosmetics, the advertising and packaging practices which distinguish between Clinique's 'male' and 'female' products draw heavily on gender stereotypes based on binary oppositions. Indeed, the very breaking down of such well-entrenched boundaries and with them certain gender stereotypes ('real' men don't use aftershave, let alone use aloe shaving gel!) may well have been accelerated by the use of stereotypes in product promotion. The anxieties aroused by the adoption of what some have seen as quintessentially 'feminine' products, i.e. cosmetics and toiletries, by men are real and complex and the advertisements discussed here offer ways for men – and women – to negotiate them. Products deemed to be in the female sphere need legitimating before entry into the male arena. The Clinique advertisements, through an astute combination of visual and literary devices, not only suitably distinguish the one gendered product range from the other but also suitably masculinise hitherto 'feminine' products.

NOTES

1 G. Dyer, *Advertising as Communication* (London: Methuen, 1982), p. 115.
2 *Ibid.*, p. 120.
3 *Ibid.*, p. 124.

Perfume: pleasure, packaging and postmodernity

THE meanings acquired by perfumes and their packagings can best be understood in terms of consumption, rather than design in the more commonly and narrowly defined sense. Or, design needs to be understood as a discourse, rather than as a language, and the emphasis taken away from objects and on to the practices, especially consumption, which provide their conditions of meaning. Unfortunately, our understanding of consumption remains extremely underdeveloped, and analyses of the imagery in perfume advertising and packaging have tended to perpetuate the assumption that consumers are passive victims of capitalist image-factories.[1] But advertising and market research are not as successful in finding markets for goods as is commonly assumed, and the abilities of consumers to behave unpredictably is hopelessly underestimated.[2] This chapter will emphasise the role of the consumer in the production of meanings for perfumes, while considering design as a source of cultural codes at the consumer's disposal.

Perfume is a fashion commodity and its gendering needs to be understood within that context. It shares with dress the potential and limitations of the body as a means of articulation and, like other fashion commodities, it represents the *contingencies* of identity – the constructedness and temporariness of selfhood. The possibilities which perfumes offer the consumer to participate in the production of social, collective identities are a consequence of the use of design as a marketing tool. These identities are arguably even more diverse and multiple than those suggested by the fashion system; perfume cannot simply be understood as a fashion accessory, it requires its own analysis. My discussion of perfume is intended to contribute to our understanding of gender as a *performance* rather than *expression*, and of identity as *practice* rather than *essence*.

Perfume packaging appears to 'move at a slower rate of development than other areas of design',[3] and the visual vocabulary which dominates most

perfume design – gold, cut glass, jewels – is not one which usually connotes sophistication in other products. But its tendency to refer directly and unashamedly to intense emotions, while most modern design assumes a more rational relationship between product and user, helps to explain its appeal. Perfume has the ability to engage even those who feel excluded from contemporary fashion, especially older and/or working-class women, or men who may refuse to wear, or feel uncomfortable in fashionable clothes, but are used to wearing, and willing to experiment with fragrances. Its status as gift, and its more private/intimate uses and connotations mean that it can acquire additional meanings distinct from those of fashionable dress.

The complexities of the fashion system exist partly because the processes of finding markets for goods are largely trial-and-error experiments which frequently fail, with designers and marketers constantly trying to grasp values and meanings which are being articulated within consumer groups. The unpredictability and inventiveness of consumers mean that the best the industry can do is provide as wide a choice as possible. In perfume, the choices are seemingly infinite, and it is the ever-expanding diversity of perfume which provides the starting point for my discussion of gender identity as necessarily plural, revealing the impossibility of a single, stable distinction between feminine and masculine.

Any politics of gender must acknowledge the current production of ambiguous and multiple sexualities if it is to represent the interests of all those who are struggling within gender relations of domination and subordination. Consumption is for most of us the only place where desires can be expressed and freedoms exercised, and therefore it is a source of power. The pleasures of consumption are not 'liberating' any more than they are a means of oppression, but they are a site of conflict. Much has been said about the 'power' of images to seduce the consumer and sell the fantasy of pleasure and glamour without delivering anything 'real', and luxury goods such as perfume are obvious targets. The point of this article is to insist that the consumer produces something real – new ways of relating as gendered subjects – and design provides the raw material.

Perfume and packaging are discussed here in terms of consumerism and mass-market fashion systems, graphics and imagery, gendered relationships with objects, and postmodern identities, in an attempt to contribute to current re-theorisations of gender. Perfume packaging will be used as evidence that specific and unprecedented (polyvalent, multiple) ways of being men and women, and of being sexual beings, are developing within contemporary culture wherein men and women are relating to commodities in quite new ways.

Consumer culture is inherently heterogeneous and unstable, its forms are sites of conflict over meanings, rather than or as well as a means of reproducing values as in a traditional culture. While consumer culture is not 'democratised' (there is dominance and subordination), neither is it monolithic; there is no stable or 'dominant' ideology of femininity or masculinity or of gendered sexuality. Capitalism depends on the continual transformation of human needs.[4] This is true of the body itself, which is the subject of constant controversy over presentation and representation, and of commodities such as clothing and cosmetics which are used in those processes.

Earlier phases of capitalism transformed the ways in which men and women related to each other, by 'masculinising' the sphere of production and 'feminising' that of consumption. Despite the historical specificity of these economic and social relations, they have been used as the basis for theorisations of gender which tend towards a fixed opposition between (narcissistic) 'feminine' identification with commodities and (voyeuristic) 'masculine' objectification of them. These opposed ways of relating to commodities have, until recently, been seen as the cultural interpretation of natural/biological sex, e.g. through the use of Freud and Lacan in media and design studies (especially the concept of 'the male gaze'). But capitalism's transformation of relations is ongoing. The market economy never fixes gender relations in the way that these theories of gender imply, and capitalism's current dependence on expanding consumption requires an increasingly complex involvement by women in consumption – one differentiated by age and ethnicity as well as class – and also that men become actively engaged in it.

The historical gendering of identification (narcissism) and objectification (voyeurism) was specific to a particular phase of capitalism's development, and was never absolute. It was partial and incomplete; feminine objectification and masculine identification were disavowed rather than eradicated.[5] During the last two decades, women have been addressed as increasingly voyeuristic (e.g. the growth in pornography and striptease for female audiences), and men as increasingly narcissistic (e.g. fashion and body maintenance for men), therefore objectification cannot be simply understood as a 'masculine' way of relating to objects and identification as a 'feminine' way. This is not to say that gender distinctions are collapsing – women and men objectify and identify in different ways by using different knowledges and skills – rather that gender relations are changing, that the sex–gender system is becoming more complex. It also implies changes in the gendering of designed objects.

The dichotomy between objectification and identification prevents us

from recognising the ways in which men and women defy established ways of being gendered.[6] Recent attempts to theorise beyond this dichotomy propose that gender is the discursive means by which sex is established as pre-discursive/natural, and that gender is radically independent of biological sex.[7] Suzanne Moore has argued that 'while it is crucial to treat women's pleasure as distinct from men's, we must avoid discussing both as though they were fixed outside social conditions'. Similarly, Elizabeth Wilson has warned against the tendency to replace 'nature' with other pre-social drives as in psychoanalytic theories of gender.[8]

Gendered ways of relating to commodities, and the pleasures and meanings which are conferred on those objects when they are consumed, need to be seen against widespread social and cultural changes involving sexual and political discourses, in this case those which follow from the massive increase in consumption since the end of the Second World War. These range from the expansion of service industries and women's labour, and the structural change of familiar gender roles, to infiltrations of homosexual subculture into more mainstream areas such as television and pop music and of feminism into women's magazines and fashion.

As a fashion commodity, perfume is marketed within an increasingly complex and contradictory system for the production and distribution of designed goods. Couture fashion is a loss-making business; its purpose is to add 'cachet' to the fashion houses' licensing spin-offs – accessories and especially perfume – rather than vice versa. The fashion industry is no longer about privileged/élite pleasures but disseminated/accessible ones; it is through the former sidelines that the couture houses now make their money. 'Cachet' covers an infinite range of different meanings (in the advertisements for the perfume of that name – 'as individual as you are'). The mass-market fashion system has had to develop ways of diversifying its product into an ever-expanding range of choices and preferences, each with its own sense of exclusivity.

Consumer culture stimulates heterogeneity/diversity not homogeneity/standardisation. The breakdown of old class distinctions which has taken place during the nineteenth and twentieth centuries has not led to the democratisation of culture but, rather, the emergence of a culture which is fundamentally heterogeneous and 'conflicted'.[9] The constant need to find more markets for fashion goods has resulted in a system in which there is virtually no 'trickle down' of styles from higher to lower status groups.[10] Distinctions in style have multiplied as a result of this system, creating a culture in which consumption – the exercise of tastes and preferences –

'symbolic struggle'[11] – is not merely a 'reflection' or expression of struggles taking place at an economic level but is *the* way in which people assert their different and specific interests. Identity is an effect, not a cause, of cultural practices.

Industries themselves are divided by specific interest groups,[12] and particular consumer groups do not aspire to emulate others, even while they may have a 'proper envy' of them.[13] Ironically, attempts to defend a cultural hierarchy against the 'horizontalising' effects of consumerism, by promoting notions of 'good taste' for example, have only served to establish more battlegrounds on which meanings and values can be contested.[14] Furthermore, it is becoming increasingly clear that fragmentation applies not only to class, but to age, ethnicity, and, importantly for the purposes of this anthology, gender.

Ways of relating to objects/images depend on a variety of skills acquired in culturally specific ways. I would suggest that the development of mass-market systems, and the extensive use of design as a marketing tool, has fostered the acquisition *and combination* of two main types of consumer skills, i.e. the ability to objectify commodities, and the ability to identify with them, and that these skills have been developed, in men as well as women, enabling the articulation of polyvalent and multiple gender identities. I am arguing that objectification and identification have become interdependent skills rather than mutually exclusive or antagonistic drives and will use the consumption of perfume as a design product to exemplify this.

Packaging is not confined to its function of protecting or transporting a product. It is inseparable from it, offering the consumer increased opportunities to invest meaning in it. Most of us know that in the case of perfume the packaging costs far more than the contents, but this does not matter because the images and meanings conjured up by our consumption of the commodity are part of, indeed *are*, the pleasures it offers. The product is a 'fragrance' – but since the mass production of soaps and deodorants this can no longer be understood as having any practical function. Fragrance is a material, symbolic and visual object, an 'image'/fantasy articulating not just luxury and glamour, but a range of desires for transformed bodies, auto-erotic, sensual and socio-sexual experiences.

There are only three types of manufactured scent: floral, cypre (citrus), and 'oriental', but over 400 fragrances on the market, each with its own identity. Such diversity and distinction can only be created through design. Men's perfume tends to belong to the cypre category (although this is now changing); women's derives from all three, particularly floral and oriental. The

recent increasing popularity of scent, and the growth of diverse markets for it, provides the context for my discussion of its meanings as a designed commodity. Packaging cannot be analysed without reference to advertisements and magazines and also to the retail environment, contexts which provide some of the conditions under which the objects are interpreted and given meaning, as is clear from the recent controversy over the sale of up-market perfumes in discount drugstores.[15]

Objectification of the commodity and identification with it imply two apparently opposed aesthetics which have in the past generated distinct styles of object – functionalist self-reference and expressionist referentiality – both accommodated within Modernist design.[16] These styles have become associated with gendered products, including perfume packaging. It is not difficult to see how (fragrance) products have been gendered through the use of graphics and packaging design during the mid/late twentieth century. The 'masculinisation' of the product has drawn either on the 'machine aesthetic' to confer a 'non-styled' functional-looking appearance, using dark and neutral colours and tones, abstract, geometric and/or minimalist forms, and smooth/shiny surfaces (Dior's 'Eau Sauvage', 'Monsieur de Givenchy', and Chanel's 'Antaeus'), or on a similarly 'uncluttered' 'classical' aesthetic (Saint Laurent's 'Kouros', and Givenchy's 'Xeryus'). The 'feminisation' of the product has ranged more widely, frequently drawing on traditional 'period' and popular as well as Modernist styles. Designs have incorporated organic or illustrative forms, pastel or bright colours and tones, decorative, textural, sculptural or sensual surfaces, and symbolic references to birds, flowers, eggs, shells, fossils, landscapes, sensuous materials and precious stones (Dior's 'Poison', 'Gres', 'Cabotine', Shiseido's 'Femininité du Bois', Guerlain's 'Samsara', Givenchy's 'Amarige', Nina Ricci's 'L'Air du Temps', Lagerfeld's 'Chloe', Saint Laurent's 'Opium' and 'Dune').

It could be said that the avoidance of imagery ('Old Spice' with its sailing ship and 'Polo' with its horse and player, are exceptions) and/or decoration in the packaging of men's perfumes is in keeping with the disavowal of narcissism (as is the use of the term 'aftershave'), because it implies a detached, 'objective' rational/functionalist relationship with the object. But the use of so-called 'functionalist' design to masculinise the product has resulted in its coming to connote masculinity (therefore enabling identification), rather than 'emptying' the object of meaning as it was originally intended to do. Functionalism has become part of the repertoire of styles being drawn on in contemporary packaging, enabling the consumer to make referential links between commodities. It could also be argued that the dependence on highly

suggestive imagery in the packaging of women's perfumes suggests a cele-
bration of narcissism, because it invites an emotional 'indentification' with
the object, as well as expressing femininity and female sexuality. But the
sheer extensiveness of the references to other images and objects requires the
ability to discriminate and make qualitative judgements between competing
brands, which would be impossible without some kind of objectification.

There are examples which do not fit these opposing aesthetic groupings,
including packs for Chanel, Armani and Calvin Klein, which might be
categorised as 'androgynous'. However, any style which minimises/reduces
gender distinction can be seen as an idealistic denial of it, and the history of
androgyny in modern culture has left gender distinction intact. Indeed, it
could be argued that androgyny intensifies the boundaries as it claims to tran-
scend them. Furthermore (with the exception of Klein's 'One'), these per-
fumes are still produced in separate ranges for men and women, and the
fashion and/or lifestyle connotations elaborated through advertising imagery
also tend to restore clear gender distinctions.

'Androgynous' packaging is part of a lifestyle image in which traditional
gender roles have been challenged but it only appeals to very specific con-
sumer groups who are self-consciously 'progressive'. More radical is perfume
packaging which shuns the values of androgyny but whose consumption
reveals the performative status of gender. Dior's 'Miss Dior', Chloe's
'Narcisse', Chanel's 'Coco', Gaultier's 'Haute Parfumerie', Rochas' 'Globe',
Chanel's 'L'Egoiste', Laroche's 'Drakkar Noir', Paloma Picasso's 'Minotaure'
and Rabanne's 'XS' [47, 48] all appear to celebrate gender difference. They
can be read as hilariously and blatantly sexist, but also as ironic quotations
of stereotypes. They also allow the consumer to indulge in emotionally 'hot'
experiences which might otherwise be considered uncool or embarrassing.
This kind of packaging, or rather this way of reading it, suggests a prolifera-
tion of gendered identities through pastiche and parody. Rather than trying
to create an alternative to the gender distinctions which have already been
established through design, such design borrows and quotes from them.

That functionalism has not succeeded in emptying objects of meaning or
prevented consumers from reading what they will into objects is one reason
why the Modernist belief in universal/objective 'reality' has collapsed.
Postmodernist design is that which relies on the consumer's capacity to inter-
pret and refer to or quote from the already-imaged, so that Jean-Paul
Gaultier's torso is not a reference to a female body but to representations of
it (1950s films/pin-ups as well as Schiaparelli's 1937 bottle for 'Shocking'), and
Paloma Picasso's 'Minotaure' (signified by typography and texture rather than

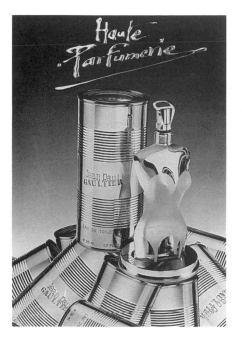

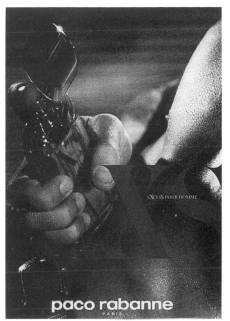

47] Gaultier perfume
advertisement

48] Paco Rabanne aftershave
advertisement

by image) refers to Pablo Picasso's metaphor for male sexuality and translates
it into a stereotypical romantic roughness and 'primitive' simplicity.[17]

Quotation and parody are forms of 'intertextuality' (reference between
one image/object and another) and as such are not features of the designed
object but a consequence of *consumer* knowledge and skill. The expansion of
consumption and the mass-market system have fostered intertextuality, in
that they have diversified the kinds of knowledges which can be mobilised in
consumption, and the kinds of pleasures which can be produced through it.
The development of design which relies on consumer knowledge/skill sug-
gests that (indeed is a consequence of the fact that) the meanings even of
'Modernist' packs are not determined/fixed by their design aesthetic/style but
by the ways in which they are consumed/appropriated.

There are many examples of perfume packaging which make reference
to already-circulated images and cultural forms; Laura Ashley's 'No. 1' refers
to William Morris textiles, 'Gala Loewe' to Goya's *Las Meninas*, Estée
Lauder's 'Spellbound' to the Hitchcock film, Guerlain's 'Shalimar' to the Taj
Mahal, Revlon's 'Scoundrel' and 'Krystle' to the soap opera *Dynasty*, 'White

Diamonds' to Liz Taylor's star-image, 'Dunhill' and 'Davidoff' to gentlemanly accoutrements, and various 'New Age' essential oils to alternative medicines. Whether consciously designed to invite such reference-making or not, the wealth of motifs, symbols and images makes it impossible to look at perfume packaging without referring to other objects. Designs incorporating images of flowers or animals (Cacharel's 'Anaïs Anaïs', Giorgio's 'Wings') or ancient/traditional patterns or symbols (Guerlain's 'Heritage' and Ralph Lauren's 'Safari') can be read as references to other images drawn from art, fashion, architecture, film, and earlier 'classic' designs, which have already been used to connote different kinds of femininity and masculinity.

This widespread use of diverse cultural references suggests a diversification of markets, not only in terms of class and/or age but also in terms of a plurality of genders and sexualities which cuts across the binary pairs masculine/feminine and heterosexual/homosexual. Such a diversity of styles means that the consumer must adopt an objectifying relation to objects in order to discriminate between alternatives, while at the same time identifying with chosen commodities in order to articulate a particular persona. Fashion has challenged the binary oppositions of gender and sexuality before, but current developments are quite different from the supposedly subversive 'blurring' of distinctions or ambivalent androgyny of the past, because in many ways gender differences are being amplified and celebrated – albeit with irony.

Although the postmodernist object has been attributed with certain textual characteristics (eclectic, nostalgic, ironic, etc.), postmodernist design cannot be defined in terms of style. While there may be some point in distinguishing between Modernist designers and their postmodernist counterparts, in terms of groupings/alliances around shared values, there is little point in categorising their work as either Modernist or postmodernist, not least because eclecticism allows Modernist designs to be appropriated within a postmodernist aesthetic. Within fashion history, for example, the work of Modernists – Poiret, Chanel, Klein, Yamamoto (all functionalists); Balenciaga, Givenchy, Miyake (formalists); Schiaparelli, Kawakubo (avantgarde innovators) – can all be read as postmodern, by emphasising particular characteristics such as Poiret's exoticism, Chanel's dandyism, Givenchy's populism, Schiaparelli's playfulness. By the same token the work of postmodernists – Hamnett, Gaultier, Westwood, Lacroix, Moschino, Gigli, Versace, Margiela, etc. – can be said to display Modernist tendencies, especially in their romantic attachment to transgression: certainly there's nothing 'late/post' about either revivalism or deconstruction.

Postmodernist design cannot be understood in terms of textual strategies, or design as language, but rather in terms of discursive practices engaged in by consumers as well as producers.[18] The 'Modernist classic', such as the Chanel suit, or the 'Eames chair', is a product of postmodern consumption not of Modernist design language. Their packaging and merchandising through advertising, retailing and various marketing strategies has enabled inadvertent symbolism to undermine Modernist rationalism. This is not to devalue the achievements of designers but to emphasise their ability to enter into a dialogue with consumers through their work, and to expand the definition of design practice accordingly. Poiret, Chanel and Dior developed a system of franchising and licensing which enables us to use perfume to engage with the style games of high fashion. Supposedly 'androgynous' packs can signify a *certain kind* of femininity, understated and elegant, which we associate with, say, Chanel. 'Miss Dior' was the accompaniment to the New Look and its original late-1940s packaging has recently been reintroduced – suggesting a very different kind of femininity; not demure or restrained but frivolous and excessive, retro and ironic.

The postmodern 'aesthetic' is a way of relating to objects which requires a rich combination of consumer skills, involving the ability to objectify and to identify with objects. This integration of skills enables a very particular mode of presentation of self. There are certain similarities between postmodern and pre-modern forms of self-stylisation,[19] but I would argue that it is mass-market systems, specific to 'late' capitalism, which make possible what has been referred to as 'masquerade', i.e. the practice of self-production which depends on an interdependence between objectification and identification.

As a plurality of ways of life supported by and essential to late capitalism, contemporary culture is 'promiscuous', testifying to the 'instability and mutability of identities which are always unfinished, always being remade'.[20] It depends on transformation, rather than replication, for its survival. Within such a culture identity is a practice, and need not be stable/coherent for it to be real. Indeed, shifting images are increasingly identified with – as Madonna's success would suggest. Identity is multiple, and 'gender is an identity tenuously constituted in time, instituted in an exterior space through a *stylised repetition of acts*'.[21] Identities are not 'absolute'; 'hybrid' identities are produced through identification with 'the other'. Self-surveillance, such as body maintenance and adornment, is a consequence of disciplinary power, but never merely an effect of it – it generates *social* (differentiated) selves. Practices of self-monitoring are highly differentiated because knowledges

and pleasures are; marketing industries stimulate diverse cultural codes, partly through packaging design, which, however inadvertently, guarantee this. Masquerade is not about concealment/deception but about licence to behave in otherwise prohibited ways, allowing the production of a plural/contradictory self. This way of relating to objects requires both objectification and identification and involves the masquerading subject/ body – not 'losing yourself' in the intensity of sensual experience (for which one needs a distanced self to lose) but objectifying desire for *and* emotional/bodily identification with commodities; for example, autoerotic dancing to music, crying at films, 'falling in love' with clothes, for which one needs consumer skills and through which you (re)produce your self. This is the self who consumes perfume – able to act out personae through the use of commodities. Since consumer skills are always shared, this self is always social and collective.

Styles do not express specific, stable or coherent identities. They are appropriated by groups in contingent and temporary ways. The mid-1980s middle-class, thirtysomething 'new New Look' was not a 1950s 'revival' but a post-power-dressing exploration of feminine identities in relation to work and the family. Early-1990s 'sexy' fashions were not irresponsibly 'provocative' but a post-AIDS exploration of the autoerotic and women-orientated possibilities of 'fetishistic' clothes. We must get away from the idea that fashion is to do with 'self-expression'. It is a meaningless, tautological concept which limits our understanding of the uses of design, and encourages spurious distinctions between those who are able to express themselves and those who are 'repressed' or 'fashion victims'. We do not choose our identities in a post-modern society any more than in any other[22] but we do inhabit multiple/contradictory/changeable identities, and it is not deterministic to insist on the historical and economic specificity of the cultural codes which enable this.

Intertextuality is commonplace in perfume packaging, as already mentioned. Women's perfumes can connote the full gamut of personae, from 'Evil' to 'Angel'.[23] Despite the vast choice of perfumes available to them, some women choose to wear men's perfume, particularly at work, a fact not unnoticed by Giorgio Armani who produced 'Gio' – a 'men's cologne' for women. The male consumer's knowledge of and pleasure in his own body has been made possible (not prohibited) by cultural mediation.[24] This is the production of masculinity, even of maleness. The consuming subject's capacity for differentiated meaning production is *nurtured* as a consequence of the penetration of the market into 'private' areas, whether the body, personal rela-

tionships, or domestic arrangements. The masculinities currently being produced by men through the consumption of fashion goods are *real*.

Such diversity and ambiguity suggest that women and men are not 'expressing' their personalities or identities by wearing perfume, but are inventing/producing themselves, as heterogeneous and contradictory subjects, by using perfumes to refer to/quote from already circulating images of femininity and masculinity. Today, virtually every established fashion designer has her/his own fragrance, which means that perfume can articulate as many different values and attitudes as fashion. Recent additions to the perfume market include those from Miyake, Ungaro, Lacroix, Claiborn, Herrera, Charles Jourdan, Dolce & Gabbana [49], Lagerfeld, Bijan, Versace, and Joop. While perfume is an 'accessory' to current fashions (Chanel's 'Cristalle' was recently 'updated'),[25] it is not expected to change seasonally but to represent a designer's style/trademark, and therefore a consumer preference or taste. Those sufficiently established to have a range of fragrances are not competing with themselves, since the consumer is expected to wear different fragrances for different situations/activities, just as s/he does clothes, in order to 'be' the different people their circumstances demand or permit.

This 'parodic practice' is not the concealment of a 'true self' but the invention of multiple selves. Prior to, and continuing alongside, the individual's engagement with fashion discourse, the 'self' has already been produced through the acquisition of skills in language and behaviour within the con texts of the family, education, exployment, etc. There is no 'pre-discursive' self to be concealed. Foucault has argued that, while the body is produced and constructed through various disciplines, all forms of control generate rebellion, and power operates from below.[26] Judith Butler has related this more specifically to gender, by emphasising the body as a construction rather than as a passive medium and by focusing on the ways in which prohibition generates fantasy.[27] Consumption is an engagement with design as a discourse, through which the consumer engages in disciplinary practices and the (re)deployment of sexuality through the body as a site of struggle.

Packaging offers the opportunity to read into perfumes. Any particular meaning which a perfume may be said to have is not as important as the practice of using design to make meanings, because this is how perfumes deliver the fantasy, by engaging the consumer in a meaning-making process. Unlike other fashion commodities, perfume is often bought as a gift; indeed, 60 per cent of men's fragrances are bought by women. The commodity-gift has multiple functions and meanings. It establishes or reaffirms symbolic bonds

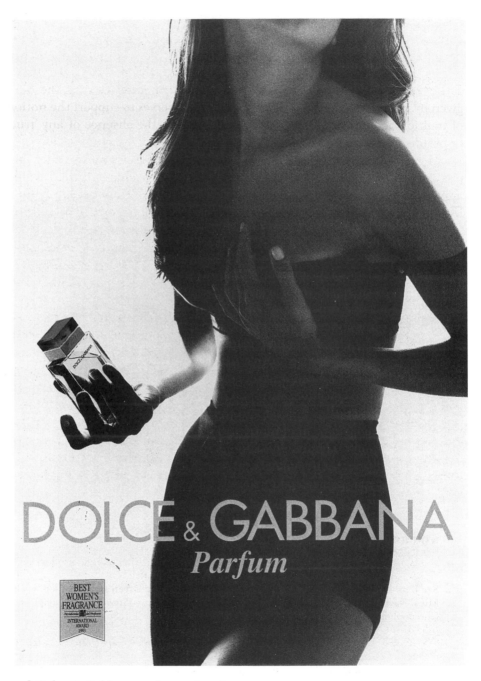

49] Dolce & Gabbana perfume advertisement

between individuals and objectifies social relationships but, at the same time, carries meanings from the broader cultural context into the domain of the personal and intimate. Gift-giving often highlights the multiplicity of identities by creating distinctions in the ways an individual is perceived by others. The fact that women buy different perfumes for themselves than the ones given by lovers, or indeed by friends or relations, serves to support the notion of multiple identities. This multiplicity dramatises the absence of any 'true' or pre-discursive self.

Feminism's traditional opposition to fashion is based on the belief in a pre-discursive femaleness which is distorted by patriarchal culture. I would argue that positive engagement in fashion is on the contrary necessary for a feminist position. The task of the feminist critic is to recognise and affirm any engagements in practices, such as the everyday consumption of designed goods, which celebrate the *absence* of any pre-discursive natural femaleness. The consumption of perfume maximises gender polyvalence, extending the range of personae beyond that of dress and throwing the terms 'masculine' and 'feminine' into chaos.

New mythologies are growing up around the body, and attitudes to 'interfering with nature' are changing; plastic surgery, despite or because of continued controversy, is becoming more and more normal. There is a postmodern fear of 'natural' bodies ('illness as metaphor' marks Cronenberg's and other horror films) and a celebration of the simulated body as egalitarian, even humanistic (*Blade Runner*, *Robocop*, *Terminator 2*, cyberculture). The contructedness of identity does not mean the end of feminism, but that feminism depends on engagement in the practices of construction; there is no politics outside discourse. Feminism must locate strategies enabled by those constructions, to affirm the local possibilities of participating in acts which constitute identity.

NOTES

1 For example, Robert Goldman, 'Marketing fragrances: advertising and the production of commodity signs', *Theory, Culture and Society*, 4 (1987), pp. 691–725.
2 See John Fiske, *Reading the Popular* (London: Routledge and Kegan Paul, 1989), p. 5, also Mica Nava, 'Consumerism and its contradictions', *Cultural Studies* 1(2) (1987), and Christopher Lorenz, *The Design Dimension* (Oxford: Blackwell, 1986).
3 Julia Thrift, 'Sweet smell of excess', *Eye*, 13(4) (1994), p. 37.
4 See Martyn J. Lee, *Consumer Culture Reborn: The Cultural Politics of Consumption* (London: Routledge and Kegan Paul, 1993).
5 See Angela Partington, 'The gendered gaze', in Nancy Honey (ed.), *Woman to Woman* (Bath: Hexagon, 1990).

6 See Lorraine Gamman and Margaret Marshment (eds.), *The Female Gaze: Women as Viewers of Popular Culture* (London: The Women's Press, 1988), pp. 5–7.

7 See Judith Butler, *Gender Trouble* (London: Routledge and Kegan Paul, 1990), pp. 6–7.

8 Suzanne Moore, 'Here's looking at you, kid', in Gamman and Marshment, *The Female Gaze*, p. 57; Elizabeth Wilson, 'Psychoanalysis: psychic law and order?', in *Hidden Agendas* (London: Tavistock, 1986).

9 Jim Collins, *Uncommon Cultures: Popular Culture and Postmodernism* (London: Routledge and Kegan Paul, 1989), p. 5.

10 See Angela Partington, 'Working-class affluence and popular fashion', in Juliet Ash and Elizabeth Wilson (eds.), *Chic Thrills* (London: Pandora, 1992).

11 Pierre Bourdieu, 'The aristocracy of culture', *Media, Culture and Society*, 2(3) (1980).

12 See Wally Olins, *Corporate Identity* (London: Thames & Hudson, 1989).

13 Carolyn Steedman, *Landscape for a Good Woman* (London: Virago, 1986), p. 123; see also Mary Douglas and Baron Isherwood, *The World of Goods* (Harmondsworth: Penguin, 1978).

14 See Judy Attfield, 'Inside pram town', in Judy Attfield and Pat Kirkham (eds.), *A View From the Interior: Feminism, Women and Design* (London: The Women's Press, 1989).

15 Towards the end of 1993, certain perfume manufacturers refused to allow the 'Superdrug' chain to sell their products.

16 See Ann Ferebee, *A History of Design from the Victorian Age to the Present* (New York: Van Nostrand Reinhold, 1970).

17 In a television interview, Paloma Picasso said that she wanted the bottle to look 'hand-crafted'.

18 See Michel Foucault, *The Archaeology of Knowledge* (London: Tavistock, 1972), pp. 46–9.

19 Mike Featherstone, *Consumer Culture and Postmodernism* (London: Sage, 1991), pp. 101, 125.

20 Paul Gilroy, *The Black Atlantic* (London: Verso, 1993), p. ix.

21 Butler, *Gender Trouble*, p. 140, emphasis in original.

22 See Elizabeth Wilson, 'These new components of the spectacle: fashion and postmodernism', in Roy Boyne and Ali Rattansi (eds.), *Postmodernism and Society* (London: Macmillan, 1990).

23 See Patricia Storace, 'Two faces of beauty', *Allure*, March 1991, and Tina Gaudoin, 'Why men wear scent', *Marie Claire*, November 1992.

24 See Moore, 'Here's looking', also Rowena Chapman and Jonathan Rutherford (eds.), *Male Order: Unwrapping Masculinity* (London: Routledge and Kegan Paul, 1988).

25 See Anna-Marie Solowij, 'Making scents', *Elle*, May 1993.

26 See Michel Foucault, *The History of Sexuality vol. 1* (Harmondsworth: Penguin, 1978), pp. 92–7.

27 See Butler, *Gender Trouble*, pp. 29–33, 47–53.

Memory and objects

AFTER a recent bereavement I found myself pondering on the aesthetics of absence, of the absence of the person, not merely from the image but permanently. For me, a female bereaved observer, the ties of my partner/husband which remain after his death become the signs of the memory of the male wearer, not as icons of existing structures within society but as icons of an aesthetic which directs the observer to the possibility of an order beyond immediate comprehension. This essay offers a 'positive' view of an aesthetic of absence through looking at clothes which remain and discusses an iconography of garments in relation to memory. A collection of ties may not have the same effects on the spectator as do painting, sculpture or music, but 'memory objects'[1] can, and do, have powerful repercussions in terms of visual and emotional affectivity. Within particular contexts clothes retain a potential revelation to the observer which goes beyond meaning within the orthodox 'objective' arena of design history. It is important to relocate *feeling* within design history, particularly within fashion history – not least because clothes are *of* human beings as much as *the property of* human beings. Clothes relate to our feelings more than perhaps any other designed artefacts, and thus require 'subjective' as well as 'objective' analysis. The ways in which objects affect 'life' and have represented people's lives deserve attention. Death and its antidote – life – feature little in cultural discourses concerning the artefacts which surround us, yet after a death 'next-of-kin' live with memories embodied in objects, garments, photographs which live on when living is over for the dead; while death lives with the living.

Clothes, their smell and texture, remind the spectator of the past presence of the person to whom they belonged, their inhabiting them, a moment when they wore them – or a moment in which they removed the item of clothing. The garment becomes imbued with the essence of the person, but,

although the instigating of the memory (like a dream manifestation of the dead) can be reassuring, it can also be disquieting.

Does it trivialise a person to feel close to and/or to image even a part of them through an item of clothing? Maybe no more than through things which our culture finds more appropriate — their words in letters or their eyes in a photograph. Each is a small part of a whole which is never complete. As much can be conveyed in an accessory as in a whole garment, a coat, a suit, a shirt. Minute parts of the whole, their significance is perhaps *more* in proportion to the whole than their own minimal entity.

The coexistence of reassurance and disquiet as part of the memory sparked by an item of clothing has as its essence — mystery. It is a prompting to our conscious lives of inexplicable mysteries which exist both in present relations with living people and as reminders of people who are absent, relations with whom are only dimly remembered despite the objective reality of the item of clothing, the photograph. The interconnections between clothes as objectively worn and the subjective sensation of wearing them and seeing them being worn indicate a possible variety of identities of people in the present, and question not only how they reappear from the past into the present, from their temporary absence into the present of the observer, but also how and in what ways the images recur, and may vary in the future.

Clothes presuppose the three-dimensional human figure as well as defining its absence. In this sense all clothes, of all people globally, are of them. The incomplete shoes of the tramp become his feet (as in Magritte's *Red Model*). But they may also 'become' him like Estragon's shoes in Beckett's *Waiting for Godot*; they 'suit' him, although he has no suit to put on. They suit his present predicament of poverty but also signify his preoccupation with being earthed, existing, and yet not knowing for what he exists, or symbolically for what or for whom he waits.

Fashion designers talk of the 'feel' or 'texture' of a fabric; the fetishist of the 'feel' of rubber; others of the 'feel' of silk lingerie against the skin or soft leather shoes. Such feelings are not necessarily gender-specific; we remember them in relation to the garment and the associations remain in our lives. The 'feelings' about the wearing of clothes are androgynous but the interpretations by self and by the audience can be gender-specific. It is no coincidence that I have focused on the tie; it is precisely through a *man's death* that the existence of ties left, signifies and underlines the absence of his presence to me as *female, living* or present.[2]

It is the 'sense' of clothes conveyed to the female spectator by a predominantly male accessory in the absence of the man which I wish to discuss,

and the 'sense' the spectator may have of the simultaneously existing presence and absence of a person, within and without their clothes. I want to examine this largely unexplored aspect of fashion design history where the 'subjective' and 'objective' history of clothes and where memory and 'memory objects' meet. At what point do clothes and their history interrelate with our experience of them? The more psychologistic fashion design historians of the early twentieth century argued a direct correlation between the wearing of clothes and personal identity, and a recent postmodernist Fine Art exhibition, 'Multiple Clothing',[3] represented clothes as two-dimensional canvases with personal identities emblazoned in felt-tip either by wearer or spectator, as surface decoration on the clothes. However, what might, at first, seem perceptive in relation to the notion of identities and appearances becomes divested of meaning in the context of both dress history and people as wearers and observers. It is a more complex relationship of ideas between gender-specific clothing, the spectator and the memory of clothes within and without 'subjective' as well as 'objective' design history which I wish to pursue.[4]

> Were you afraid? Yes, no. Fear wasn't the word. It was worse. But it passed. A death had occurred – brutally. Nothingness had surged up. There was nothing left. Nothing? Almost nothing.[5]

But what is left of the one who died is not nothing. Each memory is triggered by something that *is* left, that *is* and *is* memory, *is* words, *is* a book, *is* a table – in my case by a tie and/or ties of his in his absence.

The Kantian notion of the 'Sublime' as our shared 'terror of death in life'[6] can be applied to clothes – in so far as we can recognise both the positive and negative meanings in the object. The possibility of a collective 'memory bank' of and for clothes could prove as important a part of a sentient design analysis, as a consideration of personal identity through the appearance of clothes.

Each garment or accessory entertains simultaneously opposite meanings, just as do our lives and feelings.

> Strangely joyful in your sorrow . . . And in that joy is the strange happiness of feeling yourself close to death. Death loves me. And that gentle agonising love deep in your heart is life itself.[7]

The mind works as much in a projected dissimilitude as it reacts with what is presented to be seen. However much memory knows the absence, death even, of a person, even so there is, within that knowledge, the assumed pre-existence of that person in their absence.

The associative memory of an absent person, stimulated through the viewing and/or sensing of an existing item of clothing, requires us to be

imaginative about the past, about the object or person when they did exist, and that process is positive, not sentimental, although the contemplation is of and for absence – possibly death.

'Memory is but the servant of imagination: it performs an alchemical role in soldering the reality of things to their spiritual equivalent',[8] says Julia Kristeva of Proust's *Remembrance of Things Past*. 'The abstract notion of associationism is contrasted with the genuine association based on feelings and emotions, between memories'.[9] It is through this process connecting now with the past by way of the imagination, alighting on a mere item of clothing such as the tie, that the spectator/griever can proceed from regret to a more positive comprehension of absence, in the recognition of the once present and the ability to *feel* a past human presence through the looking at the object. The ability to imagine is positive proof of one's own existence in the knowledge of the other's absence. It is precisely the telling of this process which is, I think, the importance of Proust's novel. The protagonist goes from a negative memory of the past to a more positive feeling: 'he helped me to understand how paradoxical it is to seek in reality for the pictures that are stored in one's memory, which must inevitably lose the charm that comes to them from memory itself and from their not being apprehended by the senses. The reality I had known no longer existed . . . the memory of a particular image is but regret for a particular moment'.[10] That reality becomes near the end of the novel:

> the only one that I could recall, since, of our memories with respect to a person, the mind eliminates everything that does not concur with the immediate purpose of our daily relations . . . It allows the chain of spent days to slip away, holding on to the very end of it, often of a quite different metal from the links that have vanished in the night, and in the journey which we make through life, counts as real only the place in which we are at present.[11]

For me ties act as a link to remembering a specific man who died. The memory became, through imagined moments, a recognition of a shared past, connecting, through the present reality of the tie, with the present moment, now. Thus the absence of the person, as with the 'chic' male's absent tie, indicates a possible previous presence. The absence of a thing or person may, through memory, indicate not only a previous presence but also a possible future return to the present, the now, of self – and thus a return to a life of the imagination, not merely material reality.

I have this tie-rack, I feel each tie, and look at the vibrant colours, the sheen of silkiness, the zany 1960s pop art tie, the big-patterned chintzy tie. The exuberance of ties I noticed but took for granted in the past, now reminds me

of parties, laughter, communication, a language of touch we had and which now I again experience through touching his ties. The clearest memory is precisely of him removing his tie immediately he stepped through the door, after a professional meeting. He did this partly because of its restrictive nature and partly because of its association with 'professional normality' (being a doctor and GP) – a male normality unconnected to the 'feminine' side of his leisure activities, unconnected with his wearing mascara at home. A particular tie he would tear off was blue and slightly knotty in texture, straight and squared at the base. Conventional in colour, it was unerotic to touch, wear or to look at. It was a signifier of a male respectability from which I, the female observer, was absent and in which I played no part. This tie therefore connoted female absence from a male world of GPs and consultants. It was a symbolic demarcation which barred me from physical contact and encouraged the expression of traditionally 'male' emotions, denying him his female 'other' self. It was not exciting as were his colourful or silken printed ties worn to enhance his more exuberant 'self'; a 'self' in tune with touch by the female observer, or with the appreciation of colour and 'wit' in himself.

The memory of this specific tie is of its removal; the relief at *not* having to wear a tie, particularly *it*. My memory coincides with a photographed previous reality of the absence of both: the person and the tie; yet it *is* a photograph of a person who *was*. The representation is incomplete visually, since memory is never to be visualised or compared with the 'reality' of the photograph. In abundance, these ties retain memory for me, but with the absence of the wearer they become a collage of memories, associations. They take on a different reality from the contextualised reality of their being worn. They are incomplete without their wearer yet signify an 'aesthetic' about the wearer.

In this context, my memory of a particular man coincides with the relaxing of conventional menswear and the fashionable tielessness of the 1980s. Clothes link with other forms of cultural production in their ability to be a reassuring (in terms of their presence) and yet unnerving (in terms of their only indicating a hazy past) *aide-mémoire* in their unreal or incomplete representation of the object/garment/event/landscape/person. The variations in individual and/or collective memory, as evoked by clothes, or other objects, are many and varied and design history needs to acknowledge this.

The existence of clothes presupposes their absence, just as the existence of people presupposes the absence of ourselves. 'We encounter in our death our, quite possibly welcome, fulfilment of our existence'.[12] In encountering garments and linking them with the possible collective memory people have

of both the garments in actuality and the people who inhabited them, we may open ourselves to a different and wider view of ourselves and them. Through recognition of the absence of a person, through witnessing the still remaining clothes they wore, is recognised the bereaved observer's own possible partial absence in the history of the departed 'other'. In terms of gender and the specific (gendered) looking at the remaining male ties there is the revelation that the combined past of both absent male and female present *had* a mutual past; the absent male is partially still present in the items which remain, the present female is partially absent in the history we had together.

> The feeling of sublimity is not aroused by phenomena in their immediacy. Mountains are sublime not when they crush the human being, but when they evoke images of a space that does not fetter or hem in its occupants and when they invite the viewer to become part of their space.[13]

This is not to deny that other contexts for the analysis of designed objects are important, but to assert that the changing self in relation to thought of the object as inspiration for aesthetic experience may reside as much in the viewing of the 'Applied Arts', as it does of the 'Fine Arts'.

NOTES

1 See Jennifer A. González, 'Autotopographies', in Gabe Brahm and Mark Driscoll, *Prosthetic Territories* (Boulder, Colorado: University of Colorado Press, 1994).
2 This is a different subject from that dealt with by Elisabeth Bronfen in her important study *Over Her Dead Body: Death, Femininity and the Aesthetic* (Manchester: Manchester University Press, 1992).
3 Steve Williat, 'Multiple Clothing' Exhibition, ICA, London, July 1993.
4 This idea is represented in the aesthetic of Colin Smith's painting of clothes hanging in a wardrobe, exhibited in the John Moores Gallery Exhibition, Liverpool, October 1993. Clothes are painted as sentient in the wearer's absence, and are accompanied by a text describing this process of beholding and representing clothes as an aesthetic of absence.
5 Hélène Cixous, *Angst* (London: John Calder Ltd, 1985), pp. 186–7.
6 Jean-François Lyotard, 'Complexity and the Sublime', in *ICA Documents: Postmodernism*, (London: ICA, 1985).
7 Cixous, *Angst*, p. 172.
8 Julia Kristeva, *Proust and the Sense of Time* (London: Faber, 1993), p. 90.
9 *Ibid.*
10 Marcel Proust, *Remembrance of Things Past: 1*, (London: Penguin Books, 1989), p. 462.
11 *Ibid.*, p. 1012.
12 Michel Foucault, quoted in James Miller, *The Passion of Michel Foucault* (London: Harper Collins Publishers, 1993), p. 20.
13 Theodor Adorno, *Aesthetic Theory* (London: Routledge, 1984), p. 284.

INDEX